COLOR

AND PICTURES

COLOR

A SURVEY IN WORDS AND PICTURES

FROM ANCIENT MYSTICISM
TO MODERN SCIENCE

BY FABER BIRREN

CITADEL PRESS Secaucus, N.J.

First paperbound printing
Copyright © 1963 by University Books, Inc.
All rights reserved
Published by Citadel Press
A division of Lyle Stuart Inc.
120 Enterprise Ave., Secaucus, N.J. 07094
In Canada: Musson Book Company
A division of General Publishing Co. Limited
Don Mills, Ontario
Manufactured in the United States of America
ISBN 0-8065-0849-3

To ZOE and FAY

CONTENTS

FOREWORD

Part One THE MYSTICAL BEGINNINGS

Part Two IMPACT ON SCIENCE AND CULTURE

Part Three IMPLICATIONS FOR MODERN LIFE

FOREWORD

This book has been many years in the writing. It has served as a busman's holiday for a man who has devoted a lifetime to the subject.

It is a source of unending surprise and pleasure to note how broad man's interest in color has been, how far back it goes, and how many different courses it has taken.

To explore the mysteries of color, one may follow many intriguing pathways through many fields of learning—history, anthropology, archaeology, geology, religion, mythology, mysticism, art, painting, sculpture, architecture, literature, culture, tradition, superstition, symbolism, astrology, alchemy, science, physics, chemistry, psychology, optics, medicine, natural history—and a long list of lesser areas of inquiry. All yield up information concerning color—baffling, contradictory, challenging, illuminating.

I know of no other topic quite as fascinating, emotional and personal in its impact, and though all aspects of the subject will not be of equal interest everyone will respond to something in the pages that follow. Even the blind are not immune to the magic of color.

No single volume could exhaust so far-reaching a topic, but I have sought to encompass the subject by covering virtually every one of its significant aspects. Here is food for the eye, the mind, the heart, and the spirit.

To the many who cooperated with me both in the long and arduous research and in collecting illustrations, I wish to extend my thanks. I am deeply grateful for the scholarship and profundity so freely and graciously extended to me.

FABER BIRREN
New York, 1962

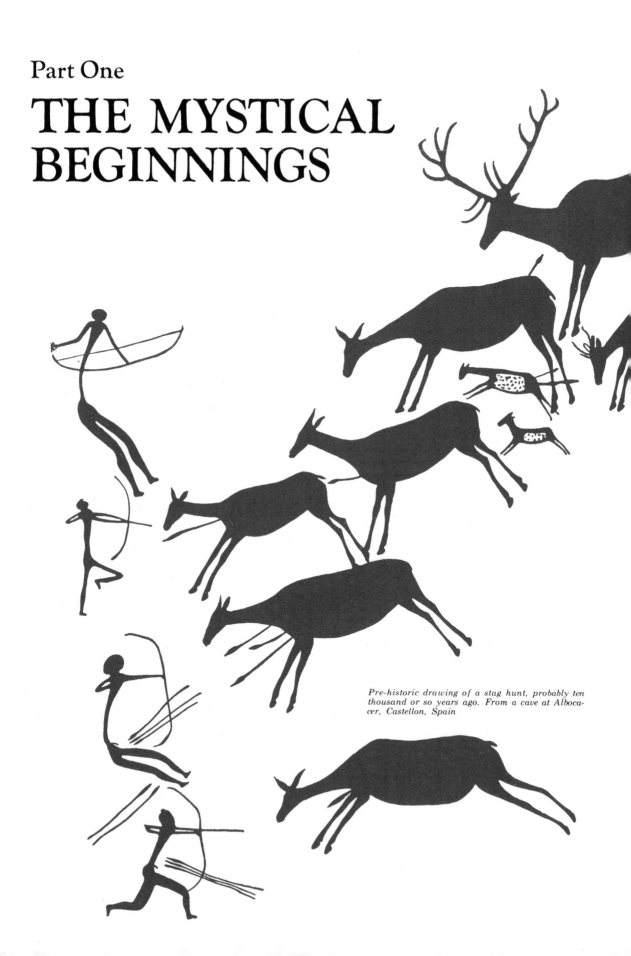

Part One
THE MYSTICAL BEGINNINGS

Pre-historic drawing of a stag hunt, probably ten thousand or so years ago. From a cave at Albocacer, Castellon, Spain

Chapter 1

OF MAN AND THE EARTH ABOUT HIM

The story of color is almost the story of civilization itself. Man's love of color is as old as his time on earth, and it is apparent in his early pottery and art. Anthropologists have reconstructed prehistoric man's appearance by the imaginative filling out of bones and skulls, but he really "comes alive" in the tools, implements and works of art which have survived him.

The cave drawings of France, Spain and Italy depict the animals that existed with man and were his food; they show his occupation with hunting and the art of healing. Dating back some ten thousand years, these paintings were executed in mineral pigments and endured through the centuries because of the constant temperature and humidity of limestone grottoes where they were found. Making pigments was an advanced art for early man. His colors, chiefly browns, blacks and reds, were made of natural clays and burnt bones.

THE MYSTIC FUNCTION OF COLOR

All nature was colored; and ancient man tried to emulate it, copy it, and symbolize it. Life and the universe were august mysteries, and color was no mere frill or decoration. It was identified with the sun, the earth, the sky, the stars, the rainbow, and therefore

related to natural and supernatural forces which had to be kept in harmony. Color had mystical import. It was a cosmic symbol looked upon with wonder and awe.

There are hazards in *guessing* what primitive man saw in color. Were the ruins of a typical American city to be excavated several thousand years from now, a naive observer might conclude that the twentieth-century American took such great delight in color that he adorned his street corners with metal columns having red, amber and green lanterns—presumably so he might be cheered as he went his way. Ancient man's use of color, as functional and symbolic as our traffic lights, has all too often been misconstrued in this fashion.

Many writers are entranced by what they see as the subtle and refined color sense of primitive peoples when, in fact, most of these peoples made no such fine distinctions. If their colors were exquisite, they were the result of the limited materials at hand. For example, when aniline dyestuffs were brought to the Indians of the southwestern United States, rugs and textiles very promptly blossomed in gaudy magentas, peacock blues and sulphur yellows. This was what the Indian had been trying to do for generations! His older robes and blankets were museum pieces and a rare pleasure to the white man's eyes; but for himself he preferred the brighter hues. Simple, pure colors seem to go with the primitive; subtle colors with sophistication.

Unlike his modern descendant, early man was little concerned with aesthetics. He was less an artist than a mystic at heart, and used color to express the ideal and mysterious rather than merely to add charm to his environment.

"The body of man is red, his mind is yellow, and his spirit is blue." With such a statement, ancient man made clear that color was an inherent part of his life, not extraneous adornment. He called himself the microcosm or "little universe" dwelling within the macrocosm or "great universe." Within his being the world itself was embodied, kept whole only as he lived in harmony with divine forces. There were gods who wrote the books of life and death, awesome secrets in the sun and stars, in the light and colors that fell from heaven and spread over the earth.

EARLY CONCEPTIONS

Nearly every trace of man dug from cavern and tomb reveals a glint of color. Unfortunately, much of the color symbolism that once was meaningful has been forgotten and archaeological findings are often wrongly interpreted. Unless early man is permitted to speak for himself—and this is made possible by translations of his hieroglyphics, cuneiform inscriptions, scrolls and papyri—the meanings he attached to color will never be truly understood.

Color was a language. Every hue had definite significance. What early man chose for his garments, artifacts, or temples had less to do with modern conceptions of aesthetics than with a sort of occult functionalism. The

An ancient Babylonian cylinder in which the Sun-God emerges from the gates at the east, turns around and retires at the West

 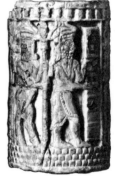

very mysteries of life prescribed his palettes, and he expected colors to protect him on earth, guide him safely to heaven, and symbolize the majesty of the universe.

In the Hindu Upanishads, it is written of man: "There is in his body the veins called *Hita,* which are as small as a hair divided a thousandfold, full of white, blue, yellow, green, and red. . . . Symmetry of form, beauty of color, strength and the compactness of the diamond constitute bodily perfection." And, not without a sense of humor, some ancient scribe added, "Man is like a pillow case. The color of one may be red, that of another blue, that of a third black, but all contain the same cotton. So it is with man— one is beautiful, another is black, a third holy, a fourth wicked, but the Divine One dwells within them all."

Races of men have always been proud of the colors of their skin. Darwin wrote, "We know . . . that the color of the skin is regarded by the men of all races as a highly important element of their beauty." Long before the rise of Western civilizations, when the so-called white man was still a barbarian, the civilized peoples of Northern Africa and Asia Minor—Egyptians and Aryans—considered themselves of the red race and were proud of the distinction.

Thus, one of the first uses of color centered on race. Extreme redness for the Egyptians, whiteness for the peoples of the North, yellowness or goldenness among Orientals, extreme blackness among Negroes, became emblems of the perfect racial type.

Here, perhaps, one finds the origin of cosmetics: not alone to enhance beauty, but to emphasize racial differences. Egyptians used henna to stain their bodies red. In most of their art forms, red was exaggerated where they were portraying themselves. The American Indian, popularly recognized today as the true red man, also idealized red. The Pawnee priest chants, "The Morning Star is like a man; he is painted red all over; that is the color of life."

Red became at once the most significant of colors. It dominated the cultures of the nations that rose along the Nile in Northern Africa, and along the Tigris and Euphrates in Asia Minor.

As the centuries passed, the use of color to identify race became more symbolic of a nationality than a mere literal reference to skin color. In the "Tale of the Ensorcelled Prince" from the *Arabian Nights,* for in-

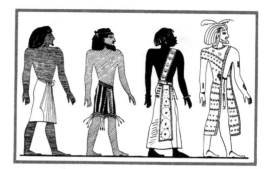

The four races of man according to the Egyptians: red, yellow, black and white

stance, the evil wife of the Prince casts upon the inhabitants of the Black Islands this spell: "And the citizens, who were of four different faiths, Moslem, Nazarene, Jew and Magian, she transformed by her enchantments into fishes; the Moslems are the white, the Magians red, the Christians blue, and the Jews yellow." And in modern times, the first flag of the Chinese Republic had five horizontal stripes with this symbolism: red for Manchurians, yellow for Chinese, blue for Mongolians, white for Mohammedans and black for the people of Tibet.

The art of jewelry, like that of cosmetics, had its origin in mysticism. Rings, necklaces, and bracelets might enhance appearance, but essentially they protected the wearer from harm, disease and the evil eye, or they brought favor from the gods.

Unlike modern artists who may express themselves in a personal way, the ancient set his own feelings aside and adhered to the dictates of the Mysteries. His "taste," in the modern sense, cannot be judged separate from his intentions. The Egyptian understood in his heart each tint he employed. Purple, for example, was the color of earth to him. It was a token of the baser qualities of nature which, in turn, were the foundation of the higher human qualities of patience and endurance. The amethyst became the talisman of the warrior and gave him moral courage and the necessary calm to insure victory. Temple ceilings were usually blue and embellished with drawings of the constellations. Floors were often green or blue, like the meadows of the Nile. Art spoke a universal language, generously shared and universally comprehended, because virtually all color expression had to adhere to what priests and mystics looked upon as divine necessities. The Mysteries had to be served.

The Tibetan World Mountain. Its sides had colors that shone like jewels, and on each side were people with faces of different shapes

THE FOUR CORNERS
OF THE EARTH

Nearly every race and civilization has had definite ideas about color in relation to the points of the compass.

Among the peoples of Tibet, the world was thought to be a high mountain. From the beginning of time, the earth grew until its summit rose to a height beyond the reach of man, and provided a dwelling place for the gods. An ancient legend relates: "In the beginning was only water and a frog, which gazed into the water. God turned this animal over and created the world on its belly. On each foot he built a continent, but on the navel of the frog he founded the Sumur Mountain. On the summit of this mountain is the North Star." The Tibetan world mountain is shaped like a pyramid with its top broken off. The sides facing the four points of the compass are colored and shine like jewels. To the north is yellow, to the south blue, to the east white, to the west red. In each of these directions is a continent in a salty sea. The continents and islands have shapes resembling the faces of the people who dwell upon them. The people to the south have oval faces; those to the north square faces; those to the west round faces; the faces of those to the east are crescent shaped.

Such color symbolism for the points of the compass has been found in lands as remote from each other as Egypt and Ireland, China and America. In Ireland, north is black, south white, east purple, and west dun-colored.

In China, there are heroic guardians as well as colors. Mo-li Shou, the guardian of the North, has a black face. He carries a bag containing a creature that assumes the form of a snake or of a white, winged elephant, and devours men. Mo-li Hung, guardian of the South, has a red face. He holds an umbrella of chaos. At its elevation, there is universal darkness, thunder and earthquake. Mo-li Ch'ing, guardian of the East, has a green face; his expression is fierce and his beard like copper wire. When he waves his sword, it raises a black wind whose countless spears pierce and destroy the bodies of men. Mo-li Hai, guardian of the West, has a white face. At the sound of his guitar, all the world listens, and the camps of his enemies take fire.

To the Western mind, these figures may

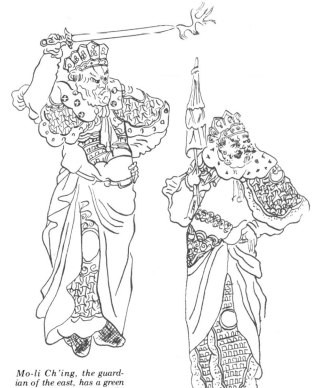

Mo-li Ch'ing, the guardian of the east, has a green face. His expression is ferocious and his beard like copper wire. With his magic sword, "The Blue Cloud", he causes a black wind which produces tens of thousands of spears to pierce and destroy the bodies of men

Mo-li Hung, the guardian of the south, has a red face. He holds the umbrella of chaos, at the elevation of which there is a universal darkness, thunder and earthquakes

Mo-li Shou, the guardian of the north, has a black face. Within his bag is a creature that assumes the form of a snake or white winged elephant and devours men

Mo-li Hai, the guardian of the west, has a white face. At the sound of his guitar all the world listens and the camps of his enemies take fire

seem quaint, but they are hardly more involved with superstition than the saints in modern churches. Modern man has not given up his belief in divine powers nor his confidence that saints will intercede for his personal welfare on earth and for his salvation in the hereafter. And the color blue, as associated with the Virgin Mary, reflects an ancient attitude.

In America, the Apache, Cherokee, Chippewa, Creek, Hopi, Pueblo, and Zuñi Indians all identify colors with the four quarters of the earth. According to Navaho legend, the tribe once lived in a land surrounded by high mountains which rose and fell to regulate day and night. The eastern mountains were white and made the day; the western mountains were yellow and brought twilight. The northern mountains were black and covered the earth in darkness; and blue mountains to the south evoked the dawn.

The American Indian also has color designations for a nether world, generally black, and an upper world of many colors. Such symbolism is an intimate part of his art. The tattooing on his face, the colors of his masks, effigies, huts, are full of significance. He applies the hues of the compass to his songs, ceremonies, prayers and games to invoke rain, fertility, abundant harvest, peace and victory over his enemies.

Even today, in executing a dry painting, or sand painting, the Hopi is a mystic before he is an artist. His designs come not from his imagination alone, but from his memory of tradition. Religiously, he first places his yellow color, which represents the north; then, in order, he places the green or blue of the west, the red of the south, and the white of the east.

To the American Indian, red always symbolizes day and black night. Red, yellow and black are masculine colors; white, blue, green are feminine. To the Cherokee, red signifies success and triumph; blue denotes tribulation and defeat. White is for peace and happiness, black for death. Prayer sticks are bright with green to call the rain, and livid with red in time of war.

Across the world, in Tibet, the very moods of human beings have a mystical relationship to color. White and yellow complexions portray a mild nature; red, blue and black fierce natures. Light blue is celestial. Gods are white, goblins red, devils black.

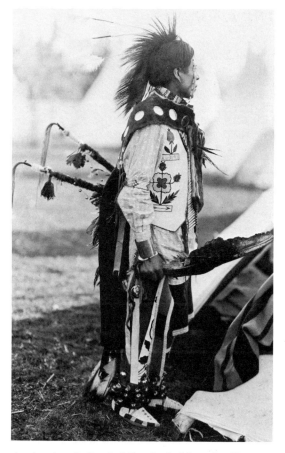

An American Indian in full and colorful regalia. The colors of everything he wore had mystical significance

An American Navajo Indian executing a sand painting. These were drawn in specified colors to please good spirits and heal the sick

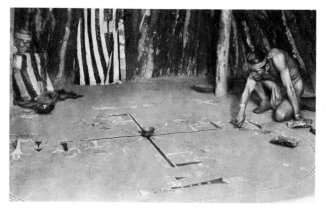

THE ELEMENTS

Early concepts of color progressed from the regions of the earth to the substance of things on it. The concepts of "ether" and "atoms" are almost as old as history, and ancient man spoke in terms of elements that are described today as electrons, neutrons and protons. Color played its role in his theorizing. It was perhaps natural to look upon the sun as the creator and sustainer of life, and the sun was God. From the sun came color, and color therefore had magic importance.

One of the earliest references to the world as made up of elements is in the Upanishads. Here is an intriguing quotation:

"Of all living things there are indeed three origins only, that which springs from an egg, that which springs from a living being, and that which springs from a germ. . . . The red color of burning fire (agni) is the color of fire, the white color of fire is the color of water, the black color of fire is the color of earth. Thus vanishes what we call fire, as a mere variety, being a name, arising from speech. What is true is the three colors (or forms). The red color of the sun (aditya) is the color of fire, the white of water, the black of earth. Thus vanishes what we call the sun, as a mere variety, being a name, arising from speech. What is true is the three colors. The red color of the moon is the color of fire, the white of water, the black of earth. Thus vanishes what we call the moon, as a mere variety, being a name, arising from speech. What is true is the three colors.

"Great householders and great theologians of olden times who knew this have declared the same, saying, 'No one can henceforth mention to us anything which we have not heard, perceived, or known.' Out of these (three colors or forms) they knew all. Whatever they thought looked red, they knew was the color of fire. Whatever they thought looked white, they knew was the color of water. Whatever they thought looked black, they knew was the color of earth. Whatever they thought was altogether unknown, they knew was some combination of these three beings (devata)."[1]

That the world is comprised of elements, colored or at least symbolized by color, was a view universally held by man for possibly four thousand years, up to the birth of modern science in the sixteenth and seventeenth centuries. This is true in the Orient as well

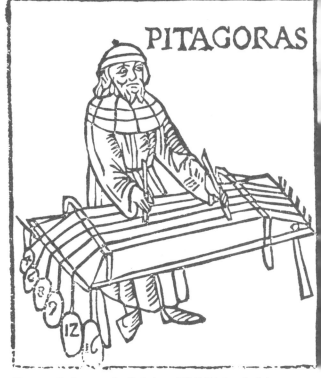

The great Pythagoras (he died about 497 B.C.) described the shapes of the elements and invented the diatonic scale in music. From an old engraving, 1492

as in the West. Since American Indian tribes also relate color to the elements of fire, wind, water and earth, the concept was obviously world wide.

In Greek science, despite the apparent complexity of the universe, the endless variety of all matter, living and dead, Pythagoras posited just four basic elements: earth, water, fire and air. He gave profound study to this doctrine and developed geometric forms to express it.

SYMBOLS AND BELIEFS

It was Pythagoras' discovery that only five basic geometric forms exist whose sides are all equal. Earth particles are cubical, this being the most stable of forms. Air particles are octahedral (a double pyramid), fire particles tetrahedral (a single pyramid), and water particles icosohedral (similar to the cut of a diamond). The fifth solid, a dodecahedron, composed of twelve five-sided faces, is the most complex form and is related by Plato to the deity who employed it "in tracing the plan of the universe." It is more likely, however, that it symbolized the fifth element of the Greek Mysteries, the ether. It permeated all the elements, and its twelve

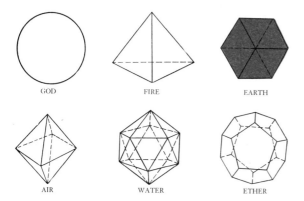

GOD FIRE EARTH

AIR WATER ETHER

The five solids of Pythagoras which were an essential part of science for many centuries

faces related to the Zodiac and to the Twelve Immortals who were thought to people the earth with all animate and inanimate things. The sphere, perfect among all symmetrical solids and the shape of the sun, was reserved for the principal deity, the god of all gods.

These elements were identified with colors. While the early Greek exact tint desig nations are unknown, it may be assumed from the writings and drawings of later scholars that earth was blue and represented man; water was green and represented the world; fire was red and represented the spirit; and air was yellow and represented the person. The sphere of the deity was white, the unity of all colors.

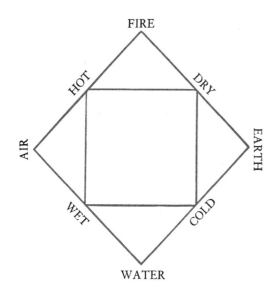

Aristotle's four elements and qualities

Two centuries after Pythagoras, Aristotle left a more precise color record. In a special treatise on color (sometimes attributed to a disciple named Theophrastus) is the following: "Simple colors are the proper colors of the elements, i.e., of fire, air, water and earth. Air and water when pure are by nature white, fire (and the sun) yellow, and the earth is naturally white. The variety of hues which earth assumes is due to coloration by tincture, as is shown by the fact that ashes turn white when the moisture that tinged them is burnt out. It is true that they do not turn a pure white, but that is because they are tinged afresh, in the process of combustion, by smoke, which is black. . . . Black is the proper color of elements in process of transmutation. The remaining colors, it may easily be seen, arise from blending by mixture of these primary colors."[2]

This doesn't make much sense today, but the great Aristotle's conclusions survived for centuries. His theory that all colors were "blends of different strengths of sunlight and firelight, and of air and water," was championed for generations and stoutly defended by Goethe against the truer insight, and proof, of Isaac Newton two thousand years later!

Josephus, the great Jewish historian who lived in the first century A.D., attempted to explain the command of the Lord to build a tabernacle and perhaps ally it with the Greek conception of the elements. The Lord had commanded: "Moreover thou shalt make the tabernacle with ten curtains of five twined linen, and blue, and purple, and scarlet; with cherubims of cunning work shalt thou make them." Josephus interpreted the Lord's command as follows: "The veils, too, which were composed of four things, they declared the four elements: for the plain (white) linen was proper to signify the earth, because the flax grows out of the earth; the purple signified the sea, because the color is dyed by the blood of a sea shellfish; the blue is fit to signify the air; and the scarlet will naturally be an indication of fire."

In China, five elements were recognized: earth, water, fire, wood and metal. Water was black, produced wood, but destroyed fire. Fire was red, produced earth, but destroyed metal. Metal was white, produced water, but destroyed wood. Wood was green, produced fire, but destroyed earth. Earth was yellow, produced metal, but destroyed water.

17

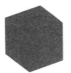

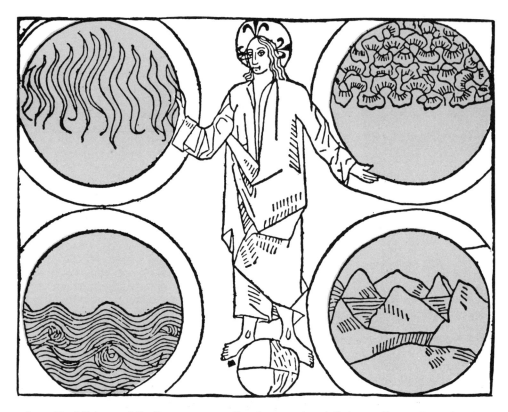

To the ancient Buddhists of India, man himself was a product of colors and the elements: the yellowness of earth, the blackness of water, the redness of fire, the greenness of wood and the whiteness of metal. Man is described in all his curious make-up in the following amusing quotation from ancient Buddhist Scriptures, *The Visuddhimagga:*

"The amount of the earthy element in the body of a man of medium size is about a bushel, and consists of an exceedingly fine and impalpable powder. This is prevented from being dispersed and scattered about abroad, because it is held together by about half a bushel of the watery element and is preserved by the fiery element and is propped up by the windy element. And thus prevented from being dispersed and scattered abroad, it masquerades in many different disguises, such as the various members and organs of women and men, and gives the body its thinness, thickness, shortness, firmness, solidity, etc. . . . Thus does this machine made up of the elements move like a puppet, and deceives all foolish people."[3]

From earth, man looked into the heavens. There was color as well, and even greater mystery. Man knew himself to be frail and felt his life and destiny controlled by divine forces that dwelt above in illimitable space.

Gnostic conception of Christ standing on the earth and surrounded by the four elements. From an old engraving, 1482

A philosopher of the middle ages pokes his head through the dome of the sky to see what is on the other side

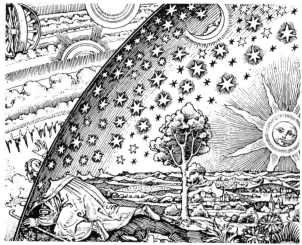

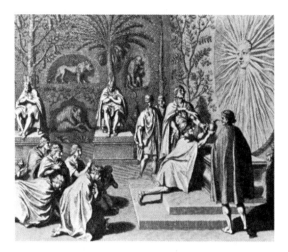

An eighteenth century engraving depicting the worship of the sun by the ancient Incas of South America

Chapter 2

COLOR AND THE GODS OF THE ORIENT

The man of old, like man today, looked to heaven when he prayed. Is heaven up by day? Then it must be down by night. Probably it would be best to say that it is beyond the earth.

Everything in existence came from nothingness and out of darkness. The most august of mysteries was the sun, whose majestic forces of heat and light were masters of heaven and earth, creating and sustaining life, controlling the elements and regulating the affairs of mortals.

The sun thus became the principle of good, personified in the gods of most nations. To the Egyptian, it was Ra, Athom, Amun, Osiris. A familiar representation of it is found in the winged globe of Egyptian art. To the Persian, it was Mithras or Ormuzd. To the Hindu, it was Brahma. To the Chaldean, it was Bel. To the Greek, it was Apollo.

In early times, the sun was often personified as a beautiful youth with golden locks. This god was slain by evil forces, but later restored through ceremonies of regeneration, which were given many personifications and colors. Egyptians, Assyrians and Babylonians knew it as a sacred bull, generally red, white, yellow or gold. In India, the sun's true color was thought to be blue; the orange rays seen by man were the result of its diffusion by substances surrounding the

19

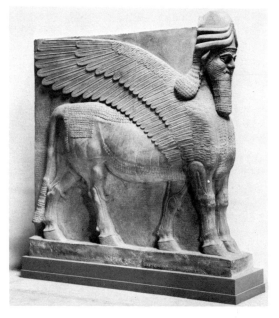

Stone sculpture of the Winged Bull of ancient Assyria. Carved of alabaster and richly colored. About 900 B.C.

earth. The name SOL-OM-ON is an expression of light, being the name of the sun in three languages.

Most often, the sun was likened to a flaming ball of gold. This precious metal, in fact, was thought to be crystallized sunlight, and was therefore adopted for the ornaments of priests and the crowns of kings. Even the nimbus of saints is still symbolized by gold. Yellow and gold became divine symbols of god and creation.

The Egyptian gods Set, Isis, Osiris and Horus. Each was associated with and symbolized by color

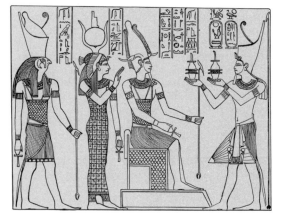

THE ANCIENT EGYPTIANS

The myth of the sun, common to virtually all early civilizations, is typified in the Egyptian Ra. Self-created, he once ruled men justly and in peace. But evil drove him into the sky, where he has remained ever since, his eyes—the sun—peering down upon men and casting its light over the earth. Also famous in Egyptian mythology is Osiris, his wife and sister Isis, and their son Horus. Osiris represented the material aspect of solar divinity, and his color was green, like the earth. An ancient Egyptian text says, "O Osiris, paint thyself with this wholesome offering—two bags of green paint."

Isis, the virgin of the world, is one of the most venerable figures of mythology. Her counterpart is found in practically every faith on earth, old or new. Her symbol is the moon. She was described in a later century by the Roman Apuleius, "Her garment was of many colors, and woven from the finest flax, and was at one time lucid with a white splendor, at another yellow from the flower of crocus, and at another flaming with a rosy redness." Her son, Horus, born of sun and moon, of the masculine and feminine principles of the universe, was a white god who ruled the South, time, and the narrow span of human existence. Of other Egyptian gods, Set, deity of the North, of evil and darkness, who made life miserable for gods and men, who mutilated Osiris, swallowed Isis and slew Horus, was black. Shu, who separated the earth from the sky, was red. Amen, the god of life and reproduction, was blue.

Egyptian temples, talismans, charms and burial ceremonies were all rich with color tokens prescribed by the mystic priests, who wore blue breastplates themselves to mark the sacredness of their judgments.

In the Zoroastrian Scriptures of the Persians is written, "We sacrifice unto the undying, shining, swift-horsed Sun. When the light of the sun waxes warmer, when the brightness of the sun waxes warmer, then up stand the heavenly Yazatas, by hundreds and thousands: they gather together its glory, they make its glory pass down, they pour its glory upon the earth made by Ahura, for the increase of the creatures of holiness, for the increase of the undying, shining, swift-horsed Sun." The Persians were great believers in astrology and practiced a form of solar therapy.

The Hindu scriptures, too, are full of color

symbols. "The face of truth remains hidden behind a circle of gold. Unveil it, O god of light, so that I who love the truth may see."

BRAHMA

Among Hindus, the word *Brahma* signified universal power or the ground of all existence. Brahma himself is represented as a red or golden-hued figure with four heads, four arms and four legs, facing the four directions of the world. He is the first member and the father of a great trinity. Vishnu, the second member, clad in the yellow of universal understanding, is the preserver. Siva, the third, the destroyer and reproducer who holds the phallic emblem, is black.

Brahmanism still recognizes yellow as a sacred color, as do most Oriental religions. The robes of the child initiate and the traditional marriage color of India are both yellow, and today, yellow is worn in the Buddhist priest's ordination. "In compassion for me, lord, give me these yellow robes and let me be ordained."

Green is described as the color of the horse with seven heads that drew Om, the Sun, across the sky. The epithet *blue,* addressed to the gods of India, refers to their origin in the sea.

BUDDHA

"With the nose of a well-fed horse, large long eyes, a red lower lip, white sharp teeth, and a thin red tongue—this face of thine will drink up the entire ocean of what is to be known." This is Buddha. The color of Buddha, as of Brahma, is yellow. "No sooner has he set his right foot within the city gate than the rays of six different colors which issue from his body rise hither and thither over palaces and pagodas, and deck them, as it were, with the yellow sheen of gold, or with the colors of a painting."

Among the thirty-two marks of the superman attributed to Buddha, four concern pigmentation:

"His complexion is like bronze, the color of gold. . . .

"The down of his body turns upward, every hair of it, blue-black in color like eyepaint, in little curling rings, curling to the right. . . .

"His eyes are intensely blue. . . .

"Between the eyebrows appears a hairy mole white and like soft cotton down. . . ."

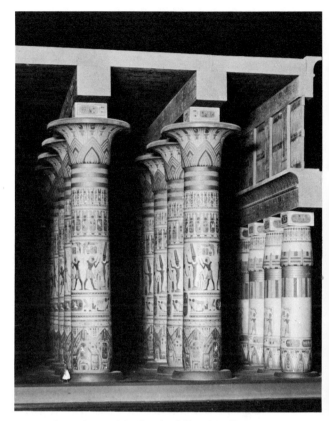

A magnificent picture of the Temple of Karnak in Egypt. Color was everywhere, and applied symbolically

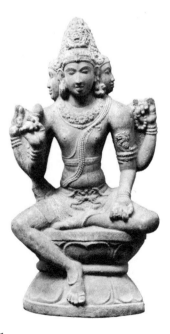

The great Brahma of India. He was red or golden-hued and had four faces to observe the entire world

21

An Indian temple. Color was extravagantly and symbolically used

For his description of evil, Buddha drew upon the color red: "Inhabitants of a heaven of sensual pleasure wander about through the world, with hair let down and flying in the wind, weeping and wiping their tears away with their hands, and their clothes red and in great disorder. When he pondered the iniquities of mankind, Buddha himself wore red as an emblem of sin. "And the Blessed One, putting on a tunic of double red cloth, and binding on his girdle, and throwing his upper robe over his right shoulder, would go thither and sit down, and for a while remain solitary, and plunged in meditation."

There follows a vivid use of color to describe the soldiers of Mara, the enemy of the good law, who sought to destroy Buddha. "Then Mara called to mind his own army, wishing to work the overthrow of the Sakya saint; and his followers swarmed round, wearing different forms and carrying arrows, trees, darts, clubs and swords in their hands, having the faces of boars, fishes, horses, asses and camels, of tigers, bears, lions and elephants—one-eyed, many-faced, three-headed—with protuberant bellies and speckled bellies; blended with goats, with knees swollen like pots, armed with tusks and with claws, carrying headless trunks in their hands, and assuming many forms, with half-mutilated faces, and with monstrous mouths; copper-red, covered with red spots, bearing clubs in their hands, with yellow or smoke-colored hair, with wreaths dangling down, with long pendulous ears like ele-

phants, clothed in leather or wearing no clothes at all; having half their faces white or half their bodies green—red and smoke-colored, yellow and black—with arms reaching out longer than a serpent, and with girdles jingling with rattling bells; with disheveled hair, or with topknots, or half-bald, with rope-garments or with head-dress all in confusion,—with triumphant faces or frowning faces,—wasting the strength or fascinating the mind."[4] Needless to say, in the midst of such demons, Buddha was triumphant.

HINDU KASINAS

The practice of Yoga makes much use of color. Among the forty subjects of meditation designed to establish communion with the infinite are the dark blue kasina, the yellow kasina, the blood red kasina, the white

Buddha's color was yellow or gold. He is seen here trampling the evil soldiers of Mara underfoot

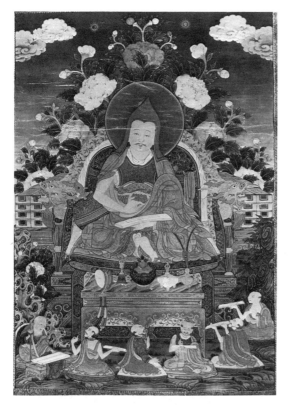

Chinese painting of the seventeenth century A.D. **The holy one is in meditation, surrounded by his disciples**

kasina, and a purple corpse. The religious one is to gaze upon unprepared earth, a plowed field or a threshing floor. In the earth kasina, careful instructions are given: "The colors dark-blue, yellow, blood-red and white are imperfections in this kasina. Therefore in practicing this kasina, one must avoid clay of any one of these colors, and use light red clay, such as if found in the bed of the Ganges."

The Western man is inclined to atone for sin by devoting himself to good works; the Eastern man withdraws from the world to meditate. One text describes the ritual to be followed by a Buddhist in preparing for meditation. Note the emphasis on color as a means of transfixing the mind.

"Then imagine on the letter A a lunar disk, red and white, about the size of the half of a pea, inside one's heart. Upon the lunar disk imagine a light-point about the size of a mustard seed which is the concentrated form of one's mind. Fix the mind on that and regulate the breath gently. . . .

"Imagine within the two pupils of the eyes, that there are two very fine bright white points, one in each eye. Close the eyes and imagine in your mind that the points are there. . . .

"After this, transfer the imagination to the ears. Imagine two blue points or dots upon two lunar disks the size of a half-pea inside each ear and meditate upon them, in a place free from noise. . . .

"Then transfer the imagination to the nose. Imagine a yellow point on a lunar disk in the cavity of each nostril in a place free from any odor, and concentrate your mind on that. . . .

"Next transfer the imagination to the tongue. Imagine a red point on a lunar disk at the root of the tongue, and meditate on it without tasting any flavor. . . .

"Then transfer your imagination to the body. Either at the root of the secret parts, or on your forehead, imagine a green point on a lunar disk, and fix your mind on it without touching anything. . . .

"Then after that, transfer the imagination to the mind, which moves everywhere. Imagine a very small pink point on the top of that already imagined as being within the heart. . . .

Then imagine that the chief passion—infatuation—which accompanies all other evil passions, is concentrated in it. Think that it is absorbed into a blue point. Fix the mind on that. . . .

"When one has attained firmness in that, sink the blue point into the pink point, and that into the white and red point below it. Then the last sinks into the moon-disk; which in its turn is dissolved or disappears in the sky like a cloud. Then there remains only emptiness, in which the mind is to be kept at a level."[5]

CONFUCIUS

The religion of Confucius is more practical and less mystical than Buddhism. Much of it is concerned with a moral system and code of ethics for individuals, good government, and proper social order. While it admits ancestor worship, its gods are few and mostly related to nature. It has always been a state system of theology.

Confucius' beliefs were recorded by his disciples in five canonical books with few references to color.

The garments of Confucius are described

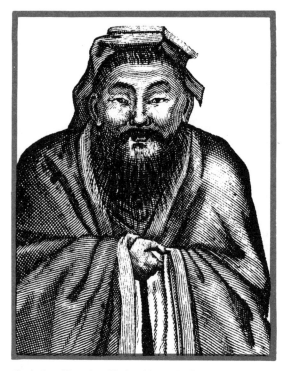

Confucius. The colors black, white and yellow are sacred

SHINTOISM

Shinto, in Japan, is based on ancestor worship, or polytheism, and has no supreme deity. Its priesthood and elaborate ritual are greatly influenced by the teachings of Buddha and the Chinese myths. The Shintoist has thousands of gods, talismans and color symbols. The four Good Spirits of Japan are the White Tiger, the Azure Dragon, the Vermilion Bird and the Somber Warrior.

Red figures prominently in Shinto. Blood, which is life, was the food once offered the dead. Then, by analogy, red cloth was substituted and placed on the corpse, together with weapons and ornaments. When a Japanese desired the help of the god Mari, he placed a red clay monkey upon a shrine and took away one which had been left by another worshiper. The word *Tama,* meaning a round object or jewel, was associated with the soul. Even to this day. Shintoists regard the soul as a round black object capable of leaving the body during sleep.

The meaning of a few Japanese color symbols is to be found in the words of blessing of the *Miyakko.* "These white jewels are a prognostic of the great august white hairs to which your majesty will reach. The red jewels are the august, healthy countenance; and the green jewels are the harmonious fitness which your Majesty will establish far and wide."

MOHAMMED

By the time of Mohammed in the sixth century, A.D., one is struck by a fading interest in color. The Koran has relatively few color references, compared with the much earlier Egyptian, Hindu, Persian and Chinese writings, and with the Bible of the Christians and Jews. Yet the land of Islam is colorful and its people delight in things gaudy and baroque.

Mohammed was probably a sober man, not the sanguinary wretch portrayed by the Christians. Historical sources say he dressed chiefly in white, but also occasionally wore red, yellow and green. He is described as entering Mecca wearing a black turban and holding a black standard which was at first adorned with the Roman Eagle. But the flag of later caliphs was black and bore the white legend, "Mohammed is the Apostle of God."

Green, symbolic of verdure, is associated

in the book *Heang Tang:* "The superior man did not use a deep purple, or a puce color, in the ornaments of his dress. Even in his undress, he did not wear anything of a red or reddish color. In warm weather, he had a single garment either of coarse or fine texture, but he wore it displayed over an inner garment. . . .

"Over lamb's fur he wore a garment of black; over fawn's fur one of white; over fox's fur one of yellow. . . .

"He did not wear lamb's fur, or a black cape, on a visit of condolence. . . .

"When fasting, he thought it necessary to have his clothes brightly clean, and made of linen."

From this one may conclude that the colors sacred to Confucius were black, white and yellow rather than red or purple. Wearing white during his fasts probably symbolized the highest spiritual attainment, a view of white held in many parts of the world.

In time, color meanings changed or degenerated. Today, for example, red and yellow, the oldest and most sacred of hues, are worn by the Hindu and Buddhist priests of northern India, where blue is abominated. Yet in other parts of India, the priests wear blue and white, never yellow!

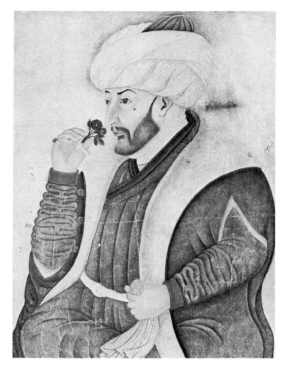

Mohammed, warrior and prophet. He promised green gardens to the devout

with the World Mother. Those who claim to be descendants of the prophet, and those who have made a pilgrimage to Mecca, wear green turbans. This color is predominant in the religious rites and culture of Islam, and is held sacred by its devotees.

Though color references in the Koran are few, they are significant and express the Moslem's passionate hopes and ideas. "As to those who believe and do good works . . . for them are prepared gardens of eternal abode, which shall be watered by rivers; they shall be adorned therein with bracelets of gold, and shall be clothed in green garments of fine silks and brocades, reposing themselves therein on thrones. . . . We will espouse them to fair damsels, having large black eyes" and "complexions like rubies." There will be gardens "of a dark green," fountains, fruit trees and pomegranates. "Therein shall they delight themselves, lying on green cushions and beautiful carpets." For evil-doers: "Verily we have prepared . . . chains and collars, and burning fire." The vain and rich man will wither and turn yellow like his gold. And hell "shall cast forth sparks as big as towers, resembling yellow camels in color."

Mohammed speaks of the last day: "On the day of resurrection thou shalt see the faces of those who have uttered lies concerning God, become black . . . On that day the trumpet shall be sounded, and we will gather the wicked together on that day, having

gray eyes. . . . The heavens shall be rent in sunder, and shall become red as a rose."

Green became the most sacred color, to be worn solely by those of perfect faith. Yet, to convince his disciples that his fervor was as mortal as it was divine, Mohammed said, "Wherefore I swear by the redness of the sky at sunset." Men would be convinced by that, for red was the color of their blood. They would also understand the bounty of God when he said, "Dost thou not see that God sendeth down rain from the heaven, and that we thereby produce fruits of various colors? In the mountains also there are some tracts white and red; of various colors; and others are of deep black: and of men, and beasts, and cattle there are those whose colors are in like manner various."

At Mecca, in the center of the Mosque is the sacred shrine of Caaba, visited by millions of pilgrims. In the southeast corner of this quadrangular shrine is the renowned "blackstone," or Keblah. It is to this point in the mosque, not to the east, that the Moslem directs his face in prayer, and on this stone that he plants his kiss during his pilgrimage. The Keblah was originally dazzling white and seen from every part of the earth. Brought directly from heaven by Gabriel and given to Abraham when he built the temple, it shone for ages as a visible sign of the omnipresence of Allah. Because of the sins of men, it became black, and every good Moslem has since prayed for its restoration to the divine whiteness that is of God.

The sacred shrine of Caaba at Mecca to which Moslems bow in prayer

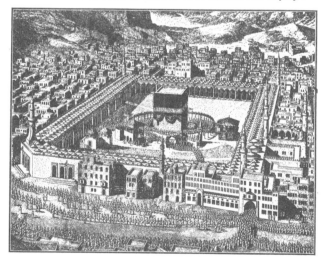

Chapter 3

TOWARD THE RELIGIONS OF THE WEST

Today, books are published on the science of color, on the psychology, physics and chemistry of it, as well as on the art of color. In each instance, the audience is generally distinct. In the writing of ancient times, however, no such specialization was possible, for man's culture was a great tapestry into which was woven everything of interest; and its warp and woof included man's fascination with color.

The historical study of color must, therefore, take into account almost every aspect of human life. Even minor things had color significance. And in modern times, because of the discoveries of modern archeology, we are able to assess the values of those ancient times more accurately. As C. W. Ceram writes in *Gods, Graves and Scholars,* "Today without exaggeration we can say that we know more about the history of Assyria and Babylonia, about the rise and death of such cities as Babylon and Ninevah, than did the learned men of 'classical' antiquity, more than all the Greek and Roman historians, who were closer to the subject by some two thousand years." And everywhere we find evidence that art and mysticism were always blended.

TEMPLES OF THE ANCIENTS

Such a blending is exemplified in the Mountain of God at Ur, between Bagdad and the Persian Gulf, which Leonard Woolley unearthed in the second decade of this century. (He was able to confirm, incidentally, that the Flood of the Bible was a historical fact.) The tower at Ur is recognized as one of the oldest buildings in the world. It dates back to 2300 B.C. and is thought to be the original home of the Patriarch Abraham. Two hundred feet in length, one hundred fifty feet in width, and originally about seventy feet high, it was a solid mass of brickwork, built in four stages. Woolley found an absence of straight lines: horizontal lines bulged outward; vertical lines were slightly convex. This graceful symmetry was once thought to be Greek in origin, because similar lines are evident in the Parthenon. The lowest stage of the tower was black, the uppermost red. The shrine was covered with blue glazed tile, the roof with gilded metal. Woolley writes, "These colors had mystical significance and stood for the various divisions of the universe, the dark underworld, the habitable earth, the heavens and the sun."

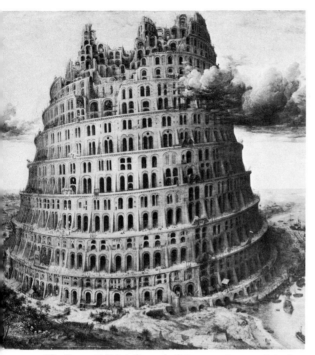

The Tower of Babel. It was built in seven stages, each having a different color in accordance with Babylonian mythology

built it in the seventh century B.C. It was two hundred and seventy-two feet square at its base and rose in seven tiers, each tier being set back. Of it James Fergusson writes, "This temple, as we know from the decipherment of the cylinders which were found on its angles, was dedicated to the seven planets or heavenly spheres, and we find it consequently adorned with the colors of each. The lower, which was also richly panelled, was black, the color of Saturn; the next, orange, the color of Jupiter; the third, red, emblematic of Mars; the fourth, yellow, belonging to the Sun; the fifth and sixth, green and blue respectively, dedicated to Venus and Mercury, and the upper probably white, that being the color belonging to the Moon, whose place in the Chaldean system would be uppermost."[6]

ASTROLOGY

Astrology, one of the oldest of all sciences, ranks possibly next to the art of healing. As is evident in the plan of the Birs Nimroud, it was of vital importance, for ancient man was sure that the will of the gods lay hidden in the mysterious plan of the universe and in the motion of sun, moon, stars and planets.

Astrology influenced Greek thought and culture, and from there was carried into early Christianity. Though astrology has given way to physics and astronomy, it still survives. Millions of its votaries buy pamphlets, read syndicated columns in the newspapers, support astrologers, consult their horoscopes in affairs of love and business, and put off a venture when the stars seem untoward.

The word *zodiac* derives from the Greek and means "circle of animals," or "little animals." The name is given to an imaginary zone in the heavens through which the sun, moon and planets travel. The twelve constellations are twelve "houses" which the sun visits each year, and each sign of the zodiac has its own symbol.

Knowledge of these twelve constellations exists throughout the world, and even existed among the Aztecs of America. The Chinese also have twelve signs, but they differ from the Greek ones with which we are familiar. The Chinese signs are: a Rat, Ox, Tiger, Hare, Crocodile, Serpent, Horse, Sheep, Monkey, Hen, Dog and Pig. In the beginnings of Christianity, the Twelve Apostles were associated with the zodiac, as were

Many ziggurats, or towers of Babel have been excavated. In fifth century, B.C., the Greek historian Herodotus wrote of Ecbatana: "The Medes built the city now called Ecbatana, the walls of which are of great size and strength, rising in circles one within the other. The plan of the place is, that each of the walls should out-top the one beyond it by the battlements. The nature of the ground, which is a gentle hill, favors this arrangement in some degree, but it is mainly effected by art. The number of the circles is seven, the royal palace and the treasuries standing within the last. The circuit of the outer wall is very nearly the same as that of Athens. On this wall the battlements are white, of the next black, of the third scarlet, of the fourth blue, of the fifth orange; all these are colored with paint. The last two have their battlements coated respectively with silver and gold. All these fortifications Deioces had caused to be raised for himself and his own palace."

Herodotus, apparently, referred to the great temple of Nebuchadnezzar at Barsippa, the Birs Nimroud. Excavated in modern times, its bricks bear the stamp of the Babylonian monarch who presumably re-

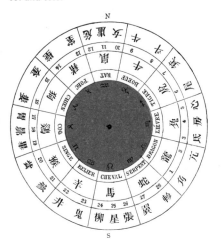

The twelve signs of the Chinese zodiac, each with its distinct symbol and color

Anglo Saxon symbols of the zodiac. From the Psalter of King Athelstan, ninth century

the twelve tribes of Israel and the twelve gates of heaven mentioned in Revelation. The number is also significant in other mythologies and religions. One of the earliest references to the zodiac is found in the Zoroastrian Scriptures. "Ahura Mazda produced illumination between the sky and the earth, the constellations, then the moon, and afterwards the sun, as I shall relate.

"First he produced the celestial sphere, and the constellation stars are assigned to it by him; especially these twelve whose names are Varak (the Lamb), Tora (the Bull), Dopatkar (the two figures of Gemini), Kalakang (the Crab), Ser (the Lion), Khusak (Virgo), Tarazuk (the Balance), Gazdum (the Scorpion), Nimasp (the Centaur or Sagittarius), Vahik (Capricorn), Dul (the Waterpot), and Mahik (the Fish); which, from their original creation, were divided into the twenty-eight subdivisions of the astronomers."

Numerous color designations were given to these signs. First, they were ruled by the planets. The Sun, yellow or gold, ruled the sign of Leo the Lion. The white or silver Moon ruled the sign of Cancer the crab. Mars was red and ruled the signs of Aries the ram and Scorpio. Mercury was symbolized by a neutral color and ruled the signs of Gemini the twins and Virgo the virgin. Jupiter was blue and ruled the signs of Sagittarius the archer and Pisces the fishes. Venus was green and ruled the signs of Taurus the bull and Libra the balance. Saturn, which was black, ruled the signs of Capricorn the goat and Aquarius the water-bearer.

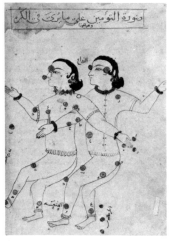

One of the early Persian drawings of the constellation Gemini, dating from the tenth century

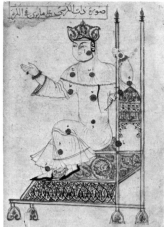

The constellation of Cassiopeia from the Persian Book of the Stars, tenth century

28

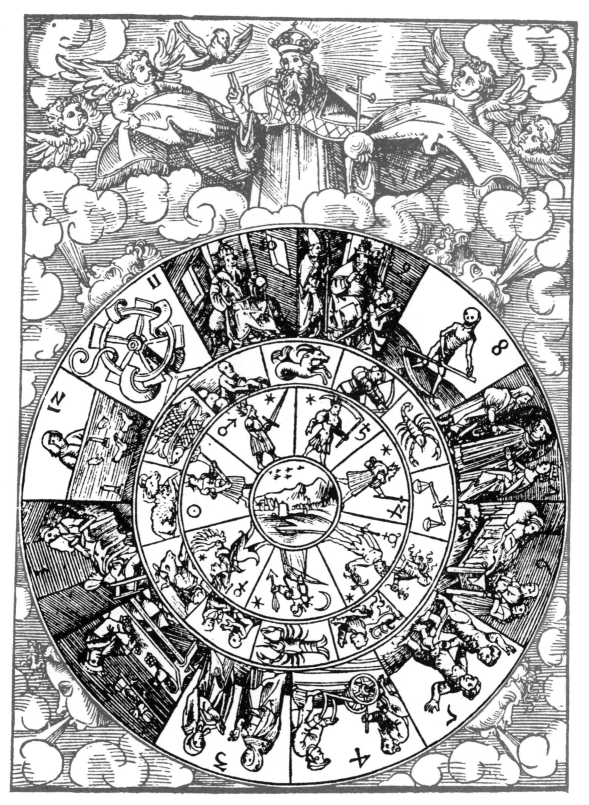

Although astrology and conceptions of the Zodiac were of Pagan origin, they were accepted in early Christianity

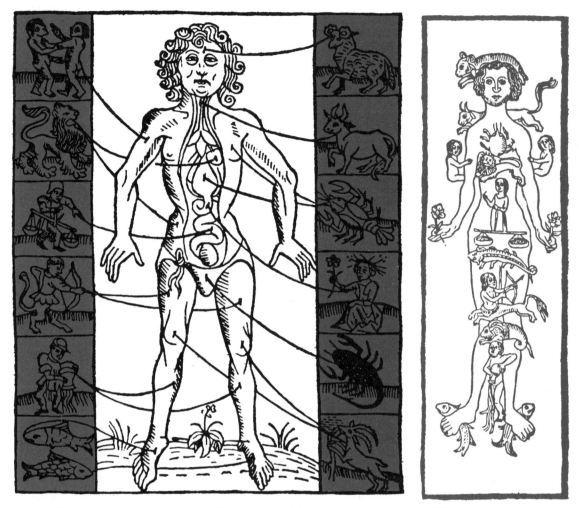

An early Renaissance conception of the signs of the Zodiac as related to the human body. About 1484

The four elements were also associated with the zodiacal signs: earth with Taurus, Virgo and Capricorn; water with Cancer, Scorpio and Pisces; fire with Aries, Leo and Sagittarius; and air with Gemini, Libra and Aquarius.

The ancient science of astrology is perhaps not as groundless as skeptics suppose. If the stars have nothing to do with a man's destiny, the season of his birth probably does. The astrologer was a sober man and his work was based on a careful study of human beings. These many "case histories" gave him his clues, his averages, and, because of the weight of these "actuarial figures," his conclusions or predictions were often acute.

Dr. Ellsworth Huntington of Yale University pointed out a possible relation between the season of birth and the course of one's life. The month of conception may hold major significance. Many geniuses, imbeciles and criminals seem to have birthdays in February, March and April, the months of conception being May, June and July. Spring conceptions supposedly follow a definite "urge of nature" among humans as well as lower animals. They seem to result in more impulsive offspring, having more extreme personalities. A record of three thousand persons suffering from dementia praecox shows more birthdays in February and March than any other months. *Who's Who*

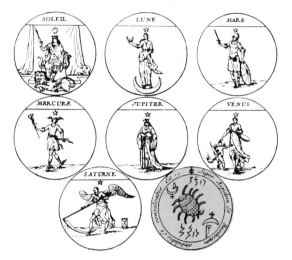

Talismans of the seven days of the week. German, 1722

shows a predominance of September and October birthdays, the months of conception being December and January (surely a time when humans are inclined to be more deliberate and therefore "mental" about such matters!). A January birth seems to influence a person toward the clergy; August towards chemistry. June and July births are also lowest both in number and "quality".

Through modern "scientific method," Dr. Huntington's study arrives at much the

The northern constellations from an old astronomical atlas

same findings as those of the astrologers. If there were more such comparisons, perhaps skeptics could be persuaded that there are things to be learned from the venerable science of the stars.

ATLANTIS

The mystic tradition moves from Mesopotamia and Babylonia to Greece and to the lost continent of Atlantis, so beautifully portrayed by Plato. Although generally considered a legend or a myth, Atlantis may well (like Troy) lie buried in obscurity. Some archaeologists and anthropologists speculate hopefully about it, for had Atlantis existed, much could be explained about the similarities of cultures throughout the world, and certain remarkable links between Asia, Europe, Africa and the Americas might more easily be explained. It might account for the unusual similarity of religious beliefs, traditions and symbolisms encountered around the globe, and the startling designs of the pyramids, ziggurats, Greek architecture and Mayan temples.

Plato's Atlantis presumably lay west of Gibraltar in a continent or series of islands in the Atlantic Ocean. Here dwelt a race of supermen who eventually wandered over the earth, spreading their culture everywhere. As it is told, when the gods divided the earth, Poseidon was given the sea and the island continent of Atlantis where great cities were built of red and black stones. Each of the land zones had three walls, the outer one covered with brass, the middle one with tin and the inner one with orichalch, a yellowish metallic substance. The capital of Atlantis was surrounded by a wall of gold. Poseidon's temple was crusted with silver, its pinnacles with gold, and its interior was ivory, gold and orichalch. Here the princes came, donned blue robes and renewed their oath before a sacred inscription carved on green stone.

But Atlantis was said to have been buried under the sea by an earthquake.

ANCIENT GREECE AND ROME

Unfortunately the enchanting story of color in Greek and Roman times must be written mainly from literary sources, and references to color are exceedingly scarce. Whereas the dry climate of the Nile valley preserved the fresh tints of archeological re-

31

mains; in Greece, time and climate have destroyed evidence that would be so interesting today. It is not widely known that Greek sculpture and architecture were brilliantly colored to symbolize the mystic principles of the universe. In this respect, the Greeks used the art of color for much the same purposes as the peoples of Asia and Africa. Greek learning had, after all, inherited many of the traditions of Egypt, Mesopotamia and India, where color had played so vital a role.

Clearly, Greek symbolism was complex, poetic, and highly involved. What colors were sacred? Pythagoras writes of the two temple virgins, one veiled in white robes to indicate the celestial, the other bedecked with jewels and earthly treasures. In the Greek conception of a god, his body was his virtue and his garments represented his achievements. White was thus the emblem of divinity, red the token of human love and sacrifice and blue the sign of truth.

When the Greeks presented Homer's *Odyssey,* they wore purple to signify the sea-wanderings of Ulysses. When acting in the *Iliad,* they were clothed in scarlet, emblematic of the bloody encounters described in the poem.

Athena, wise in the ways of peace and in the arts of war, represented union with the mind of Zeus, chief of the Olympian gods. She wore a robe called the *peplus,* gold in color and embroidered with the figures of the gods conquering the giants. An emerald upon her breastplate marked her divine and enduring wisdom. The red poppy was sacred to Ceres, goddess of the harvest, and Ceres was often portrayed ornamented with a garland of poppies about her neck. The face of the wine-god Dionysus was sometimes painted red. Iris, goddess of the rainbow and cupbearer of the gods, was clothed in many bright hues. The temple priests wore white garments.

On the first of the new year, in Rome, the consul, wearing a white robe and mounted on a white horse, ascended the capitol to celebrate the triumph of Jupiter.

THE DRUIDS

The ancient Druids of Britain and Gaul also saw magic in the spectrum. They built temples to the sun and had gods that resembled those of the Mediterranean nations. The story of Atlantis is sometimes invoked

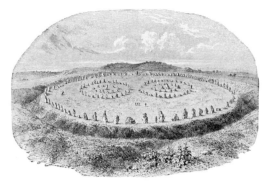

The ruins of a Druid temple built in worship of the sun

to explain the coincidence. However, glorification of the sun and color symbolism were just as natural to the North as to the South, and the same traditions might easily have grown up independently.

The head of the Druidic Order, the Arch-Druid, wore a tiara to represent the sun's rays. His breastplate had mysterious powers thought to strangle anyone making a false statement while wearing it. On the front of his belt was a white stone brooch with which the fire of the gods could be drawn from heaven.

At certain seasons the Druids climbed the oak tree and cut the mistletoe with a golden sickle. The mistletoe was then caught in a white robe, lest it be desecrated by contact with the earth. A white bull was usually sacrificed under the tree.

The school of the Druids had three divisions, and the secret teachings are claimed as part of the Blue Lodge of Masonry today. The lowest division was that of Ovate, an honorary degree requiring no special preparation. The Ovates wore green, the Druidic color of learning, and were expected to be versed in medicine and astrology.

The second division was that of Bard. Its members wore blue to represent harmony and truth, memorized the sacred Druidic poetry, and were often pictured with the primitive Irish harp. The Bards were teachers, and neophytes seeking entrance into the mysteries wore blue, green and white robes.

In the third division, white robes, symbolic of purity and the sun, were worn. The members here were the Druids who ministered to the religious needs of the people.

Thus to the Druid, green represented wisdom, blue truth, and white was the supreme emblem of purity, the same designations as applied in Greece!

OLD TESTAMENT AND NEW

The pagan was orderly in the symbolism he applied to the colors of the spectrum. Direct in his ideas, he nearly always left an unmistakably clear record. Color symbolism in the Bible and in Jewish rites is considerably less clear. Though the Bible is filled with references to jewels and silks, brilliant colors and rainbows, and with descriptions and metaphors that make it probably the most "colorful" of literary and religious works, there is far more exuberance than there is symbolism.

According to an old Hebrew story, red, blue, purple and white fire were collectively a symbol of the being of God. Red referred to love, sacrifice and sin, blue symbolized glory, purple stood for splendor and dignity and white was the emblem of purity and joy.

Red, blue, purple and white appear again and again throughout the Old Testament. The Lord commanded Moses to "speak unto the children of Israel, that they bring me an offering: of every man that giveth it willingly with his heart ye shall take my offering. And this is the offering ye shall take of them: gold, and silver, and brass. And blue, and purple, and scarlet, and fine linen, and goats' hair, and rams' skins dyed red, and badgers' skins, and shittim wood, oil for the light, spices for anointing oil, and for sweet incense, onyx stones, and stones to be set in the ephod, and in the breastplate."

Blue, however, is predominantly the Lord's color. In Exodus one reads, "Then up went Moses, and Aaron, and Nadab, and Abihu, and seventy of the elders of Israel; and they saw the God of Israel; and there was under his feet as it were a paved work of sapphire stones and as it were the very heaven for clearness."

Ezekiel likens God's majesty to a rainbow: "As the appearance of the bow that is in the cloud in the day of rain, so was the appearance of the brightness round about. This was the appearance of the likeness of the glory of the Lord." Ezekiel continues, "And above the firmament that was over their heads was the likeness of a throne, as the appearance of a sapphire stone: and upon the likeness of the throne was the likeness as the appear-

The Tabernacle in the Wilderness. Its colors are described in the Bible

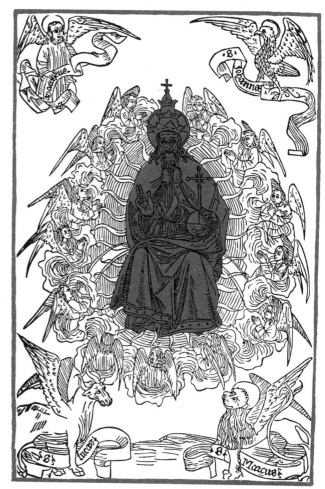

An early (1487) conception of God whose color, according to the Bible, was blue

A charming symbol of the rainbow god as conceived by the Zuni Indians, New Mexico

Heaven and hell as conceived by a fifteenth century artist

ance of a man above it. And I saw as the color of amber."

The throne of God was thus blue as sapphire, surrounded by a rainbow, and pierced by the golden hue of amber which apparently emanated from the Lord. That the Lord preferred blue may be inferred from his command to Moses to "speak unto the children of Israel, and bid them that they make them fringes in the borders of their garments, throughout their generations, and that they put upon the fringe of the borders a ribband of blue . . . that ye may remember, and do all my commands, and be holy unto your God."

The Hebrew priest wore a girdle which he fastened about his loins. Over this he put a linen vestment which reached to the ground and had sleeves. About his breast was tied a girdle "so loosely woven that you would think it were the skin of a serpent. It is embroidered with flowers of scarlet, and purple, and fine twined linen." Upon his head he wore a linen-covered cap made to resemble a crown.

According to Josephus, the high priest "is indeed adorned with the same garments that we have described, without abating one; only over these he puts on a vestment of blue." This garment was a long robe that reached to the priest's feet. It, too, was tied with a girdle embroidered with scarlet, blue and purple, and had a fringed bottom "in color like pomegranates, with golden bells." The final garment was the ephod. It was short and came slightly below the waist. It had sleeves and was embroidered in color, "but it left the middle of the breast uncovered."

Over the ephod in the center of the high priest's chest was fixed the essen or breastplate. It was held in place with blue ribbons attached to four golden rings. Two sardonyxes on the shoulders of the ephod served as buttons to hold the breastplate. The breastplate itself had twelve stones, "extraordinary in largeness and beauty," which stood in four horizontal rows. In the first row were a sardonyx, topaz and emerald. In the second were a carbuncle, jasper and sapphire. In the third were a ligure, amethyst and agate. In the last row, a chrysolite, onyx and beryl were set. The names of the sons of Jacob were engraved on the gems, each representing one of the twelve tribes of Israel.

The Hebrew priest who wore a breastplate adorned with twelve precious stones of different hues

Noah's ark had a red stone at its prow. The holy man accepted the rainbow as a covenant with God

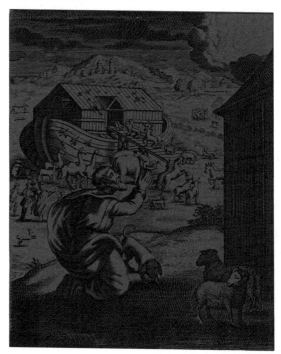

The high priest also wore a colored mitre out of which rose a cup of gold which Josephus describes in some detail. Referring to the Greek conception of the universe, he wrote: "Now the vestment of the high priest, being made of linen, signified the earth; the blue denoted the sky, being like lightning in its pomegranates, and in the noise of the bells resembling thunder. And for the ephod, it showed that God had made the universe of four (elements); and as for the gold interwoven, I suppose it related to the splendor by which all things are enlightened. He also appointed the breastplate to be placed in the middle of the ephod, to resemble the earth, for that has the very middle place of the world. And the girdle which encompassed the high priest round, signified the ocean, for that goes round about and includes the universe. Each of the sardonyxes declare to us the sun and the moon; those, I mean, that were in the nature of buttons on the high priest's shoulders. And for the twelve stones, whether we understand by them the months, or whether we understand the like number of the signs of that circle which the Greeks call the zodiac, we shall not be mistaken by their meaning. And for the mitre, which was of a blue color, it appears to mean heaven; for how otherwise could the name of God be inscribed upon it?"

Scholars have endeavored to explain the meaning of these color symbols. The twelve gems of the breastplate were said to represent the twelve great qualities and virtues: illumination, love, wisdom, truth, justice, peace, equilibrium, humility, strength, faith, joy, victory.

Red was properly a token of love and sacrifice, of sin and salvation. In Isaiah one reads: "Come now, and let us reason together, saith the Lord: though your sins be as scarlet, they shall be white as snow; though they be red like crimson, they shall be as wool." Blue, the main color, predominant in the high priest's vestments, was used to wrap sacred vessels and referred to the glory of the Lord. Purple represented His divine condescension. White signified purity and victory. With red it implied that the priest was not only the servant of the God of love, but also of the God of anger. Black, yellow and green do not seem to receive much religious sanction in the Old Testament, although the colors do appear in the

New Testament and are included in the Roman Catholic rite.

Through the centuries these colors have become a part of tradition and legend. It is believed, for example, that the tablet given Moses on Mount Sinai was fashioned of sapphire to indicate its divine origin. A red carbuncle was at the prow of Noah's ark to give him light and guidance, and he was also shown the rainbow as a sign that peace was again upon the earth. The rainbow symbolized the unity of man and Deity, stretching as it did from earth to heaven and containing all the colors. "And God said: This is the token of the covenant which I make between me and you, and every living creature that is with you, for perpetual generations. I do set my bow in the cloud, and it shall be for a token of a covenant between me and the earth. And it shall come to pass, when I bring a cloud over the earth, that the bow shall be seen in the cloud: and I will remember my covenant, which is between me and you, and every living creature of all flesh; and the waters shall no more become a flood to destroy all flesh."

THE KABBALAH

Kabbalism, an ancient offshoot of Judaism, is a faith of the mystic, and the color symbolism embodied in it has strange echoes from Egypt, Babylonia, Assyria and Greece, as well as from Israel and Galilee. The true origins of Kabbalism have been lost. Some believers say Moses went up Mount Sinai three times: once to receive the Table of Written Law, once to receive the Soul of the Lord, and a third time to be instructed in the mysteries of Kabbalah, the Soul of the Soul of the Law. Another tradition has it that Kabbalah's first principles were taught by God to His angels, through whom they were then transmitted to Adam, and subsequently to Noah, Abraham, David and Solomon. The oldest known book of Kabbalism was written about 600 A.D., although it is certain that the substance of the faith is far more ancient. The Kabbalah was regarded as the exposition of a great secret, a mystical and religious system of philosophy. It explained the creation of heaven and earth and man's dealings with God. It flourished for many centuries, and during the Middle Ages comprised an extensive mass of beliefs and traditions which Jews had adopted from

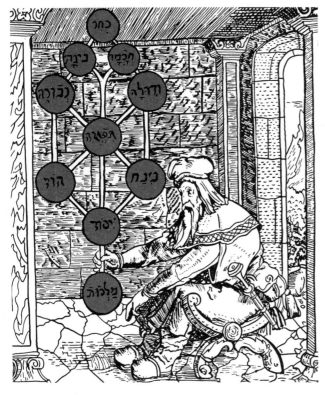

The Sephirothic Tree of the Kabbalah held ten globes of colored light and mixed Paganism with Hebraism and Christianity

many countries. In part, it was later woven into the tenets of Rosicrucianism and Freemasonry.

In Kabbalah the material body, like that of the universe, was believed to be an expression of ten globes or spheres of colored light. This conception is illustrated in what is called the Sephirothic Tree. The ten globes form a tree of luminous beauty arranged in three columns. To the left is the column of Strength; in the center is the column of Mildness, the reconciling power; to the right is the column of Wisdom and Beauty. The twenty-two connecting channels are said to correspond to the letters of the Hebrew alphabet. When the ten globes and twenty-two channels are combined, they are said to represent the thirty-two nerves that branch out from the Divine Brain (this symbolism is also found in the thirty-two degrees of Freemasonry).

The Kabbalah may be explained in a fairly simple way. God, the cause of all things, is the supreme, all-pervading source of "light." From Him come ten emanations to form the Tree of the Sephiroth. But the deity is not actually contained in the Sephiroth, which are only ten emanations of the deity. This Sephiroth Tree is likened to man, the Microcosm. From God, man receives the emanations which become his body, understanding, mind, soul and spirit. Through the twenty-two channels connecting the ten Sephiroth, the whole is made to form a single unity, all permeated by the might of the Lord. Simply, then, the Tree is the symbol of God's glory and also a chart of the nature and constitution of man.

The color symbolism, therefore, is significant. Kether, the crown—the concentration of divine light—is white. The Greeks, Druids, Confucianist, Shintoists and Persians also conceived of white as the token of supreme divinity. This white of Kether forms a triad with Understanding and Wisdom. The symbol of Understanding is black because it absorbs all light. The symbol of Wisdom is therefore gray, a blend of white and black. These three Sephiroth form a triad leading to a second triad of blue, red and yellow. Here blue is the symbol of Mercy, red of Strength, and yellow of Beauty.

From this second triad now comes a third. The blue and yellow of Mercy and Beauty lead to the green of Victory. The red and yellow of Strength and Beauty lead to the orange of Glory. The blue of Mercy and the red of Strength lead to the purple of the "Foundation," the basis of all that is.

Finally, this triad of green, orange and purple lead to the tenth Sephiroth of the "Kingdom." Here the colors are combined to form citrine, olive, russet and black—a synthesis of *all* colors, ending in the ever-extinguishing black.

Thus is man the Microcosm, the little universe, fashioned in the likeness of God and born of His emanations so he would be worthy to reflect the glory of the great power that created him.

EARLY CHRISTIANITY

Much of the pagan mysticism and Hebrew belief found their way into early Christianity, if not into the New Testament itself. The crucifix was familiar to the Egyptians and Babylonians and even to the Aztecs. In Greece the world was symbolized by a cross, its four quarters embellished with a bull to signify earth, a scorpion to signify water, a lion to signify fire, and the human head to signify air.

The nimbus or halo of the saint had been used in Egypt as an expression of power

The Heavenly Trinity, with blue for God the Father, yellow for God the Son and red for God the Holy Ghost

rather than holiness. Worship of the sun led to the conception of the deity as a trinity, representing dawn, midday and dusk, and three life stages—growth, maturity and decay. Philosophers had also spoken of past, present and future, of body, mind and spirit.

In early Christianity, the trinity became associated with the colors blue, yellow and red. God the Father was blue; God the Son, yellow; and God the Holy Ghost, red. The deity was thus symbolized by the triangle, the shamrock, the three candles found in contemporary Masonic ritual. The threefold aspect of man was expressed in color by having his body red, his mind yellow and his spirit blue. And heaven was blue, earth yellow and hell red.

One fascinating story is that of the Holy Grail. When the Archangel Michael swooped down upon Lucifer, his sword struck the green stone from the coronet of the rebellious one. It fell to earth and later was fashioned into the Holy Grail, from which Christ is said to have drunk at the Last Supper. Later the cup was brought to the Crucifixion and used to catch the blood from the wounds of the Son of man. It was then carried away to England. Finally, Parsifal, the last of the Grail Kings, carried the Holy Cup to India where it disappeared.

This legend became the motif of many of the stories of the King Arthur cycle. Some believe the Knights of the Holy Grail to have been a powerful organization of Christian mystics whose search for the vessel represented the eternal quest for truth. Its green color, signifying the Great Mother Nature, may also have been related to Venus.

Color symbolism in the New Testament is not limited to a tetrad of red, blue, purple and white, as it was among the Jews. Green notably becomes significant and is called the color of God. St. John the Divine writes: "And he that sat was to look upon like a jasper and a sardine stone: and there was a rainbow round about the throne, in sight like unto an emerald."

Red was the symbol of charity and martyrdom for faith. It signified the blood of Christ, and the martyr was clothed in it. Red became the color of the lamp flickering before the high altar, an everlasting reminder of the suffering and sacrifice of the Son of Man. In the familiar Christmas legend of the shepherd's daughter, the white rose she presented to the Infant turned red when He touched it and so foretold His future suffering.

Gold and yellow represented power and glory. Here was the color of the nimbus of the saint, the gates of heaven—and a reminder of the pompous glory of the golden cock, golden eagle, hawk, ass and calf. Saffron was the hue of the confessors. Green symbolized faith, immortality and contemplation, and was everlasting as nature. The walls of the New Jerusalem were described as made of green jasper. Saints were adorned with green robes to indicate their eternal life. Pale green was the hue of baptism. Blue signified hope, love of divine works, sincerity and piety. It was the color assigned to the Virgin Mary and through it she entered the dominion of God. Pale blue was symbolic of peace, serene conscience, Christian prudence and the love of good works. Purple was emblematic of suffering and endurance, and also the hue of the penitent. Christ was believed to have worn purple garments before his Crucifixion; in purple robes, He is the self-sacrificing God. As a sign of repentance and of devout faith in the compassion of the Savior, martyrs wore purple and so did some old orders of nuns. Rosaries were frequently made of amethyst for these reasons.

White represented chastity, innocence and purity. Black represented death and regeneration. The black rose was a symbol of silence among Christian initiates. "I will give thee the treasures of darkness." Gray was an emblem of Christ risen, a blend of the divine light of creation and the darkness of sin and death. In early Christianity, white was the usual color of vestments, though occasionally striped with purple. The newly baptized also wore white for eight days, and white was apparently the color of mourning clothes and of garments used to swathe the bodies of holy people. Tradition tells that Dominicans wear a black and white habit, symbolizing mortification and purity, at the express desire of the Virgin Mary.

In a vision one early Church father saw the church as white. "Behold, there met me a certain virgin, well adorned, and as if she had just come out of her bride chamber—all in white, having on white shoes, and a veil down her face, and her head covered with shining hair. Now, I knew by my former vision that it was the Church."

The Christian had revolted against pagan ostentation. To him, white was divine, simple, pure, and it seemed proper to the humble principles of his faith. Yet he continued to be the mystic and to use color to glorify and represent God and his faith. Churches in Italy and Spain, the St. Sophia of Constantinople, Notre Dame in Paris, were all colorful and remained so up to the Reformation.

Swedenborg wrote extensively of color and saw celestial light as a manifestation of God

CHRISTIANITY TODAY

What remains of color for the Christian today? Not a great deal. In early times mysticism came first, then beauty. During the Renaissance, this order was reversed. Renaissance artists, individualists before they were disciples, discarded the sacred color formulas in favor of expressing their own individual genius. The art of color changed completely and became sophisticated; the decorative and aesthetic viewpoint overrode the functional.

Then came the Reformation, and color was ruled out of the church as a distraction and an ostentatious display. When Protestantism was born, whitewash was smeared over many churches.

In England, in one of the later reforms of the Benedictine Order, black had been appointed. It had gone to Oxford and Cambridge, where it is still worn. And when the Reform Church of England adopted black, it became the dress of students and ministers, and was then adopted as the ministerial color of virtually all Protestant churches. Most Protestant faiths, particularly those of the "Puritanical" tradition, more or less disregard color because they consider it ostentatious. Color symbolism and mysticism are rejected. Such Protestant great religious leaders as Luther, Calvin, Knox, Fox, Mosley are more or less silent on the subject.

One exception is Emmanuel Swedenborg, who wrote like a true mystic: "The sphere of a man or Spirit, whenever the Lord pleases, is represented by colors like those of the rainbow. . . . In the other life, there are colors which in brightness and resplendence far surpass the beauty of the colors seen on earth; each color represents something spiritual and celestial. These colors are from the light of Heaven, and from the variegation of spiritual light. The light of Heaven is to the light of the world as the noonday sun to a candle; in Heaven there are celestial light and spiritual light . . . and it is the same with the color there."

He had special regard for red and white. "There are two fundamental colors, from which all the rest come, the color red, and the color white; the color red signifies the good, which is of love, and the color white the truth which is of faith. . . . Hence it is evident what the rest of the colors signify; for in proportion as they are derived from red they signify the good which is of love, and in proportion as they are derived from white they signify the truth which is of faith; for all the colors which appear in the other life are modifications of heavenly light upon these two planes."

In his *Spiritual Diary,* Swedenborg thought that the hereditary evils in infants and children could be likened to black, green and azure. He seemed to accept the existence of an aura, for he wrote, "From the colors black, white, flesh, azure, yellow, around a Spirit or a man, some evil Spirits infer the state of the man as to his proprium or self-love."

Fortunately, color remains a part of most religions, though its symbolic definitions seem to have been almost entirely lost. Will the evangelism of the future seek to restore the spectrum?

Chapter 4

OF CULTURE, TRADITION AND SUPERSTITION

Ancient man had an insatiable desire to know the future. In terror of death, he was convinced that as there were divine gods to reward him for virtue, so there were evil gods and demons to curse and destroy him. To win the favor of the just gods, he gave himself to good works, prayer, ceremonies and building temples; but to thwart evil, it was necessary for him to resort to magic.

In *Amulets and Talismans,* E. A. Wallis Budge quotes an Egyptian papyrus describing the great things that God did for men, how he made heaven and earth, dissipated darkness, created fruits and vegetables, animals, birds and fish. He made the full brightness of daylight to gratify them, and "He made for them magic for a weapon for resisting the power of [evil] happenings [and] the dream of the night as well as of the day."

PRESERVATION FROM EVIL

Evil was to be repelled through certain rituals, incantations, talismans, charms and colors. Even the gods resorted to them. Marduk, for example, carried between his teeth a red stone shaped like an eye to overcome all inimical influences. The Egyptians similarly charmed their lives against the black Set. And in later centuries the Christian wore the crucifix to defy the red Satan.

One of man's most primitive fears was the evil eye, the fabulous witch that went about wrecking the life, love, labor and sanity of men. One glimpse of it and a man was likely to be stricken with misfortune, insanity or disease. Some primitive peoples wore round blue disks strung together with beads and painted with the symbol of an eye for protection. In Persia a bit of turquoise was placed in the eye of a sacrificial lamb, the animal roasted, and the stone then put in an amulet case and sewn into a child's headdress.

Pliny states that the magicians once protected themselves with jet. In India the Hindu mother daubed black on the nose and forehead, or on the eyelids of her baby. She also tied a piece of white or blue cloth on her own dress. In Jerusalem the "hand of might," almost always blue, was worn as a bracelet. In Scotland the newborn child was made safe from the evil eye by a piece of red ribbon tied about its neck; in parts of England a ring or amulet of red chalcedony was

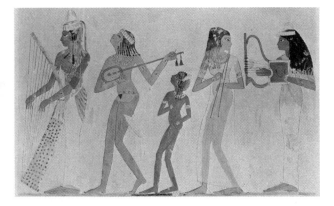

Color has always been a part of culture. View shows musicians from ancient Egyptian wall painting

worn; and in Italy a piece of coral was used for similar purposes.

From Egyptian and Babylonian inscriptions, it is known that amulets of certain gems and colors were thought to bless their wearers with the gods' favor and bring them into daily contact with divine beings. Some of these stones had curious markings like veins, others resembled eyes, and they were to be worn next to the scalp or forehead, against the ear, heart, genital organs, wrists or spine. Some were fastened to poles in the field, attached to the horns of cattle, tied to the beds of the sick. The right color was supposed to bring success in commerce, to prevent disease, to afford safety from shipwreck, lightning and animal attack, to assure abundant harvests and favorable control of the elements.

Again one is reminded that the ancients revered color for its divine significance, not merely because it was "pretty." Rings, necklaces and bracelets were associated less with opulence and beauty than with practical religious strategy. Budge writes, "In the bazaars of Cairo and Tanttah large blue-glazed pottery beads, fully half an inch in diameter, used to be sold to caravan men, who made bandlets of them and tied them to the foreheads of their camels before they set out on their journeys across the desert. The natives believed that the baleful glances of the evil eye would be attracted to the beads, and averted from the animals. . . . It is tolerably certain that the brass bosses and ornaments which decorate the harness of cart horses and shire-stallions were, like the great brass horns which rise from their collars, originally intended to protect the ani-

mal from the evil eye; but this fact has been forgotten, and amulets have degenerated into mere ornaments."

In fashioning amulets, the preferred colors were red, blue, yellow, green and white. Red stones were efficacious in treating disease and in protecting their wearers from fire and lightning. Blue and violet stones were associated with virtue and faith. They were hung about the necks of children not only to assure the watchfulness of heaven but also to make youngsters obedient to their parents. Yellow stones brought happiness and prosperity. Green stones caused fertility in man and beast and had mysterious connections with vegetation, rain and strength, generally. White stones averted the evil eye and, because they were thought to come from heaven, carried its protection with them.

SIGNIFICANCE OF GEMS

A few miscellaneous notes on the symbolic use of gems, gleaned from the lore of many nations and races, is of interest. Further reference to amulets and their use in the prevention and treatment of disease will be found in the next chapter.

Agate: Pliny mentions the red agate as a protection against spiders and scorpions. The brown agate was the most indiscriminately powerful of all, bringing victory to the warrior, favor to a lover in the sight of his lady, intelligence, happiness, health and long life.

Amber: This is one of the oldest of all magical gems. Because of its electrical properties, man associated it with divine powers. It afforded protection against the evil eye, witchcraft and misfortune.

Amethyst: Its purplish color prevented drunkenness, brought peace and devotion.

Cat's Eye: The Arabs thought this stone made the wearer invisible in battle. It also overcame witchcraft and sudden death.

Crystal: The ancients believed that crystal was petrified ice. In Scotland crystal balls were "stones of victory." In Mexico the souls of living and dead dwelt in the substance. In Australia it was a rain-maker. Throughout the world it was used in divination.

Diamond: According to Pliny, the diamond rendered all poisons harmless, drove away madness, the evil eye, demons and wild beasts.

Emerald: This green stone brought wis-

dom. The sight of it struck such terror in the viper and cobra that their eyes burst from their heads.

Garnet: The garnet prevented evil and fearful dreams. When danger approached, its red color was thought to dim. In Italy it was the token of the widow, and it assured love and faithfulness.

Jade: Green jade brought the rain and frightened wild beasts and evil spirits. In China jade is still worn by the businessman for luck in his various business transactions.

Jet: This black substance has been magical from the earliest times. It nullified spells, drove away snakes, quelled the thunderstorm. It also brought safety to the traveler and kept him free of the evil eye.

Moonstone: When hung in the field or orchard, moonstone produced abundant crops and fruit. It was regarded in the Orient as the "lucky" stone.

Opal: Because of its many colors, the opal had the varied powers of red, yellow, green, blue and purple. It conquered the evil eye and was used in healing of the sick and injured. Today many superstitious people believe that it brings bad luck.

Ruby: The full redness of the gem brought health and protection from disease.

Sapphire: It brought soundness of body and equanimity of mind.

Turquoise: Its greenish-blue brilliance was thought magical wherever used as an amulet. It resisted the evil eye and warned of approaching death by changing color.

Colorful gems, of course, were but one item in the paraphernalia of magic. The efficacy of color in invoking spirits, both good and evil, was part of nearly all ritualism and ceremony. The Chinese wrote incantations against demons with red ink on bits of yellow paper. The paper was then burned, its ashes mixed with water and swallowed. Other talismans consisted of red or yellow strips of paper that were pasted up in the home or tied about the neck. One quaint charm was fashioned of bits of colored thread which the Chinese mother assembled from the homes of her neighbors and tied to the dress of her child.

Like the races of Africa, Europe and Asia, primitive Americans had a color for the universal deity. Mexicans, for example, gave the name Kan to a god who supported the sky. The word Kan itself meant yellow. One can easily comprehend the symbolism of the American Indian's pipe, or Calumet; the

Red and black gods of old Mexico. Symbolism and color pervaded art. Courtesy, Bettmann Archive

41

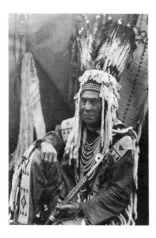

The American Indian saw magic in color. His pipe of peace was red

Human sacrifice was common to many ancient cultures, and color held much symbolism

A French engraving depicting sacrificial rites to Bacchus

smoke of its fire reached to the sky and was seen by the gods. And even the gods smoked; for they built fires of petrified wood, used a comet for the flame, and blew clouds into the wind for man to see. The Calumet was the Indian's altar, its smoke a proper offering. Almost invariably the Indian sought a red stone from which to make it, for the sun god was red, the underworld god black and the fire god vari-colored.

When human sacrifice was practiced among the Aztecs, on the eve of the yearly festival (in July), a young woman was adorned to portray the Goddess of the Young Maize. The upper part of her face was painted red and the lower part yellow. Her legs and arms were covered with red feathers, her shoes striped with red. It was she who died for the gods on the summit of the temple, her head chopped off and her heart torn from her breast. In Harran, the priest, clothed in red and smeared with blood, offered a red-haired, red-cheeked youth as a sacrifice inside a temple painted red and draped with red hangings.

How vital to rule nature and control the elements! In Egypt red-headed youths and red oxen were sacrificed to the gods to assure an abundant harvest. The Bavarian sower wore a gold ring to endow his grain with a rich color. Storms in Ireland were quelled by burning the pelt of a black dog and scattering its ashes down the wind. In provinces of Central India a twin saved the crops from ravages of rain or hail by standing in the direction of the wind with his right buttock painted black and his left some other color. Sacrifice of black animals, like the black cloud, drew water from the sky. White beasts brought forth the sun. In Scotland, Hungary, Portugal, Norway, Denmark and Germany, red strings and bits of cloth were tied to animals to protect them from death. In Afghanistan, Syria and Macedonia, blue performed the same function.

There were also good luck tokens to bless the households of mankind. Syrians used a special red design. The red hand in Ireland, India, Turkey and Mexico shielded the family from harm; in Jerusalem a blue hand was painted on doors or the walls of dwellings.

Many of these superstitions linger to this day and follow traditions centuries old.

Just as color brought security to man, so also did it warn him of impending tragedy. In Spain the black insect was portentous, the black cat and white insect omens of good

Egyptians dreaded red and brown cats and saw divine powers in black ones

posed to assure success for a new theatrical production. Yellow, however, is treacherous in the theater, and must not appear on posters, trunk labels, or even in a clarinet in the orchestra pit.

COLOR AND CASTE

Magic and superstition found a permanent place and solemn meaning in the more enduring stations of man's life: his caste systems, the ceremonies of birth, marriage and death.

Hinduism in India, for example, established four castes: Brahmans, Kshatriyas, Vaisyas and Sudras because, as the story goes, mankind once comprised four races. From the mouth of the creator came the Brahmans; from his arms the Kshatriyas; from his thighs the Vaisyas; and from his feet came the Sudras. These were the four *varnas*, a word which in Sanskrit means color, the branding irons of caste.

The Brahmans were white. They were to study and teach, to sacrifice for themselves and be priests to others. They gave alms and received alms. They were the privileged and sacred class. The Kshatriyas were red. They were to study but not teach, to sacrifice for themselves but not to officiate as priests. They gave but did not receive alms. They were the military who governed and fought the wars. The Vaisyas were yellow. As the mercantile class they were to study, sacrifice for themselves, give alms, cultivate the fields, breed cattle, trade and lend money at interest. The Sudras were black, the servile class, and they were to obtain their livelihood by laboring for others. They might practice the useful arts, but they were not to study the holy Vedas.

COLOR AND CULTURE

Color and culture have gone together over the centuries. Often entire eras have been identified by color officially as well as proverbially. By their very names the Golden Age and the Mauve Decade provide a mental picture. In China these associations were nationally recognized. The royal color of the Sung Dynasty (960–1127 A.D.) was brown; the Ming Dynasty (1368–1644) was green; the Ch'ing Dynasty (1644–1911) was yellow, a time when only the emperor was privileged to wear that color. Officials of the emperor were known by their colors. Ranks were dis-

fortune. In parts of Castile and Spanish Galicia the white moth was a harbinger of death. Japanese dreaded red or pinkish-brown cats most of all. The all-black cat had divine powers, one of which was to foretell weather.

How can we explain these curious beliefs? Even today it is said that Yorkshire fishermen dread white, while their Northumberland neighbors, only fifty miles away, fear black. In America the black cat is generally accused of bringing bad luck, yet it is sup-

A Chinese emperor. Dynasties were distinguished by colors, and rank had an involved symbolism

of Jupiter. His chariot was drawn by white horses. In his right hand, he carried a branch of laurel, in his left an ivory scepter topped with an eagle. A wreath of laurel was upon his head. His face was reddened with vermilion and over him a slave held a crown fashioned of gold to resemble oak leaves.

As late as the second century, a Roman magistrate, clad in purple, would on a certain day wash the tombstones of soldiers who had died in combat with the Persians. The Roman lady wore white because it was an emblem of virtue and purity. While Nero wore purple, his servants wore red. The Gauls are said to have clothed their slaves in blue, a color that later became the common livery of many servants.

The Christians despised yellow for its pagan allusions. The hue of Judas was yellow. Venetians once forced Jews to wear yellow hats. In 10th-century France, the doors of the abodes and hovels of criminals, felons and traitors were painted yellow, the stigma of Judas. As late as World War II, Hitler used yellow in his monstrous persecution of Jews, making them wear yellow armbands and even restricting them to yellow-painted benches in public parks.

Whether it signified good or evil, color has been omnipresent in the history of mankind. From the purple baptismal stole of the Christian priest in Europe to the Creek Indian boy smeared with white clay at his circumcision in America—color was one of man's first blessings and the last sacred benison to shroud his cadaver.

tinguished by a colored button worn on the top of a cap. The first rank was coral, then blue, purple, crystal, white and gold, in that order. The emperor's grandsons rode in purple sedans, the sedans of higher officials were blue and those of lower officials green.

Such traditions led to numerous customs in dress. When the Chinese emperor worshiped the sky, he wore azure blue. To honor the earth, his garments were yellow. Red was sacred to the sun, and white sacred to the moon. The literati and educated persons of the realm affected deep purple. Respectable Chinese wore sober hues: soft blues, grays and browns. Men preferred deep blue and black. Pink, green and blue were almost universally feminine. Above all, blue was and still is the conventional hue for clothing in China.

Purple became the royal hue of the Caesars. Richard Payne Knight says, "The bodies of Roman consuls and dictators were painted red during the sacred ceremony of the triumph, and from this custom the imperial purple of later ages is derived."[7] The emperor in his purple robes embroidered or spangled with gold was the personification

The painting on the African's body charmed and protected him

44

Marriage rite of eighteenth century Jews, performed under the golden Talis—as in Biblical times

MARRIAGE AND FERTILITY

Life was precious, blood and death tragic and awesome. Man's struggle against the forces of nature, the will of the gods, and the curse of demons was endless. He came from the body of woman, and when he died, his flesh rotted and turned black. The blood of puberty frightened him, so he secluded his daughter. She must be covered with red pigment, buried in the ground, or immured in a hut. She must come forth with her face painted red and white lest she give birth to monsters after her marriage. She must marry, and the ceremony must be the most colorful of rites. Bride and groom must be preserved by the magic power of color through their years of marriage. Among ancient Jews the marriage ceremony was performed under the *Talis,* a golden silk robe supported by four pillars. Around this the bride walked seven times in memory of the siege of Jericho. In India, red paint and even blood were used. Six days before her wedding the Hindu bride wore old tattered yellow garments to drive away evil spirits. Her clothing at the ceremony was yellow, and so, too, were the robes of the priest. And once married, the wife wore yellow when her husband returned from a long journey.

In China the bride wore red embroidered with dragons. She was carried in a red marriage chair adorned with lanterns inscribed with the groom's family name in red. She held a red parasol. Red firecrackers were exploded in her behalf. During the rite the bride and bridegroom drank a pledge of wine and honey from two cups tied together by a red cord.

In Japan the daughter of a man who fed a thousand white hares in his house would marry a prince. In the Dutch East Indies red or yellow rice was sprinkled over the bridegroom to keep his soul from flying away. Here red was also a love potion, and if the names of boy and girl were written on white paper with the blood of a red hen, the girl would become infatuated when touched by it.

Red and yellow were the marriage colors of Egypt, the Orient, Russia and the Balkans—and they still are. In western countries blue was and is associated with marriage ceremonies. An old English rhyme, familiar to everyone, cautions the bride to wear:

"Something old and something new,
Something borrowed and something
blue."

Turquoise was the amulet for connubial harmony. It was thought to change color with change of heart, and to reconcile man and wife. In Morocco a blue spot was painted behind the bridegroom's ear to thwart the powers of evil. In Ireland the devil himself would curse the newlyweds if some scoundrel attended the ceremony with a red handkerchief tied in knots.

To love, honor, obey—and to bring forth offspring to populate the earth. In Algeria black hens were sacrificed to promote fertility. In the eastern part of Central Africa the native wife who desired a babe wore blue beads and carried a black hen on her back. In Japan red and white girdles offered protection during pregnancy, and blue and white were used the same way in France.

THE LAST RITE

Man faced the greatest of all mysteries, death, from which no one returned. Though an impeccable mortal life might assure salvation, even the sinful might not die forever. His family must prepare his shroud and equip his tomb with what he needed for his expedition to the realm of the immortals.

First of all, however, the ancient and the primitive prepared himself. The Egyptian warrior carried amulets of purple stone. The Chinese carried red, a hue that was also used later by Scottish and Indian soldiers. The Englishman used a blue charm.

In wilder countries the native was superstitious about the treachery of demons. When a Nandi of eastern Africa killed a member of another tribe, he painted one side

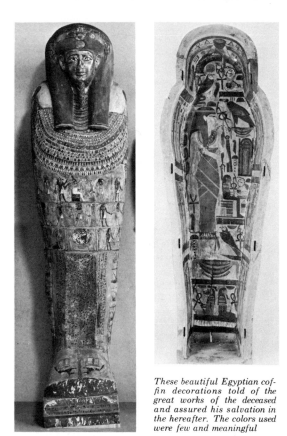

These beautiful Egyptian coffin decorations told of the great works of the deceased and assured his salvation in the hereafter. The colors used were few and meaningful

of his body, spear and sword red, and the other side white, to protect him from the ghost of his victim. In Fiji a native, after having clubbed a man to death, was smeared with red from head to foot by the chief of his tribe. In South Africa the lion killer painted his body white, went into seclusion for four days and then returned to the village with his skin coated red.

In China jade was the precious talisman. Its significance is revealed in the burial ceremonies of illustrious and imperial persons. Six jade objects were called upon. With a round green tablet, homage was paid to heaven. A yellow tube paid homage to earth, green jade paid respects to the region of the east, red jade to the south, white jade to the west, and black jade to the north. Those who were left to mourn expressed their grief with color. The customs of mourning were and are quite different throughout the world. In China the accepted color is white. Silks, satins and red garments are not worn for several months after the death of a parent. The tint of visiting cards while in mourning is light brown though the usual color is red. In Japan white is also the emblem of death. When worn in the marriage rite of the Japanese bride, it signifies that she is dead to her family and that she now belongs solely to her husband. In Borneo white or dark blue bespeak the bereaved. Blue is worn in Mexico, in Chaldee and in some parts of Germany. Guatemalan widowers have been known to dye their bodies yellow.

Among nearly all Western peoples black is the color of mourning, for black has the very appearance of death. Certain primitives dye their teeth black after the death of a relative. In England the widows' garments are white, faced with black. In mourning for their masters, servants wear black, unrelieved by any other color, even on buttons.

HERALDRY

The science of heraldry is peculiar to Western culture. In medieval times it exercised much influence over the manners and habits of men. To the people of Europe, mostly illiterate, a knowledge of heraldry was essential. It was a visible token of chivalry, a record and an index of nobility and achievement.

The practice of heraldry is centuries old. Standards and emblems have always been associated with nations, races and armies. The Egyptian ox, the Athenian owl, the eagle and dragon of the Romans were heraldic symbols. The Bible mentions the standards of the twelve Jewish tribes and the symbolism and mysticism that was a part of them. To Judah was assigned the lion and the color scarlet. Issachar was assigned the ass and the color blue. The charge of Zebulon was purple and a ship. Reuben was red and a man; Simeon was yellow and a sword; Gad was white and a troop of horsemen; and Ephraim was green and an ox. Mannassen was flesh-color and a vine. Benjamin was green and a wolf; and Dan green and an eagle. Asher was purple and a cup; Naphali blue and a hind.

An old scholar even ascribed arms to Adam: "To Adam was assigned a shield gules, and to Eve another, argent; which later Adam bore over his as an escutcheon, his wife being sole Heiress."

The science of heraldry as known today had its origin in 12th-century Germany. From there is passed through France into England. During the Crusades soldiers of different nations bore distinguishing emblems. The English soldier wore a white cross on his right shoulder, the Frenchman a red cross and the Fleming a green one. The

The crosses of heraldry

The birds and fishes of heraldry

Crusaders from Roman states used the symbol of two keys.

Though at first used to reward heroes upon the field of battle and in tournament, heraldry later identified high honor and service to the nation. Because the one favored was granted certain figures and colors, which in turn were embroidered on a garment he wore over his armor, these devices became known as "coats of arms," a description which survives to this day and includes all heraldic designs.

Colors in heraldry are called tinctures. They consist of two metals and five hues:

Gold (or yellow) is called *or*.
Silver is caller *argent (arg.)*.
Red is called *gules (gu.)*.
Blue is called *azure (az.)*.
Black is called *sable (sa.)*.
Green is called *vert*.

Purple is called *purpure (purp.)*.

Two other colors are used, though rarely:

Tenne is an orange color and *murrey* is a reddish purple.

The symbolism of these tinctures follows the traditions of ancient civilizations and the Bible:

Or, yellow or gold, stands for honor and loyalty.
Argent, silver, represents faith and purity.
Gules, red, is the token of courage and zeal.
Azure, blue, signifies piety and sincerity.
Sable, black, means grief and penitence.
Vert, green, means youth and hope.
Purpure means royalty and rank.
Tenne, orange, means strength and endurance.
Murrey, red-purple, means sacrifice.

In the heraldic use of color, many strict

The tinctures of heraldry were indicated by these hatchings in black and white. The custom is still followed and used for many purposes

OR (Yellow) **GULES** (Red) **AZURE** (Blue) **VERT** (Green)

PURPURE (Purple) **SABLE** (Black) **TENNÉ** (Orange) **MURREY** (Red-purple)

proprieties are observed. The immutable law is that no great ideal can possibly be symbolized except by pure color! Pink, lavender and buff have no place on flags and devices. Dilute a color and the virtue for which it stands is thereby besmirched. Again, in heraldry, the two metals, *or* and *argent,* always take precedence over the hues. A strict law states that metal shall not be placed upon metal, nor hue upon hue! One scholar has said, "And because it was the custom to embroider gold and silver on silk, or silk on cloth of gold or silver, the herald did therefore appoint that in imitation of the clothes so embroidered, color shall never be used upon color, nor metal upon metal."[8]

There are violations of this rule, particularly in French, Italian, Spanish and German heraldry, but the English are strict about its observance. Yet they do accept the old arms of the Crusader Kings of Jerusalem, which bore five golden crosses on a silver shield.

MODERN SIGNIFICANCE

Heraldry remains part of modern culture, particularly in England. Here the art has been preserved and continues to charm the populace. England has its royal families, its princes and princesses, dukes and duchesses, earls, barons and viscounts. Coats of arms are part of all these titles and have even been extended to corporations such as the

British Broadcasting Company, Lloyds of London, the Worshipful Company of Haberdashers, to municipalities, schools, colleges and rugby teams. In the Olympic Games the Englishman's badge resembles the Union Jack. Irishmen wear the symbol of a shamrock or harp, Scots the arms of Scotland, or the emblem of a thistle, and Welshmen are adorned with the sign of three plumes or a daffodil.

The English, with their love of heraldry, have, among modern nations, developed perhaps the most formal traditions in dress. The royal crown of England, for example, is fashioned of gold and purple (usually identified as red). By custom, scarlet is to be found solely on royal livery. In lieu of this, the lesser nobility makes use of claret, brown or maroon. Gold and silver are also reserved for the high and mighty. Even yellow, the heraldic equivalent of gold, is not a cloth to be found on those who perform public or private duties. So fastidious are the English in their insistence upon propriety that certain officers, public officials and servants receive yards of cloth in hues appropriate to their rank. While the English gentlemen himself could not adhere to any such medievalism without losing face in the opinion of other nations, he does burden his servants with it. Generally, the hues of his lackeys and maids are taken from his family coat of arms—scarlet, gold and silver excepted—whose colors were granted to his ancestors as symbolic of noble deeds and were not chosen for the artistic effect on stationery, coach doors or silk pillows. The Plantagenets used white and red for their servants, the Lancastrians white and blue, the Tudors white and green and the Stuarts white.

As a rule, English teams wear white jerseys. Scottish teams wear dark blue. Welsh teams wear red. In Rugby, Amateur Association football, the color is royal blue.

SYMBOLISM OF THE FLAG

Heraldry in America, however, is less pretentious, and for good reasons. In England a decoration meant knighthood, and knighthood a coat of arms. Such patronage was not for those who dwelt in the "land of the free." However, heraldry did have its role in creating the flag of the United States, in the design of governmental seals, and in school and college crests. The art was not always pure and simple. One writer describes the arms of

Oregon: "On a Fess, the words, *THE UNION;* in Chief a Landscape, an Ox-wagon, a Deer, Trees, Mountains, and Prairie; in distance, the Sea, thereon a sailing Ship and a Steamer; in base, a Plough, Rake Scythe, Garbs, etc.—which I may venture to blazon as, All any how!" This, no doubt, was the work of a Victorian craftsman with the soul of a mural painter, not a herald.

Most seals and crests fail to impress the average American, who looks upon them as so much vanity and pretense. Yet he is reverent about his flag. Though flags may be part of the glory of heraldry, their history is far older than the coat of arms. They were probably an Egyptian invention, and Homer tells that Agamemnon used a purple veil to rally his men. Ancient ensigns generally had figures on them. The dragon, familiar to the Chinese, was also used by the barbarians who fought against Rome and was later adopted by the Romans. The Trojan standard consisted of such a beast with a head of metal and a tail of different colored cloths.

In the history of England, standards were borne by both Saxons and Normans. Richard I, the Lion Hearted, had a shield charged with three golden lions on a red ground. Later, Edward III quartered the shield and placed the arms of France in the first and fourth quarters. The flag of England subsequently underwent almost as many changes as England had kings. Today the Royal Standard preserves the arms of the heroic Richard. In the first and fourth quarters are the familiar gold lions on red ground. In the second quarter are the arms of Scotland, a red lion rampant on golden ground. In the third quarter are the arms of Ireland, "Azure, a harp or, stringent argent" (a gold and silver harp on a blue ground). The arms of Wales hold no place on the emblem, presumably because Wales is a principality and not a kingdom of the empire.

The British Union Jack rather than the Royal Standard played its part in the history of the American flag. The present Union Jack comprises three crosses: those of St. George of England, St. Andrew of Scotland and St. Patrick of Ireland, in the familiar red, white and blue.

With the first recalcitrant peep of the new America, flags were unfurled. Favorite devices in those early days, which bore no trace of English influence, were the pine tree and the rattlesnake. George Washington's

Some early flags of the United States. Here color symbolizes the ideal and follows traditions as old as history

first naval flag carried the New England pine tree with the words, *"AN APPEAL TO HEAVEN."* From the South came an expression of defiance, the coiled snake with the warning, *"DON'T TREAD ON ME."*

When Washington took command of the colonial army, he found a multitude of flags. He interpreted this as a divided loyalty to the cause of freedom. He was interested in a single national emblem and went about having one accepted. The Grand Union Flag resulted and combined the British Jack with thirteen red and white stripes. Despite its "Englishness," it was flown by John Paul Jones and remained the national ensign of the colonies for more than a year.

In June 1777, a year after the Declaration of Independence, the Stars and Stripes was born—thirteen white stars arranged in a circle upon a blue ground, and thirteen red and white stripes. This flag is similar to the coat of arms of Washington himself, although many scholars refuse to admit that the emblem is to be traced to this source.

In years that followed, the United States flag underwent several modifications. At times its white stripes would number seven and its red stripes six. The stars upon the blue field would be arranged in lines rather than in a circle. When Vermont (1790) and Kentucky (1792) entered the union, the flag contained fifteen stars and fifteen stripes, and this was the ensign that floated over Fort McHenry when Francis Scott Key wrote "The Star Spangled Banner." In 1818 Congress restored the thirteen stripes to the flag and ruled that these were to remain as symbolic of the original colonies, while each new state would be honored by the addition of a new star.

MODERN COLOR SYMBOLISM

Most modern color symbolism is motley. Obscure though its origin may be, it is not without its fascination, for color is still part of culture, even in the places of learning. Since 1893 American universities and America have recognized by code—and before this by custom—a palette of eight colors to identify their major faculties. These hues make up part of the insignia of the learned and are worn in gown, braid or tassel as follows: Scarlet represents theology, blue philosophy, and white is for arts and letters. Green is for medicine, purple for law, while golden yellow is for science. Orange is for engineering and pink for music.

It is no problem to defend these choices—they bespeak the heart and mind of the ancient. Surely red with its allusion to blood, to sacrifice and sin, belongs to religion. Blue, always emblematic of truth, divinity and glory, is proper to philosophy. The purity of white for arts and letters, the immortality of green for medicine, the dignity of purple for law—these colors and branches of learning have much in common. Perhaps the modern savant was troubled about hues for science and engineering. Yet the sun for one and gold for the other were plausible. Pink for music, however, is but a meager laurel; the color is best expressed with magenta, however, its real parent.

In Brazil, a country abounding in precious and semi-precious stones, professional rank is denoted by gems. The physician wears an emerald ring, the lawyer a ruby and the engineer a sapphire. The professor affects the green tourmaline, the dentist the topaz and the merchant or businessman the pink tourmaline. The symbolism here is not so venerable and smacks more of modern merchandising practice.

Colors have also become the honoraria of stock, horse, dog, cat and other shows. Generally, the first prize award is a blue ribbon, the second prize a red ribbon, the third yellow or gold and the fourth white. Purple may be used for winner-over-all classes, and green for special prizes.

Finally, the sacred and profane holidays of a modern world bear tribute to the convenience, if not the divinity, of the rainbow in glorifying things festive. Red belongs to Christmas, St. Valentine's Day, the Fourth of July. Green is for St. Patrick's Day. Yellow and purple are for Easter; and orange for Thanksgiving and Hallowe'en. The red carnation on Mother's Day is for the living, the white carnation for the deceased.

The earliest known portrait of a doctor, dating back some twenty thousand years. From a painting on the walls of a cave in France

Chapter 5

THE SACRED ART OF HEALING

In *The Story of Man,* Carleton S. Coon refers to healing as the oldest profession, and the healer, witch doctor or shaman can be found inscribed in early cave art dating back to the upper Paleolithic age, long before recorded history. Color has always been associated with healing, because man related the power of the sun and rainbow to divine forces. (The effects of color on the human mind and body, and recent uses of color for therapeutic and psychotherapeutic purposes will be discussed in subsequent chapters.) But nothing was stranger than life, or more terrifying than illness and death, because the primitive knew little of the workings of disease or of the human body. For him, flesh and blood were a combination of earth, fire, water and air, animated by the spirit from some supernatural deity. That deity had made not only the elements of man, but

The shaman, or witch doctor, of British Columbia shook these colored rattles to drive away illness

Mandrake roots in the form of a man and woman. This was perhaps the most famous herb of antiquity

those of the universe; and to keep those elements in harmony, to be attuned to the harmony of the gods and the universe, was the only way to avoid sickness and death.

ANCIENT THEORIES OF DISEASE

But all power was not with the gods. Disease was an evil spirit that entered the body of man and wrought havoc there. Indeed, the Gods themselves were not immune! In unwary moments, the evil one penetrated through eyes, ears, mouth or nose, and threw it into spasms and eruptions. In Teutonic magic, disease was said to be caused by nine venoms: red, white, purple, yellow, green, livid, blue, brown and crimson. These were banished from the human system by special ceremonies known to the elect. "Then took Wodan nine magic twigs, smote then that serpent that in nine bits she flew apart. Now these nine herbs avail against nine spirits of evil, against nine venoms and against nine winged onsets."

THE ART OF HEALING

The use of herbs was one of the earliest of remedies. Many of these brought actual physical benefit and perhaps were discovered by trial and error. Yet in many cases, magic was based on weird associations only. Almost any substance might be used: fungus from a grave, dew from grass, noxious concoctions that were often little more than fantastic inventions. Often, the healer associated the form of a plant with the affliction itself. The juices of fern and moss were good for the hair. The *Palma Christi,* shaped like a hand, cured the hand. Another plant, tooth-shaped, relieved the ache of a tooth. The onion, with its rings and layers, was thought to possess healing virtues because it was supposed to be designed like the world itself. The strong odor of garlic was thought to exude powers that chased away illness.

Mandrake is among the most famous of all plants. In *Genesis,* Leah speaks to Rachel, "Is it a small matter that thou hast

taken my husband? And woulds't thou take away my son's mandrakes also?" Commonly used as a narcotic and purgative, mandrake was supposed to have magical properties. Because its roots took human shape, it seemed human. If pulled from the earth, the mandrake screamed and caused either death or madness. In *Romeo and Juliet* Shakespeare wrote, "And shrieks like mandrakes torn out of the earth, that living mortals, hearing them, run mad." To play safe, a dog was tied to the plant on a moonless night and then called from a distance. Witches used the plant in their cauldrons as an opiate and love potion. Mandrake was said to grow particularly well under the gallows of hanged men.

Most color symbolism in healing was quite direct. Colors were associated with disease because disease produced color. Plants, flowers, minerals, elixirs were efficacious when their hues resembled the pallor of the flesh or the sores upon it. Thus, red, yellow and black had great medicinal value, for they were identified respectively with fever, plague and death.

Red is the most interesting color in magic healing. It is found not only in the lore of ancient medicine but in the superstitions of modern times. Scarlet cloth has for many centuries been used to stop bleeding. In the 11th century Avicenna dressed and covered his patients with red. The physician to Edward II, to thwart smallpox, directed that everything about the sick room be red, and Francis I was treated in a scarlet blanket for the same affliction. The children of one of the Mikados were surrounded by red in all furnishings during a smallpox attack.

At times physicians would go to the extremes of prescribing red medicines and foods so that everything the patient ate or saw was crimson. The custom was so persistent that English physicians once wore scarlet cloaks as a distinguishing mark of their profession. In rural districts of Massachusetts a red flag was once displayed to call the doctor as he made his rounds. In Ireland and Russia red flannel was a remedy for scarlet fever. Red wool cured sprains in Scotland, sore throat in Ireland, and prevented fevers in Macedonia. Red thread was thought necessary in the teething of English children. The breath of a red ox was a palliative in convulsions. Red sealing wax cured certain eruptions. Red coral kept teeth from loosening in England and relieved head troubles in Portugal. Red overcame nightmares in Japan. In Macedonia red yarn was tied on the bedroom door after the birth of a child to bind evil. In China the ruby was worn to promote long life. A ribbon of red cloth was tied to the pigtail of the child for the same reason. The garnet in India and Persia similarly protected their wearers. Roman coral and red carnelian drove away the evils of disease.

E. A. Wallis Budge has written in *Amulets and Talismans* of the red amulets so common in Egypt centuries ago: "A considerable number of rings made of red jasper, red *faience,* and red glass have been found in the tombs of Egypt; all are uninscribed and all have a gap in them. How and why they were used is not known, but a recent view about them is that they were worn as amulets by soldiers and by men whose work or duties brought them into conflict with their enemies, to prevent them from being wounded, or if wounded, to stop the flow of blood. It is possible that they were worn by women to prevent bleeding."

Yellow cured jaundice, because jaundice was yellow. In Germany the disease was attacked with yellow turnips, gold coins, saffron and a dozen other yellowing things. Yellow spiders rolled in butter were English remedies. In one part of Russia gold beads were worn; in another section the patient stared at a black surface, the opposite of yellow and therefore capable of drawing the jaundice from the system. In India jaundice was banished to yellow bodies, creatures, and things such as the sun, where it properly belonged. The red, vigorous color of health was then "drawn" from a bull after certain recitations by a priest.

In Greece an affliction called "gold disease" was cured when the patient drank wine in which a gold piece had been placed and exposed to the stars for three nights. Bits of gold were also sprinkled on food as a safeguard against poisoning. In one of the Malay states disease and plague were driven away in a yellow ship; or a buffalo covered with red pigment lumbered out of the village with the scourge upon him.

Among ancient Greeks it was thought that a raven's eggs would restore blackness to the hair. So effective was the remedy believed to be that the Greek kept his mouth filled with oil while the egg was rubbed into his hair in order to keep his teeth from turning black. Black threads from the wool of

black sheep cured earache in Ireland, England and parts of Vermont. Black snails were rubbed on warts. In France the skins of black animals, applied warm to the limbs of the body, relieved rheumatism. Black fowl, if buried where caught, would cure epilepsy. The blood of a black cat has been prescribed for pneumonia in places as remote from each other as England and South Africa.

Plutarch mentions that a white reed found on the banks of a river while one journeyed to a dawn sacrifice, if strewn in a wife's bedroom, drove an adulterer mad and forced him to confess his sin. The milk of a white hare cured fever in Brittany.

Few other colors are found in amulets and charms meant to cure disease. Blue and green have mostly been used as preventatives, to ward off the evil eye and to spare the wearer from visitation of demons. However, in Ireland blue ribbon was used for the croup, and indigestion was relieved when a person measured his waist with a green thread in the name of the Trinity, and then ate three dandelion leaves on a piece of bread and butter for three consecutive mornings.

THE POWER OF GEMS

Because disease arose mysteriously out of nature, the most potent colors to combat it must also come out of nature. Therefore, precious and semi-precious stones were particularly therapeutic. Brown agate drove away fevers, epilepsy and madness. It stopped the flow of rheum in the eye, reduced menstruation, dispersed the water of dropsy.

Amber was mixed with honey for earache or failure of sight. Amber dust relieved pains in the stomach and helped the kidneys, liver and intestines. The smell of burnt amber aided women in labor. An amber ball, held in the palm of the hand, reduced fever and even kept a man cool on the hottest of days. Amber beads preserved the wearer from rheumatism, toothache, headache, rickets and jaundice. A bit placed in the nose stopped bleeding. Placed about the neck, it made the largest goiter disappear. Arab physicians used powdered amber to prevent miscarriage, to overcome boils, carbuncles and ulcers.

Amethyst cured the gout. Placed under the pillow, it gave the sleeper pleasant dreams.

Green beryl, through sympathetic magic, overcame diseases of the eye. Yellowish beryl was prescribed for jaundice and a bad liver.

Carnelian, the "blood stone," restrained the hemorrhage and removed blotches, pimples and sores from the flesh.

According to Budge, the cat's eye was washed in milk and the liquid drunk by the Kordofan's wife. Should she commit adultery after her husband's departure, no child would be born of the illicit union.

Crystal was used as a burning-glass in medical operations. In powder form it was a cure for swellings of the glands, diseased eyes, heart disease, fever and intestinal pains. Mixed with honey, it increased the milk of a mother.

The diamond fortified mind and body, and cured virtually everything. Dipped in water and wine, it created an elixir that thwarted gout, jaundice and apoplexy.

The emerald cured diseases of the eyes.

The garnet prevented skin eruptions.

Jade assisted in childbirth. It cured dropsy, quenched the thirst and relieved palpitation of the heart.

Jet healed epilepsy, toothache, headache and glandular swellings.

Opal cured diseases of the eye.

The ruby was dipped in water for a stomachic and ground into powder to check the flux of blood.

Sapphire prevented disease and plague.

Turquoise protected its wearer from poison, the bites of reptiles, diseases of the eyes. Dipped or washed in water, it charged the liquid and made it a palliative for those who suffered from retention of urine.

OUR DEBT TO THE ANCIENTS

Today men are taught to be wary of nostrums. Disease is no longer a complete mystery. Although reaction in science to all things superstitious has thrown them into the discard, man continues to be the mystic at heart. Something within him persists in whispering that elixirs of life do exist. He buys patent medicines, mineral waters, pills and tablets with fervid hope. He consults occult healers, quacks and fakirs.

In psychosomatic medicine today, the medical practitioner recognizes and acknowledges the therapeutic value of his patients' "frame of mind and spirit." In other words, the will to get well may be as impor-

tant as medicines. If color cured sickness in the old days, it may have been because of its favorable influence on the sick, so one must not discount superstitions entirely. In some instances the ancient may have credited his recovery to color without fully appreciating the chemistry involved. Thus, the purple dye extracted from Murex shells was used to check overgrowth of granulation tissue and to draw pus from boils. What the ancient failed to realize was "that their efficacy was unrelated to the glamorous color of the purpura, but due to the formation of calcium oxide, one of the first compounds which was to lead to Dakin's solution two thousand years later."

The modern physician traces the art of medicine to Hippocrates; the mystic goes back further still and bows at the shrine of Hermes the great. Hermes, the Thrice Greatest, Master of All Arts and Sciences, Perfect in All Crafts, Ruler of the Three Worlds, Scribe of the Gods and Keeper of the Books of Life, is perhaps the most remarkable figure in the history of mysticism. Accepted as god and mortal in Egypt, he was revered by the Greeks and became the Mercury of the Romans. He is said to have been the author of twenty thousand or more

The thrice Greatest Hermes who was perhaps the most wondrous of ancient divinities and keeper of the books of life

books, works founding the entire mythology of Greece and dealing with medicine, alchemy, law, art, astrology, music, magic, philosophy, mathematics and anatomy. Francis Barrett thus finds reason to write of him, "If God ever appeared in man, he appeared in him."

The famous Emerald Tablet, said to have been found in the valley of Ebron, epitomizes the teachings of the amazing Hermes. It contains an alchemical formula and involves color, simply because color is part of alchemy and, in turn, obedient to one supreme and divine entity associated with light. Did Hermes heal with color? Unquestionably he did, for his Egypt abounds in many symbols. One ancient papyrus exclaims, "Come verdigris ointment! Come thou verdant one!"

EGYPTIAN HEALING

Egyptians believed in the efficacy of the spectrum, the power of charms, gems and hues. In one papyrus dating back nearly four thousand years the age-old problem of revealing the sex of an unborn child was answered in these words: "Another time: if thou seest her face green . . . she will bring forth a male child, but if thou seest things upon her eyes, she will not bear ever." Again, in the Zoroastrian Scriptures, reference is made to the sex of the unborn: "The female seed is cold and moist, and its flow is from the loins, and the color is white, red, and yellow; and the male seed is hot and dry, its flow is from the brain of the head, and the color is white and mud-colored."

In Asia Minor the ancient Persians understood and practiced a sort of color therapy based on light emanations. The Babylonians believed that the seat of all passions and emotions was in the liver, not in the heart. When the sun god created man, he arranged man's entrails in such a way that they would indicate the will of the deity. Thus, the liver was studied and even employed in sacrificial rites and ceremonies (using sheep).

Numerous Egyptian surgical and medical manuscripts have been found in modern times. One of the most fascinating is the Papyrus Ebers, dating back to about 1500 B.C. and said to be "the oldest (complete) book the world possesses." Because of its frankness, an unexpurgated translation was not released to the public until 1937 (the papyrus was discovered in 1873). While there is

A column from the Papyrus Ebers, one of the oldest and greatest medical manuscripts. About 1500 B.C.

no pornography here, there is much Rabelaisian candor which might more easily upset the stomach than arouse the passions. The manuscript is beautifully preserved, and its 110-wide columns and 68-foot length are intact. It consists of a collection of medical prescriptions. "Throughout the manuscript the heading of different chapters, the names of the diseases, the directions for treatment, and in many cases the weights and dosages of the drugs are written in vivid red."

Here one finds what was early advice to apply raw meat to a black eye! Colored minerals, malachite, red and yellow ochre, hematite (a red clay) are endowed with efficacy, apparently because of their color. For constipation it advises white or red cake. To salve a wound take vermilion writing fluid mixed with goat's fat and honey. For other ailments the blood of a black cat and numerous other colored things, organic and inorganic, are potent.

GREECE AND ROME

In Greece the Egyptian theories prevailed. White garments were worn by the afflicted to cause pleasant dreams. Pythagoras, like Hermes, also taught unity and harmony. God, to him, was a living and absolute truth clothed in light. He was acquainted with the Mysteries and declared the motion of god to be circular, his body composed of the substance of light. Everything in nature was divisible into three parts. There was the supreme and spiritual world, the home of the deity; the superior world, the home of the immortals; the inferior world, the home of mankind. Although the exact medical practices of Pythagoras are unknown, he is said to have cured disease through the aid of music, poetry and color.

Unlike Pythagoras, whose credo was universal harmony, the great Hippocrates (460?-377? B.C.) cast a suspicious eye on the habits of men, talked about their diets, listened to the beating of their hearts and founded that critical and diagnostic attitude that is intrinsic to modern medicine. Here, perhaps, a new viewpoint began: color as an outward expression of an internal and strictly pathological condition. Hippocrates, too, prognosticated the sex of the unborn in terms of color: "A woman with child, if it be a male, has a good color, and if a female, she has a bad color."

Celsus, who lived at the beginning of the Christian era, followed the Hippocratic doctrines. His attitude toward color was practical rather than occult, though he prescribed medicines with color in mind: white violets, purple violets, the lily, iris, narcissus, rose, saffron, and so on. The plasters he used to relieve wounds were black, green, red and white. Of red he wrote, "There is one plaster almost of a red color, which seems to bring wounds very rapidly to cicatrize."[9]

Celsus declared spring to be the most salubrious season, then winter and summer, with autumn most inimical. Of the insane he wrote, "It is best . . . to keep him in light who dreads darkness; and to keep him in darkness who dreads light." One of his potions was yellow: "Saffron ointment with iris-oil applied on the head, aids in procuring sleep, and also in tranquilizing the mind."

Galen (130-200? A.D.) said, "I have been anointed with the white ointment of the tree of life," and was thereby being the mystic. He was attracted to motion and change as significant in diagnosis. "Thus, if that which is white becomes black, or that which is black becomes white, it undergoes motion in respect to *color*." He worked out an elaborate theory in which these visible changes were reckoned with. One of his queries in

this connection is amusing. "How, then, could blood ever turn into bone without having first become, as far as possible, thickened and white? And how could bread turn into blood without having gradually parted with its whiteness and gradually acquired redness?"

THE GREAT AVICENNA

During the Dark Ages, progress in medicine passed from Rome to Islam and there found its greatest leader in Avicenna, an Arabian physician and philosopher (980–1037?). In his *Canon of Medicine,* one of the most venerable medical documents, he pays rare tribute to color, both as a guide in diagnosis and as an actual curative. Avicenna's attitude was more searching and passionate than that of Hippocrates, Celsus or Galen. Color was of vital importance, worthy of profound study. In consequence, the Arabian dealt freely with it and wrote it into almost every page of his *Canon.*

An acknowledged disciple of Aristotle, Avicenna believed the world comprised of five elements which he allied to the senses, the mind and the emotions. These elements created tendencies that formed the body and soul of man. Also, a man's breathing had different phases, strong and weak, and the vibration rates of breath were related to the elements. The breath of earth was slow, the breath of ether fine and quick.

Avicenna diagnosed his patients' diseases with an eye on hue. The color of hair and skin, of eyes, excrement and urine were significant. "In jaundice, if the urine becomes of a deeper red until it is nearly black, and if its stain on linen can no longer be removed, it is a good sign—the better the deeper red. But if the urine becomes white or slightly reddish, and the jaundice is not subsiding, the advent of dropsy is to be feared." If the skin of the patient changed to yellow, he suspected a disorder of the liver. If the change was to white, the disorder was probably in the spleen. A yellowing-green complexion might be attributed to piles. All these colors must be carefully observed.

Avicenna devoted much study to the fluids and humors of the body. He developed an unusual chart in which color was related to temperament and to the body's physical condition. These conclusions were based on experience, and he made use of them in his practice.

The predecessors of the great Arabian had also noted that color was an observable symptom in disease. But Avicenna was more of a mystic. Color was not only the sign of affliction; it might also be the cure! First, the innate temperaments of men might be found written in the color of hair. People with black hair had hot temperaments, those with brown hair had cold temperaments. The tawny-headed or red-headed person was volatile. Here there was an excess of "unburnt heat," hence a tendency to anger. The temperament of the fair-haired was cold and very moist, that of the gray-headed cold and very dry. In both instances Avicenna saw weakness and physical deterioration. Like plants, men lost color when they dried out!

Avicenna had confidence in color therapy. Of humors Avicenna wrote: "Even imagination, emotional states and other agents cause the humors to move. Thus, if one were to gaze intently at something red, one would cause the sanguineous humor to move. This is why one must not let a person suffering from nosebleeding see things of a brilliant red color." He also declared red and yellow to be injurious to the eye. Blue light slowed the movement of blood, red light stimulated it. The clear light of morning aided nutrition. Because red moved the blood, it was used profusely and even prescribed in medicines. White, conversely, was a refrigerant. Potions of red flowers cured disorders of the blood. Yellow flowers cured disorders of the biliary system.[10]

ALCHEMY

Alchemy, though of ancient origin, dominated Western thought and healing during the Middle Ages. Although a great deal of mystery surrounds its origin, the astonishing Hermes was probably its creator.

Egypt, or Khem, was "the country of dark soil." It became known to Islam as *al Khem,* and through Islam the term *alchemy* made its way into Western civilization. As far back as 3000 B.C. Egyptians practiced metallurgy. Gold, most precious and unsullied of metals, was mined and fashioned into amulets. The Egyptians became expert in tinting metals as well as fabrics, in applying chemistry to the manufacture of pigments. There was magic in all this, and just as the ancient might, through alchemy, produce the most celestial of all metals—gold—so also might he comprehend the spirit of creation, restore

DEBENT IGNARI RES FERRE ET POST OPERARI QVATVOR INSERTA NATVRIS IN NVBE REFERTA
IVS LAPIDIS CARI VILIS SED DENIQ5 RARI NVLLA MINERALIS RES EST VBI PRINCIPALIS
VNICA RES CERTA VILIS SED VBIQ5 REPERTA SED TALIS QVALIS REPERITVR VBIQ5 LOCALIS

The Alchemist, by Peter Brueghel the Elder. An obviously satirical portrayal of man's search for the Philosopher's Stone

The Sorcerer of Mallaghem, by Peter Brueghel the Elder. Here quackery in medicine is brilliantly shown

harmony to the troubled world of mankind, and heal human ills.

Alchemy can also be traced to China, where it flourished before the Christian era and was involved with the religion of Taoism. The Taoist *Cannon,* in fact, is replete with alchemistic writings. The Chinese prepared liquid gold, the Elixir of Life. Jade itself was a solidified liquid that once flowed from a holy mountain. It was to be converted from stone to divine medicine through the magic of a certain herb and used to cure the many ills of humankind.

These were the beginnings. Later, in Europe, alchemy became the most important of the sciences, mixed up with paganism, Christianity and mysticism. Among its exponents were men like Roger Bacon, Ben Jonson, Albertus Magnus, Paracelsus, Thomas Aquinas, Nicholas Flamel, Raymond Lully and Jakob Boehme. In the 15th century alchemists banded into a religious and political organization whose initiates delved into the mysteries of nature, prophesied the future and cured disease. They concealed their writings to preserve their necks against the wrath of the Church.

While some alchemists devoted themselves to transmutation of metal, all were mystics who saw in alchemy a true expression of their doctrines of human unity. Boehme's theories, for example, were almost wholly transcendental. To him, alchemy was not a physical science at all, but a spiritual one. Thus, the Philosopher's Stone was likened unto Christ; transmutation meant faith, the separation of good from evil, and the coarse expunged from the divine.

Of first importance to alchemy were the Seven Metals. Men believed that the influence of a planet was never stronger than when it acted through its corresponding metal. Also in the various stages of the Work were various regimens, each distinguished by color. These hues appeared as the alchemist busied himself with his furnaces and retorts. All metals had one essence, but all were not equally mature. Gold was the highest product and signified regenerate or perfect man. Lead was the basest metal, signifying unregenerate or evil man. Brass, for example, was regarded as copper on its way to becoming gold. Similarly, the whitening of copper by mercury denoted an incomplete transmutation of the substance into silver. Again, the making of the Philosopher's Stone was said to embody

Paracelsus, leading mystic and healer of his day (1493-1541). He is shown here performing an operation

View of a sixteenth century hospital

An old German engraving of the alchemist in his laboratory. Here the science of chemistry was founded

The alchemist with his stills and retorts

A handbill distributed by an English quack doctor about 1690

salt, sulphur, mercury and Azoth—these four substances being frequently symbolized by a cross. The *prima materia* was the mercury of the philosopher treated with a special sulphur. Mercury, feminine and composed of water and air, was positive. Sulphur was masculine and composed of earth and fire. It was negative.

While theories varied, most alchemists saw the Philosopher's Stone as a divine harmony of the four elements: earth, fire, water and air. If these could be united, a substance would be derived capable of transmuting baser metals into gold and silver and a medicine to cure the diseases of men. One old alchemist wrote, "There abides in nature a certain pure matter, which, being discovered and brought by art to perfection, converts to itself proportionally all imperfect bodies that it touches." The Philosopher's Stone was thus variously described as the harmony of the elements, the crystallization of solar and lunar rays to form virgin earth, a unity of the human with the divine spirit, the Philosopher's Egg (a symbol of creation, enclosing within itself the four elements) and the Spirit of Christ.

The process was indeed elaborate; and color was vital to it. In his *Prelude to Chemistry,* John Read writes: "The various stages necessary for the accomplishment of the Great Work, or preparation of the Philosopher's Stone, was supposed to be marked by the appearance of the characteristic colors: and unless these colors followed one another in proper sequence the operations were dismissed as useless."

THE MEANING OF COLOR

The principal colors of alchemy were black, white, gold and red—in that specific order. An ancient writer states, "The Means of demonstrative signs are Colors, successively and orderly affecting the matter and its affections and demonstrative passions." Thus, black was the first and showed the beginning of the action of fire. Its symbol was the cross. White followed and formed perfection of the first degree. Its symbol was the swan. Third was the color orange or gold, produced in the transition from white to red, a forerunner of the sun and comparable to the sunrise. Fourth was red, symbolized by the phoenix and extracted from white. "The deep redness of the Sun perfecteth the work of Sulphur, which is called the Sperm

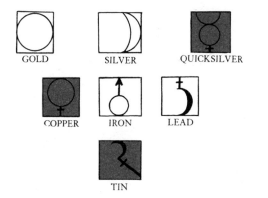

GOLD SILVER QUICKSILVER

COPPER IRON LEAD

TIN

The symbols of alchemy. Lead was base and gold the symbol of regenerate man

of the male, the fire of the Stone, the King's Crown, the Son of Sol, wherein the first labor of the workman resteth." Rainbow colors were also used, their fugitive presence having significance and their symbol being the peacock.

To express all this in alchemical formulas, strange heraldic emblems were used. Sophic sulphur or gold was frequently called the Red King. The White King was sophic mercury or silver. The Ascending Dove or Swan was a white sublimate. The Black Crow was putrefying matter. The Toad was earthly matter. The Winged Lion was mercury. The Wingless Lion was "sulphyr". These devices became a part of writing, useful to impart knowledge to the initiate, and a hopeless mystery to the ignorant. One alchemist wrote: "Soon after your Lili (tincture) shall have become heated in the Philosophic Egg, it becomes, with wonderful appearances, blacker than the crow; afterward, in succession of time, whiter than the swan; and at last passing through a yellow color, it turns out more red than any blood."

The Philosopher's Stone. In its creation it was black, then white, yellow, and "more red than any blood"

PANCOAST AND BABBITT

Alchemy died, and color was forgotten. In the late 19th century America, a resurrection occurred. Notably through the efforts of S. Pancoast and Edwin D. Babbitt the world again stormed the ethereal realm of light to find the universal panacea. All the mysterious fascination of alchemy, of the Philosopher's Stone and the Elixir of Life, known to other generations, now charmed a more modern world. Color therapies and color practitioners sprang up everywhere.

In 1877, S. Pancoast published his *Blue and Red Light.* He turned abruptly away from the rational teachings of the medical profession and hailed the wisdom of ancient philosophers and Kabbalistic literature. After writing on the secrets of mysticism he said, "Our reader has, we trust, learned to respect, as we do, the Ancient Sages, at whom modern Scientists, in their overweening self-esteem, their ignorant vainglory, are wont to scoff." Pancoast believed that "white is the color of the quintessence of Light: toward its negative pole, White is condensed in Blue, and fixed in Black: toward its positive pole, White is condensed in Yellow, and fixed in Red. Blue invites to repose, or to slumber, Black is absolute rest, the sleep of death; Yellow is activity; Red is absolute motion, the motion of life; and White is the equilibration of motion, healthful activity." And again, "In Life-unfoldment, the progress is from Black to Red—Red is the Zenith of manhood's prime; in the decline of Life the course is from Red to Black; in both unfoldment and decline, White is traversed, the healthful, elastic period of first maturity and of the medium stage of old age."

Pancoast worked in a rather simple way. Sunlight was passed through panes of red or blue glass—the two chief therapeutic agencies. "To ACCELERATE the Nervous System, in all cases of relaxation, the RED ray must be used, and to RELAX the Nervous System, in all cases of excessively accelerated tension, the BLUE ray must be used." Pancoast declared that he effected a great number of miraculous cures and quoted numerous case histories.

Edwin D. Babbitt was a curious combination of scientist, mystic, physician, artist and essayist. His viewpoint was broader than Pancoast's. He had a cosmic interest in life and the world, and confidently assumed

The Victorian quack treated illness with musical vibrations and colored slides of "enchanting beauty"

an attitude that made him at once an initiate into the most complex mysteries of ancient philosophy as well as the intricacies of modern science. From his *The Principles of Light and Color,* published in a first edition in 1878 and in an 1896 second edition, he won world fame, and his doctrines were translated into many languages. Cults based on his theories survive to this day. Babbitt also brought red, yellow and blue window panes to Victorian homes as he dealt with the most treacherous afflictions. For many exciting years an anxious but fickle world paid him homage as a miracle man.

Babbitt chose three primaries. Red was the center of heat, the ruling spectrum of hydrogen, a thermal or heat-producing color. Yellow was the center of luminosity, and blue was the center of electricity, the ruling spectrum of oxygen. In color therapy there must be unity and affinity. Thus, each hue had its complement: red with blue, red-orange with indigo-blue, orange with indigo, yellow-orange with violet-indigo, yellow with violet, yellow-green with dark violet.

"Substances in which thermal colors predominate must affinitize with those in which the electrical colors rule."

Babbitt summed up his major doctrine as follows: "There is a trianal series of graduations in the peculiar potencies of colors, the center and climax of electrical action, which cools the nerves, being in violet; the climax of electrical action, which is soothing to the vascular system, being in blue; the climax of luminosity being in yellow; and the climax of thermism or heat being in red. This is not an imaginary division of qualities, but a real one, the flame-like red color having a principle of warmth in itself; the blue and violet, a principle of cold and electricity. Thus we have many styles of chromatic action, including progression of hues of lights and shades, of fineness and coarseness, of electrical power, luminous power, thermal power, etc."

Pancoast's use of sunlight and a mere pane of glass were insufficient for the mighty Babbitt. Instead he developed and sold a special cabinet, the "Thermolume." This

made use of natural sunlight. Then, to be less dependent on nature, another cabinet of similar type was employed, this one getting its light source from the electric arc. He also used a "Chromo Disk," a funnel-shaped affair that localized light and which could be fitted with special color filters. Blue light, for example, was localized on inflamed parts, wounds and hemorrhages. Yellow light was localized on the brain, the liver and the abdomen.

The powers of Babbitt's hues and some of the diseases and ills they were supposed to cure are interesting. Red stimulated and increased "the action of the warm red principle in the human system, as for instance, the *arterial blood,* and also acts as the harmonizing affinitive element of the cold blue principle, which causes blueness of veins, paleness of countenance, etc." Red was prescribed for paralysis, consumption of the third stage, physical exhaustion and chronic rheumatism.

Like Avicenna, Babbit saw a relationship between color and the efficacy of a medicine. "Red light, like red drugs, is the warming element of sunlight, with an especially rousing effect upon the blood and to some extent upon the nerves, especially as strained through some grades of red glass which will admit not only the red but the yellow rays, and thus prove valuable in paralysis and other dormant and chronic conditions."

Yellow and orange stimulated the nerves. "Yellow is the central principle of nerve stimulus as well as the exciting principle of the brain which is the foundation head of the nerves." It was a laxative, an emetic and a purgative. It was used by Babbitt in costiveness, bronchial difficulties and hemorrhoids. Yellow with considerable red was a diuretic. With a little red it was a cerebral stimulant. About half-and-half it was a tonic and helped the human system in general. Blue and violet had "cold, electrical and contracting potencies." The colors were soothing to all systems in which inflammatory and nervous conditions predominated—sciatica, hemorrhage of the lungs, cerebrospinal meningitis, neuralgic headache, nervousness, sunstroke and nervous irritability. Blue and white were particularly effective in sciatica, rheumatism, nervous prostration, baldness and concussion.

Babbitt, of course, was led astray by prejudice and unwarranted exuberance. Many

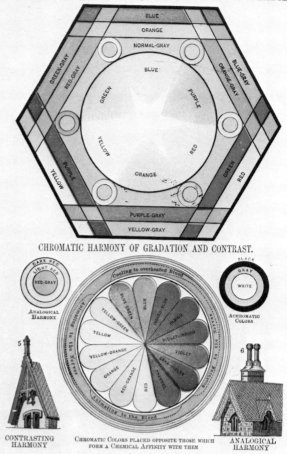

A plate from Babbitt's treatise. His views were a curious and fascinating mixture of art, mysticism, science

cults which he founded still exist. Unfortunately, he was one of several who subsequently imposed an almost complete skepticism upon the devout and objective medical researcher. Yet mysticism and naturalism, opposite though they are, can't be completely separated. In modern psychosomatic medicine, the spirit and body of man are recognized as a unity. Such old mystics as Jakob Boehme are today being given renewed attention for their views of man's total being—body, mind and soul. If, for example, worry and fear lead to ulcers, allergies and asthma, surgery or medicine will hardly cure the *basic* causes of such afflictions. Color may not be as directly therapeutic as men once believed; but, as a psychic or psychological force in healing, it is certainly efficacious.

Babbitt's Atom. With rare prescience he wrote (1878), "If such an atom should be set in the midst of New York, it must create such a whirlwind that all its palatial structures, bridges and surrounding cities . . . would be swept into fragments and carried into the sky."

Part Two

IMPACT ON SCIENCE AND CULTURE

Da Vinci's ideally proportioned man, created by God in divine symmetry

Chapter 6

THE EARLY QUANDARIES OF SCIENCE

The Zoroastrian priest of ancient Persia looked into the sky to seek the mysteries of the cosmos

In the Zoroastrian Scriptures one reads about the rainbow: "What is this appearance which is girded on the sky? The reply is this, that it is a mingling of the brilliance of the sun with mist and cloud that is seen, of which it is at all times and seasons, moreover, a characteristic appearance, whereby it has become their sign above from spiritual to earthly beings. That which is earthly is the water above to which its brilliance is acceptable; and the many brilliant colors which are formed from that much mingling of brilliance and water, and are depicted, are the one portion for appearing."

The ancient looked on color as a spiritual rather than physical phenomenon; his were the believing eyes of the mystic, not the calculating eyes of the scientist. Light was the emanation of a great deity, falling from heaven and pervading all space. It penetrated the bodies of men and, in turn, shone forth as an aura. Metaphors and not explanations occupied ancient thought. It was im-

portant to decide upon the significance of red, yellow, green and blue, not to question their nature as energy. God had created colors; what profound meaning did they have?

Color theory was pretty nearly all occult. Hues were the glorious manifestations of light, and the only thought that approached a scientific attitude was the belief that white light was the essence of purity, and colors admixtures with less ethereal substances. Even this idea had its esoteric implications. Not until the 17th century did men really give themselves an analytic view of the universe and attempt to take things apart and see how they worked.

ARISTOTLE

Before the scientific age, Aristotle made sweeping deductions as to the nature of all things. Like Hermes, he is credited with authorship of hundreds of books dealing with practically every branch of human

knowledge. As the founder of science, he naturally delved into the mysteries of color. References to color are found throughout Aristotle's work. His special treatise, *De Coloribus,* developed the theory that all colors were derived from mixtures of white and black—an idea that stubbornly persisted through the centuries and was later, despite overwhelming evidence to the contrary, championed by no less a genius than Johann Wolfgang von Goethe. Aristotle dealt with the major color phenomena of nature. He described the hues of *flora* and *fauna,* of water and rock, and established their laws, tying them up in neat little bundles and setting them aside one after the other. Black made a choice parcel. It could not be mere nothingness, as many other philosophers supposed, for black could be seen in bright light. "The color black occurs when air and water are thoroughly burnt by fire."

From his primary colors (black and white) came all hues in orderly fashion: "The different shades of crimson and violet depend upon differences in the strength of their constituents, whilst blending is exemplified by mixture of white with black which gives crimson. For observation teaches us that black mixed with sunlight or firelight always turns crimson, and that black objects heated in the fire all change to a crimson color, as *e.g.,* smoky tongues of flame, or charcoal when subjected to intense heat, are seen to have a crimson color. But a vivid bright violet is obtained from a blend of feeble sunlight with a thin dusky white."

Following this, Aristotle summed up his theory: "Verifications from experience and observation of similarities are necessary, if we are to arrive at clear conclusions about the origin of different colors, and the chief ground of similarities is the common origin of nearly all colors in blends of different strengths of sunlight and firelight, and of air and water." Aristotle spoke of white, black, gray, yellow, gold, crimson, pink, brown and violet, but made no mention of blue.

PLINY

Four centuries later, Pliny enunciated a similar doctrine in which he bowed to the wisdom of the eminent Greek. Basing his ideas on a curious observation, he wrote: "I remark that the following are the three principal colors; the red, that of kermes, for instance, which, beginning in the tints of the

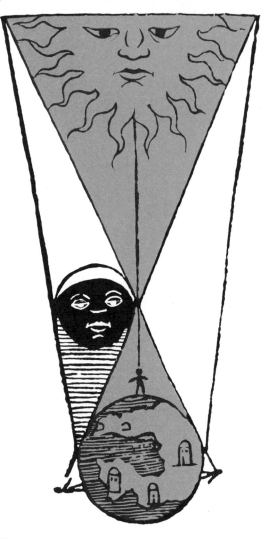

The universe as conceived by Ptolemy in the second century

rose, reflects, when viewed sideways and held up to the light, the shades that are found in the Tyrian purple. . . . The amethystine color, which is borrowed from the violet. . . . and a third, properly known as the 'conchyliated' color, but which comprehends a variety of shades, such, for instance, as the tints of the heliotropium, and others of a deeper color, the hues of the mallow, inclining to a full purple, and the colors of the late violet."

This conclusion omitted reference to yellow. To find a place for the golden hue of the rainbow Pliny turned from nature: "I find it stated that, in the most ancient times, yellow was held in the highest esteem, but was reserved exclusively for the nuptial veils of females; for which reason it is perhaps that we do not find it included among the principal colors, these being used in common by

males and females: indeed, it is the circumstance of their being used by both sexes in common that gives them their rank as principal colors."

Pliny also ventured to be the scientist, to look into the heavens and account for the colors of stars and planets. "The difference of their color depends on the difference in their attitudes; for they acquire a resemblance to those planets into the vapor of which they are carried, the orbit of each tinging those that approach it in each direction. A colder planet renders one that approaches it paler, one more hot renders it redder, a windy planet gives it a lowering aspect, which the sun, at the union of their apsides, or the extremity of their orbits, completely obscures them. Each of the planets has its peculiar color; Saturn is white, Jupiter brilliant, Mars fiery, Lucifer is glowing, Vesper refulgent, Mercury sparkling, the Moon mild; the Sun, when he rises, is blazing, afterwards he becomes radiating."

Reasoning like this stunned the brains of men and seemed to paralyze all desire to make further inquiry. Aristotle had founded the laws. Eminent men like Pliny had verified them. Obedient scholars of the time saw no reason to contradict.

DA VINCI AND THE RENAISSANCE

Fourteen centuries passed before the Renaissance, when Leonardo da Vinci attempted a new interpretation. The Greeks had been logicians striving to isolate color without really understanding its meaning for human sensation. This would not do for Leonardo. Color was a living ideal da Vinci worked with in his painting, saw everywhere in nature, and very frankly related it to his own personal experience rather than to the world beyond. He wrote: "The first of all simple colors is white, though philosophers will not acknowledge either white or black to be colors; because the first is the cause, or the receiver of colors, the other totally deprived of them. But as painters cannot do without either, we shall place them among the others; and according to this order of things, white will be the first, yellow the second, green the third, blue the fourth, red the fifth, and black the sixth. We shall set down white for the representative of light, without which no color can be seen; yellow for the earth; green for water; blue for air; red for fire; and black for total darkness."

This statement is one of the most remarkable in all the literature of color. To da Vinci the primary colors were red, yellow, green and blue. After him men were to argue about the triads of red, yellow and blue; and red, green and blue-violet. But not until the late 19th century was the tetrad of red, yellow, green and blue to be used, permanently fixed as the true elements in sensation. Even before science had spoken, Leonardo had corrected its attitude. To Leonardo, therefore, goes credit for the first sensible statement of color theory as it concerns human experience. Centuries before him, Aristotle had commented on a fanciful relationship between color and music. This idea that laws of vibration ruled all color phenomena was taken up in other years by other theorists, but the Renaissance master held to the evidence of the senses.

Today there are divided camps on this subject of color theory. One camp, that of the physicist, looks on color objectively, as something to be dissected and analyzed with instruments. The other camp, paying its tribute to the psychologist, departs from photometers and spectrometers, and accepts color as a vital, personal art. The two viewpoints are remote from each other, though each is perfectly right in its own field—energy and sensation.

With the exception of da Vinci, Renaissance painters did not attempt to develop their empirical knowledge of color into a science. In their default, the early scientific inquirers into the nature of light took over full authority. The problem confronting them was to slay the ghost of Aristotle which, during eighteen centuries, had grown to monstrous proportions. Giordano Bruno, who visited Oxford in 1583, wrote: "Masters and Bachelors who did not follow Aristotle faithfully were liable to a fine of five shillings for every divergence." In the 17th century men continued to see color as a blend of light and shade. Plato had talked about flame-like particles darted by objects against the eye. This was still largely believed. "Colors are inherent and real qualities, which Light doth but disclose."

Apparently no one had the courage to doubt the omniscience of the Greeks until French philosopher René Descartes (1596–1650) denounced and abandoned Aristotle's theory in its entirety. All space was pervaded by the ether—the "plenum." Light was essentially a pressure transmitted

A Hermetic conversation of the seventeenth century. Sage and scholar discourse under the tree of knowledge whose branches are the sun, the moon and the planets

The well-dressed astronomer in the time of Descartes

through a dense mass of invisible particles, and "diversities of color and light" were due to the different ways in which the matter moved. Various hues had different rotary speeds, rapid for red, slow for blue.

BOYLE AND NEWTON

Later, Robert Boyle (1627–1691) published a treatise on the subject in which the clear thinking of genius began to lead men further away from the Hellenistic view. His book, *Experiments and Considerations Touching Colours,* was dedicated to a friend.

"I have seen you so passionately addicted, *Pyrophilus,* to the delightful Art of Limning and Painting, that I cannot but think myself obliged to acquaint you with some of the things that have occurred to me concerning the changes of Colours."

At the beginning of his thesis Boyle wrote: "I have not found that by any Mixture of White and True Black . . . there can be a Blew, a Yellow, or a Red, to name no other color." He assumed the existence of the ether, because light had to travel in or upon something. All hues were contained in white light, distorted by objects to produce colors "The Beams of Light, Modify'd by the Bodies whence they are sent (Reflected or Refracted) to the Eye, produce there that Kind of Sensation Men commonly call Colours."

Colors were of two different types: atmospheric, as in the sky or the rainbow; and structural, as in rocks or flowers. The former he called "Apparent" hues, the latter "Genuine." And he classified them shrewdly. "Genuine Colours seem to be produc'd in Opacous Bodies by Reflection, but Apparent ones in Diaphanous Bodies, and principally by Refraction." These statements already anticipated the laws of Isaac Newton.

Boyle also respected the purely human factors in the sensation of color. Hues could not be the inherent qualities of objects, for "an apparition of them may be produc'd from within." He agreed with the chemists of his time that colors were "produc'd by the Impulses made upon the Organs of Sight, by certain extremely Minute and solid Globules." These were seen as follows: "I think we may probably enough conceive in general that the Eye may be Variously affected, not only by the Entire Beams of Light that fall upon it as they are such, but by the Order, and by the Degrees of Swiftness, and in a word by the Manner according to which the Particles that compose each particular Beam arrive at the Sensory."

Yet Boyle too gave himself to speculation. He was guessing and could not bring forth any scientific evidence to convince his dear *Pyrophilus.* But, gropingly, he got his hands on something. What he found was a strange looking key which permitted the full escape from Greece.

The physics of color has always been a complex enigma, unsolved even today. Color has bewildered men because they have failed to appreciate that its physical nature is one thing and human nature another. Color is

primarily sensation, and as sensation indifferent to complex theories of electromagnetic energy.

What the scientific world of Newton's time thought about color may be expressed in the words of Dr. Barrow, Newton's friend and tutor, who apparently chose to ignore Boyle's treatise. "White is that which discharges a copious light equally clear in every direction. Black is that which does not emit light at all, or which does it very sparingly. Red is that which emits a light more clear than usual, but interrupted by shady interstices. Blue is that which discharges a rarefied light, as in bodies which consist of white and black particles arranged alternately. Green is nearly allied to blue. Yellow is a mixture of much white and little red; and purple consists of a great deal of blue mixed with a small portion of red. The blue color of the sea arises from the whiteness of the salt it contains, mixed with the blackness of the pure water in which the salt is dissolved;

Here is the first known drawing of a color circle. Newton pulled the two ends of the solar spectrum together to form a continuous belt or circuit

and the blueness of the shadows of bodies, seen at the same time by candle and daylight, arises from the whiteness of the paper mixed with the faint light of blackness of twilight."

This was verbiage that had been rehashed time and again since Aristotle. But rebellion was in the air. Even the word *science* was now working its way into the English language and taking on the meaning it has now. Prior to the 17th century men had been philosophers; now they were *scientists,* little concerned with anything but the realities of matter. Sir Isaac Newton was now trying to solve the problems of the telescope. In 1666, while experimenting with a prism and observing the phenomenon of refraction, he saw a beam of sunlight converted into a rainbow. He began to formulate his doctrine that white light was not simple, but was a mixture of rays which the prism separated. He saw seven colors, perhaps because he had been classically schooled, and saw an analogy with music, with the harmony of the spheres, the seven planets. Mysticism was not yet dead. His seven colors became the poetic tokens of the rainbow.

In his famous book, *Opticks* (1730), Newton noted the visual similarity of red to violet, the two extreme bands of the spectrum, and arranged his hues to form the original color circle. He then went on to more investigation and discovery of the phenomena of diffraction and interference, the bending of light. An atomist at heart, Newton posited a theory of corpuscles of light in which light was generated by emission of particles which

Diagram of Newton's observations on the refraction of light. All colors were contained in sunlight. From an original edition of Newton's Optics

spun about and moved forward in a straight line. There were primary atoms for the seven colors, the red particles large, the violet particles small. Then he wrote: "Do not several sort of rays make vibrations of several bignesses, which according to their bigness excite sensations of several colors, much after the manner that the vibrations of air, according to the several bignesses excite sensations of several sounds?"

Newton's discovery, a mere beginning for the new science of physics, was a major achievement which closed the doors on the past and finally buried the ghost of Aristotle. Spectrum analysis was to lead to spectroscopy, and to man's knowledge of the chemistry of the sun and planets and of the composition of matter. Where colors were once used to symbolize the mysteries of the universe, their function was now to reveal them. Man would discover the elements, the nature of material things, and color would play a principal role.

Newton's emission theory was bitterly attacked by able scientists like Robert Hooke, who championed a wave theory for the structure of light. However, Newton's genius overrode the minds of lesser men. The emission theory was to hold sway for a full century and a half. Two centuries were to pass before Newton's discoveries were to be capitalized on and extended in a big way.

Goethe (1749-1832) bitterly attacked the mighty Newton. The poet was wrong on matters of physics but quite perceptive as to the human nature of color

VOLTAIRE

Newton became world famous during his lifetime. Like many eminent men he was simultaneously praised and damned. One of his greatest champions was Voltaire, who declared Newton to be the greatest man who ever lived. Impetuous as he was, Voltaire set out to become a scientist on his own. At Cirey, he set up a laboratory with his mistress, Madame du Châtelet, and for a while at least was overwhelmed by his obsession. But he was a poet, essayist, dramatist and critic at heart, and he soon went back to his literary loves. Out of his efforts, however, came a book, *Elémens de la Philosophie de Newton,* which was promptly banned in France because of its apparent heresy. Voltaire left the manuscript with a publisher in Amsterdam and then, in the rush of his activities, apparently forgot about it.

The publisher, an enterprising man and aware of the magic of Voltaire's name, had a hack writer touch up the volume, and then issued it in 1738 in a truly beautiful book suitably illustrated with allegorical engravings, charts, diagrams and decorations. But he did so without Voltaire's knowledge and permission. The fiery Frenchman ranted, raved and protested, but to no avail. Because of the eminence of the two men connected with it, the work stands as one of the great curiosities in the literature of color.

GOETHE AND SCHOPENHAUER

Johann Wolfgang von Goethe was among those who took up the cause of the dying mystic. He was to lead an unsuccessful revolt against Newton in an attempt to save the art of color from the new school of heretics and despoilers. Goethe's attraction to color was inspired by his love of mysticism, alchemy and philosophy. As a youth he studied art and painted still life. He soon discovered, however, that he was forced to theorize about art, and as a young man he

wrangled with friends on the subject of color but found their notions exceedingly vague. Goethe began to investigate the subject and nowhere could he find an intelligent answer to his queries. A Professor Buettner sent him prisms and optical instruments, and referred him to the writings of Isaac Newton. But Goethe was then preoccupied. When Buettner later wrote for the return of his equipment, the poet failed to answer. Eventually pressed to restore the prisms to their owner, Goethe tried a few cursory experiments, and found immediate reason to declare Newton's theory false. He wrote Buettner and pleaded for the loan to be extended.

Newton's theories have survived, while Goethe's words on color are for the most part forgotten. Yet the battle that raged at the time held worldwide interest. Goethe had apparently made up his mind to contradict the Englishman and was blind to reason. He misconstrued Newton's doctrines and actually disputed statements that Newton had never made. In looking through a prism Goethe did not see an entire spectrum, as had Newton, but only bands of color around the edges of the objects. He im-

Goethe studied these charts through a prism to develop his theories. Also shown is his color circle, 1792

Illustration from Goethe's work on color, 1792, showing the prism he used. To Goethe, color was a blend of light and darkness

mediately concluded that color was not contained solely in light, but was the product of an intermingling of light and darkness.

Aristotle and da Vinci had stated this doctrine centuries before. Da Vinci had written: "Blue and green are not simple colors in their nature, for blue is composed of light and darkness; such is the azure of the sky, *viz.*, perfect black and perfect white." Similarly, Goethe was very sure that color originated in this fashion. For one thing, black was positive, not negative. Again, he noted that no color was brighter than white; the spectrum merged from white into yellow, thence into other hues, and faded out through blue and violet into blackness. Goethe wrote: "If we move a dark boundary toward a light surface, the yellow

border is foremost, and the narrower yellow-red edge follows close to the outline. If we move a light boundary toward a dark surface, the broader violet border is foremost, and the narrower blue edge follows."

In his *Farbenlehere* Goethe took Newton and his followers to task: "We compare the Newtonian theory of colors to an old castle, which was at first constructed by its architect with youthful precipitation; it was, however, gradually enlarged and equipped by him to the exigencies of time and circumstances, and moreover was still further fortified and secured in consequence of feuds and hostile demonstrations." Later Goethe said caustically, "We find this eighth wonder of the world already nodding to its fall as a deserted piece of antiquity." And he hails this fall, "so that the sun can at last shine into this old nest of rats and owls."

Goethe was a famous man—loved, envied and respected as a genius. His ideas were supported by patriotic anatomists, chemists, writers and philosophers, but he did not have a single adherent among the physicists, even of his own country. Bitterly, he wrote, "Everywhere I found incredulity as to my competence in such a matter; everywhere was a sort of repulsion at my efforts; and the more learned and well informed the men were, the more decided was their opposition."

In 1813, he met the youthful Schopenhauer at Weimar. The master was then sixty-four years old; Schopenhauer was twenty-five. Soon Goethe enlisted the younger philosopher's enthusiasm and explained his own convictions to him: "The colors are acts of light; its active and passive modifications: thus considered we may expect from them some explanation respecting light itself. Color and light, it is true, stand in the most intimate relation to each other, but we should think of both as belonging to nature as a whole, for it is nature as a whole which manifests itself by this means in an especial manner to the sense of sight." Goethe explained that the eye took an active rather than passive part in perceiving color. He defended his red, yellow and blue color chart, spoke of afterimages, the hues of shadows, and challenged the belief that color theory belonged to physics. His arguments were uncompromising and he delivered them eloquently.

Schopenhauer soon took the problems of color to heart. He received Goethe's own op-tical equipment and instructions, and set to work. At first, he blindly deferred to his master's opinions. Yet he had discerning eyes of his own. He began to see through the poet's vagaries and, in time, he published a pamphlet, *On Vision and Colors*, which enraged Goethe. Schopenhauer went beyond Goethe and interpreted color by placing appropriate emphasis on vision rather than on the physics of light. He dealt with the human retina but failed, however, to attach due importance to the brain. He accepted the idea that white was a unity of colors and in this defied Goethe.

Science did not pay the least attention to the efforts of Goethe and Schopenhauer. In principle, Goethe and Schopenhauer were right. They talked about human factors in the sensation of color, both fighting the battles of the psychologist who was to come later. The overwhelming importance attached to the conclusions of physics, overshadowing as it did a more commonsense attitude toward color, was to be corrected in the years to come.

Schopenhauer (1788-1860) took up Goethe's interest in color. The dispute that followed broke up their friendship

The French Academy of Science at the time of Louis XIV

Chapter 7

THE MODERN CONCEPTIONS OF SCIENCE

The study of color is essentially a mental and psychological science, for the term color itself refers to sensation. The exact nature of light and color is still an enigma, and LeGrand H. Hardy writes, "A wave theory, an electrical theory of matter, or an atomic theory of energy can be made perfectly legitimate and defensible." Newton supposed that light was generated by emission of particles, and though opposed by Hooke's wave theory, his ideas prevailed for a full century and a half. Then the wave theory again came into vogue, to be questioned still later by exponents of a corpuscular theory. In the midst of this wavering, William Bragg was once led to remark that scientists ought to use the wave theory on Mondays, Wednesdays and Fridays, and the corpuscular theory on Tuesdays, Thursdays and Saturdays.

Through the efforts of such men as Max Planck and Niels Bohr, however, scientists

today are in pretty fair agreement. Radiant energy is said to be propagated through space in the form of electromagnetic waves, the visible portion of which is seen as light. A substance excited to luminosity radiates energy in the form of electromagnetic waves. This collection of waves is characteristic of the substance and may be analyzed with a spectroscope. In addition, the waves that a substance radiates when excited are identical with those it will absorb when radiant energy falls upon it.

Radiant energy, however, not only has a wave structure but a corpuscular structure as well. This means that radiant energy has tangible substance. It has mass and may be "bent"; for example, by the force of gravity. In a sense, one is justified in speaking of a pound of light energy, just as one speaks of a pound of sugar. The sun emits rays whose material pressure is said to be equal to about two hundred and fifty tons a minute. Feeble though their strength may be, these rays can push things.

THE QUANTUM THEORY

It was Max Planck who, in 1900, developed his Quantum Theory. By mathematical means he assumed that radiant energy was not emitted in a flowing stream of different wave lengths, but in definite bundles or quanta. To quote Lincoln Barnett's *The Universe and Dr. Einstein*, "The far-reaching implications of Planck's conjecture did not become apparent till 1905, when Einstein, who almost alone among contemporary physicists appreciated its significance, carried the Quantum Theory into a new domain. Planck had believed he was simply patching up the equations of radiation. But Einstein postulated that all forms of radiant energy—light, heat, X rays—actually travel through space in separate and discontinuous quanta. Thus the sensation of warmth we experience when sitting in front of a fire results from the bombardment of our skin by innumerable quanta of radiant heat. Similarly sensations of color arise from the bombardment of our optic nerves by light quanta which differ from each other

"Einstein substantiated this idea by working out a law accurately defining a puzzling phenomenon known as the photoelectric effect. Physicists had been at a loss to explain the fact that when a beam of pure violet light is allowed to shine upon a metal plate the plate ejects a shower of electrons. If light of lower frequency, say yellow or red, falls on the plate, electrons will again be ejected but at reduced velocities. The vehemence with which the electrons are torn from the metal depends only on the color of the light and not at all on its intensity. If the light source is removed to a considerable distance and dimmed to a faint glow the electrons that pop forth are fewer in number but their velocity is undiminished. The action is instantaneous even when the light fades to imperceptibility

"He expressed these principles in a series of historic equations which won him the Nobel Prize and profoundly influenced later work in quantum physics and spectroscopy. Television and other applications of the photoelectric cell owe their existence to Einstein's photoelectric Law."

The complete spectrum of electromagnetic energy, to be described, contains sixty or seventy "octaves." It begins, at one end, with radio waves of exceedingly great wave lengths, proceeds through infra-red rays, visible light, ultra-violet—the wave lengths getting shorter—and reaches its other extreme in X rays, gamma rays and cosmic rays.

All this energy travels at the same rate of

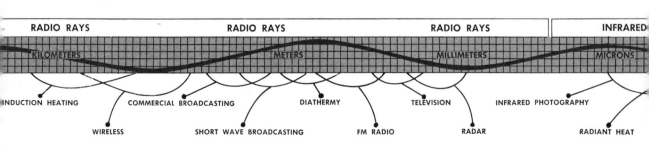

RADIO RAYS RADIO RAYS RADIO RAYS INFRARED

KILOMETERS METERS MILLIMETERS MICRONS

INDUCTION HEATING COMMERCIAL BROADCASTING DIATHERMY TELEVISION INFRARED PHOTOGRAPHY

WIRELESS SHORT WAVE BROADCASTING FM RADIO RADAR RADIANT HEAT

speed—about one hundred eighty-six thousand miles a second—and differs in length of waves as measured from crest to crest. Though mathematics of an extraordinary order are involved, measurements of the speed of light, of frequencies and wavelengths, are extremely accurate and accepted throughout the scientific world.

THE ELECTROMAGNETIC SPECTRUM

A quick review of the forms of electromagnetic energy is supplemented by some facts on their medical applications.

The longest of all electromagnetic waves are employed for "wireless," high-power transoceanic communication, ship-to-shore calling, direction finding and the like. Such waves may measure several thousand feet from crest to crest. In the form of induction heat, long radio rays are employed in industry for instantaneously raising temperatures of metals to harden them.

Commercial broadcasting rays are next in order. Because they "bounce" back from the ionosphere, they travel completely around the earth.

Next is the so-called "short-wave band" used for certain distance radio broadcasting, for police, ship, amateur and government radio. These waves are also used in diathermy. By clamping electrodes to parts of the body, heat may be generated to relieve rheumatism, arthritis and neuralgia.

Frequency modulation (FM) radio, television and radar follow; their wavelengths getting shorter and ranging from several meters to a fraction of a meter. This energy, however, penetrates the ionosphere and is not reflected back. It follows a straight path, requires rebroadcasting points, and may be sent out in controlled directions.

Induction heating equipment. Long waves of electromagnetic energy are used to heat and harden metal in a matter of seconds. Courtesy, Induction Heating Corporation

Next in order, the long (invisible) infrared waves can penetrate distance and heavy atmosphere. Plates sensitive to infra-red rays are used to take photographs where the human eye has difficulty in seeing.

Radiant heat comes next. Its energy is used for heating and drying purposes and is emitted by steam radiators, electric heaters and infra-red lamps.

The sun's spectrum extends from relatively long waves of infra-red light, through the entire gamut of visible light (red, orange, yellow, green, blue and violet), into the shorter waves of ultra-violet light. Visible light rays measure about 1/33,000 inch at the red end of the visible spectrum and about 1/67,000 inch at the violet end. Longer ultra-violet waves produce fluorescence in many substances.

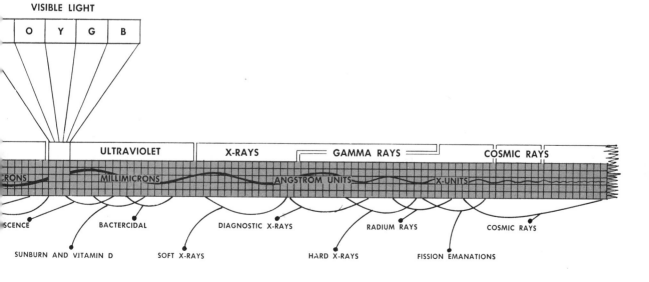

VISIBLE LIGHT

| O | Y | G | B |

ULTRAVIOLET — X-RAYS — GAMMA RAYS — COSMIC RAYS

RONS — MILLIMICRONS — ANGSTROM UNITS — X-UNITS

SCENCE — BACTERCIDAL — DIAGNOSTIC X-RAYS — RADIUM RAYS — COSMIC RAYS

SUNBURN AND VITAMIN D — SOFT X-RAYS — HARD X-RAYS — FISSION EMANATIONS

Television and FM radio use electromagnetic waves which follow a straight path and need rebroadcasting points

The erythemal rays, the energy which produces sun tan and which is employed for synthetic production of Vitamin D, comes next in order.

Still shorter ultraviolet energy has bactericidal properties, and is used to destroy certain microorganisms and to sterilize materials, water and air.

On up the electromagnetic spectrum are the Grenz rays, or soft X rays, used therapeutically for many skin diseases. Their energy does not have much penetrating power.

X rays of higher voltage and shorter frequency are used for diagnostic purposes and for therapy in certain forms of cancer. Hard X rays, next in order, are used medically for deep-seated afflictions, as well as to take radiographic pictures to detect flaws in metal. X ray frequencies may measure 1/2,500,000 inch where high voltages are involved.

The radium rays, discovered by Pierre and Marie Curie, follow next. They are now used to cure many forms of cancer.

Toward the short-wave end of the electromagnetic spectrum are the emanations from nuclear fission associated with the atomic bomb and the bombardment of the atomic nucleus. Such energy is also rapidly finding its way into medicine.

The last and shortest wavelengths are the cosmic rays. Still a mystery, they probably are produced beyond the earth's atmosphere and spread their waves throughout the universe.

The laboratories of physicians and hospitals are well-equipped with devices for producing electromagnetic energy of various wavelengths other than visible light. Rays of color, however, are seldom found. Yet visible light is of vital significance in the growth and development of plants and animals. In his *The Biologic Fundamentals of Radiation Therapy,* Friedrich Ellinger writes, "Knowledge of the significance of visible light as a healing agent is inversely proportional to the universal importance of visible light in biology." From this observation it would appear that inconsistencies exist in the study of color, that its value to human life has not yet been fairly evaluated by medical science.

Of waves longer than visible light (infrared), there is little to be told. Such energy produces heat within the human body as do the still longer radio waves of diathermy. In his remarkable book, *Photodynamic Action and Diseases Caused by Light,* Harold F. Blum remarks that "it cannot be assumed this part of the spectrum, infra-red, is very active biologically." However, the heating effect of invisible rays at the red end of the spectrum is known to everyone who has ever used a hot-water bottle.

Infra-red rays are also thought to weaken the bactericidal action of ultra-violet rays. They also seem to destroy the antirachitic effect of Vitamin D. While such "heat" rays may in general be beneficial, they represent great hazards to the human eye. Ultra-violet waves are strongly absorbed by the eye, but infra-red waves are not, though the latter may be partly responsible for development of cataracts. Ellinger writes, "On the basis of animal experiments, A. Vogt believes that cataracts in workers exposed to fire (welders, glassblowers, etc.) are due to the action of infra-red rays."

HELIOTHERAPY

The energy used most frequently and extensively in medicine is of shorter wavelength than visible light: ultra-violet, X rays (Roentgen rays), and radium's gamma rays. Yet not until the twentieth century did sci-

Betatron—the world's most advanced device for radiation treatment of cancer. It hangs from an elevator mechanism which raises and lowers the beam as the patient rests comfortably on a moving table. As the patient is moved under the machine, the beam generator itself rotates. The treatment is known as "pendulum therapy". Courtesy of Montefiore Hospital, New York

ence build equipment capable of utilizing them therapeutically.

Heliotherapy is perhaps as old as civilization. Ellinger also writes, "Knowledge of the therapeutic action of light is one of mankind's oldest intellectual possessions. The earliest experiences depended of course upon nature's own light source, the sun. Sunbathing was practiced even long ago by the Assyrians, Babylonians and Egyptians. A highly developed sun- and air-bathing cult existed in ancient Greece and Rome. The old Germans regarded the healing power of sunlight very highly and worshipped the rising sun as a deity. The Incas of South America also practiced a sun cult." Together with the alchemists and mysticists, the sun worshippers lost prestige after the Middle Ages. Though there were a few obscure champions of the sun from time to time, not until the nineteenth century was heliotherapy again recognized.

Credit is also due to Downs and Blunt of England who, in 1877, discovered the bactericidal action of ultra-violet radiation. They gave full evidence that sunburn was not produced by heat rays alone, and that in waves of higher frequency than visible light, science had a great therapeutic medium.

Scientists associate photosensitivity with heliotherapy; and both with the energy of sunlight, which ranges from infra-red through visible light to ultra-violet. On the other hand, radiosensitivity is the term associated with radiotherapy and is concerned with the high-frequency radiation of X rays and gamma or radium rays.

The human body is particularly photosensitive; that is, responsive to ultra-violet light. Blonds are more sensitive than brunets, infants less sensitive than adults. According to Ellinger, the influential factors are hair color, age, sex and the season of the year. In girls photosensitivity increases during adolescence. "Endocrine influences play an important part and are probably bound up with the sex function," for with

Treatment with ultraviolet (carbon arc) light at the Finsen Institute, Copenhagen, during the latter part of the nineteenth century. This pioneering work in the use of radiant energy to relieve many human ills had a rather difficult course before its complete scientific acceptance

This is skin cancer. Regardless of the basic cause, such lesions are likely to appear on areas of the flesh normally exposed to sunlight. Courtesy, Dr. W. H. Ward, Newcastle, Australia

menopause photosensitivity in women tends to diminish.

Two interesting observations may be noted regarding sunlight and human life. In India, rickets is a common affliction among higher caste Hindus, probably because the religious system requires mothers and children to dwell in complete indoor isolation. Because the body is thereby deprived of sunlight, it suffers from Vitamin D deficiency. Among Eskimo women, menstruation may cease during the long Arctic night, and the libido of Eskimo man may also be dormant at that time. Here, in effect, lack of sunlight leads to human hibernation.

Ultra-violet radiation is essential to human welfare. It prevents rickets, keeps the skin healthy, is responsible for production of Vitamin D, destroys germs, and effects certain necessary chemical changes in the body. It is used in the treatment of various skin diseases, in erysipelas and in tuberculosis of the skin. Foodstuffs such as lard, oil, and milk are irradiated with ultra-violet rays to enrich them with Vitamin D, but some foods, such as cod-liver oil, lose their better properties after irradiation. Although ordinary window glass and many other materials absorb ultra-violet light, it is effectively scattered by the atmosphere and makes its benefits felt even in smoky cities.

After exposure to ultra-violet rays, human skin becomes pigmented, and a tanned complexion may be nature's way of building pro-

tection against further ultra-violet penetration. Yet a glowing tan is not always a sign of vigorous health. Overexposure to sunlight may wrinkle and age the skin, and Blum points out that prolonged exposure "may stimulate the production of malignant tumors of the skin."

In the phenomenon of fluorescence, certain substances are made luminous by the action of ultra-violet light. Fluorescence offers many aids to science and medicine in diagnosis and detection. Foods may be examined and many facts gleaned about them. Butter, for example, glows yellow, while margarine glows blue, and as little as fifteen per cent adulteration of butter may be noted. Fungi in cheese fluoresce a brilliant green, and natural ripening can easily be detected from artificial. Healthy potatoes show color; those affected by ring rot do not. Fresh eggs fluoresce a pale red, while older eggs become more bluish.

Caucasians' skin fluoresces more than the skin of Negroes. Live teeth glow; dead ones or artificial ones do not. The same is true of natural hair and dyed hair or wigs. Aspirin taken orally will make urine appear purplish; quinine will make urine greenish. Tuberculosis germs in human sputum will fluoresce yellow. A fluorescent dye injected into the blood stream has been used as an aid to surgery. Cancer tissue will glow a vivid yellow, and the blood stream will carry the dye to the infected area. By examinations under ultra-violet light, the surgeon can perform his work more accurately and effectively.

THE EFFECTS OF
RADIOACTIVE ENERGY

The first cure by Roentgen rays (X rays) was effected by Tor Stenbeck of Sweden in 1900. It was the successful removal of a tumor from the tip of a woman's nose. Since then, X ray and radium therapy have performed countless miracles. Radiotherapy cures because of certain reverse effects; in brief, diseased tissue is more easily destroyed than healthy tissue. After radiation has had its effect in breaking down the diseased area, the recuperative powers of the human body take over and restore it to normal health. The cell and cell nucleus are most sensitive to radiotherapy. Again, children and blonds are more susceptible than adults and brunets. A long list of afflictions

responds to radiotherapy, from superficial eczema to deep-seated cancer of the inner organs, bones and joints. Malignant tumors are particularly sensitive. As Ellinger states, "And so for many, the concept of radiotherapy is synonymous with the fight against cancer." White blood corpuscles are radiosensitive, and red corpuscles are not. Muscles, brain and eye are little affected but cartilage and bone, stomach and liver, all respond actively to irradiation.

Overdoses of X rays or radium rays cause serious tissue damage, or may be psychologically and physically depressing or destructive, depending on the body's health and the sensitivity of its tissue. Hair may fall out, the sweat glands may slow down, inflammation and discoloration of the skin and sexual sterility may result. At worst anemia and the dreaded Roentgen carcinoma may ensue. Equally macabre, misuse of irradiation in the early months of pregnancy may result in abortion, and in later months may produce monsters and imbeciles.

High-frequency radiation hazards are now brought to mind in discussions of the atomic and hydrogen bombs. As yet science has no sure defense against them. Once spread, this radiation has a lasting, deadly effect. Man, who generated the forces of electromagnetic energy, must now learn to control them to assure security and lengthen the days of his life.

Showing "burns" on finger caused by exposure to radioactive phosphorous. However, damage was slight and healed within one month. Courtesy, Dr. Robert Jackson. From Medical Services Journal, Canada

An early drawing of the spectroscope. The device, though simple in design, has become one of the most useful of all scientific instruments

SPECTROSCOPY

In science no other instrument has meant more than the spectroscope. In *The Outline of Science*, J. Arthur Thomson writes: "That the spectroscope will detect the millionth of a milligram of matter, and on that account has discovered new elements, commands our admiration; but when we find in addition that it will detect the nature of forms of matter . . . and that it will measure the velocities with which these forms of matter are moving with an absurdly small per cent of possible error, we can easily acquiesce in the statement that it is the greatest instrument ever devised by the brain and hand of man."

The basis of the spectroscope is the prism. In 1666, when Newton produced a rainbow by directing a beam of light through a prism, he unknowingly gave science one of its major clues to investigating the universe. The prism led to the spectroscope, and the spectroscope to a comprehensive knowledge of the intricate nature of all matter. After Newton many other experimenters worked on analysis of sunlight. In 1802, William Hyde Wollaston noted that, in addition to color, certain lines were seen to cross the spectrum. In 1814, Joseph von Fraunhofer, a Munich optician, studied these lines more carefully. He created a better image of the spectrum through the use of lenses, thereby inventing the spectroscope as it is known today. Following Fraunhofer came John Herschel, Gustav Kirchoff, Robert Bunsen and H. E. Roscoe. The science of spectroscopy was developed and extended, a veritable "eye of God" through which man could peer into the innermost secrets of nature.

With the spectroscope man can detect and identify traces of elements and analyze them qualitatively as well as quantitatively. How is this accomplished? All substances have a characteristic spectrum, revealed when the substance is made to emit light by the use of heat or electricity, and when that light is dispersed either by refraction through a prism or diffraction through a grating. The spectrum thus created is then measured. When the substance is non-luminous, the spectrum is determined by passing light through it. Thomson states; "Every chemical element known . . . has a distinctive spectrum of its own when it is raised to incandescence, and this distinctive spectrum is as reliable a means of identification for the element as a human face is for its owner. Whether it is a substance glowing in the laboratory or in a remote star makes no difference to the spectroscope; if the light of any substance reaches it, that substance will be

A diagram of the analyzing spectroscope. With it man can probe the secrets of the earth, sun and stars

FIG. 14.—The analysing spectroscope

A. Collimator. C. Spark.
B. Observing Telescope. D. Lens.

recognized and identified by the characteristic set of waves."

Two major types of spectra are studied by spectroscopy. An emission spectrum is one produced directly from *emitted* light. For example, when common salt is exposed to flame it emits a yellow light, revealing the presence of sodium. In an absorption spectrum, on the other hand, light passes through a medium such as gas, and certain areas of the spectrum are *absorbed*. In the spectroscope the sodium in the sun's atmosphere shows as a black line crossing the yellow bands, because in this instance, sodium in the atmosphere is absorbing rather than emitting light.

Man has studied the spectra of countless substances here on earth, and also studied the sun's spectrum. The sun was found to contain enormous amounts of hydrogen and lesser amounts of sodium, iron, copper, zinc, magnesium and other elements in a gaseous state—the same elements as those on earth. The magnesium spectrum, for example, consists chiefly of a green line, the hydrogen spectrum chiefly red, the calcium one violet. Just as table salt will emit a predominantly yellow line, so lithium salt will produce a predominantly red one. Potassium salt will show red and violet lines to form a beautiful, purplish color.

In 1868, Norman Lockyer detected through the spectroscope an element which he called helium—thirty years before it was found on earth! Another substance called coronium, found in the light from the sun's corona, is still to be discovered on earth.

Spectroscopy has a multitude of uses. Physics has determined the constitution of the sun. Stars have been grouped into various classes according to their spectra—red, yellow, white. The red stars are the coolest, the white hottest. Further, a star's motion is estimated from its spectrum. If the sodium line (yellow) of a celestial body is shifted toward the violet end of the spectrum, the star is said to be moving toward earth. If the sodium line is shifted toward the red end of the spectrum, the star is moving away from the earth. Chemists use the spectroscope to determine the elementary composition of substances. Metallurgists locate impurities in steel; doctors diagnose certain diseases; criminologists detect the presence of poisons in cadavers, and copper, lead and zinc traces and the like can be exposed in foods. The pigments of Old Masters' paintings have been analyzed and so have the ancient Egyptians' embalming fluids.

Spectroscopes making use of electric eyes have recently been developed, but the principle remains the same. Nature is revealed through color, for all its products—organic, inorganic, solid, liquid and gaseous—are comprised of the same essential elements. Ancient man gazed at the rainbow and was convinced that the secrets of the universe lay hidden in its colors. Today modern man knows that, for the rainbow he sees in his spectroscope has miraculously taken the universe apart down to the most infinitesimal detail.

THE HUMAN REALM OF COLOR

In the human realm, the psychologist rather than the physicist speaks of color with authority. Color is, after all, a sensation, a mental and emotional interpretation

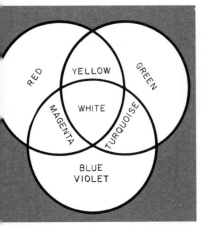

The primaries of light. Mixtures are additive and work toward white

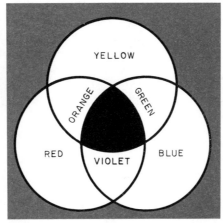

The primaries of pigments. Mixtures are subtractive and work toward black

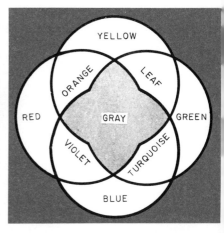

The primaries of vision. Mixtures are medial and work toward gray

of what the eye records. Physics and chemistry are not concerned with color's spiritual, aesthetic or psychic qualities. Color has three separate and distinct aspects: light, chemistry and sensation, each with its own unique laws and phenomena.

The chemistry of color involves pigments and compounds. It has three primary tones: red, yellow and blue, which when mixed together give various other shades. Red and yellow give orange; yellow and blue make green; and blue and red form violet. These mixtures are subtractive, working down toward black, the result of combining the three primaries.

The physics of color involves light. Its three primaries are red, green and blue-violet. Hermann von Helmholtz first noted that light rays seem to travel in these three hues. Red and green light blended give yellow; green and blue make a clear, light turquoise; and blue and red produce magenta light. (Red, green and blue-violet filters are consequently used in process engraving to produce the blue, red and yellow printing plates.) Light mixtures are additive, with white the unity of all hues.

The sensory aspect of color is visual and embraces physiology and psychology. The human eye discerns four primary shades: red, yellow, green and blue. All are unique and bear no resemblance to each other, yet all other tints seem to be blends of those four primaries. Visual mixtures (accomplished in one way by spinning disks on a color wheel) are medial (though the average physicist even today does not appreciate that fact), and generally tend to work toward a neutral gray.

A modern dyestuffs laboratory. Color is both important to science and big industry in the styling of everyday products. Courtesy, National Aniline Division, Allied Chemical Corporation

Woodcuts of the human eye dating back to 1583. Such drawings were used to facilitate eye operations

Chapter 8

THE WONDERS OF HUMAN VISION

Voltaire's tribute to Newton contains this illustration of a gentleman (1738) casting an inverted image on the retina of the eye

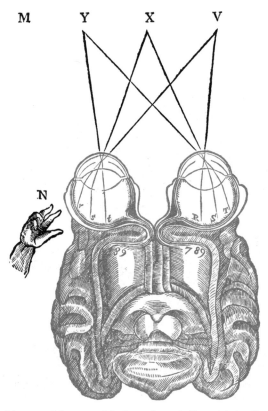

M Y X V

N

Diagram of the eye and brain as shown in Descarte's treatise on optics, 1677

COMPLEXITIES OF VISION

The human eye has apparently been designed by nature to see with good efficiency under widely different conditions of illumination. Man cannot see as well in darkness as a cat or an owl, but he can see better in daylight than they. While man cannot tolerate full sunlight as well as a prairie dog or an eagle, he does not have to retire when the sun goes down. Thus, while man may not have the best daylight or the best nighttime eye, he does have vision surpassing that of any other creature for all conditions of life.

The optical system of the human eye is perhaps none too good. Indeed, the lens system is such that colors and forms may appear blurred under certain conditions. "Fortunately," says W. D. Wright in *The Measurement of Colour*, "the more serious effects of these aberrations are compensated in some way, either in the retina or the brain, to an extent sufficient to make us quite unaware of their existence in normal observation."

The human eye functions much like a camera. Over the eyeball is the cornea, a transparent outer covering shaped like a watch crystal. Behind this is the iris, a ring-like structure which forms the pupil of the eye. Back of the pupil is the lens, which accommodates for seeing objects near or far. The iris, in front of the lens, expands or contracts to regulate the size of the pupillary opening—wide in dim light, narrow in brilliant light. Behind the entire mechanism is the retina, a network of sensitive nerve endings, where the light is focused and from which impulses are transmitted to the brain.

The amount of light entering the eye is regulated by the iris. While in man the pupillary opening is round, it is slit vertically in cats and tigers, and horizontally in goats and horses. Each aperture is suited to the needs of the animal.

Virtually all mammals, including man, have blue eyes at birth. In this condition, the iris is without pigmentation and the blue seen is the result of scattered light in the dioptrical media of the eye. In some birds, iris color may change over a period of time, generally growing darker. Male birds often have different colored irises from females. In the common box turtle, the male usually has a red iris and the female a yellowish or brownish one. In one species of penguin, both iris and beak change from red to yellow and back again with the seasons.

MAKEUP OF VISION

Vision does not answer the simple laws of optics. If the optical system of the human eye is far from perfect, nature has performed miracles designing the retina and cortical system of vision. One of the great books in this field is Stephen L. Polyak's *The Retina*.

"Structurally, the retina may be regarded as a light-sensitive expansion of the brain," W. D. Wright has said. It is the photosensitive lining at the back of the eyeball within which physical light produces nervous impulses that are forwarded to the brain. The human retina has two types of photoreceptor cells, the rods, (about one hundred thirty million in each eye) distributed rather uniformly over its entire expanse, and the cones (about seven million) especially numerous and refined in the central area and fovea of the retina.

Although the exact process of vision is

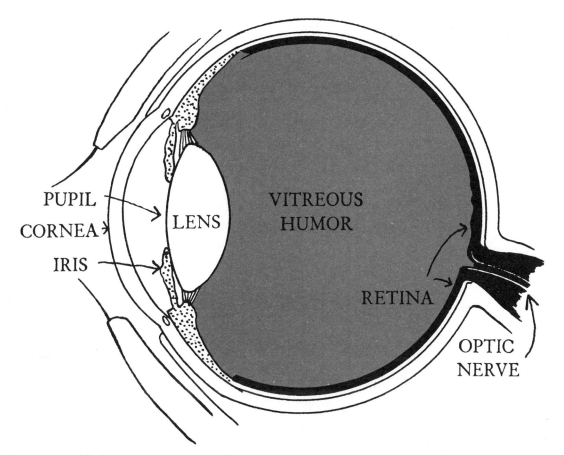

A cross-section of the human eye showing its significant parts and areas

still a mystery, science generally approves the so-called "duplicity theory," first stated by Max Schultze in 1866. This theory states that low-intensity vision is a function of the rods of the retina and high-intensity vision is a function of the cones. The rods, it is believed, react chiefly to brightness and motion in subdued light. The cones react to brightness and motion, but also to colors. Accordingly, in the central fovea and in the region next to it, most of the action of seeing takes place; for only here does the eye perceive fine detail and color. Foveal sight is essentially cone vision and day vision; peripheral sight is rod vision, especially useful at night.

The foveal area of the retina is permeated by a yellowish pigment (the so-called "maculalutea" or yellow spot). Although this tiny area measures less than one-sixteenth of an inch in diameter, it is crowded with tens of thousands of photoreceptors, especially the cones, *each* of which is thought to have its own connection to the brain. Hence, there is good reason for the fovea to be remarkably sensitive to fine detail. In the periphery, however, nerve connections to the cones and rods are arranged in groups. Wright observes, "This in turn implies that the peripheral retina is quite incapable of resolving fine detail in an image, although at the same time it enables the responses from weak stimuli to be summated and gives the periphery an advantage over the fovea in the detection of faint images."

The cortical region of the human brain responsible for sight has areas corresponding to the fovea and periphery of the eye, with one interesting difference: the area devoted to peripheral vision is relatively small; the area devoted to foveal vision is relatively large. In effect, this means that

The human eye works in two directions. High-intensity *vision* is a function of cone nerve endings; low-intensity *vision* is taken over by the rod nerve endings

These excellent photographs of the retina of the human eye were made by Dr. J. Reimer Wolter of The University of Michigan Medical Center. Upper view shows cross section through the cones of the central or foveal area. Lower view, further enlarged, shows section of rods and cones

while the fovea is little more than a dot on the retina, its function in responding to fine detail and color is extremely vital and requires a sizable bit of "gray matter." Conversely, while the extrafoveal periphery of the retina is relatively large, its simpler response to brightness, motion and crude form needs less area within the brain.

The fact that the right side of the brain controls the left side of the body (and the converse) also applies rather strangely to vision. In human vision, the corresponding halves of both retinas connect with their own side of the brain. Thus, the right half of the right retina and the right half of the left retina, which together see the left side of the world, send their fibers to the right cerebral hemisphere. Conversely, the left halves of the right and left eyes, which see the right side of the world, send their fibers to the left cerebral hemisphere. Some authorities believe, however, that the foveal cones connect with both sides of the brain. Wright comments, "It is still a matter of doubt whether the fibers from the whole fovea of each eye are duplicated in the two optic tracts or whether each half-fovea sends fibers along only one optic tract, in analogy with the rest of the retina. The evidence on the whole appears to support the latter arrangement."

IMPORTANCE OF THE BRAIN

That vision is as much in the brain as it is in the eye is well demonstrated by a few more oddities. Human eyes see better than the eyes of lower animals because human brains are superior. Stimuli received by any eye, in fact, have no particular meaning until the brain interprets them. A rundimentary eye bud can be taken from a hen's egg and made to grow in a salt solution. It will actually develop and form a lens. Without a brain connection, however, it does not "see."

James P. C. Southall writes in *Introduction to Physiological Optics*, "If the eye has had no previous experience to guide it in some particular instance, it may be difficult for the brain to interpret the visual phenomenon correctly. If therefore the chain of communication between the central part of the organ of sight and the adjacent optical memory tract is impaired or entirely broken in one of its links, the external object may indeed be visible to the eye but it cannot be comprehended by the brain. Under such cir-

Cross section of the retina with high power enlargement beneath it. Courtesy, The Johns Hopkins Hospital, Baltimore

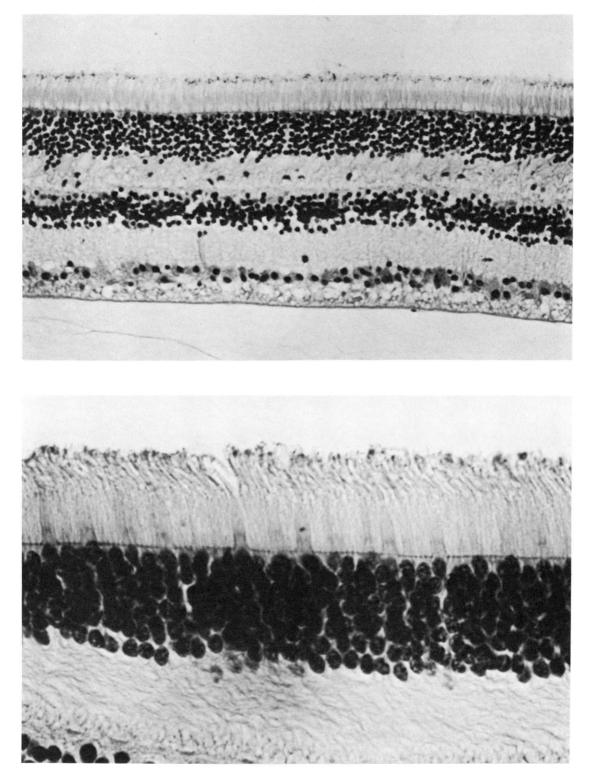

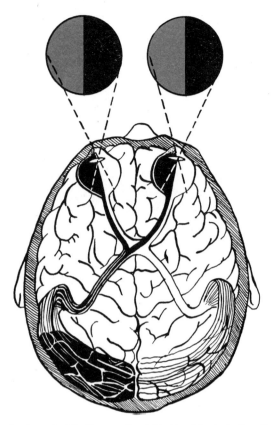

As shown in this diagram, the right side of the brain "sees" the left side of the world, and the converse. Central vision, however, seems to require both sides of the brain

Not much is known about the complexities of human vision after the point where light strikes the retina. In an article for *The Archives of Ophthalmology* (January, 1945), LeGrand H. Hardy writes, "What happens when light acts upon a photoreceptor is in essentials unknown." It is likely, however, that electrical currents are produced in the optic nerve and conveyed to the brain.

Flooding the retina is a substance known as visual purple. Its color is normally a magenta red. It is bleached under the action of light and resynthesized in darkness. According to an article which appeared in a symposium on *Visual Mechanisms*, A. C. Krause writes, "The color of visual purple upon exposure to light at room temperature changes rapidly to yellow but in the cold it slowly turns into orange and then yellow. In both cases it becomes colorless in time."[11]

Science has recently shown that vital connections exist between the eye, Vitamin A, and the general health of the body. Krause writes, "The synthesis of visual purple is dependent upon the availability of Vitamin A and the metabolic activity in the retina." Retinal Vitamin A deficiency may, of course, be caused by abuse of the eyes, by extreme glare, or by prolonged exposure to extreme brightness. It may also be caused by certain diseases.

A recent observation by George Wald is highly significant. He points out that "as Vitamin A is liberated during light adaptation, the retinal capacity to hold it is exceeded, and most of it diffuses out into contiguous tissues and the circulation This is an important phenomenon, for it connects the otherwise closed retinal cycle with the general circulation and metabolism of Vitamin A throughout the organism."[12] This may mean that the eye is not only an organ of sight, but an organ for distribution of Vitamin A throughout the human body. Not only may Vitamin A deficiency reduce the power of the eye to see clearly (especially in dim light), but some authorities believe that undue exposure of the eye to glare and extreme brightness may needlessly destroy Vitamin A, interfere with its circulation throughout the body and hence lead to general debility.

cumstances the spectator will see it *per se* and indeed may perhaps even be able to draw a sketch of its outlines, but he cannot call it by name or make out what it signifies, unless he can also touch it and reinforce his sense of sight by the aid of other senses." In short, seeing is not a matter of recording external stimuli alone, but of bringing forth mental recollections and experiences.

Another such phenomenon has been described by Walls. When the right or left optic tract is severed between the eye and the brain, a person becomes blind to the left or right half of his visual field. Despite this, however, he may still experience contrast effects and after-images. After looking at a bright area he may experience a sensation of brightness in the blind half of his vision. Concentration upon a specific color may likewise produce a complementary afterimage in the blind field. Walls concludes, "Only an interaction of the two sides of the cortex could account for such phenomena."

Vision is in the brain as well as the eye. The brain must make sense out of what the eye records. The process requires experience and intelligence

THE DYNAMICS OF SEEING

In his *Introduction to Physiological Optics*, James P. C. Southall writes: "Good and reliable eyesight is a faculty that is acquired only by a long process of training, practice and experience. Adult vision is the result of an accumulation of observations and associations of ideas of all sorts and is therefore quite different from the untutored vision of an infant who has not yet learned to focus and adjust his eyes and to interpret correctly what he sees. Much of our young lives is unconsciously spent in obtaining and coordinating a vast amount of data about our environment, and each of us has to learn to use his eyes to see just as he has to learn to use his legs to walk and his tongue to talk."

An insect seeing through a compound eye will respond to a crude mosaic of brightness patterns. Birds and fishes, with eyes on the sides of their heads, may not be able to focus upon one object with the degree of clarity known to man. Such creatures probably see two conflicting worlds at the same time, concentrating on one or the other by some process of "blanking out" right or left.

In man's binocular vision, the foveal areas of the retina will simultaneously focus form, brightness, color and detail, assuring a clear image and a perfect sense of size, shape and distance. At the same time, the retina's peripheral areas will respond to brightness change or motion on the outer boundaries of the field of vision. The baseball player, with his fovea on the ball, will use his periphery to guide the arc of his bat, and the prizefighter, with his eye on his opponent's chin, will be protected from "haymakers" coming in from the sides.

The human equation operates as well in discriminating detail. Ralph M. Evans writes, "A telephone wire may be seen at a distance greater than a quarter of a mile." Under the best of conditions an image so small could hardly be recorded by a glass lens and photographic plate, but the human eye and brain are able to construct a remarkably accurate image. Apparently, the retina requires only a few hints of the existence of the wire, whereupon the brain pieces it together.

In speed of seeing, the brain records a fairly clear image of a scene or object though the exposure may be a mere fraction of a second. Flashes of light will produce higher subjective brightness than light shone con-

A head-on, enlarged view of the common house fly, showing its compound eyes

tinuously. When two lights are flashed simultaneously, one striking the fovea and the other the periphery of the retina, the light seen foveally will appear to flash ahead of the other. Similarly, blue lights require a slower blinking rate than red lights, if such blinking is to be seen. In his *The Vertebrate Eye*, G. L. Walls states, "A Swedish railroad recently found that certain red signals, which had to be seen as blinking, could be so seen if they flashed seventy-five times per minute. Blue ones could be allowed to flash only twenty times per minute, else there was danger of fusion by the dark-adapted eye of the engineer."

Near the fovea of the retina is a "blind spot" where the optic nerve of the eye is connected. Located slightly inward toward the nose, near the center of the retina, it points out obliquely into the world. This "dead spot" was discovered toward the end of the 17th century by Friar Mariotte, a French student of optics. E. W. Scripture wrote (1895): "Although man and his animal ancestors have always had blind spots as long as they have had eyes, these spots were not discovered until about two hundred years ago, when Mariotte caused a great sensation by showing people at the English court how to make royalty entirely disappear."

At close distance the blind spot covers a relatively small area in the field of vision. At seven feet it measures eight inches across

91

and increases in amplitude into the distance. When looking into the sky, it covers a region about eleven times the size of the moon. Though the eye sees nothing at this point, a person is never conscious of emptiness or blackness; the brain "fills in" with whatever happens to be in the environment. The blind spot surrounded by type will seem to be filled with type. The same is true of colors. The eye will "think" it sees red in its blind spot if the surrounding area is red.

There is a certain amount of retinal lag in perceiving objects and colors. Vision is not an instantaneous retinal process. When the eye scans, it does not do so in a continuous sweep, but skips and hops. Stimulation of any one moment holds over to the next—and so moving pictures are made possible—and visual impression remains lucid and unblurred.

But more than this takes place. In seeing any color the eye has a tendency to bring up a strong response to its opposite. So pronounced is this reaction that it actually brings after-images to view. When staring at a red area and then at a neutral surface, a sensation of green will be experienced. The after-image of yellow will be blue. The phenomenon has great influence over color effects and gives intensity to strong contrasts and mellowness to blended color arrangements.

Recent scientific experiments indicate that after-image effects take place in the brain rather than in the eye. This also seems true of illusions associated with brightness contrast (the fact that colors look relatively light on dark backgrounds and relatively dark on light backgrounds). With reference to after-images, hypnotized subjects have been asked to concentrate upon color stimuli which had no literal existence. Though the subjects' eyes actually saw nothing, colors were experienced. Subjects "saw" complementary after-images despite the fact that their retinas had not been stimulated. Most amazing, "these were persons who, in the waking state, did not know that there is such a thing as an after-image—let

The afterimage. The stimulation of any color will bring up a reaction to its opposite. Stare for thirty seconds at the colored flower, then look at the small cross at the right. An opposite color will be seen

alone, that it should be expected to be complementary to the stimulus!" (Walls).

In lower forms of animal life, the nerves of eyes have "direct wire" connections to the body muscles. Reactions to light are often involuntary. To a surprising degree this same condition exists in man. Sudden brightness or motion on the outer boundaries of his vision may cause his head to dodge and his muscles to grow taut—even before he has a chance to think. Man's emotional response to a sunny or rainy day may be traceable to the reaction of his autonomic nervous system. Under the influence of drugs such as hashish or mescalin, objects seen may change in size, form and position, and that which is static may become dynamic.

Human vision has a flow which rises and ebbs with the whole physiological rhythm of the body. Illness may affect visual acuity and color perception. Extreme fear may impair sight, in whole or in part. Bright days will, through vision, effect a different attitude and even a different perception from dismal days. Man sees best when he feels best, physically and mentally. To a large extent cheerful environment is conducive to soundness of body and mind. The application of color to life—in the home, in industry, in schools—serves humble as well as lofty purposes, and it is as vital to the physical as the spiritual.

THE MYSTERIES OF COLOR VISION

In its sensitivity to color, the human eye responds to a relatively small span of the total electromagnetic spectrum. Human vision may have had its evolution in water, for the visible spectrum is in general the

transmission spectrum of water. According to Walls, "The rod spectrum is closely fitted to water, the cone spectrum a little better to air." In evolutionary terms, such development is perhaps natural enough.

Though perception of color may connote spiritual, emotional and aesthetic things to man, nature is less interested in beauty than in clear vision. Light and color have biological significance. Color sense aids perception. It has a functional basis, and was evolved by nature not to make men happy, but to assure their better adaptation to environment. Just as nature imposes herself on man through vision, so man interprets nature as his brain directs. In short, seeing works two ways: physical stimuli from the outside world enter the eye which then sends impulses to the brain; the brain adds its experience, judgment and perception to what it receives, and "looks" wisely back at the world and "sees" it.

Science has been at a loss to explain the mysteries of color vision though many theories have been propounded over the years. For example Ewald Hering (1834–1918), a psychologist, has proposed a theory in which three reversible processes or substances are said to exist in the visual mechanism: a white-black, blue-yellow and a red-green process. Where "breaking down" occurs under the action of light, white, blue and red are experienced; where "building up" occurs, sensations of black, yellow and green are perceived. The Hering theory neatly explains complementaries and after-images, but still falls short when other phenomena are considered.

In the Ladd-Franklin Theory, evolution of the color sense is supposed to have begun with a light-sensitive substance which enabled the eye to distinguish light from dark. Next came a yellow-sensitive and blue-sensitive substance. Finally, the yellow component was still further divided to permit the eye to see red and green. While these theories may explain some forms of color blindness, and while they take into account the red-green-blue primaries of the physicist, and the red-yellow-green-blue primaries of the psychologist, there is little concrete evidence that the retinal nerve fibers act in any such way.

In the Müller Theory, stoutly championed by many scientists, photochemical processes are assumed in an initial stage, followed by added processes which give rise to sensations of black, white, yellow, blue, green and red. The optic nerves are stimulated by various bands of the spectrum. Chemical processes take place in the retina and transmit impulses to the brain. Color blindness is the result of defects in the optic nerves and, consequently, certain impulses are not transmitted. Deane B. Judd writes in *Color in Business, Science and Industry*, "A frequent criticism of the Müller Theory is that because of its elaboration it explains everything but predicts nothing."

"A common assumption in theories of color vision is that there exists in retinal cones of the normal human eye a set of three spectrally selective substances capable of being decomposed independently by the action of radiant energy" (Judd). In the Young-Helmholtz theory, three different types of cones are supposed to exist on the retina, one with maximum sensitivity in the red end of the spectrum, one with maximum sensitivity in the green, and the third in the blue. Various color sensations are accounted for by stimulation of these receptors; stimulation of red and green-type cones presumably gives rise to yellow; stimulation of all three receptors produces white. Although no conclusive evidence has been forthcoming that the retina contains cones of different types, the theory's supporters have not been discouraged. Recently, Stephen L. Polyak has mentioned three types of neural connections to the cones, and A. R. Granit has similarly obtained evidence of different spectral sensitivities.

Work in the field of color vision and color blindness today generally proceeds on the assumption that the human eye has a tri-receptor mechanism. With three lights—red, green and blue—all the colors of the spectrum are formed. "The evidence is, therefore, consistent in its indication that color of a uniform element in the visual field of a normal observer requires at least three independent variables for its specification" (Judd). Color blindness may be analyzed on a three-color basis. Colorimetry and spectrophotometry may likewise be carried out with three colors and utilized to measure and specify colors.

Although color blindness is fairly common in human beings, apparently little attention was paid to it until the latter part of the 18th century. The first intelligent description of it was attempted by John Dalton, an English chemist, in 1798. Dalton at first at-

tributed errors in judgment to an ignorance of color terms, but later discovered that he saw no difference between a laurel leaf and a stick of red sealing wax. Dalton compared the color of a scarlet gown to the scarlet of the trees, and once attended a Quaker meeting attired in drab coat and flaming red stockings. So famous was his report that "Daltonism" became a synonym for color blindness.

Color blindness may be congenital or acquired. Where a person is born color blind, there is generally no loss of his ability to see brightness, form and detail. Color blindness is far more common among men than among women, and is generally transmitted to offspring through the distaff side of the family so that normal mothers may transmit the defect to their sons. About ten per cent of men are color blind while the frequency among women is less than one-half per cent.

Acquired color blindness may occur as the result of diseases of the eye, optic tract or cerebral cortex. It may accompany pernicious anemia, Vitamin B_1 deficiency and exposure to certain poisons such as carbon disulfide, lead or thallium. Cases of acquired color blindness usually involve a general deficiency of vision, and a study of such cases is seldom of much value to understanding what healthy color-blind persons see.

MODERN THINKING

Terminology in the field of color blindness is replete with multi-syllabic words such as protanopia, deuteranopia, trichromatism, and dichromatism. An attempt will be made to describe the phenomenon in simpler terms. In normal color vision, the spectrum is seen to comprise red, orange, yellow, green, blue and violet. The region of greatest brightness is in the yellow and yellow-green. All these colors of the spectrum may be formed by mixtures of three lights: red, green and blue. To quote Judd: "It is convenient to classify the discriminations of a normal observer as light-dark, yellow-blue, and red-green; that is, a normal observer can tell light colors from dark ones, yellowish colors from blue ones, and greenish colors from red ones."

In a first group (protopania) of color-blind individuals, three colored lights (as in a normal person) may be required to form all other shades of the spectrum, but the proportions needed to effect certain matches

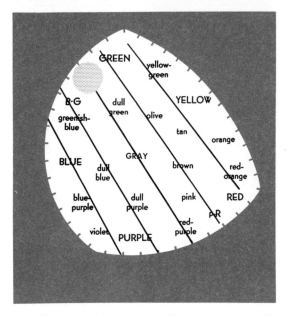

Dean Farnsworth devised this remarkable chart to explain the vision of a deutan (green blindness), the most common of all forms of color deficiency. All colors lying within the zones of the parallel lines will be confused; red with green, blue-green with purple, etc

will differ radically from normal. In some persons (deutoropania) there may be an abnormal green function; in others, an abnormal red function. Such people may be thought to have a fairly good color sense and may, with effort, name many colors. In some instances, however, experience may be a guiding factor, because the individual knows that the sky is blue, grass is green, butter yellow and so on. Where fine distinctions may be set up, or where the colors may be grayish in tone, the so-called "anomalous trichromats" may find themselves hopelessly confused.

In a second group, only two colored lights are necessary for the afflicted individual to match all spectrum hues. Almost always such a person (the dichromat) has visual discrimination for light-dark and for yellow-blue, but not for red-green. He will generally agree with any color match set up by a normal observer, but when he does his own matching he may do strange things. To quote Wright, "For instance, a gray surface may sometimes be described as gray and at other times be referred to as blue-green or purple by one type of color defective. Or, on the other hand, a red surface, a dark yellow surface or a green surface may all be described as brown." Colors with short wavelengths are likely to appear bluish (not greenish), and those with long wavelengths

94

are likely to appear yellowish (not red or orange).

Red and green cause most confusion among color-blind individuals. Among the ten per cent of men who are color blind, such red-green blindness in some form or other is predominant. A few rare individuals are deficient in yellow-blue discrimination, and a few others are totally blind to all spectrum hues.

Although much experimental work has been done, no known cures for congenital color blindness have been found. Much quackery is promoted in the form of drugs, psychotherapy, special training and special diet. In a research report for the U.S. Navy, Dean Farnsworth writes, "The best informed and most experienced specialists in the field of color vision are emphatically of the belief that congenital color deficiency cannot be remedied by the use of diet, medicine, training, or other treatment now known to science."

The human nervous system is highly sensitive to lowering of the oxygen tension in the blood. Lack of oxygen affects vision and reduces the ability to see clearly. So-called "anoxia" (oxygen shortage) may occur at normal air pressures where the concentration of oxygen in the atmosphere is weak, or it may follow exposure to the "thin" air of high altitudes. Lowered visual acuity, less sensitivity to brightness and color, and partial or complete disappearance of afterimages may result. Voluntary eye movements may be disturbed and tasks such as reading made difficult. Perhaps to compensate for all this, the pupil of the eye tends to dilate and admit more light to the retina.

Temporary loss of vision (without loss of consciousness) may take place when sudden high speeds or pressures are encountered, as in dive bombing. If suction is maintained over the eyeball, however, "blackout" may be prevented.

DARK ADAPTATION

The ability to see does not follow in a straight progression from darkness to brightness, nor is the reaction of vision directly proportional to stimulus. Vision has its mechanism adapted to seeing in dim light and its mechanism adapted to seeing in bright light, and the two tend to function separately. In particular, as light grows dim cone vision fades out while rod vision is en-

hanced. Strangely enough, a given stimulus of low intensity may actually appear to *increase in brightness* as general illumination is diminished. This would mean that rod vision grows better and better as less and less light enters the eye!

The eye sees yellow-green as the brightest region of the spectrum under daylight adaptation, while the region of highest brightness to the dark-adapted eye is in the blue-green. As vision shifts from cones to rods, there is reduced sensitivity to red colors and increased sensitivity to blue ones. This phenomenon, known as the Purkinje effect, adds further mystery and fascination to the study of vision. A red and a blue, for example, if equal in brightness under normal light, may fail to match under dim light; the red may appear dark and the blue light in tone.

Color is seen only under normal light and in the center of the eye. To demonstrate this, a person may experiment with bits of colored paper drawn around from behind his head. Although he will be able to "see" the papers far to the side of his head, he will not be able to distinguish their precise hue until they are well in front of him.

That eyes are color blind during dark adaptation may be determined by remaining in dim illumination for at least thirty minutes, and then attempting to distinguish unidentified samples of color. A further experiment is to cup one eye with the palm of the hand, then expose the other eye to a lighted lamp. In darkness again, vision will be quite acute in the dark-adapted eye and quite blind in the eye that had been exposed to light.

In the *Journal of the Optical Society of America* (August 1944), Charles Sheard writes, "The most striking thing about the change of visual threshold, as one enters and remains in a dark room, is its range; it can easily cover a gamut from one hundred thousand units of light intensity at the beginning to one unit at the end of dark adaptation." As vision shifts from cones to rods, discrimination of color and brightness will be reduced. For example, the steps of a gray scale will remain distinct under normal or bright light. Under very dim light, however,

In full daylight, the point of highest visibility in the spectrum is yellow. To the dark-adapted eye, the brightest region is in blue-green

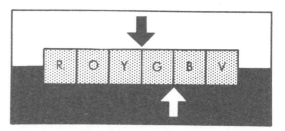

medium and deep colors tend to "melt together" in brightness and resemble black. Night vision thus tends to be colorless, filmy and lacking in detail; the silhouettes of objects appear flat, vague and very difficult to bring into focus.

In near darkness the center or fovea of the eye is more or less blind. Hence, dim objects are better seen when looked at "askance." In fact, small objects of low brightness may disappear if looked at directly.

Negroes are said to see better in extremely dim light than people of other races. Persons with dark-brown eyes may also have lower thresholds than those with blue eyes. Because Vitamin A is essential to good vision in dim light, and because it accumulates during dark adaptation, any Vitamin A deficiency will reduce the eye's seeing ability. (Lack of Vitamin A in the human system may be attended by other troubles such as dermatitis.) In *The Eye Manifestations of Internal Diseases*, I. S. Tassman reports that fifty per cent of pregnant women have night blindness, which can be improved when substantial amounts of Vitamin A are given them. Night blindness is the poor man's ailment, for it is usually the result of inadequate diet.

During the Second World War, good night vision was very important to the armed forces. The aviator, the lookout on a submarine or surface vessel and the reconnaissance scout needed the best of vision at night and during the twilight hours of dusk and dawn. Their diets were usually supervised and supplemented by extra quantities of Vitamin A.

Both in England and in America, extensive work was carried out to unlock the mysteries of night blindness and night vision, and to develop methods to achieve the best possible vision. Where it was impractical to keep the eye in total darkness to aid dark adaptation, what color or colors would be most effective? Again, where objects such as instruments and dials had to be seen and where at the same time the observer had to peer into the night, what hues would cause the least disturbance to sharpness of vision?

As has been mentioned, when the human eye is dark-adapted, sensitivity to red is relatively less than sensitivity to blue. In other words, a red color or light is seen distinctly only in the very center (fovea) of the eye; it is less distinct, if not invisible, on the outer boundaries of the eye (periphery). Because night vision is essentially rod vision, red light was therefore found to have great usefulness. Red illumination is frequently employed as a general light source where men's eyes are being dark-adapted, or where night vision must be maintained. Red goggles are used for the same purpose. An aviator about to go on a night mission, or a sailor about to go on night watch, will have his vision fairly well-adjusted if he has been exposed to red light of low intensity. (He will not have to stay in darkness preparatory to his assignment.) Also, red light used as a local illuminant over instruments and dials will not disrupt dark-adapted vision.

Thus, the rods of the human eye, accumulated mostly outside the central fovea of the retina, are virtually insensitive to red light of low intensity. In fact, through wearing red goggles, it is sometimes possible to condition the eye to dark adaptation while going about in daylight. The red filters will permit the cones of the eye to function, but will leave the rods inactive and therefore ready and waiting to see in darkness.

Perhaps the visual purple contained in the rods does not absorb much of the red light and hence is not bleached or chemically affected. Under red light, central vision is fairly clear and sharp, but peripheral vision is poor. Conversely, under blue light, central vision is blurred but peripheral vision operates fairly well. Instruments and dials are thus more sharply focused at night if illuminated by red light. However, a blue flashlight would enable a person to get about more safely at night, for the light it threw would be seen over a far wider range.

The author wearing red goggles for dark-adaptation. In the Navy special playing cards are used, with diamonds and hearts outlined in black to make them visible

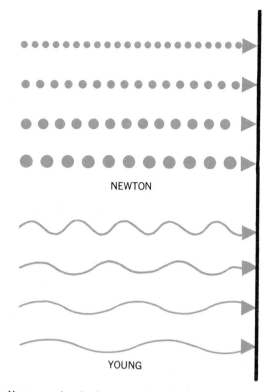

Newton spoke of color as particles of different size hurling through space and striking the retina of the eye. Thomas Young and others spoke of waves of different frequency. The answer is in both

Chapter 9

THE HUMAN SIDE OF SENSATION

Newton spoke of color as a barrage of particles and of the eye as a nerve mechanism responding to them. His notions, however, were purely speculative. As a physicist rather than a physiologist, he was not really capable of speaking with authority on the sensory make-up of vision. Yet Newton's ideas persisted for over a century. Then the genius of Thomas Young, professor of natural philosophy at the Royal Institute of London, to whom physics was more of a hobby than a vocation, led to a new and radically different viewpoint. Young developed an "undulatory theory" in which sensation of color was accounted for as a response to different *vibrations* of light. He said: "It is probable that the motion of the retina is rather of a vibratory . . . nature, the frequency of the vibrations must be dependent on the constitution of the substance. Now as it is almost impossible to conceive each sen-

sitive point of the retina to contain an infinite number of particles, each capable of vibrating in perfect unison with every possible undulation, it becomes necessary to suppose the number limited."

At first, Young chose red, yellow and blue as his primaries, probably because of the beliefs of his day. Later, he accepted correction by other physicists, and used red, green and blue-violet. He assumed that three elements on the retina, corresponding to those three colors, had different vibrations which were interpreted as colors by the brain.

FROM PHYSICS TO PSYCHOLOGY

Young founded the science of physiological optics by starting to wean it from physics. Immediately after his time, physicists began to realize that they could not master sensation as well as light waves. Young had written, "It seems almost a truism to say that color is a sensation." What did he mean? Simply that color was something that had its origin in man; light was merely a stimulus, not the substance of color itself as experienced in human consciousness.

After him other scientists dealt with the phenomenon more discreetly. James Clerk Maxwell, celebrated in the field of electromagnetic induction, who said, "The science of color must . . . be regarded as essentially a mental science," endeavored to formulate laws for color sensation. Maxwell invented the color wheel and declared all visual mixtures were linear, or of the first degree. He believed that three colors, arbitrarily chosen, could be given distinctive numbers, and used to form all perceptible shades, thereby creating a nomenclature that might reduce the world of color to simple formulas measurable in terms of human vision.

After Maxwell, and still from the ranks of physics, came Hermann von Helmholtz, one of the greatest scientists of modern times. While not a colorist at heart, Helmholtz built the final bridge enabling the art of color to move from physics into psychology—a bridge he did not cross. His achievements were many. He wrote an accurate description of the spectrum. He showed where and how mixtures of light rays differed from mixtures of pigments. He determined the correct relationship of complementary hues. And he refined Young's theory of vision, which then became known as the Young-Helmholtz theory of light.

Yet, without intending to do so, Helmholtz confused the physical aspects of color with the psychological. He assumed, for example, that simple, monochromatic colors were the real elements of color vision; that is, the sensation of color was produced by the stimuli of certain definite frequencies of light. This is untrue. Yellow, for example, occupies but one-twentieth of the full spectrum of light but is the brightest of all colors—a quality that could not exist in any surface or medium that reflected or transmitted only one-twentieth of light and absorbed the rest. As a matter of fact, yellow, like all other colors, represents a blend of frequencies which includes a large portion of the spectrum and not merely a narrow segment of it.

Again, Helmholtz stated that any given color impression could be defined strictly in terms of radiant energy. It cannot, except in a way that rules out the evidence of the senses. Orange and brown, though different in intensity, may have identical wavelengths. To the spectrometer they are similar, but to the eye they are quite distinct.

A far more credible doctrine of color sensation was to be promulgated by the psychologist, Ewald Hering, who did not inquire into the spectrum at all. Turning his back on physics, Hering studied man, the microcosm, and his research was in human sensation. He observed that two colors, exactly alike to the eye, could be of different composition, and that two colors of the same composition could be made to look unlike. How could laws of energy handle such paradoxical facts?

He established red, yellow, green, blue, white and black as fundamental colors, and pointed out that all perceptible colors could be produced by graded mixtures of pure hues with white and black. The natural symbol of color was an equilateral triangle. Color sense was at once a complex psychophysical process, yet simple in general plan. To understand it man must study his eye and brain, the influences of illumination, environment and imagination.

For a good many generations after Newton, science had a static conception of the universe. Everything to be studied by man was laid out before him in the world, waiting to be analyzed, measured and reduced to law. Not until the growth of psychology was this attitude corrected. The dogmatist looked on vision as a matter-of-fact sensory

To the ancients, many of the great mysteries of life were to be symbolized by light and color. Vision and visual phenomena were of great interest and concern

process: the eye was a photographic plate and simply recorded what fell upon it.

THE LIVE APPROACH

Color has always needed a live approach. While color as radiant energy is intriguing, it is also a "dead" study in that radiant energy exists externally whether man sees it or not. But color in the human sense, an experience of consciousness, exists only within man. James P. C. Southall writes: "From the standpoint of psychology, colors are the properties neither of luminous objects nor of luminous radiations but are contents of consciousness, definite qualities of vision."

Ancient man, mystic at heart, identified the colors of the spectrum with his own being. His symbolism was created not to explain the nature of light as energy, but to associate the spectrum with his own body, mind and spirit, the essence of things natural and supernatural. He strove to build an art of color that gave expression to his personal feelings—almost as the modern colorist attempts to get at the elements of human emotion.

When science has finished with its astonishing theories, a thousand questions still remain unanswered.

First, there is no close, orderly or measurable relationship between light energy and sensation of color. It is impossible to seize upon certain wavelengths or intensities and to establish them as fixed stimuli to the eye. What, for example, is the difference between black and white, or between gray and white? Physics cannot answer this satisfactorily with spectrometers or theories of electromagnetic energy. White is not synonymous with bright light or black with feeble light— or even with no light at all.

With his eyes tightly closed in a dark room, man does not see black but a deep "subjective" gray that seems to fill space. This gray does not have the depth or solidity of a black surface. Again, black always appears blacker the stronger it is illuminated. No average surface absorbs all light. What the eye sees as black may reflect ten per cent or more of the light shining upon it. Yet a surface like this looks increasingly blacker when more light strikes it—and when, in truth, more light is reflected into the eye.

More curious than this phenomenon is the transformation of a white surface into the appearance of a gray surface without in any way changing the volume of light reflected by it. In a classical experiment devised by Ewald Hering, a piece of white cardboard is placed upon a window sill with the observer facing the light. A second white card is held on a horizontal plane over it. In the center of the second card is a square hole. If both pieces are exactly horizontal, and if the upper piece does not cast a shadow over the lower, they will both appear white.

Now, if the upper card is tilted away and down on its horizontal axis toward the window sill, it will immediately reflect more light, and the card seen through the hole will appear gray or even black. By changing

The author performing Hering's experiment described in the text. It proves that what man sees may be personal to his senses and not a mere response to light energy

Southall says, "To argue that because a black body apparently does not deliver a specific physical stimulus to the retina, therefore black is a mere negation or complete lack of sensation, is not only to beg the question from the start but to deny the evidence of our senses."

OTHER PHENOMENA

Other peculiarities of vision are not explainable in terms of physics. The human eye cannot distinguish and separate the component elements of a dominant hue. When several notes are struck simultaneously on a piano, the trained ear can easily identify each one. But when light rays are mixed, the eye sees the result only. Goethe, in supporting the red, yellow and blue doctrine, once argued that he could see both yellow and blue in green. Later the physicist, with his red, green, blue-violet primaries, insisted that yellow was a color-blend of red and green. Yet yellow is quite primary in vision and hasn't the slightest resemblance to red or green.

The eye pays little heed to physical laws. Polarized light looks the same as ordinary

the conditions of the experiment, the lower card shifts from white to gray; yet the volume of light it reflects is not modified in the least! Color as radiant energy and color as sensation are different affairs!

Black has always been confusing. In vision it is decidedly positive, not negative. Black is a sensation quite different from "nothingness." In his *Colour Vision*, W. Peddie writes, "Physiologically *black* implies the absence of stimulation: psychologically the recognition that illumination is absent is itself a positive perception." Helmholtz also understood this: "Black is a real sensation, even if it is produced by entire absence of light. The sensation of black is distinctly different from the lack of all sensation."

Black is a color as definite and unique as red or blue or white. It mixes with other colors to change their appearance. An orange light in a dark room will maintain its same general appearance whether the intensity of the light is strong or weak; it will merely be a bright or a dim orange. But lower the itensity of an orange paint by mixing black with it and it will change to brown. In light rays, black seldom plays much of a role; there is no brown or maroon in a rainbow or a sunset. Yet in life black is found everywhere, an integral part of other full colors, modifying their appearance and forever making itself apparent in vision.

100

Black and white are colors and will create different and unique visual sensations when combined with spectral hues

Background will affect the apparent brightness of colors. The hued disk here will tend to appear darker on a white ground and lighter on a black ground

light. Grays mixed through a combination of white and black are not visually different from grays formed with red and green, or orange and blue. Again, most colors will appear brighter on a black background than on white. A piece of blue paper, though made to match the blue of the sky, will never look the same as the sky. In both such instances a spectrometer might register identical stimuli. But the eye sees differently.

Finally, a number of subjective illusions do not have the slightest relationship to electromagnetic energy. Pressure on the eyeball will produce color sensations. Visualization of an area of red may bring out a response to its opposite, green. Lustrous surfaces such as silks involve other visual phenomena. The eye sees a difference between white cotton and white silk: one has gloss or luster; the other does not. Yet both are white and would be identified as white by a scientific instrument.

Certain sensitive persons are able to hold a mental picture of a red area in their minds, then actually see a green after-image. Likewise, the appearance of certain colors is affected by mind and imagination. It is human to see blue eyes as bluer and red hair as redder than they actually are.

Psychology has always had an open mind on recondite color phenomena because it appreciates the subtleties of human consciousness. What it gives to the art of color is research on the mental and emotional peculiarities of man, inquiries outside the province of the physicist, chemist or physiologist.

Subjective color effects exist abundantly in man, the microcosm, colors that register in his brain without any colors actually being in front of his eyes. Centuries ago Aris-

totle noted a "flight of colors" when looking into the sun, and he wrote, "If after having looked at the sun or some other bright object, we close the eyes, then, if we watch carefully, it appears on a right line with the direction of vision at first with its own color, then it changes to crimson, next to purple, until it becomes black and disappears."

Goethe saw the sequence as brightness first, then yellow, purple and blue. Sungazing is a dangerous pastime. With less risk a person may gaze at a frosted electric light bulb or a strongly illuminated piece of white paper. If the stimulus is of high intensity, the sequence may begin at green and proceed through yellow, orange, red and purple, then to blue, fading out in green and black. If the stimulus is weaker, the sequence may begin at purple and proceed through blue, green, into black. Though these colors have no external existence, they are quite real to the senses and will move with the eyes, have form, and be localized in space.

UNITY OF THE SENSES

In writing of the senses, Helen Keller concluded that "the eye is the most superficial, the ear the most arrogant, smell the most voluptuous, taste the most superstitious

Colors have different modes of appearance. One and the same hue can be solid and opaque, filmy, luminous, three-dimensional, transparent, iridescent, etc

Impressions of color seem to relate to all the senses—not vision alone. Colors appear to have tastes, odors, sounds, temperatures and the like

in the world in one big but complex gulp, it tends to mix things and to let the reactions of one sense influence the reactions of others.

One authority has related color preference to season. From winter to spring, most persons are likely to fancy light, pale colors in the pastel range—a refinement of human desire capitalized on in women's fashions, for example, with the introduction of pinks, pale yellows and pale blues in spring. It may well be that more sunlight and heat affect the glands and cause an inner compulsion for delicate hues. In a somewhat obvious way pastel tints are related to spring, pure colors to summer, rich shades to autumn and muted tones to winter.

It is not contradictory to speak of light colors, light beer, light perfumes, light tones; of heavy colors, tastes, odors and sounds; of sharp sauces, sharp notes, sharp words; of strong or weak colors, odors, flavors; of

and fickle, touch the most profound and the most philosophical."

Though each sense may have its special features differently valued by different persons, there is no doubt that a strange unity exists between senses. Sensory relationships have been investigated by science. Attributes seem to be coordinated. The phrase "unity of the senses" expresses the concept that colors, sounds, odors, tastes, tactile experiences, all may be "heavy," or "light," or have "volume," and dozens of other psychological similarities. In *Sensation and Perception in the History of Experimental Psychology*, Edwin G. Boring writes, "Von Hornbostel in 1931, having regard to the fact that colors have brightness and that brightness is one of the vigorous candidates for attributehood with tones, undertook to equate the brightness of a gray to the brightness of an odor, and then the brightness of a tone to the same olfactory brightness. He found that things equal to the same thing equal each other, that the brightness of the gray and tone appear equal when both equal the brightness of the odor."

Possibly because the brain of man takes

Colors have qualities of the seasons—tints for spring, full colors for summer, shades for fall, muted tones for winter

wines that are dry, music that is hot, feelings that are cold, bright or dull. All human beings understand such descriptions, because all of us innately feel their consistency.

Virtually everyone is sensitive to the colors of foods. Appetite will be quickened or dulled by reaction to color. Among pure colors, a spectrum red (vermilion) seems to be quite appealing. This is the rich color of the apple, the cherry and rare cuts of beef. For orange the appeal is very high, at yellow it begins to fall off decidedly, and at yellow-green it finds a low point. There is a pickup at clear green, the hue of freshness in nature. Blue, however, despite its esthetic beauty, is none too appealing in most foods, although it does seem to make a good background for them. A similar attitude seems to apply to violet or purple. The greatest drops occur in small intervals of the spectrum—between yellow-orange and yellow-green, and between red and red-violet. Tints are neither as upsetting nor as savory as pure colors. Although pure red is succulent, pink is by no means so. The best tint seems to be orange. A yellow tint is slightly better than a pure yellow. A green tint is also agreeable. Tints of blue and violet are not as "inedible" as pure hues or shades of the same colors.

Among shades, orange stands dominant. Here is the rich hue of brown associated with well-cooked meats, with breads and wholesome cereals. Red shades tend to be purplish and thus lose out. A shade of yellow-green somewhat resembles a pure, clear green and picks up in appeal. But shades of blue and violet are by no means good food colors.

However, foods which might taste good with the eyes blindfolded (such as a black fig) may take on a good appearance if the palate properly converts the eye. Yet where the association is well established, liberties cannot be taken with color. For the most part, peach, red, orange, brown, buff, warm yellow, clear green, are the true appetite colors. Pink and tints of blue and violet are decidedly "sweet" and not for the entrée or filling part of a meal.

Pale, delicate colors seem best associated with flowers and perfumes. Best of all, perhaps, are pale green which is reminiscent of pine; pink which suggests crushed flowers; lavender, orchid and lilac tints which appear to have the fragrance of perfume. The following list gives the most preferred odors.

As each is mentioned, a color association will seem almost automatic; rose, lilac, pine, lily of the valley, violet, coffee, balsam, cedar, wintergreen, chocolate, carnation, orange and vanilla. Now, note the almost total lack of color associations with odors which most of us dislike; lard, rubber, kerosene, fish, turpentine, vinegar, onion, garlic, perspiration! The French poet Baudelaire wrote, "Perfumes, colors and sounds are interchangeable. There are perfumes fresh as the flesh of babes, sweet as oboes and green as the prairies."

EIDETIC IMAGERY

Vision is the most amazing of the senses, and among its wonders is eidetic imagery. In recent years psychologists have studied mental imagery in general and have discovered numerous and astonishing phenomena. A notable investigator in this field is E. R. Jaensch. Images experienced by human beings fall into three types: memory images, after-images, eidetic images. The first is the product of mind and imagination, and has the quality of an idea or thought. The after-image is more literal. It is actually seen and may have shape, design, dimension and precise hue. Its size will vary as the eye gazes at near or far surfaces. Generally, it is a complementary image, white being seen where black was originally, red being replaced by green, and so on. The third, the eidetic image, is the most remarkable. E. R. Jaensch writes in his *Eidetic Imagery:* "Eidetic images are phenomena that take up an intermediate position between sensations and images. Like ordinary physiological after-images, they are always *seen* in the literal sense. They have this property of necessity under all conditions and share it with sensations." Eidetic imagery is the gift of childhood and youth; and while seemingly akin to the supernatural, is nonetheless a sensory reality. The child playing with his toys may be able to project living pictures of them in his mind. These may not be mere products of the imagination; they may be far more tangible, with dimension, color and movement in their make-up. They are "lantern slides" of the eye and brain, projected into definite, localized space and as real as projected lantern slides.

According to Jaensch, eidetic images are subject to the same laws as other sensations and perceptions. They are, "in truth, merely

Drawings used in study of eidetic imagery. Some people, after viewing them, can retain all details and even see movement and action

the most obvious sign of the structure of personality normal to youth." Through them science might find plausible explanations for the reports of saints that walk out of pictures, of weird creatures, ghouls and demons seen by human eyes. Because eidetic images are real sensations, ghouls and demons may also be real. And instead of singing incantations and prescribing sanity tests, the confessed observer might be treated as a sane human with a mental acuteness perhaps beyond the ordinary.

For most persons an admitted gap exists between sensation and imagery, a viewpoint generally used to support the cliché that reality and imagination are distinct and different. Jaensch says, "Some people have peculiar 'intermediate experiences' between sensations and images." They are true eidetics whose responses are quite frank and spontaneous. To them sensation and imagination may go hand in hand and be closely united in some literal and graphic visual experience.

Eidetic images are film-like after-images. Although the original objects which prompt them may be of textured hues, the eidetic image is more like light. As stated, it is a positive rather than a negative "picture." In some instances it may be tri-dimensional. Jaensch reports that eidetic images are easier to recall than the memory images. He also found that calcium treatments caused the eidetic disposition to be *weaker*. The image seen under this circumstance was likely to be complementary in hue and brightness to the original. Conversely, treatments with potassium occasionally made a latent type active, and heightened considerably the eidetic disposition.

The phenomenon of eidetic imagery has all the charm of magic and clairvoyance.

More practically, however, it may serve useful ends. Jaensch writes, "The eidetic investigators have already shown that the closest resemblance to the mind of the child is not the mental structure of the logician, but that of the artist." In education, the forcing of an adult viewpoint, mind and manner upon the child suppresses the eidetic personality and consequently may stand in the way of creative and natural expression. Heinrich Klüver writes: "For example, an eidetic child may, without special effort, reproduce symbols taken from the Phoenician alphabet, Hebrew words, etc. Or a person with a strong eidetic imagery may look at a number of printed words for a while and then go to the dark room and revive the text eidetically. It is possible to photograph the eye movements occurring during the reading of the eidetic text."[13]

Some authorities have striven to relate eidetic imagery to personality. Introverts are said to show a tendency to see meaningful, interrelated wholes; extroverts tend to have more objective and analytical reactions. In psychiatry, the eidetic image has been termed an "undertone of psychosis." No doubt the subject has psychiatric importance. It may, for example, have bearing on theories of hallucinations; it may also throw new light on the mysteries of human perception and on the dynamics of life in general, and the science of medicine may profit accordingly.

As far as the art of color is concerned, the eidetic faculty, rare though it is, pleads for a personal rather than an impersonal expression. The colorist may well understand that effects with color may be mixed up with human consciousness—influenced, affected and interpreted by strange happenings in the mind.

Chapter 10

MYSTERIES OF
THE HUMAN AURA

No comprehensive work on color can overlook the theory of the human aura even though it belongs to the realm of the mysterious and unproven.

On matters of magic and mysticism, there are believers, skeptics and in-between agnostics. Those who incline toward mysticism will read this chapter sympathetically; perhaps the skeptics will find it an interesting aspect of the enduring body of myth and superstition.

In speaking of the religious "instinct" with which most humans seem to be endowed, William James wrote, "Like love, like wrath, like hope, ambition, jealousy, like every other instinctive eagerness and impulse, it adds to life an enchantment which is not rationally or logically deductible from anything else." And the great English physiologist, A. S. Eddington declared, "There are some to whom the sense of a divine presence irradiating the soul is one of the most obvious things of experience."

The doubter of things mystical has every right to his suspicions or denials. However, his ancestors believed and many of his living cousins still believe that strange forces exist which are beyond the power of intellect to grasp. The story of astral light is surely pertinent here; for if one cannot prove the existence of auras, neither can one deny them.

THE AURIC LIGHT

Early man, superstitious at heart, found color could be used to symbolize virtually everything concerning life and death. Some mystics, however, went beyond the formal symbolism of the Mysteries and studied the auric light that was thought to issue from the body. Here the true marks of culture were to be found as unmistakable as the rainbow--visible, actual, and the real index to a man's inherent qualities.

Man had been compared to a celestial body emitting vibrations of light. This conception usually referred to the sun or to a supreme invisible deity whose emanations gave life and spirit to human beings. The halos, robes, insignia, jewels and ornaments on their own persons and on the effigies of their gods symbolized the spiritual energies that radiated from the body. The elaborate headdress of the Egyptian and the nimbus of the Christian saint represented the auric bodies of the elect. These rays were

Apollo, radiant in the Sun Chariot of Jupiter, riding across the sky. From an eighteenth century engraving

The Anima Mundi, or world soul, with its colorful radiations. From an old woodcut

The nimbus and halo of the saint were meant to reveal the divine emanations of holy personages. A Belgian tapestry of the sixteenth century

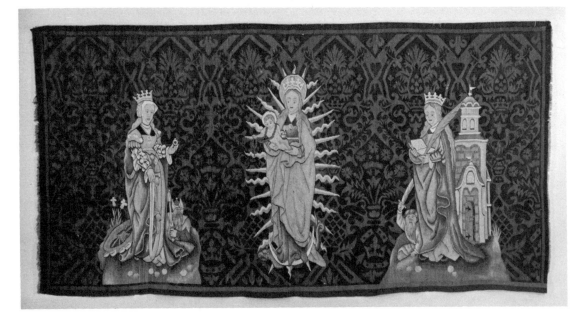

supposed to pour from the surface of the flesh, and their colors were a gauge of cultural development, spiritual perfection and physical health.

To the mystic all plants and animals emitted an aura, and in man the aura was as much a part of his entity as his body. Celebrated men like Benvenuto Cellini had noted it. "Ever since the time of my strange vision until now an aureole of glory (marvelous to relate) has rested on my head. This is visible to every sort of men to whom I have chosen to point it out; but there have been very few. This halo can be observed above my shadow in the morning from the rising of the sun for about two hours, and far better when the grass is drenched with dew."

CHARACTER AND EMOTIONS

Just as the occultist said the brain was the central organ for circulation of nerve fluid, and the heart the central organ for blood circulation, so the spleen was the organ from which the astral elements drew their vitality. In consequence, the emanations were affected by the physical, emotional and spiritual state of the body. Colors differed as individuals differed and also as an individual's mood and thought changed. Franz Hartmann in *Magic, White and Black,* writes: "The quality of psychic emanations depends on the state of activity of the center from which they originate, for each thing and each being is tinctured with that particular principle which exists at the invisible center, and from this center receives the form of its own character or attributes."

A rather involved statement, yet the mystic insisted that men's true character was shown in their auras. In low natures the predominating color was dark red; in high natures, hues were white and blue, gold and green, in various tints. Red indicated desire, blue love, and green benevolence.

In his *The Astral World,* Swami Panchadasi writes: "The human aura may be described as a fine, ethereal radiation or emanation surrounding each and every human being. It extends from two to three feet, in all directions, from the body." It may be likened to the heat rising from a stove. The colors of the aura are said to be seen best by those having psychic insight. The colors fluctuate and change; they may be tranquil like water or impulsive like flames; they will reveal peace of heart and flash deep rays of anger and hatred. Some hues are soft and misty while others shoot out in straight lines and still others unfold like coils. In *Man, Visible and Invisible,* C. W. Leadbeater describes the significance of these emanations:

Black clouds indicate hatred and malice.

Deep flashes of red on a black ground show anger. A sanguine red exposes an unmistakable sensuality.

A dull brown means avarice. A grayish brown means selfishness. A greenish brown means jealousy.

Gray is to be associated with depression and fear.

Crimson shows a loving nature.

Orange reveals pride and ambition.

Yellow emanates from the aura of the intellectual person.

A grayish green signifies deceit and cunning. An emerald green shows versatility and ingenuity. A pale, delicate green means sympathy and compassion.

Dark blue shines forth from the person having great religious feeling. Light blue indicates devotion to noble ideals.

Thus, human character reads like a neon sign for the elect. The aura of the savage is dull yellow over his head and shows rays of grayish blue, dull orange and the brownish red of sensuality. All the colors are irregular in outline. The average person emits hues of a higher octave, more yellow, pure red and clear blue. In anger black swirls and flashes of red are seen. In fear there is a livid gray mist. In devotion the colors are bluish.

Floating specks of scarlet issue from the irritable man. The miser is exposed by deep brownish bars of light. The depressed soul sends forth dull gray rays. The devotional type has an aura greatly developed in blue.

Finally, the aura of the superman is filled with iridescent hues: "All the colors of an Egyptian sunset and the softness of an English sky at eventide." There is a yellow nimbus about his head.

By these tokens is the innate personality of a being divulged. Beyond this, the colors of the astral spectrum may be even more complex.

MEANING OF COLORS

The primary astral hues are red, yellow and blue. Black is the absence of color, and white the harmonious blending of all colors. Red is the physical phase of mentality, indicating health, vigor, friendship and love.

Man's baser qualities show themselves in deep shades of red. Yellow is the intellectual phase of being and golden yellow its highest form. Blue is the religious or spiritual phase whose higher form is a violet tint and whose lower form is an indigo shade. Orange is the union of mind and body, a sign of sound wisdom and justice. Green marks the lover of nature and is indicative of sympathy, altruism, charity. Slate green is a telling symbol of jealousy and deceit. Violet exposes a love of form and ceremony. Here is the union of spirit and body (blue and red), a symbol of great idealism and sublimity.

Black is the negation of spirit, the negative pole of being, and white the Pure Spirit, the positive pole of being. White transcends all other lights and signifies the perfect degree of spiritual attainment and development.

Edwin D. Babbitt, in his celebrated book on color, presents a good deal of material on Mrs. Minnie Weston's work on the psychic colors that are said to issue from the brain. These hues comprise what Babbitt terms the odic atmosphere. He points out, first of all, a need for harmony between the vibrations of the world and the human body and recommends that a person sleep with his head to the north to "lie in the magnetic meridian." (The worst position is with the head toward the west.) Odic light appears in five forms: as incandescence, flame, threads, streaks or nebulae, smoke and sparks. The odic atmosphere is thought to be twice as fine as ordinary atmosphere because its vibrations are twice as fine as those of light.

Generally, the vulgar brain emits brownish, deep red and blackish colors. The higher brain emits clear yellowish tints and far more brilliance. Benevolence is shown by a soft green light. Firmness emits scarlet and self-esteem purple. To quote Babbitt: "The region of Religious aspiration, pointing heavenward, is the sun-realm of the human soul, and the most luminous of all, being in a person of noble and spiritual nature of an exquisite golden yellow, approaching a pure and dazzling white. The front brain, being the realm of Reason and Perception, manifests itself naturally in the cool and calm color, blue, while the love principle, typified all over the world by warmth, finds its natural manifestation in red. Such faculties as those of Ideality, Spirituality, and Sublimity, combining as they do both thought and emotion, radiate the violet, or the union

Minnie Weston's psychic colors of the human brain. From Babbitt's celebrated book on color and healing

108

of blue and red, while such faculties as Patience, Firmness, Integrity and Temperance, have more to do with coolness than heat, and have a predominance of the blue."

Some occultists tell of an astral world where culture reigns supreme. It is inhabited by the nature-spirits of Paracelsus, the undines (water spirits), the sylphs (air spirits), the gnomes (earth spirits), and the salamanders (fire spirits). Fortunately or unfortunately, they seldom choose to visit the mortal haunts of men. Leadbeater says, "Under ordinary conditions they are not visible to physical sight at all, but they have the power of making themselves so by materialization when they wish to be seen."

The astral world itself, which is likened to the celestial realms of the Atlanteans, Greeks and Christians, is indeed beautiful to behold in fancy. Franz Hartmann says, "Wherever a man's consciousness is, there is the man himself, no matter whether his physical body is there or not." In Panchadasi's book this world is described as having seven planes graded according to degrees of vibration. These planes are to be attained by those having an astral sense. How fortunate the man who reaches them! Hartmann declares, "He who can see the images existing in the Astral Light can read the history of all past events and prophesy the future!" For here culture reaches the true Golden Age that has been the dream of mankind since the beginning of time.

AURIC HEALING

All this may seem fanciful; no doubt it is. However, to indulge in further speculations on the human aura (if only for the sake of serious or amusing fancy), here are notes which lead from the past into the present.

It is natural perhaps that modern medical science persists in being at loggerheads with auric cultists and indeed with all principles of divine healing. Yet one cannot doubt the truth of miraculous cures. Though diseases for the most part may be born of germs, man has other means of thwarting them besides so-called scientific means. The body in good health resists contamination, and psychiatry demonstrates that the mind in good health will, to a considerable extent, preserve the body. Unquestionably, there is something psychic in the art of healing, something akin to the supernatural. The will to live is itself an effective remedy. But beyond this it is en-

tirely likely than ancient healers did effect astonishing cures. How? Was there intercession from the deity or did the healer's ritual so inspire the patient as to give him the necessary "injection" to thrill him to recovery? Today psychosomatic medicine knows that mental disturbances produce physical ones. If affliction works in this fashion, then the process may be reversed: mental calm may assist in restoring bodily calm.

There is in color a psychic factor, appealing, emotional, in every way inspiring and suggestive of mysterious powers. The study of the human aura and of astral light is not necessarily a matter of mysticism and abracadabra. Even the most incredulous person is forced to admit that an emanation of some sort issues from the human body. This cannot only be sensed as heat or odor, but under proper conditions can actually be seen. Sir Oliver Lodge wrote, "All evidence tends to convince me that we have an Etheric body as well as a physical body . . . it is the organized entity that builds up the body."

To certain passionately inspired mystics, astral light is a healing force representing divine emanations from within the body of man. Auras are said to flow from the holy buildings of the orientals and Mohammedans, more so than from the temples of the

Christ raising the daughter of Jairus. The health-giving spirit of the Holy One passes into the dead or afflicted

Christians, who disdain psychic phenomena. The hands of Christ may have healed because from them came emanations that flooded the being of the afflicted one.

Paracelsus credited the body with having two substances, invisible and visible. The latter, the etheric shadow, was beyond disintegration. Derangements of it produced disease. He therefore sought to reharmonize the substance by bringing it into contact with healthy bodies whose vital energy might supply the elements needed to conquer the affliction.

The auric healer of the occult school works in three ways: by thought transference, by influencing the patient's aura, and by encouraging the right emanations. In short, he (a) sets up vibrations in the mind of his patient through concentration; (b) his thought on certain hues will build up his own aura and then act directly on his patient's aura; (c) and this, in turn, will arouse corresponding vibrations in the patient's mind—and effect the cure. Auric healing is mental and spiritual rather than literal. No colored lights or colored mediums are employed. The whole process is psychic. Babbitt's theories are in reverse.

For the nervous system, the auric colors used in mental concentration are violet and lavender for soothing effects, grass greens for invigorating effects, and medium yellows and oranges for inspiring effects. For the blood and organs of the body, clear, dark blues are soothing, grass greens are invigorating, and bright reds are stimulating. Blue is the hue to think of in cases of fever, high blood pressure or hysteria. Red is the color in cases of chill or lack of sufficient bodily warmth.

Panchadasi writes: "A nervous, unstrung patient may be treated by bathing him mentally, in a flood of violet or lavender auric color; while a tired, used-up, fatigued person may be invigorated by flooding him with bright reds, followed by bright, rich yellows, finishing the treatment with a steady flow of warm orange color." The concluding vibration will then be the Great White Light. "This will leave the patient in an inspired, exalted, illuminated state of mind and soul, which will be of great benefit to him, and will also have the effect of reinvigorating the healer by cosmic energy."

Lest the skeptical physician frown upon the therapy of auric healing, one of its champions warns: "The purblind atheist scientists who practice vivisection, the injection of disgusting lymph and other abominable iniquities in the vain hope of annihilating disease by propagating it, must, sooner or later, be brought to see the error of their ways."

MODERN INVESTIGATIONS

If much of the mystic's exuberance can be discounted, the aura itself cannot be wholly set aside. Any number of devout investigators of these phenomena have been satisfied to report only what they have seen and experienced, and to refrain from losing themselves to the vagaries of their imaginations. All admit that simple colors are visible to the eye. If a full array of colors, rivaling the sunset or rainbow, is to be seen, one must indeed be psychic and a prodigy among men.

The Story of the Human Aura, by George Starr White, takes a fairly middle course between the exaggeration point of the mystic and the modesty of the scientist. White declares that a magnetic atmosphere surrounds animals and plants whose emanations differ and are subject to change. In accepting them, one may account for the mysteries of thought transference, the weird prescience of strange happenings that often strike individuals. White states that health and disease make themselves evident in the aura, that the color of the average aura is grayish blue, and that the rays change in appearance when an individual is turned toward different points of the compass. "No matter what form life or vital force may

The intercession of a saint is called upon to cure the sick with his divine radiation. From an old engraving, 1537

take, no matter what vehicle life is carried in—be it animate or inanimate—its magnetic atmosphere must be characteristic of the vehicle." White concludes that magnetic emanations from the forefinger of the left hand and the thumb of the right hand are positive, and those from the forefinger of the right hand and the thumb of the left hand are negative; and he describes an auric cabinet to study the phenomenon.

Walter J. Kilner's *The Human Atmosphere* is more logical and unprejudiced. Kilner very deliberately shunned the mystic aspects of auric light and conducted his investigation with all the care of a laboratory worker. His conclusions are that the human body is surrounded by a visible envelope with three definite parts. The first is a narrow dark band, a quarter of an inch wide, adjacent to the skin. Beyond this, projecting from two to four inches outward, is a second and clearest aura. And beyond that a third aura, misty and without sharp outline on its farther edge, is generally about six inches across.

Normally, radiations shoot out at right angles from the body, electric in appearance and with a fugitive quality, shifting and changing. Longer rays project from the fingers, elbows, knees, hips and breasts. According to Kilner, the color of health is bluish gray, tinged with yellow and red. A grayer, duller color is typical of a diseased body. Kilner preferred to base his diagnoses on the shape of the aura rather than on its chromatic qualities.

Kilner's work has been taken up and developed by Oscar Bagnall. In *The Origin and Properties of the Human Aura,* a number of engaging theories are set forth, along with a detailed explanation of how to make the aura visible. Some may observe it merely by gazing at a person in a dimly lit room though Bagnall, following the example of Kilner, makes use of a special screen.

He divides the aura into two parts, inner and outer. The inner aura, about three inches across, is marked by a clear brightness and rays shooting out in straight lines. This aura is approximately the same in all persons. It may be supplemented by special bundles of rays emanating from various parts of the body, not necessarily parallel to the other rays.

The outer, more filmy aura enlarges with age and generally has greater dimension in women than in men. Its average width is

THE NORMAL AURA

Modern conceptions of the human aura. There are said to be outer and inner bands where emissions and changes reveal psychic temperament and physical illness

GOOD HEALTH TUBERCULOSIS DIABETES

111

about six inches. Color is best seen here—bluish or grayish. The bluer the hue, the finer the intellect; the grayer the tone, the duller the intellect. The outer aura is subject to radical change brought about by mood or disease. Bagnall declares that no aura shines from any dead thing.

In studying the aura, the eye is first sensitized by gazing at the sky through a special dicyanin (blue) filter. The observer then sits with his back to the window. Feeble illumination is permitted to enter the room. The patient, naked, stands before a neutral screen.

According to Bagnall, auric light is ultraviolet and has definite wavelengths that lie beyond the visible spectrum (in the region extending from four hundred millimicrons to about three hundred and ten). Because blue and violet rays are seen better by the rods of the eye than by the cones, the blue filter tends to eliminate the longer red and orange rays of light and to emphasize the violet. Sensitizing of the eye can also be achieved by first gazing at areas of yellow paper which fatigue the retinal nerves to red and green and at the same time bring out a stronger response to blue.

In a fascinating theory, Bagnall credits nocturnal birds and animals with ultraviolet vision. Rod vision, so prevalent in animals, may add dimension to the sense of sight in many creatures, enabling them to see emanations invisible to the human eye.

In mankind, organic diseases seem to affect the inner aura. The emanating rays may lose their sparkle and appear dull or limpid.

Intellectual and nervous disorders, puberty, menstruation, seem to affect the outer aura. Bagnall says that the aura of a strong person will apparently flow into the aura of a weak person. While some therapeutic "healing" may be possible that way, he does not venture any bold assertions. In disease certain dark patches may appear, but more telling will be the general shape of the aura. An aura that falls away suddenly in the neighborhood of the thigh may indicate that a person suffers from nervous complaint. An outward bulge, away from the spine, is a typical sign of hysteria. Neurotics usually have a poor outer aura and a dull inner aura. Physical disturbances seem to affect brightness. Nervous conditions seem to affect the quality of color.

Bagnall diagnoses pregnancy as follows. The aura broadens and deepens over the breasts, there is a widening of the haze immediately below the navel, and a slight decrease in the clearness of the bluish color—a phenomenon that changes as pregnancy advances.

He believes that medicine and surgery may some day be served through further clinical study. These emanations apparently have profound significance. The aura of a Negro is likely to be brownish and coarse in texture. The aura of a new-born baby is slightly greenish. A clear blue is a good token of intelligence. After some investigation, Bagnall believes that this bluish color is as innate to an individual as any other inherited quality—and that it follows the laws of heredity!

THE LANGUAGE OF
THE SPECTRUM

Adam means red! Because civilization and culture find their best expression in language, it is interesting to discuss the development of vocabulary for the colors of the spectrum. There is less romance than one might expect, for root words are few and far between. Man has borrowed freely from nature, preferring to build identification upon likeness to other things. There are also plenty of enigmas. Words for green and blue, for example, are incredibly scarce in the Vedas, the Bible and the classics. That the ancients saw green and blue is evident in the art they have left behind; why they failed to have words for these colors is anyone's guess.

The Bible mentions the sky over four hundred times and yet never once calls attention to its blue color. The *Iliad* and the *Odyssey* are equally silent, and the Mediterranean sky is *ultramarine!* Thus, with noses buried in faded tomes, eminent men such as William Ewart Gladstone led themselves to believe that blue was not seen in the centuries before Christ! Elaborate theories were posited and, of course, duly upset.

The ambiguities and baffling omissions of the Bible are explained this way by the *Jewish Encyclopedia*. "Elementary colors are expressed by words denoting degrees of lightness and darkness; while non-elementary colors are identified by the names of objects from which they are derived. Moreover, one and the same word is used to denote not only several shades of one color, but even what are known as different colors; the context, or the object to which the color was applied, afforded the clue as to the particular color intended."

Biblical Hebrew did not contain a term to express the property of light known as hue. The terms *eye* and *appearance* were used instead. And the same odd habits prevailed in Sanskrit, Greek and Latin.

ROOT WORDS OF COLOR

Thus, not only in English but in all languages is there a paucity of color terms. There are very few root words whose meanings are confined to the spectrum. The primitives who developed the languages of men showed little inventiveness. The Universal Dictionary states, "Ancient color-words are very variable in meaning when distributed among the different tribes of Aryan speakers. Nothing as a rule is more

difficult than to ascertain the precise shade of color intended even in modern descriptions, unless there be comparison with some natural object whose color is more or less fixed, but even that may vary in different lights."

Though the English language boasts a vocabulary of a million words, a mere handful is all it gives to color alone. One of these is the word *color* itself, apparently an etymon or root derived from the Latin. The Old English term, however, was *hiw* from which came *hue,* a synonym for *color.* This derivation may possibly have followed the Gothic *hiwi,* which meant form, appearance or show; the Swedish *hy,* which meant skin or complexion; and the Sanskrit *chawi,* which referred to hide, skin, or color, and beauty in general. Apparently, the covering of a thing was its *chawi* or hue.

Regarding other general terms used in color, the word *value* is borrowed to describe the worth or substance of a hue. *Tint* comes from *tinct,* meaning color, or the Italian *tinta* which was commonly employed by the Renaissance painters. *Tone* is direct from the art of music. *Shade* is taken from shadow and until recent times referred only to colors having a somber or blackish quality. Today it is used to describe any variation in hue. Thus, to say "pastel shade" is good English, despite the fact that the "pastel" color is no child of shadow.

Now to play etymology with the rainbow.

The word *red* is perhaps the oldest, purest and most primitive of color terms. There is no question but that its original forms were meant to signify this particular hue of the spectrum and nothing else. The Sanskrit root is *rudhirá;* the Anglo-Saxon is *réad.* There is a corresponding term in every language. But for every fair etymon like red, there are a hundred borrowings from other fields: color terms that refer to flowers, fruits, precious stones, birds, and on and on. The word creators of early times seldom named a color for the sake of the color itself.

Yellow is derived from the Latin *helvus,* meaning light bay. The Sanskrit *hari* was a tawny or yellowish hue.

Blue in its present spelling was rare in English but became prevalent under French influence about 1700. The French *bleu* is itself a Germanic loan word, the base of which is cognate with the Latin *flavus,* meaning yellow or gold. One untenable guess is that *blue* descended from a Gothic word meaning

to beat, "the color caused by a blow." Some scholars trace *blue* to word roots meaning black.

Green is from the Anglo-Saxon *gréne* and probably is derived from the Old Teutonic root *grô* associated with the verb *grow* and hence of greenish and grassy things.

Purple is from the Latin *purpure,* the name of a shellfish from which the pigment was manufactured.

White is probably a primitive root or etymon. The Anglo-Saxon form was *hivit. Gray* is also primitive. *Black* is from the Greek, meaning burnt or scorched, and has replaced the Germanic *swart* in the English language. *Brown* was a term originally given to dark colors. Samuel Johnson's sole explanation of brown was "the name of a colour compounded of black and any other colour."

Many other color names in the English language have lost their original meanings and associations over the years, and are thus unknown to the average person. Here are a few of them. *Auburn* originally meant white. In the 17th century the word was written *abron, abrune, abroun,* and was similar to a word used to describe leather aprons. This probably encouraged the association of *auburn* with brown.

Beige is from the French, meaning raw. *Buff* is a term derived from buff leather and in turn from the buffalo. *Cerulean* is from the Latin, meaning dark blue, like the sky. *Crimson, carmine,* and *vermilion* are all taken from words associated with worms. The Sanskrit root of *crimson* is *krmija,* "produced by a worm." *Vermilion* is from the Latin *vermiculus,* meaning "little worm."

Ecru traces from crude and raw in Latin. *Russet* is an old French diminutive of *rous,* meaning red. It was once applied to a homespun woolen cloth of a reddish brown color worn by peasants. *Scarlet* is also Old French and probably once described a rich fabric that came from Persia or Arabia. *Tan* is associated with the bark of trees, an infusion of which was used in converting animal hides into leather.

LARCENY IN LANGUAGE

The foregoing lists exhaust those terms which do not arouse mental pictures of other things. Briefly, words like red, yellow, blue, vermilion, ecru, scarlet have become true entities in the language of color and are not

Color names derive from many curious sources. Here are a few. Adam meant red. Blue was a color "caused from a blow" Green meant to grow. Brown came from apron. Vermilion was from a worm, tan from bark. Other names came from gems, flowers, birds

likely to be confused with anything but colors. Yet how few they are when compared with the gleanings from other fields! From among precious stones and rare materials spring such color names as *amber, amethyst, azure* (from *lapis lazuli*), *carnelian, coral, crystal, emerald, ivory, jade, jasper, malachite, pearl, ruby, sapphire, topaz* and *turquoise*. From minerals and ores come terms like *brass, bronze, cadmium* (an element), *chrome, cobalt, copper, gold, gunmetal, nickel, ochre, old gold, rust, silver, slate, steel gray, sulphur yellow, terra cotta* and *viridian* (a chromic hydroxide). *Umber* is the hue of earth, but is possibly derived from a word meaning shadow.

There is almost no end of larceny from the colors of nature. Among flowers are *daffodil, fern, fuchsia, geranium, heliotrope, hyacinth, jasmine, leaf green, lavender, lilac, moss, mustard yellow, musk, old rose, orchid, pansy, pink, primrose, rose, sage green, straw, violet* and *wisteria*. The term *mauve* is from the French, the color of the common mallow. *Saffron* comes from the name of a flower whose stigmas and styles were used to make a deep orange-yellow dye.

From fruit and other foods, nuts and woods come the terms: *apple, apricot, cerise* (French for cherry), *cherry, chestnut, citron, cocoa, chocolate, coffee, eggplant, hazel, henna, indigo, lemon, lime, madder,* (a root), *mahogany, mandarin* (from the mandarin orange), *maple, maroon* (after the French *marron,* meaning chestnut), *olive, orange, peach, pimento, pistachio, plum, strawberry, tangerine* and *walnut*.

Salmon and *sepia* are derived from fish. Birds have provided *canary yellow, dove, peacock blue. Cardinal red* refers both to the bird and to the traditional robes of ecclesiasticism. *Fawn* is an animal color. *Taupe* means mole in French.

From wines and liqueurs come *burgundy, chartreuse, claret, wine* and several others. Named after peoples and places are *Chinese red, French blue, Indian red* and *orange, Delft blue, Prussian blue, Nile green* and *Sienna. Magenta* is a curiosity. This gaudy color was a new dyestuff named to commemorate a battle fought at Magenta, Italy, in 1859, in which the French and Sardinians were victorious over the Austrians.

Finally, some miscellaneous terms, each of which has an obvious connotation: *baby blue, baby pink, blood red, burnt orange, cream, dust, navy blue, sky blue* and *Vandyke brown*.

There are not many root words for color. Most of them derive from a direct likeness to familiar things. A few examples are shown here, but thousands more exist

The language of color is both unoriginal and inadequate. To clutter the vocabulary still further, modern stylists invent the most fantastic and ludicrous expressions: elephant's breath, glowworm, passion and thousands more. The world, however, continues to be entranced. Color is in man's blood though, like Robert Louis Stevenson, he is often at a loss to make sense out of the English language. "For a little work-room of my own . . . I should like to see some patterns of unglossy—well, I'll be hanged if I can describe this red—it's not Turkish and it's not Roman and it's not Indian, but it seems to partake of the two last, and yet it can't be either of them because it ought to be able to go with vermilion."

STUDIES OF LITERATURE

Color vision itself is still pretty much a mystery. This one sense has defied the scientist, and no theory today is close to having universal acceptance. Some sixty years ago, when science was beginning to formulate plausible theories of color vision, students of literature and the classics busied themselves with deductions of their own based on the records of literature. The studies of two eminent men are worthy of note: William Ewart Gladstone and Havelock Ellis.

Before his term as Prime Minister, Gladstone published a study of the Homeric poems in 1858 in which he elaborated a theory proposed before him by Hugo Magnus, and which was reprinted nineteen years later, when Gladstone was at the height of his political career, in more complete form in the October, 1877, issue of *The Nineteenth Century Magazine.*

Though Gladstone was no color expert, his knowledge of the classics was considerable. He supported Goethe's idea that color was a product of light and dark, and in analyzing the *Iliad* and *Odyssey,* he noted the scarcity of color terms and Homer's neglecting to name the most obvious colors. In the last eight books of the *Iliad,* for example, there were two hundred and eight light and color phrases. Of these, sixty-three concerned light in general, and twenty-three darkness. Whiteness and blackness were referred to twenty-six times each, and ten phrases related to gray. Of the remaining sixty color epithets, red, brown and purple were mentioned, but no blue or green!

In the last ten books of the *Odyssey,* color was less frequently mentioned. Here there

were one hundred thirty-two phrases, forty-nine concerning brightness, four concerning darkness, thirteen referring to whiteness and twenty-three to blackness. Twelve phrases described gray. Only thirty-one color references were found in five thousand lines. As in the *Iliad,* these described redness, brownness and, in a vague way, tones of red, brown and purple merging into black.

Gladstone was inspired to believe that the full color sense of modern man was comparatively late in developing. Primitive reaction was to hues of long wavelength, the red end of the spectrum. Green and blue were not seen until civilization had developed over the centuries. Of the color sense, Gladstone effusively wrote: "So full grown is it, that a child of three years in our nurseries knows, that is to say sees, more of color than the man who founded for the race the sublime office of the poet, and who built upon his own foundations an edifice so lofty, and so firm that it still towers unapproachably above the handiwork not only of common, but even of many uncommon men."

Gladstone, of course, was wrong, because the works of antiquity survive to prove that man saw all the colors of the spectrum and used them freely in his art forms.

Years after Gladstone, Havelock Ellis made similar inquiries, but was wise enough not to attempt to contradict modern scientific thought. Famous in English letters, he was also an eminent authority on literary records of color, who burrowed into the predilections of bards and playwrights to find out what had been in their hearts and minds. To some extent the poet's sensitive nature is a sounding-board for the rest of humanity. The poet speaks the emotions of all men, echoing what they feel within them just as he sings of his own inner self. Ellis tried to determine if any great, abiding laws ruled the pen. He observed, for example, that a poet was likely to be freer with color terms and epithets when young than when he was old. In the art of several imaginative writers, he was unable to prove that one hue was sacred above all others. Certain writers were attracted to certain colors. These might be red, yellow, white, blue, or even black. Cervantes was fond of green which he used for the eyes of Dulcinea and the raiment of most of his pet characters. Goethe also championed green.

Ellis recognized only simple color words, not such metaphorical terms as "sapphire," "emerald," "sable" and "argent." The one exception was "golden," the equivalent of yellow or orange. In a monograph published at London in 1931, Ellis recorded the frequency of mention for some seventeen colors in writings taken from twenty-five sources. In another, he summarized his entire findings, grouping colors into six classifications—white, yellow, red, green, blue, black—and working them out on a percentage basis. He then appended notes on the "colors of predilection," and the "predominant colors" found in the writings.

The first reference in Ellis' book, *The Colour-Sense in Literature,* is to a report on the "Mountain Chant of the Navajo Indians," written by Dr. Washington Matthews of the U.S. Bureau of Ethnology. Color is used freely and symbolically, with black used most. In *The Wooing of Emer,* an Irish tale from the sixth century, red and white are predominant, with fewer references to black, purple, gray and yellow. Blue is absent. In the *Volsunga Saga,* red predominates with ten mentions, as against two each for blue, brown, white and gray.

In Isaiah, Job and The Song of Songs, blue is not mentioned at all. Green ranks first, followed by white, red, black, scarlet, crimson, purple, golden and brown. The reds grouped together fail to surpass green.

In the first three books of Homer's *Iliad,* black checkers the lines because of the persistent mention of "black ships." Catullus was not attracted to black. Chaucer liked yellow hair. His most frequently mentioned colors were white, red and green. Marlowe employed his epithets with more alacrity in youth than in maturity. Black, yellow, white and purple were his favorites.

Studying the *Sonnets* as Shakespeare's most personal utterances, Ellis found abundant black and yellow. In general, however, the Bard of Avon was fascinated by red, white and black, with red his consuming joy. Of his literary habits Ellis wrote: "Shakespeare's use of color is very extravagant, symbolic, often contradictory. He plays with color, lays it on to an impossible thickness, uses it in utterly unreal senses to describe spiritual facts. Colors seem to become colorless algebraic formulae in his hands. It may be safely said that no great poet ever used the colors of the world so disdainfully, making them the playthings of a mighty imagination, only valuing them

for the emphasis they may give to the shape of his inner vision."

James Thomson, the Scottish poet, was content with a lean vocabulary of color terms, showing a slight preference for black, green and brown.

William Blake, great artist and mystic, used numerous black epithets. White, golden and green appear about equally in his poems. Why did he give so little expression to red? Strange for one who was a mystic.

Coleridge had a repugnance for black, although he used it often. Green, white, blue and red were his preferences. He is the only poet who used as many as sixteen out of the seventeen colors studied by Ellis.

Percy Bysshe Shelley's love of color developed as he did. Ellis remarks that he was a visual type and saw the world more than he felt or heard it. "Everywhere he sees color, fused with light and in perpetual movement."

John Keats, on the contrary, had sensitive ears. Green was his preferred color, called by its simple name. Ellis wrote, "His color-words are not epithets of colors he has seen; they are words that have appealed to his ear, that he found in books and brooded over, vague, exotic color-words that no one would think of using in the presence of actual color."

William Wordsworth mentioned green twice as frequently as any other color.

Edgar Allan Poe had perhaps the most mystical of vocabularies—just as the man himself was strange and abstruse. Of all the writers listed by Ellis, he is the only one who used yellow (and golden) in excess. Such preference often goes with disturbed minds and is to be noted also with Vincent Van Gogh, the painter.

Charles Baudelaire used black and loved it.

Alfred Tennyson had a lighter and brighter feeling for color, a fondness for rich deep colors for "amber" and for associations with fruits and flowers. Tennyson's heroines did not have "golden" curls; they were brunettes with dark tresses.

Dante Gabriel Rossetti, also a painter and leader of the Pre-Raphaelite school, had a knack for color epithets. He liked white, yellow, red and gray. Ellis wrote: "He shows as fine a sense of the value of color in poetry as in painting, perhaps a finer sense. He uses the simplest and clearest color-words, like

The Whirlwind of Lovers, by William Blake

all the writers who have really seen color, and he uses them rarely and strongly."

Algernon Swinburne's palette was more restricted. Red and white were his fairest colors.

Walt Whitman's style was impulsive. He abhorred the poetic "golden" and preferred white, red, green and brown.

In his *Marius the Epicurean,* Walter Pater returned to classical ideals. His liking for white and yellow follows the preferences of Catullus and reflects the age in which he was interested.

Paul Verlaine, the French symbolist poet, was a lover of mist, twilight and moonlight. He most frequently mentions white, black, blue, golden, red, gray and green. He was partial to gray.

In Olive Schreiner's *Dreams,* white predominates.

Gabrielle D'Annunzio's passion was for red—vermilion red.

Ellis has summarized his data. White and black are the most frequently mentioned colors. Red is next, followed by green, blue and yellow. More telling, however, are the "colors of predilection." Here red stands in the lead, as one might expect. But yellow (and golden) are second and ahead of blue! Blue is tied for third with white and black. Purple is fourth, brown and violet fifth, and pink sixth and last.

It is fascinating to note the impact of color on language and man's efforts to con-

vey his feelings. Do these erudite men of letters respond like the rest of mankind?

COLOR AND COLLOQUIAL SPEECH

Beyond a fastidious language for color is also a vulgar one. Man can summon metaphors, similes and colloquialisms by the score. The colors of the spectrum have robust traditions, personality and virility. Through them man can bedaub his sentences, curses and blessings with the gaudiness he desires.

Red is one of his most vivid hues. Jakob Boeme writes, "It is manifest in the anguish and strife of being—in the alternation of the revolving wheel of life. It may become heavenly rapture or hellish torment. Its influence is dominant in sulphur, in the planet Mars, in war, in dogs. It produces red colors and reigns in choleric temperaments." Red is the passionate and ardent hue, marking the saint and the prostitute, patriotism and anarchy, love and hatred, compassion and war. All great emotions, all extremes, heroic or vile, seem akin to red. It is the symbol of courage, bloodshed, cruelty, martyrdom, justice, health and danger—fervid all.

Man must paint the town red, for no other hue could possibly do for a wild and ribald time. The phrase is American in origin (1890). Man pours liquor down the red lane of his throat. He sees red, like the infuriated bull, and waves the red flannel of his tongue in loud vituperation. The red lamp is a brothel, the scarlet woman a prostitute and the red-neck a Catholic. A man's newspaper is filled with red-hot news. When he is broke, he is in the red (the bookkeeper started the practice). Since 1840 his life has been plagued by red tape. Since 1892 he has seen politicians draw red herrings across the path, and has heard them shout about reds and radicals in order to dodge their own corruption. He speaks of pink tea parties, red-letter days, red caps and red heads. The bum hasn't a red cent to his name. The communist is a red. Yet, dejected and glum, he gazes through rose-colored glasses for a blissful if untrue glimpse of life.

Yellow man despises. Not once does he use it with joy or generosity in his heart. Without knowing that yellow once marked the heathen, he refers to any scoundrel as a yellow dog and to any coward as having a yellow streak. His yellow journalism sprang up in 1896 when the New York *World* ran

Yellow was a token of persecution among Jews by Hitler. The yellow badge shown here was courageously worn by Dutch gentiles during World War II. "Jew and non-Jew are one in their struggle." Courtesy, the Jewish Museum, New York

a picture of a child—the yellow kid—in a yellow dress as a printing experiment. In 1898 a newspaper head cried, "The YELLOW PRESS IS FOR WAR WITH SPAIN AT ALL COSTS." Thus, sensationalism became yellow journalism. And William Randolph Hearst was bedaubed worst of all. The *Times* of 1906 wrote, "The President of the United States sent his Secretary of State to New York to throw the whole weight of Mr. Theodore Roosevelt's . . . authority and influence against the 'yellow' candidate."

Green is made the demon of jealousy. In England the green goose is a harlot. Greenbacks are paper currency. The greener is an inexperienced worker, the greenhorn a dolt fresh from the country. Green lacks importunate, holy or profane qualities, and

Cartoon of the Yellow Kid, 1896, the New York World. This experiment in printing gave rise to the term, yellow journalism

thus does not compare with the rest of the spectrum as a source of slang.

Blue, however, is indispensable. No literary genius has yet lived who could surpass the simple statement, "I feel blue!" What is its derivation? The allusion to blue as synonymous with dejection and despair is almost as old as the English language itself. Back in 1550, a poet wrote, "Then answerit Meg full blew." In 1660, "It made the sunne looke blue." In 1682, "But when he cam to't, the poor Lad look't Blew." Later, to have the blue devils was to be insane, and this shortened to blues as a token of mental depression. In the blue meant to be mentally astray. The idea has struck man's fancy. Blue looks moribund and glum. Blue music is mournful.

From the blues came blue ruin for gin (1820), blue gloom for the reformer, blue laws (said to have been bound in blue covers), blue funk for hysteria and panic and blue Monday for the first day of school. To yell blue murder was popular in 1874, and to curse the air blue (1870) still survives.

The blue apron was a tradesman, the blue gown a prostitute and blue skin a Presbyterian. True blue referred to the integrity of the sky. A bolt from the blue expressed the suddenness of lightning. Once in a blue moon was apparently the invention of a Miss Braddon, who in 1869 wrote, "A fruit party once in a blue moon."

The blue blood is one who claims eminent ancestry, whose blood is therefore not vulgar and red like the blood of the mob. The bluestocking is a person of cultivated intellect, but without much compassion for his neighbors. The word dates back to 1790 in England when a number of dilettantes organized to discuss literature rather than play cards. A few, or all of them, wore blue stockings.

Purple expresses rage, regality or priggishness. The Mauve Decade tells of an era when people were neither red nor blue but a combination of both—purple. A purple time (1894) expressed the Englishman's conception of a happy affair. The garden violet was an onion.

In 1832 Dickens wrote in *Pickwick Papers,* "He'll come out done so exceeding' brown that his friends won't know him." To do a person brown thus became the verbal token of a genteel swindle. Brown talk meant very proper conversation in 1700.

Black has many of the connotations of

Chinese dancers. Colors were symbolic of human virtues and vices—like blond curls for heroines and black mustaches for villains in Victorian melodramas

blue—a black look, black despair, black conscience. Like blue, it speaks for itself. The word blackguard dates back to 1730 when black was worn by servants, camp followers and runagates in general. The black sheep was the disgrace of his family. To blackball a man was to put him out of favor through slander. Blackmail was blackmail—how else to describe it? Blacklist was used by Milton in the 17th century. The black army was the female underworld. Black art was burglary in the 18th century and a mortician's work in the 19th. A black Maria was a patrol wagon, then a coffin. A black box was a lawyer, a black coat a clergyman and a blackleg a scab laborer. In the 17th century men blushed like black dogs. And in the 20th century, when they find themselves "out in the cold", they are in the black books.

White is associated with the Aryan race; its members, vain as they are, naturally assume that no other hue is quite so honorable. To say that a man is white all the way through—or just white—is an Americanism dating back to 1877. Then the white man was contrasting his noble humanity to the inhumanity of the Indian and Negro, the red man and the black man. The white-haired boy, however, is Irish and the pride of his family. To show the white feather or to wave the white flag is to surrender or "back out" of a mess. As a symbol of peace, white is supposed to soften the heart of the conqueror and make him merciful.

Color has fed the language of man a protein diet. If man's jargon lacks the graciousness of his literature, it is no less succinct—and much handier in his clumsy effort to express himself.

Chapter 12

THE HARMONY OF MUSIC AND COLOR

Music has an emotional quality akin to the appeal of color. In the arts of painting, sculpture, architecture and dance, form is vital, and intellectual interpretation is required. Beauty lies in a careful blending of many elements: design, proportion and movement, all of which please or displease insofar as they suggest harmonious coordination. But music and color require virtually no effort to be enjoyed; they have a primitive charm and flow readily over the dikes of the brain to innundate the emotions.

The similarity between color and music has been noted by many musicians and artists. Some composers have, in an abstract way, tried to ally the two arts. Others have deliberately tried to make color a definite part of music, to assign scales to it and to "play" it as one might an organ. Still others have looked on color as an independent art, devoid of sound, but none the less "melodious."

Terms from the two arts have been borrowed and exchanged. A. B. Klein, in his remarkable book, *Colour-Music, The Art of Light*, writes, "Musicians have appropriated the word *color* principally to describe the sensuous charm of their art." Hue is used to denote the shifts in effect that followed various changes in timbre. The *Standard Dictionary*, for example, gives tone color as a synonym for *timbre*. In truth, timbre in music, aside from what are called *intensity* and *pitch*, is easily asociated with hue. For color has *timbre*, fullness, delicacy, volume and softness.

SYNESTHESIA

In the history of music one finds many instances of what is called synesthesia or color hearing. Its experience seems to be inborn. Many persons associate certain colors with certain sounds. Why, no one seems to know. Such associations, inherent in the individual's psychic make-up, apparently have little to do with memory or experience. A child who "sees" red in a certain musical note is likely to do so throughout his life.

Synesthesia has been responsible for many odd opinions. In a Boston Symphony Orchestra program some years ago, Philip Hale commented on a few of the color associations of musicians. He told that Raff held the tone of the flute to be intensely sky-blue. The oboe was clear yellow, the trumpet scarlet, the flageolet deep gray. The trombone

was purplish to brownish, the horn greenish to brownish, and the bassoon a grayish black. He remarked that A major was green to one musician and that another felt the color of the flute to be red rather than blue. In 1890 a woman was found to whom the music of Mozart was blue, that of Chopin yellow, and that of Wagner a luminous atmosphere with changing colors. To another, *Aida* and *Tannhauser* were blue, while the *Flying Dutchman* was misty green.

The alliance of color with various instruments is often encountered. Christopher Ward wrote, "From the faintest murmur of pearl-gray, through the fluttering of blue, the oboe note of violet, the cool, clear woodwind of green, the mellow piping of yellow, the bass of brown, the bugle-call of scarlet, the sounding brass of orange, the colors are music." Goethe records that to one of his friends, the violoncello was indigo, the violin ultramarine, the oboe rose, the clarinet yellow, the horn purple, the trumpet red and the flageolet violet.

Speculating on the general character of songs, E. G. Lind, a Baltimore music critic, thought *Yankee Doodle* and *Dixie* to be decidedly American—red, white and blue throughout. *God Save the King* was typically English in "look" as well as sound. In *Auld Lang Syne* he detected a strong resemblance to plaid! However, of *St. Patrick's Day* and *The Wearing of the Green,* he said, "Our prejudices in favor of green are ridden over roughshod by the prominent, and so more powerful, orange color, a most unexpected and unlooked-for result."

Franz Liszt is credited with a number of pet phrases: "More pink here, if you please. That is too black. I want it all azure." Beethoven is said to have called B minor the black key. Schubert likened E minor "unto a maiden robed in white with a rose-red bow on her breast." One Russian composer said, "Rimsky-Korsakoff and many of us in Russia have felt the connection between colors and sonorities. Surely for everybody sunlight is C major and cold colors are minors. And F♯ is decidedly strawberry red!" Of his subtle compositions, Debussy wrote: "I realize that music is very delicate, and it takes, therefore, the soul at its softest fluttering to catch these violet rays of emotion."

Klein believes that the idea of true orchestral "tone-color" was perhaps not well understood until the time of Wagner. Wag-

Score of Scriabin's Prometheus. A part for color organ is included at the top and is called Luce

ner frequently had color in mind and drew musical pictures with it. He wrote to Frau Willie, "I am differently organized from other men. I must have beauty, color, light." In speaking of Auber, Wagner said: "Even as the subject lacked nothing of either the utmost terror or the utmost tenderness, so Auber made his music reproduce each contrast, every blend in contours and colors of so drastic, so vivid a distinctness, as we cannot remember to have ever seen before. We might almost fancy we had actual music-paintings before us, and the idea of the picturesque in music might easily have found substantiation here."

About one of his own compositions, Wag-

ner said: "Here the trumpets and kettle-drums, which for two bars long have filled the whole with splendor, pause suddenly for close upon two bars, then re-enter for one bar, and cease again for another. Owing to the character of these instruments, the hearer's attention is inevitably diverted to this color-incident, inexplicable on purely musical grounds, and therewith is distracted from the main affair, the melodic progress of the basses." In Part II of his *Opera and Drama,* Wagner wrote: "To music alone was it reserved to represent this stuff to the senses also, namely, by an outwardly perceptible motion; albeit merely in this wise, that she resolved it altogether into moments of feeling, into blends of color without drawing, expiring in the tinted waves of harmony in like fashion as the dying sun dissolves from out the actuality of life."

Much of Wagner's music was color translated into sound. His "fire" music, for example, was meant to interpret the crackling and flickering of flames. In one of his overtures he used different hues to mark his score: red for strings, green for woodwinds, black for brass. Yet Wagner apparently refused to recognize synesthesia as a part of his own make-up. He wrote: "I have met intelligent people with no sense at all of music, and for whom tone forms had no expression, who tried to interpret them by analogy with color impressions; but never have I met a musical person to whom sounds conveyed colors, excepting by a figure of speech."

COLOR MUSIC

Alexander Scriabin was one composer, however, who devoutly allied color with sound, and who actually prepared scores with a color accompaniment. His sense of color-hearing was unquestionably vital and real. Writing of this strange faculty, Dr. C. S. Myers, a psychologist who talked with Scriabin, said: "Scriabin's attention was first seriously drawn to his colored hearing owing to an experience at a concert in Paris, where, sitting next to his fellow countryman and composer Rimsky-Korsakoff, he remarked that the piece to which they were listening (in D major) seemed to him yellow; whereupon his neighbor replied that to him, too, the color seemed golden. Scriabin has since compared with his compatriot and with other musicians the color effects of other

keys, especially B, C major, and F♯ major, and believes a general agreement to exist in this respect. He admits, however, that whereas to him the key of F♯ major appears violet, to Rimsky-Korsakoff it appears green; but this derivation he attributes to an accidental association with the color of leaves and grass arising from the frequent use of this key for pastoral music. He also allows that there is some disagreement as to the color effect of the key of G major. Nevertheless, as is so universally the case with the subjects of synesthesia, he believes that the particular colors which he obtains must be shared by all endowed with colored hearing."[14]

A natural mystic, Scriabin devoted much time to color-music analogies. In writing *Prometheus*, he adopted a unique color scale which, according to Klein, "has no order from the spectroscopic point of view if written in the order of the chromatic scale, but which assumes an approximately spectral order if we commence with the note C and proceed in the 'circle of fifths.' "

C	Red
G	Rosy orange
D	Yellow
A	Green
E♭⎰	Pearly blue,
B♯⎱	The shimmer of moonshine
F♯	Bright blue
D♭	Violet
A♭	Purple
E♭⎰	Steely with the
B♭⎱	glint of metal
F	Dark red

Prometheus, the Poem of Fire, was originally played in Moscow and Petrograd. It was the first musical score ever written to include a part for the color-organ. This part, called *Luce,* headed the page and was written to blend the hues of his color scale with the concords of the music itself. Later, the music was presented in America. The performance took place in darkness, and as the orchestra played, colored lights were thrown upon a screen. But the critics were not pleased. One wrote: "It is not likely that Scriabin's experiment will be repeated by other composers."

Color hearing is rare. Those who experience it usually do so in a highly individual way. Scriabin's scale was founded on mental and emotional associations unique to his own character. If music and color are to

have fixed analogies, they must be based on the reactions of the many rather than the personal notions of the few.

For centuries men have also sought to ally music with color scientifically. Newton wrote: "Considering the lastingness of the emotions excited in the bottom of the eye by light, are they not of a vibratory nature? Do not the most refrangible rays excite the shortest vibrations—the least refrangible the largest? May not the harmony and discord of colors arise from the proportions of the vibrations propagated through the fibers of the optic nerve into the brain, as the harmony and discord of sounds arise from the proportions of the vibrations of the air?" Newton himself chose seven primary colors and related them to the musical scale. Note C was red; D was orange; E was yellow; F was green; G was blue; A was indigo; B was violet.

Even before Newton, of course, the mystic number seven had been dominant in philosophy, in color and music. Astronomers had written of the Music of the Spheres. The seven planets were said to emit sounds as they revolved in their orbits. Plato and Aristotle dealt with the fancy, as did Cicero, Pliny and others. The following list was prepared in modern times by Alan Leo, but the color designations of the music scale are Newton's. The colors of the planets are arbitrarily chosen.

Planet	Color	Sound
Mars	red	C-do
Sun	orange	D-re
Mercury	yellow	E-mi
Saturn	green	F-fa
Venus	blue	G-so
Jupiter	indigo	A-la
Moon	violet	B-ti

COLOR ORGANS

The real father of color-music was Louis Bertrand Castel (1688–1757), a Jesuit, eminent in mathematics, philosophy and aesthetics. In 1720 he published his *La Musique en Couleurs,* where he wrote: "Can anyone imagine anything in the arts that would surpass the visible rendering of sound, which would enable the eyes to partake of all the pleasures which music gives to the ears?" The English promptly made him a Fellow of the Royal Society.

His first attempt at such an art was pure theory. Later, however, he constructed his "Clavessin Oculaire." While no good description remains of it, Castel apparently worked with prisms and later with transparent tapes. The instrument stood in a dark room. Light came through a window and illuminated his specially prepared film. About his "Clavessin" he said: "It is a series of stretched chords which conform in their length and their thickness to a certain harmonic proportion, which enables them to produce with the help of a little tongue which plucks them, all the various sounds and chords of music. Now colors follow the same harmonic proportions; therefore, take as many as you need to make a complete clavessin, and dispose them in such manner that by applying the fingers to certain keys, they shall appear in the same order and in the same combination as the tones corresponding to these keys."

In Castel's scale: C was blue; C♯ was blue-green; D was green; D♯ was yellow-green; E was yellow; F was yellow-orange; F♯ was orange; G was red; G♯ was crimson; A was violet; A♯ was pale violet; B was indigo. When his instrument was completed, he wrote: "All that visible objects have of magnificence and brilliance can be turned to the profit of the new clavessin. It is susceptible to all manner of embellishments Let all Paris have color clavessins up to 800,000!"

In a pamphlet, *Colour-Music,* published

Illustration from one of the earliest known works on color-music, 1740, by the father of the color organ, Louis Bertrand Castel (1688-1757)

Castel used this illustration to reconcile Newton's discoveries with old theories of color as a product of black and white

in 1844 D. D. Jameson described an instrument for playing color-music. The keys of a pianoforte were specially prepared with stains or bits of colored paper. Corresponding swatches were then pasted to the musical score. This not only enabled a person to read music easily, but to see it in terms of color and to have the colors themselves appear. His instrument had keys connected with a series of twelve round apertures in a chamber holding glass globes filled with translucent liquids. Artificial light sources provided controlled illumination. When the keys of the instrument were struck, colors were evolved. "The factors of music and colorific exhibition being thus correlatively fixed, the performance of the one is attended with the other; which has an enchanting effect."

Jameson's methods were more logical than Castel's and he was perhaps first to think of clear, transmitted light. Yet the limitations of artificial illumination were so great that one doubts if his color effects were as enchanting as he claimed.

George Field, one of the strangest, most paradoxical figures in the story of color, developed virtually all of his theories of color in terms of music. In his book, *Chromatics,* he wrote (1845): "As the acuteness, tone, and gravity of musical notes blend or run into each other through an infinite series in the musical scale, imparting *melody* to musical composition, so do the like infinite sequences of the tints, hues, and shades of colors impart mellowness, or melody, to colors and coloring. Upon these gradations and successions depend the sweetest effects of colors in nature and painting, so analogous to the melody of musical sounds, that we have not hesitated to call them *the melody of colors.*" Field, however, was a colorist and not a musician at heart. He did not construct a color-organ and was satisfied to talk about the whole idea rather than put it into practice. In his color scale C was blue; D was violet; E was red; F was orange; G was yellow; A was yellow-green; and B was green.

Little was done after Field until the birth and rise of A. Wallace Rimington, one of the greatest exponents of color-music. His color-organ, developed about 1893, was designed for a joint symphony of music and color. As Klein writes, "All Rimington's early researches were directed towards determining whether there was any natural relationship between sound-music and colors." Rimington's "music" became the rage of London. The instrument he used was elaborately contrived of lights and filters. The keyboard was similar to the console of an organ. His scale was as follows: C was deep red; C♯ was crimson; D was orange-crimson; D♯ was orange; E was yellow; F was yellow-green; F♯ was green; G was bluish-green; G♯ was blue-green; A was indigo; A♯ was deep blue; and B was violet. As the best of compositions were played, he projected abstract forms which flowed into each other on a screen.

In America Bainbridge Bishop (1877) built an instrument atop a house organ, and with it blended colors on a small screen. These colors were controlled from a keyboard, and both daylight and artificial light were employed. P. T. Barnum had one installed in his home at Bridgeport, Connecticut.

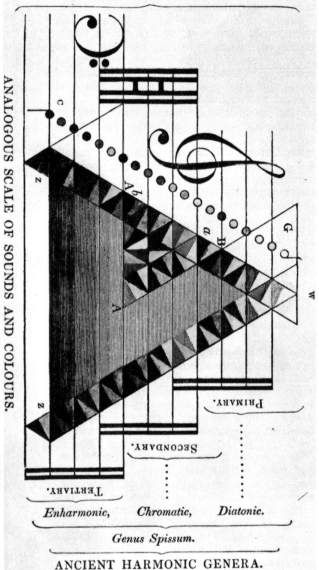

EXAMPLE XXIII.

MODERN DIATONIC.

ANALOGOUS SCALE OF SOUNDS AND COLOURS.

PRIMARY.

SECONDARY.

TERTIARY.

Enharmonic, *Chromatic,* *Diatonic.*

Genus Spissum.

ANCIENT HARMONIC GENERA.

George Field (1845) created this diagram to relate colors to the music scale. He wrote of the melody of colors

VanDeering Perrine, an American painter, developed two similar gadgets. One used hydraulic pistons to blend liquids in a tank; the other had colors painted on tissues in various blends, these concords being projected in an aperture.

In Australia Alexander Hector gave concerts with an instrument made of incandescent lamps, Geissler and X-ray tubes. Like Rimington, his color projections were accompanied by music. In some of his compositions, he used this scale: C was yellow; C♯ was yellow-green; D was green; D♯ was blue-green; E was blue; F was indigo; F♯ was blue-violet; G was violet; G♯ was red-violet; A was red; A♯ was red-orange; and B was orange.

About 1900 E. G. Lind of Baltimore wrote some glowing notes on color-music. He translated national songs into colored diagrams, and worked out a mathematical scale in which he compared the vibrations of sounds with the vibrations of colors, each figure being divisible by the magical number seven. His designations had the same order as Newton's.

The American Taylor System of color harmony, a color-music analogy, has a scale in which D is red; C♯ is red-orange; D is orange; D♯ is orange-yellow; E is yellow; F is yellow-green; F♯ is green; G is blue-green; G♯ is blue; A is blue-violet; A♯ is violet; and B is violet-red.

AN INDEPENDENT ART

In more recent years three persons have ably carried on the traditions of color-music. One is Mrs. Mary Hallock-Greenewalt, a pianist who constructed and patented a color-organ, and won a Gold Medal for it at the Sesqui-Centennial International Exposition at Philadelphia in 1926. Her instrument has a series of lights, controlled by rheostats, which throw colors upon a background. "It is made to stand in the orchestra pit, with the player under the control of the conductor. The instrument is capable of giving forth a light scale conforming with a musical scale." Her theory about the relationship of color and sound is best expressed in her own words: "Light and color are two entirely separate, distinct, and different things. Light and color can speak as an art alone, as an art of abstract expression made in time succession, but, since the nature of light is that of an accompaniment to all happenings, it will, for some time, in great part be used as such."

A. B. Klein, to whose *Colour-Music* we have referred so extensively, has also constructed color-organs and devised principles and theories of color-music. He has written numerous musical compositions. As to his choice of colors, he says, "This provides a scale of wave lengths whose ratios may be compared directly to the twelve equally-spaced intervals of the chromatic scale." That scale is as follows: C is dark red; C♯ is red; D is red-orange; D♯ is orange; E is yellow; F is yellow-green; F♯ is green; G is blue-green; G♯ is blue; A is blue-violet; A♯ is violet; and B is dark violet.

Klein's scales of octaves form a beautiful color chart. One scale is "saturated," and extends from rich shades through pure hues into clear tints. The other scale is "desaturated," and consists of delicate grayish tones running from dark to light. Klein believes that the color art should develop independently and rise on foundations of its own.

Perhaps the highest art of color-music has been achieved by Thomas Wilfred of the United States. His famous "Clavilux" has become synonymous with the general conception of a color-organ. Comprised of spot and flood lights, rheostats, screens and filters, and prisms, all under control of an elaborate console, it is capable of remarkable effects. Wilfred has given concerts in various parts of the world. His art is somewhat independent of sound, although music is frequently used in conjunction with it. Describing his harmonies, Wilfred says: "The even color which floods the screen is called the accompaniment. In the center of this is the 'solo' figure. This figure may be square, it may be circular, it may be a combination of various figures, as, say, a combination of pyramids, which will turn, and twist, and stretch upwards like arms. The solo figure is always opening and closing, approaching and withdrawing. I have no pet color. The whole spectrum is my favorite. No special color has an especial meaning. Green is generally considered a restful color, but green has a thousand qualities. It may be stirring rather than restful. Blue may mean one thing when applied to a square and another thing when applied to a circle. The key of C major has no especial meaning, but can be made to mean anything that one wishes to make it mean." Wilfred calls this form of expression Lumia, or the Art of Light.

Illustrations on these pages offer a static

From Thomas Wilfred's Spiral Etude, Opus 59. He endeavored to create a new form of art expression. This he called Lumis, the Art of Light

portrayal of these mobile forms. In reality, they move and appear to float in tri-dimensional space, shifting gradually or suddenly in hue and brightness. One has new and exciting visual experiences.

In the field of motion pictures, credit must also be reserved for Mary Ellen Bute of New York. "Stills" from some of her work are shown. As one critic writes of her work, "Abstract photography begins where realistic photography leaves off . . . the abstract film has no relation to life but only to emotions." Miss Bute is a "purist" because she avoids figures or natural forms. She is completely non-objective, and though music accompanies her animations, there is harmony of spirit only. The images, forms and movement evoked by the sound of music has led Miss Bute to a most unusual, dramatic and exciting art form. She uses a host of techniques—all under the control of an artist—to achieve her ends. These may consist of such movie devices as stop-motion, skip frames, cuts, dissolves, zooms and the like. They may be created by combining hand drawings with photographs; colors produced by optical devices and prisms; the animated cartoon method; electronically generated figures such as are seen on an oscilloscope, in which sound vibrations are converted to rhythmic lines and patterns. The final effect has a free-flowing beauty, rich in color and dynamic in abstract action.

Frame from a non-objective motion picture by Mary Ellen Bute, Mood Contrasts. Harmony is sought between the spirit of color and music

Mobile color involves a time element, a beginning, a duration and an end. In this it differs from a static canvas. The art form has tremendous potential, but it is not easy to do for it takes a few dozen motion picture frames to fill a mere second of time.

Colors may be associated with the sound qualities of the human voice. E. G. Lind writes: "We have still another instance of colored sound recorded by a physician . . . who declares he can distinctly see the colors of sounds emitted by the human voice. He says they are red and blue, black, tan, slate, and all other colors, and that the color of some handsome women's voices is like buttermilk; not a very poetic tint but near enough to suggest milk and honey."

In a special article Cyril Scott of England has given the phenomenon an occult twist. "Every musical composition produces a thought and color form in the astral space, and, according to that, form and color is to be gauged the spiritual value of the composition under review. If the preponderating colors be lilac, violet, blue, pink, yellow, and apple-green combined with a form of lofty structure and vastness, then the work is one of intrinsic spiritual value; if, however, the preponderating colors be muddy browns, greys, cloudy reds, etc., then the work may be recognized at once to be one of a lower order. This method of gauging the spiritual value of art, however, is only possible to him who has awakened the latent faculties of the pineal gland and pituitary body." Scott apparently credits the man endowed with synesthesia with the ability to see auras above the orchestra pit.

Color hearing has been rather exhaustively treated in a monograph by Theodore F. Karwoski and Henry S. Odbert, *Color-Music.* According to them, while synesthesia may not be consistent from one person to another, general reactions to musical phrases are quite uniform. In a study of one hundred and forty-eight college students, thirty-nine per cent were able to "*see*" a color or colors, fifty-three per cent were able to *associate* a color and thirty-one per cent *felt* a color response. At least sixty per cent gave some kind of color response when they heard music. "It seems safe to say that a good majority of the population in one way or another relates colors to music." Karwoski and Odbert found that slow music was generally associated with blue; fast music with red; high notes with light colors; deep notes with dark colors; and that patterns as well as hues were involved.

Further investigation of this sort may lead to new dimensions for an independent art of color-music. In describing forms, Karwoski and Odbert make an unusual reference to time and space conceptions, which seem to have real logic to them. "The horizontal dimension might be related to the development of music in time; the vertical dimension to changes in pitch. A third dimension of depth may eventually be available to denote volume or intensity." Surely, most people who have given thought to correlation of music, form and color will sympathize with this conclusion.

Diagram used by Karwoski and Odbert to illustrate general nature of color, form and sound associations. There may be simple color response to a musical selection, or color ' may reach complex stages involving patterns as we'

Chapter 13

COLOR IN THE ART OF PAINTING

The photographs in this chapter have been provided through the courtesy of the Metropolitan Museum of Art and the Collection Museum of Modern Art. For detailed list of all picture credits in this book, see end of volume

Art came from Egypt, Greece, Rome, Persia and China, where major emphasis was on delineation of line. Although clear expression of form was at times indicated, there was seldom any attempt to show the realistic appearance of things. Consequently, little attention was paid to variations of light and dark in modeling an object. Arthur Pope, in *The Painter's Modes of Expression*, states that Chinese writers defended this attitude on the ground that highlight and shadow were accidental, an irrelevant condition apart from the object itself. Where intermediate tones were added to simple delineation, they often served purely decorative ends.

In his *Natural History*, Pliny wrote of the ancient Greek painters: "It was with four colors only, that Apelles, Echion, Melanthius, and Nichomachus, those most illustrious painters, executed their immortal works; melinim for the white, attic sil for the yellow, Pontic sinopsis for the red, and aramentum for the black." Palettes as simple as this became the heritage of art and survived through the centuries up to the Renaissance.

RENAISSANCE ARTISTS

Then, suddenly, the art of painting was imbued with a new feeling of light and shade, a flare for naturalism and painting as men know it today was born.

Whether or not Hubert and Jan van Eyck may be credited with the invention of oil painting in the early part of the 15th century, they were certainly pioneers and masters in the medium. Oil pigments were flexible and easily manipulated. By their very nature they suggested subtleties of light and shade, and made possible the great art that flourished during the Renaissance.

Arthur Pope, in *The Painter's Terms*, has described many of the techniques and palettes that marked the beginnings of oil painting. A combination of red, yellow and black was common. Because mixtures of these hues gave predominantly warm tones, the artists, by careful adjustments of the areas on their canvases, were able to imply touches of green, blue and violet. These colors were seen more or less as optical illusions, their coolness heightened by juxtaposition with large areas of warm tones.

In simpler drawings, two colors would often be employed. Such combinations

might consist of a brownish and a bluish pigment. Pope writes: "The limited palette, which conditioned an abstract rendering of color relations, was used constantly during the later Renaissance, from the sixteenth to the end of the eighteenth century, and in many paintings also of the nineteenth century This palette meant a very decided harmony of color and intensity in the painting as a whole, and the resulting tonality usually fitted in very well with the general decorative schemes of the rooms in the houses and palaces of the later Renaissance. More extended ranges were also used, with positive greens and blues; usually, however, these were not very intense, and violets and blue-violets were ordinarily left out entirely, so that the range of colors and intensities was always fairly limited. Pictorial color was based for the most part on a harmony of orange or orange-yellow tonality."

Very often the artist worked with a sizable number of mixed tones derived from a few basic pigments. These fixed palettes would be arranged in values of a series of hues: red, yellow, blue and black. Frequently, the canvas would be handled as two separate fields, one palette used for the foreground and another for background. Glazes were also used. The Venetians followed a system of opaque underpainting, using the simplest of colors and neutrals, and then building up form, light and shade through subsequent transparent layers of clear yellow and clear red.

A 15th century Italian writer, Cennino Cennini, has left a record of the early painter's methods. He ground his own pigments, which he kept in little jars. A variety of tones was mixed beforehand. Over a carefully prepared drawing he successively laid down his shades, then his half tones, and finally his highlights. His education began in boyhood, and he served at least ten years of apprenticeship studying fresco, tempera and oil. He was learned in anatomy and perspective, manufactured his own pigments, and prepared his own panels.

Italy was dominated by a love of sculpture, particularly that of Donatello. Italian painting, therefore, had a distinctly sculptural tendency, and on some canvases ornamental details were actually applied in relief. Michelangelo was a notable example of this school. Like many of his predecessors and contemporaries, he was attracted to highlight and shadow for their power to reveal plastic appearances. However, the manifestations of light were seldom portrayed beyond this. Cast shadows were rare. In a grouping of figures, each would be perfectly modeled from light to dark, yet the shadow cast by one figure on another, or even the shadows cast by a wall, a table or a column, would be omitted. Artists evidently disdained this latter sort of realism, which might interfere with their passion to "sculpture" with pigments.

Detail from Scenes from the Story of the Argonauts, School of Pesellino, fifteenth century. Note absence of cast shadows

Titian, portrait of Filippo Archinto, Archbishop of Milan Colors were glazed in layers.

THE MAGIC OF CHIAROSCURO

With men like da Vinci this sort of realism was largely disregarded. Now there was a desire to compose a painting, to balance its areas and colors agreeably. A master of light and shade, da Vinci's style of painting, termed chiaroscuro, flourished in his own day and was later adopted by Rembrandt. It consisted of transparent tones, with highlights and forms built up in opaques. To explain his viewpoint, da Vinci wrote: "The first aim of the painter is to make it appear that a round body in relief is presented upon the flat surface of his picture; and he who surpasses others in this respect, deserves to be esteemed more skillful than they in his calling. Now this perfection of art comes from the true and natural arrangement of light and shade, or what is called chiaroscuro; thus if a painter dispenses with shadows when they are necessary, he wrongs himself and renders his work despicable to connoisseurs, to win the worthless applause of the vulgar and ignorant, who look only at the brilliance and gaiety of the color in a picture, and care nothing for the relief."

The Venetian school, most notably represented by Titian, used principles of chiaroscuro differently. The panel was covered with a flat ground (impasto) of tempera upon which layers of semi-transparent glazes were placed. These thin coats intensified the richness of tones; shadows were warmed with color, outlines softened, and hues were given depth. Titian remarked that flesh on his canvases was as in nature—layer placed over layer.

As the knowledge of painting spread from Italy, other masters achieved even more brilliant color expression. Rubens worked with a smooth, glazed style. His canvases had a light gray oil priming. His drawing was heightened with a brown wash. His shadows were thin and often intensified with opaque touches, his lights heavy and opaque. As one artist wrote: "Rubens did not paint with colors prepared like ours, but overlaid his panel with an unctuous matter, liquid enough to check the movement of the brush, viscous enough to pick up the color and make it adhere, and at the same time greasy enough to arrest the tendency of some colors to spread beyond the place they were applied.

Rembrandt was an experimenter. In his earlier work he followed a smooth impasto. Later, and more impulsively, he worked with a palette knife, piling up his impasto and using his glazes to correct errors. His style was varied and his own. As a chiaroscuro painter he had magical control over light and shade, plus a rare spirit. On the quality of his technique, Millais wrote: "I have closely examined his pictures . . . and

Rubens, Worship of Holy Family. Shadows were thin; highlights were heavy

Rembrandt, Old Woman Cutting Her Nails. The rare combination of masterful technique and universal spirit

Vermeer, Lady with Lute

have actually seen beneath the grand veil of breath, the early work that his art conceals from trained eyes—the whole science of painting."

Vermeer, one of the greatest Dutch painters, had one of the most finished styles in the history of art. Attracted to subtleties of light and shade, to the mingled reflections of objects, to textures, he portrayed the simpler aspects of life with magical beauty. What he apparently lacked in temperament and the more ardent spirit of Rubens and Rembrandt, he compensated for with gentility of feeling, with dignified composure and incredible technical perfection.

Velásquez, the Spaniard, was one of the few so-called perfect painters of all times. Master of color, light and shade, his eye was unerring. His style was realistic beyond the photograph—for it was human. Subtle in his understanding of tones and their relation to structure, he created effects that have rarely if ever been surpassed. His compositions were always simple in conception, his figures like still life. With masses of color choicely blended, graded and arranged, he created remarkable illusions of luminosity and perspective. El Greco sought weirdness with color, took liberties with nature and created effects which have become the envy of modern painters.

Sir Joshua Reynolds deduced from the Venetian school that an ideal color balance was to be achieved in a canvas in which two-thirds of the area was warm and one-third cool. He wrote: "It ought, in my opinion, to be indispensably observed that the masses of light in a picture be always of a warm mellow color, yellow, red, or a yellowish-white; and that the blue, the gray, or the green colors be kept almost entirely out of these masses, and be used only to support and set off these warm colors; and for this purpose a small portion of cool colors will be sufficient. Let this conduct be reversed; let the light be cold and the surrounding colors warm, as we often see in the works of the Roman and Florentine painters, and it will be out of the power of art, even in the hands of Rubens or Titian, to make a picture splendid and harmonious." Reynolds apparently felt quite sure of his generalization, but it is said that Gainsborough deliberately refuted and reversed the principle, and in so doing painted his masterpiece, "The Blue Boy."

El Greco, St. Catherine. Weird distortions and colors—a prelude to the art of later centuries

Velasquez, portrait of Philip IV in Armor. Astounding control over light and shade

Sir Joshua Reynolds, portrait of Nancy Parsons, Viscountess Maynard. He sought dominant warmth of color

IMPRESSIONISM

Techniques and styles in art changed as time passed. Whistler was a transitionalist. He followed many of the ideals of the old school, but tempered them with a newer viewpoint. Then, with the growth of Impressionism, the subtlety of highlight and shadow upon form was abandoned for frank expression with full hues. Now the art of color entered a proud era and witnessed the ennoblement of intense reds, yellows, greens, blues and purples. Black was renounced, and gray tones were more or less excluded. Expression was brilliant, with colors confined almost entirely to pure hues, clear whitish tints, and in some instances to deep blackish shades. The later artists attempted to paint all the glories of light. The school of Impressionism which soon reigned supreme in art during the latter part of the 19th century was dedicated to color throughout. As far as color is concerned, it was by all odds the most courageous and brilliant of all periods in the history of painting.

Courbet, who heralded the spirit of Impressionism, was a sworn enemy of pretense. He contended that an art of sight ought to concern itself with things. He opposed romanticism and classicism, and disdained the vanity of the artist who would take his material from poetry, myth and legend. He persisted in remaining the democrat in viewpoint and in painting life as he saw it. His

Manet, Funeral. He saw no lines in nature

credo was admirable: "To translate the manners, the ideas, and the aspect of my own times according to my perception, to be not only a painter but still more a man, in a word, to create a living art, this is my aim." He influenced the younger painter, cried out for greater honesty and veracity in art, and gave Impressionism its conscience if not its style.

Manet was by nature more of an aristocrat. Making a deliberate study of the masters, influenced greatly by Velásquez, he evolved a technique that was modern in method as well as thought. He abandoned the conventions of outlines and modeled his form with subtle gradations that "melted" together in the eye of the observer. He was attracted to illumination as a major rather than an accessory quality in beauty.

In older schools, a composition had been posed and reproduced exactly throughout. Art was "petrified." The Impressionist held that such procedure violated truth. When looking at nature, the eye saw it simultaneously, in one impression. A person was affected by the immediate circumstances and conditions of the moment. A painting should catch the aspect of a particular illumination, a particular time. In addition, the eye did not have complete mastery of focus over all it surveyed. In looking at one thing, other objects in the environment were blurred and indefinite; the eye was not photographic, nor was the mind.

Courbet, Les Demoiselles de Village. He opposed romanticism for a truer, living art

Pissaro, Hillside at Jallais, Pontoise. Brown and black were to be eliminated from the artist's palette

In color, El Greco and Velásquez had used divisionalism, and Delacroix had studied the results of juxtaposition. New science had made revolutionary discoveries. Artists suddenly became aware of the fact that no hue was monochromatic and flat, or influenced in its gradations solely by neutral light and shade. Grass had a local color of green. Yet it was changed by sunlight, by reflection from the sky, by atmosphere, by after-images produced in its environment. Colors also changed as illumination changed. Nature had different faces at different hours of the day. Highlights were always keyed by the prevailing illumination; shadows were always complementary to such light. The world scintillated—and light was everything.

Colors primary in pigment were not primary in light. The Impressionist looked with suspicion upon black and brown. He set his palette with bright pigments. He began to analyze hues and to attempt the re-creation of light and brilliance by juxtapositions that admitted laws of physics. Pissarro, for example, eliminated black and brown from his palette altogether.

Techniques were invented and given such names as "pointillism," "divisionism" and "luminism." Mixtures were to be optical. Strong hues were applied in spots, and the principle was to arrange them as though they were colored lights. Full hues were formed with pure colors. Secondaries and tertiaries were formed by combining spots of adjacents, complements and near-complements. Grays and browns were produced in the same fashion. Where the older painter labored in terms of black and white, the pointillist thought entirely of color and gave his enthusiasm to it, because he considered it the very essence of form.

Delacroix had been a vigorous exponent of such ideas. He studied nature in its elusive moments and saw that all the world was bright and animated, not dead. He wrote in his *Journal,* "From my window I see a joiner working, naked to the waist, in a gallery. Comparing the color of his body to that of the outside wall, I notice how strongly the half tones of flesh are colored as compared with inert matter. I noticed the same thing yesterday in the Place Saint Sulpice, where a loafer had climbed up on the statues of the fountain, in the sun. Dull orange in the carnations, the strongest violets for the cast shadows, and golden reflections in the shadows which were relieved against the ground. The orange and violet tints dominated alternately, or mingled. The golden tone had green in it. Flesh only shows its true color in the open air, and above all in

Delacroix, The Abduction of Rebecca. To him the world was all light and color

135

the sun. When a man puts his head out of the window he is quite different from what he was inside. Hence the folly of studio studies, which do their best to falsify this color."

Men had never seen with the eyes of a Delacroix. They were fascinated. Art turned from its portrayal of static things to catch the fugitive aspects of nature. New styles were needed, new viewpoints. Genius must be born to free painting from its heavy and burdensome shackles.

In the opinion of many critics, Monet became the most able of the pointillists. While somewhat "scientific" in his color application, he did not divorce his technique violently from form. He was not a dogmatist. Monet's practice was to work on several canvases a day, going from one to the other as the light changed. His separate touches of color were applied in excellent conformity with his subjects. Rock looks like rock,

Monet, Rouen Cathedral. One of the greatest of the Impressionists. His spots of color conformed to his subjects

water like water, foliage delicate and lace-like.

The divisionism of Seurat and Signac, on the other hand, was far more analytical and technical. Their touches were scientifically juxtaposed without regard to form. For that reason the style was almost abstract, designed primarily to get vivid color, using nature more or less as a pattern. The work of these two artists, who were known as Neo-Impressionists, was perhaps the purest expression of pointillist technique. They painted by rule and laid their "beads" of color by the thousands, "embroidering" them into compositions with incredible patience. They exercised a great influence on artists who followed them.

Renoir and Van Gogh, though widely different in temperament, nonetheless painted in a similar way with reference to color divisionalism. Renoir, working with separate brush strokes, produced dominant and radiant tones by a shrewd sequence of hues. Values were replaced by color contrasts. All shadows were luminous and hued. He gave attention to mass, achieved rotundity in his forms and built luminosity by clever anal-

Renoir, In the Meadow. His Impressionism was one of broader color sequences and contrasts

Signac, View of the Port of Marseilles. Now the spots were scientifically placed to achieve vivid color

*Van Gogh, Sunflowers. A bold
and passionate expression that
revealed form*

ogies. Van Gogh attained his modeling by sweeping lines of hue—as against minute spots or flat planes. He had a passion for color and excelled in his ability to use it. He preserved form and silhouette, and coordinated them with color to get effects at once decorative and forceful. Less "scientific" than the pointillists, his viewpoint was inspired by inherent love of color and a moving desire to make his canvases resplendent with the glory of light.

Cezanne, Still Life. Here there is a return to solidarity. **The mass of objects must be expressed**

CÉZANNE—RETURN TO FORM

With Cézanne there was a return of color to achieve form and structure, not merely illumination. Though in his lifetime Cézanne exhibited with the Impressionists, he neither adopted their palette nor became totally preoccupied with the fugitive effects of light. His viewpoint is best described in his own words: "I wish to make of Impressionism something solid and durable, like the art of the old masters." His contemporaries portrayed nature with spots and lines of color, and in so doing got away from structure. Their pictures were rather flimsy. Cézanne wanted to express the mass of an object and to use color, not strictly as an expression of light, but as a revelation of solidity. His analysis of color was more summary. Unlike

the Impressionists he used much brown. He struggled to paint the world as his eyes saw it, without any preconceived tricks of color application in mind. His experiments were many. For example, he submitted objects to a series of hue divisions, working from yellow in the foreground to violet, tracing intermediates through the spectrum. Through gradations from warmth to coolness and from high to low values, he got both dimension and weight. He studied planes and reflections. Color was united with form, not merely a covering over it.

Cézanne's still-life models were obedient and he could work with them without distractions. In portraying an apple, he knew its shape to be spherical. Yet, in the lighting of his studio, it appeared broken into planes of color and tone. One could not express such

facts by mere light and shade; there was the red hue of the apple itself, the reflections of the table covering, blue and green from the world outside the window, yellow from the walls of the interior. Thus, the apple was not red, and tints and shades of red, but orange, yellow, green, blue and purple. However, when Cézanne endeavored to portray all this, his subjects became distorted. When his planes could not be crowded into spherical shape, his apple grew lopsided. Then he had to increase the dimensions of the table. All these abnormalities influenced others because they were the unavoidable consequences of his searchings. Add his use of heavy outlines to remedy some of these defects, and much of his art appears odd.

Nevertheless, if he did not improve upon their rich color effects Cézanne corrected the attitude of the Impressionists. His teachings, by example, forced the subsequent painters to be more levelheaded.

MODERN PAINTING

In recent years color expression in painting has been retrogressive. With the advent of non-objective art, scientific interest—such as shown by the Impressionists—has been set aside for so-called freedom of expression. Color, however, is a progressive art and needs inquiring minds. Where the Impressionists took inspiration from physics and physiological optics, there is now a chance to profit from recent inquiries into the psychology of seeing and perception.

Yet after Impressionism art became little more than audacious. One exception is Wassily Kandinsky, who wrote extensively on color. A few of his ideas will be mentioned in a later chapter. In what is known as Cloisonnism bold colors were given black outlines, not a very original idea. In Fauvism, the first revolutionary art movement of the 20th century, color was used like "sticks of dynamite," and men like Matisse, Derain and Vlaminck applied color boldly, often on flat planes without modeling. There was an attempt to reduce the art of painting to color and a few elements of line and rhythm. As Vlaminck declared, "We are always intoxicated with color, with words that speak of color, and with the sun that makes color live!"

With the school of Orphism, color was all important. Robert Delaunay, a leading Orphist, believed that primary color shat-

Derain, London Bridge. He was a leading Fauvist. Freshness and simplicity were the true rules of art

Vlaminck, Mont Valerien. He used colors like sticks of dynamite

tered the atmosphere and simultaneously produced all the hues of the spectrum. His compositions were prismatic in feeling.

The art of color needs more than enthusiasm and "intoxication." It needs more than splashes of brilliant hues, or blobs and streams poured from cans or flung impulsively. It needs the spirit of Impressionism, but re-directed into other channels. One such channel is that revealed by the Gestalt psychologist on the mysteries of human perception. Here lies an art highly personal to man's experience in seeing. It can pick up where the Impressionist left off and restore to art a profound and unending study of color phenomena, to lead it ahead, not back.

Matisse, Still Life. He dominated the school of Fauvism. **There would be a happy, free expression for color**

A palette or paint box of an Egyptian artist. About 1450 B. C. Note compartments for eight colors

A palette or paint box of an Egyptian artist. About 1450 B. C. Note compartments for eight colors

Chapter 14

COLOR THEORY— ORDER OUT OF CHAOS

Ancient man gave little thought to theories of color harmony. Not until the Renaissance and after—when color expression was no longer a matter of symbolism—did men attempt to contrive laws that might reveal principles of beauty.

Color was, of course, given many applications outside the field of painting. In pure design, textiles, ceramics and stained glass, there were opportunities for abstract effects. The painter was forced to keep an eye on nature, to be pictorial and somewhat realistic, but in weaving and pottery the worker could do as his heart desired. He could use color for the sake of color, compose it like music, invent scales and harmonies, and model conventions as his feelings dictated.

LEONARDO DA VINCI

Perhaps the first great color theorist was Leonardo da Vinci. A practical genius, as philosophical as he was versatile and artistic, he was quick to understand essentials in art. Centuries before the psychologist, he recognized the primary character of red, yellow, green and blue. In so doing he became perhaps the true founder of the modern art of abstract color. In his *Treatise on Painting,* Leonardo said: "Of different bodies

141

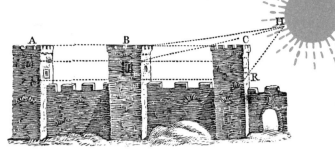

equal in whiteness, and in distance from the eye, that which is surrounded by the greatest darkness will appear the whitest; and on the contrary, that shadow will appear the darkest which has the brightest white round it.

"Of different colors equally perfect, that will appear most excellent which is seen near its direct contrary: a pale color against red; a black upon white . . . blue near yellow; green near red: because each color is more distinctly seen, when opposed to its contrary, than to any other similar to it."

This may be elementary today, but it is still good practice and taught in schools and academies everywhere. Leonardo had a sharp eye. "If you mean to represent great darkness, it must be done by contrasting it with great light; on the contrary, if you want to produce great brightness, you must oppose to it a very dark shade: so a pale yellow will cause red to appear more beautiful than if opposed to a purple color.

"There is another rule, by observing which, though you do not increase the natural beauty of the colors, yet by bringing them together they may give additional grace to each other, as green placed near red, while the effect would be quite the reverse, if placed near blue.

"Harmony and grace are also produced by a judicious arrangement of colors, such as blue with pale yellow or white, and the like."

Such sound advice abounds in his notes. While there was beauty in contrast, there was beauty also in analogy. "If you mean that the proximity of one color should give beauty to another that terminates near it, observe the rays of the sun in the composition of the rainbow, the colors of which are generated by the falling rain, when each drop in its descent takes every color of that bow."

When da Vinci painted, he was careful to follow a procedure which he thought would respect a natural law. Thus, "After black and white comes blue and yellow, then green and tawny or umber, and then purple and red. These eight colors are all that nature produces. With these I begin my mixtures, first black and white, black and yellow, black and red; then yellow and red." To this he adds, "Black is most beautiful in the shades; white in the strongest light; blue and green in the half tint; yellow and red in the principal light; gold in the reflexes; and lake in the half tint."

142

Drawings to explain color and light phenomena. From da Vinci's Treastise on Painting

And he knew what he was talking about. "Whoever flatters himself that he can retain in his memory all the effects of nature, is deceived, for our memory is not so capacious: therefore consult nature for everything."

Perhaps no other artist had a greater critical influence than da Vinci, whose style of painting dominated the Renaissance. His *Treatise* became the notebook for students, his theories of color their rituals.

Newton designed the first of all color circles in the latter part of the 17th century. He drew the two extremes of the spectrum together to form a circle, connecting blue and violet (separated by purple), and exhibiting an orderly circuit from red through orange, yellow, green, blue, indigo to violet and back again to red. Here, perhaps, was the earliest attempt ever made to design a chart that might give an organized picture of the world of color.

J. C. LE BLON

Sixty years later (1730) a German engraver named J. C. Le Blon discovered the primary nature of red, yellow and blue in the mixture of pigments. Gautier of Paris also made the same discovery in independent experiments and subsequently wrangled with Le Blon. The fact that red, yellow and blue are primary in pigment mixtures—and that their combinations produce orange, green and violet—may seem elementary today. Still, color theory had to wait until the 18th century for such obvious facts to be

Facing pages, in English and French, in which Le Blon set forth the primary nature of red, yellow and blue

28 TRACT OF COLOURING.

PAINTING can *reprefent all* visible *Objects, with three Colours*, Yellow, Red, *and* Blue; *fort all other Colours can be compos'd of thefe* Three, *which I call* Primitive; *for Example.*

Yellow
and } *make an* Orange Colour.
Red

Red
and } *make a* Purple *and* Violet
Blue } Colour.

Blue
and } *make a* Green Colour.
Yellow

And a Mixture *of thofe* Three Ori-*ginal Colours makes a* Black, *and all other Colours whatfoever; as I have demonftrated by my Invention of* Printing *Pictures* and *Figures* with their *natural* Colours.

TRAITÉ DU COLORIS. 29

La Peinture peut repréfenter tous les Objets vifibles avec trois Couleurs, fçavoir le *Jaune*, le *Rouge* & le *Bleu*; car toutes les autres Couleurs fe peuvent compofer de ces trois, que je nomme Couleurs primitives. Par exemple,

Le *Jaune*
& } font l'*Orangé.*
Le *Rouge*

Le *Rouge*
& } font le *Pourpre* & le
Le *Bleu* } *Violet.*

Le *Bleu*
& } font le *Verd.*
Le *Jaune*

Et le mélange de ces trois Couleurs primitives enfemble produit le Noir & toutes les autres Couleurs, comme je l'ai fait voir dans la Pratique de mon Invention d'imprimer tous les Objets avec leurs couleurs naturelles.

Le Blon's palette. It influenced many artists and revolutionized the art of printing and engraving

discovered and enunciated. This Le Blon did, and his achievement was promptly recognized as phenomenal. "That invention has been well approv'd thru'out Europe, tho' at first it was thought impossible."

Some thirty or more years later, Moses Harris of England in a rare book, *The Natural System of Colours* (CA. 1766) reproduced the red-yellow-blue chart in magnificent form. If Newton's was the first color circle in black and white, Harris' chart was probably the first to appear in full color.

Of Harris' achievement, in 1839 W. B. Sarsfield Taylor declared, "This work of Mr. Harris is so very scarce, that I have never seen a copy of it." Thomas Phillips in a series of lectures given in 1849 stated, "Harris's treatise is said to be exceedingly scarce." More recently (1948), F. Schmidt, in an excellent book, *The Practice of Painting*, came to the conclusion "that only one copy was taken from the press," but fortunately, this is an exaggeration, for this author located a copy a few years ago, and the title page and one chart are reproduced in these pages. The dedication was to Sir Joshua Reynolds, and the volume certainly is one of the rarest on the subject of color.

In 1831 Sir David Brewster, who perfected the kaleidoscope and spectroscope, published *A Treatise on Optics*. In agreeing with Newton, he declared that sunlight was composed of seven different kinds of light. However, there were three essential primaries. "I conclude that the solar spectrum consists of three spectra of equal lengths, viz., a *red* spectrum, a *yellow* spectrum, and a *blue* spectrum." This theory was widely accepted, and the red-yellow-blue chart subsequently became known as the Brewsterian

color circle. It expressed the doctrines of Goethe, Schopenhauer, Chevreul, and was later endorsed in this country by Herbert E. Ives, Denman Ross, Arthur Pope and Walter Sargent, and used throughout the American educational system.

The primary colors of pigments (red, yellow, blue), the primary colors of light (red, green, blue), and the primary colors of vision (red, yellow, green, blue) have already been mentioned, and each theory or principle is distinct. As to light primaries, the choice of red, green and blue can perhaps be attributed to Professor Wünch of Germany in 1792. While this led to much argument, science promptly realized that colored rays of light do not combine in the same way as pigments or dyestuffs, and the matter was easy enough to prove.

Thomas Young, one of the founders of physiological optics, helped to put the undulatory or wave theory of light on a sound basis. He took over the red, green, blue theory of light and passed it on to Hermann von Helmholtz and James Clerk Maxwell.

The color circle of Moses Harris. This is the first known example ever to be reproduced in full color. (1766)

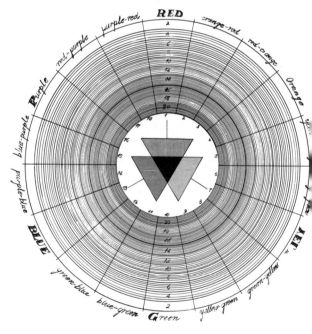

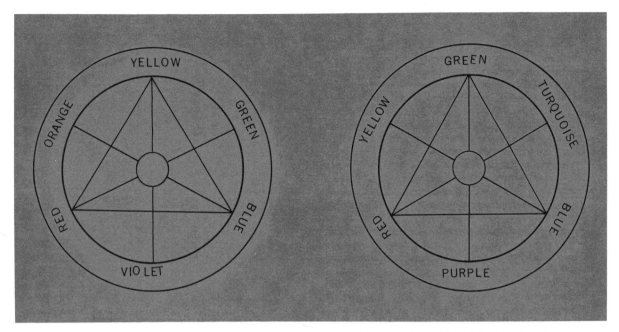

The red, yellow, blue color circle with its pigment primaries

The red, green, blue color circle with its light primaries

The Munsell color circle. There are five basic colors, red, yellow, green, blue, purple

The Ostwald color circle. The basic colors are red, yellow, green, blue

Helmholtz, for example, wrote an accurate description of the spectrum, pointed out the difference between spectral and pigment mixtures, and greatly enlarged man's knowledge of optics.

Maxwell, a world authority on electromagnetic energy, devised a triangle of red, green and blue which physicists still use in analyses of color. He was also one of the founders of color photography and was able to create full-color scenes by projecting images of red, green and blue to form all other hues. The red, green, blue theory also has had its champions—A. H. Church and R. A. Houstoun of England, Wilhelm von Bezold of Germany, Ogden Rood, Michael Jacobs and Albert H. Munsell (to some extent only) of America.

Although da Vinci had written of four primary colors—red, yellow, green, blue—credit for a substantial four-color doctrine in human vision goes to Ewald Hering, who made clear that what man saw in color differed essentially from what took place in mixtures of pigments or lights. Hering was one of the first to look on color as a personal experience and to deal with it in human terms. His red, yellow, green and blue primaries were later used by Ostwald and also adopted by this author in 1928. A color solid based on the

RUSKIN'S COLOR CIRCLE

The color circle of John Ruskin having twelve zodiacal hues

four visual primaries has been designed by Höfler (Ostwald also featured the idea) and can be found in most psychology textbooks.

Typical color circles are shown in these pages. All are good ones and have been given many interpretations. Also shown is the John Ruskin's unique color circle, a chart of twelve zodiacal colors with picturesque names. Ruskin wrote: "The principal use of the zodiacal arrangement is that each color is placed over its proper opponent, Jacinth being the hue which most properly relieves Or, and Primrose being the most lovely opponent of Heath. The best rubrics of ecclesiastical literature are founded on the opposition of Jasper to Sapphire."

COLOR SOLIDS

A well-designed color circle is only incidental to the organization of a figure that may portray all visible colors, tints, shades and tones. The first attempt of this sort was probably made by R. Waller in 1689. He planned a rectangular chessboard, placing blues and greens along one edge and reds and yellows along the other. The squares between were reserved for mixtures of the outer colors. His chart, with only two dimensions, was extremely elementary.

In 1745 Tobias Mayer, a distinguished mathematician, developed a color solid

This double pyramid of Hofler is commonly used to illustrate the visual and psychological relationships of colors

WALLER—1689

MAYER—1745

RUNGE—1810

VON BEZOLD—1876

LAMBERT—1772

ROOD—1879

A group of historical color solids. Color organization has always been a complex problem

based on a red, yellow and blue triangle. Secondaries ran along the sides and tertiaries on the interior. He then added other triangles, working up toward white and down toward black, thinking that all colors might thereby be charted.

J. H. Lambert's pyramid (1772) was the first color solid of appreciable merit. Lambert also chose a triangle and used red, yellow and blue. He discovered that those primaries in combination produced black and, therefore, saw no reason to add black. Thus, his base triangle had red, yellow and blue at its angles, intermediates along its sides, and shades of dull tertiaries scaling toward the center into black. Then he followed the same plan with subsequent triangles, adding white in fixed proportions, and making his new triangles progressively smaller as they led to a white apex. This conception made a good deal of sense but minimized the importance of black and shades in which black occurs.

A progressive step was now taken by Ph. O. Runge, who in 1810 designed a color sphere. Pure hues ran in a circle about the equator. White was at the top pole, black at the bottom, connected by a gray series along the axis. The colors within the figure then included tints, shades and tones. He conceived of his sphere as having continuous transitions. Here, for the first time, was a plan that gave equal importance to white and black, to conform with the present-day viewpoint of psychology.

Following Runge two retrogressive solids came into existence. The first was a hemisphere designed by M. E. Chevreul and hopelessly inadequate. The second was a cone designed by Wilhelm von Bezold, following a pattern set by Helmholtz, which was precisely the reverse of Lambert's pyramid. Accepting the physicist's word, von Bezold arranged pure hues in a circle and scaled them toward white. This disk became the base of a cone that tapered off in steps toward a black apex.

Ogden Rood, the first eminent colorist on this side of the Atlantic, united the two solids of Lambert and Runge to form a double cone. "In this double cone, then, we are at last able to include all the colors which under any circumstance we are able to perceive." He set a style later adopted by Munsell and Ostwald which was in agreement with the modern psychologist's viewpoint. Pure hues ran about the circumfer-

147

ence of the figure and then scaled to white at the upper apex and to black at the lower, the two extremes being connected by a series of neutral grays.

M. E. CHEVREUL

Before delving into the two best-known contemporary color systems, Munsell's and Ostwald's, tribute should be paid to a great Frenchman, a man who stands out as a giant: M. E. Chevreul. In 1839 he published his famous work on the laws of simultaneous contrast. This remarkable book is notable because: it greatly influenced and inspired Impressionism in painting; it founded laws of color harmony still taught today and still a part of color education; it was translated into several languages, reprinted in dozens of editions, and sold in large numbers for well over sixty years! No other work (or body of work) on color has achieved that record.

Virtually alone, Chevreul organized the world of color harmony in capable and succint form on the basis of a red-yellow-blue

color circle. Born in 1786, he lived to the age of one hundred and three, and in 1889, while he was still alive, was honored by a magnificent centenary volume of his accomplishments.

Chevreul noted that, in seeing colors, the eye presented certain subjective reactions which influenced appearances. Immediately, he understood the necessity of dealing with color as a visual phenomenon. He studied the after-image and prepared charts and diagrams to explain every minor detail. He achieved scintillating effects through juxtaposition and diffusion of color areas (which led to pointillism) and applied his conclusions to a wide variety of fields. When he had finished, he published his masterpiece, a page of which appears in these pages.

Chevreul set forth a series of propositions which have become classical in art education. When one hears of the harmony of adjacents, complements, split-complements, triads, such principles—and many others— hark back to Chevreul. So many of his ideas have become part of the tradition of color harmony that the creator of them has been all but forgotten.

ALBERT H. MUNSELL

The most important color system of American origin is Albert H. Munsell's. Used extensively in this country and abroad, its nomenclature has been adopted by the United States Bureau of Standards as well as by organizations in other countries.

As a youth Munsell studied Rood's *Modern Chromatics*. Soon he devoted his life to study in the field of color, graduated from college an honor student, traveled to Paris and Rome to complete his education, and became America's outstanding missionary of the color gospel. By 1900 his system was developed. The first edition of his book came in 1905, and his atlas appeared in 1915. Subsequently, he lectured in America, England, and on the Continent.

Munsell adopted Helmholtz's conception: the three constants of color were hue, value and intensity. The final term he changed to chroma. In short, colors were to be distinguished first by their hue, (red, yellow, etc), second by their brightness or value (light or dark), and last by their chroma (pure or grayish).

His ten pure key hues were: red, yellow-red, yellow, green-yellow, green, blue-green,

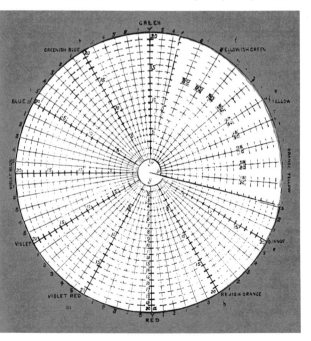

Chevreul's color circle with its primary red, yellow, blue

blue, purple-blue, purple and red-purple. This arrangement, incidentally, was similar to Wilhelm von Bezold's proposal. The circle was then divided into one hundred segments, and all colors indicated by numerals in groups of ten running clockwise. For value, Munsell worked out a series of grays scaling from black to white, with two ideal extremes, 0 for black and 10 for white. The practical scale had numerals from 1 to 9. For chroma, there were steps that ran out horizontally from the nine value levels, but this dimension had no fixed limits. As more intense hues were found in pigments, they could be added to the ends of the horizontal scales. Thus, Munsell located hues by charting them around his sphere. Values were located by working up and down in vertical series. Chromas were located by working across in horizontal series.

As first developed, the solid had the form of a perfect sphere. Munsell made allowances for differences in the values of his pure hues by tilting the color circle so that yellow was near white and purple near black. Now he added another feature to comply with certain facts of vision. Some hues were apparently stronger or purer than others. Consequently, his red stretched out further from the neutral value scale than green. His spherical solid took on the aspect of a color "tree."

Munsell was able to plot all his colors and tones within this solid with Maxwell disks. Everything was balanced. Equal areas of the five key hues (red, yellow, green, blue, purple), when spun on disks formed neutral gray. His complementaries also formed gray in 50-50 mixtures. Red, which had relatively twice as many chroma steps as blue-green, nonetheless formed gray mixtures when the steps of the complements had the same numerical designation. A pure green, thus, would be combined with a grayish red of equal chroma. If the red were more "intense" than the green, compensation had to be made by increasing the area for green.

The solid is flattering to the physicist's viewpoint, even though carried out in terms of visual mixtures. It represents an empirical conception of hue arrangement, all neatly worked out in accordance with the three color qualities accepted by physics. But in taking to a middle course between color as energy and color as sensation, it falls short of the kind of perfection realized by Wilhelm Ostwald.

Sections of Munsell color solid. These are vertical sections. The numbers from one to nine indicate the gray scale. The upper diagram shows tone variations and scales of red and blue-green. The lower diagram shows scales of yellow and purple-blue

Munsell color solid. This is but one of several ways in which the system may be illustrated. Light colors appear at a level near white, and dark colors at a level near black. Intense hues extend farther from the gray scale than pale colors

WILHELM OSTWALD

Wilhelm Ostwald was one of the few renowned scientists ever to devote a considerable portion of time to the problems of color theory and harmony. A Nobel Prize winner in chemistry (1909), honorary member of several venerable institutes and societies, he brought to the art of color much of the technical authority it required. He did more than reflect upon aesthetics, as did Newton and Helmholtz; instead, he shook colorists out of their apathy, questioned the physicist's omniscience in the field and enunciated doctrines that hailed a new order.

In the introduction to Part I of *Color Science*, Ostwald wrote: "The science of color has not hitherto been referred to its rightful habitat. The painters and dyers, the first to become familiar with colors in the course of their daily routine, did not find themselves in a position to develop their empirical knowledge into a science. It was Newton's fundamental discovery that white light can be decomposed by a prism into a continuous band of varied colors which enabled the *physicist* to pose as the originator and custodian of color science—a claim which, even up to the present day, has remained practically unchallenged. The painters and dyers then made the discovery that from three fundamental colors all intermediate hues could be produced, and in this way developed a practical three-color doctrine which was afterwards taken over by the physicists. Then again, in the manufacture of artificial coloring matters—known to us today in their thousands—it was necessary that the resources of *chemistry* should be utilized, the result being that color science has to some extent passed under the care of the chemists, who have, however, also omitted to organize it scientifically. Next, following Goethe's example, the physiological side of color science was explored and cultivated until it developed into a branch of *physiological* instruction, aided by the progress of ophthalmology. Finally it became increasingly evident that, in the last analysis, color is a sensation, and that its science must therefore be included in modern *psychology*."

Ostwald went through the literature of color, studying systems and conceptions. He doubted the authority of the physicist and chemist, finally concluded that color as sensation properly belonged in the realm of sensation, and that a true solution of color's mysteries lay in analysis of the physiological

Section of the Ostwald color solid. All rows parallel to color and white have an equal black content. All rows parallel to color and black have an equal white content

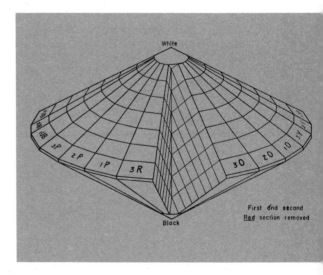

Ostwald color solid. Pure hues extend about the equator. These form graded scales toward white, black and gray

150

and psychological processes of seeing. He accepted Hering's doctrine of red, yellow, green and blue primaries, and the theory that all possible colors were derivatives of pure hue, white and black. With patient deliberation he then created a new pattern for the architecture of the house of color. Ostwald standardized a chromatic circle using red, yellow, green and blue as his primary keys, spaced at equal intervals around a circle. He then added intermediates to make a total of twenty-four pure hues. Next, he built a gray scale with eight steps based on the Weber-Fechner law (subsequently adopted by other colorists). Ostwald then arranged his colors within equilateral triangles. Pure hue was placed at one angle, white at the second and black at the third. His modified tones of each pure color were placed within the boundaries of the triangle, and were formed by a simple magic that is one of the great wonders of color invention.

Hering had stated that all colors seen by the eye were derivatives of pure hue, white and black. The natural symbol of color was the triangle. Every sensation was a perfect unity of these three qualities, and they always equaled unity. Before Ostwald, color modifications and mixtures had been compared to pouring dyes into a tube. A little pure red in the tube might be said to correspond to a brilliant color. A little white, or clear water added, would fill the tube more and make a tint. A little black would fill it still more and make a grayish tone. Now Ostwald insisted that the tube was always full, always a complete sensation! In short, white could not be added to red without automatically decreasing the red content of the sensation. Unity always existed. Every color seen by the eye was made up as pure hue, white, black—any or all—and the qualities were always measurable.

THE ELEMENTS OF COLOR

Color organization is a complex problem, yet elements of color as sensation can be reduced to a surprisingly simple order. How many colors are there? To the physicist, the number may be infinite. But to the human eye (and brain), this is by no means the case. Selig Hecht writes, "Color vision may be defined as the capacity of the eye to divide the visible spectrum into a series of regions which produce qualitatively different sensory effects." Seeing, in brief, is a process of mental interpretation, of looking at the world of color and reducing it to its simplest elements. The eye and the mind always struggle to make order out of chaos and to see as few colors as possible![15]

Pure hues are a good example. To the eye four colors are primary: red, yellow, green and blue. Why are they primary? First, because these colors cannot be formed by visual mixtures of any other. No two disks can be placed on a color-wheel to produce a pure red, pure yellow, pure green or pure blue. More significant, each of these four colors is unique in appearance and resembles nothing else. Orange can be made by mixing red and yellow on the color wheel. Orange is a color blend and looks the part. But while orange looks like red and like yellow, red and yellow do not look like orange. Similarly violet or purple looks like red and like blue, but red and blue do not look like violet or purple.

The eye distinguishes a color quality in what it sees, and red, yellow, green and blue are the major notes. Pure hues, thus, are one form of sensation. What else is unique? The second primary form in color sensation

The Color Triangle. Here is a basic simplification of color as sensation. Everything seen by the eye may be classified as one of seven forms of perception

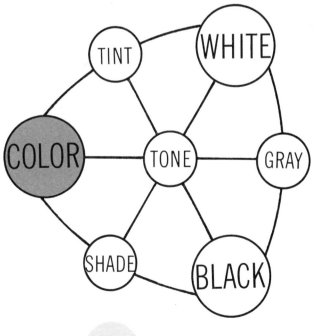

is white. White is a unique color and doesn't look in the least like red, yellow, green or blue. The third primary form is black, and again, black looks nothing like white or any pure hue.

The world of color has seven forms, no more, no less. Three are primary: pure hues (any and all), white and black. When these three primary forms are combined, they produce four secondary forms. Pure hues and white produce tints, or whitish colors. Pure hues and black produce shades, or blackish colors. Pure hues, white, *and* black produce tones, which are grayish colors. These secondary forms resemble their pure components. Tints have both a color quality and a white quality; shades look both like pure color and black; and tones show traces of all three primary forms. These relationships take the natural form of a triangle.

Every color seen by the human eye can be classified as one of these seven forms. Here the entire world of color is reduced to its elements, in accordance with a law inherent in man's psychological make-up. It has taken the combined efforts of a dozen or more great men—da Vinci, Newton, Young, Goethe, Chevreul, Helmholtz, Hering, Munsell, Ostwald, to mention but a few—to make possible a statement as simple and as veracious as this!

How different the attitude of future colorists must be! Color theory is basically simple, not intricate. An elementary diagram, the symbol of an equilateral triangle, tells the fundamental story.

Part Three
IMPLICATIONS FOR MODERN LIFE

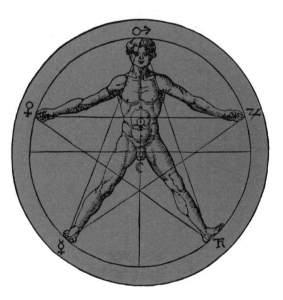

The perfect man is in complete harmony with the universe. He is the microcosm, or little world, attuned to the majestic harmony of the macrocosm, or great world

Remarkable adaption of the flounder to background. Courtesy, U. S. Fish and Wildlife Service

Chapter 15

NATURE'S ART OF COLOR

What does man understand of nature, of himself? What does the world see, and how does it see? What are the functions of color in the life of plant, insect, bird and beast, in the civilized and uncivilized habitats of men? What is *known* about color so that a great and useful art might be built of it?

To serve life, color must find natural expression. Too many fanciful theories have been propounded, too much that is abstruse, artificial and arbitrary. Man's love for the spectrum is essentially primitive. Red, yellow, green and blue are eternal appeals. Within man's nature taut chords stretch which for centuries have thrummed exotic melodies. Through mysticism, religion, philosophy, science and psychology he has struggled to define them. To define them, man, among his other pursuits, has gone to nature.

NATURE'S PURPOSES

Nature has functions for color and specializes in them. These functions have an important bearing on the art of color, because they reveal practices in which the business of existence is served before its pleasures. Fundamentally, nature's purpose is to adapt its creatures to environment. In this, nature is resourceful, not aesthetic. One of its simpler devices is to use color (and form) to give its children a likeness to something else. The walking stick looks like a stick. Caterpillars resemble dried leaves. Some have forked heads like twigs; others have leaf-vein markings and leaf-like contours. Dr. H. O. Farber describes a flat spider, ragged in shape and grayish in hue like a bird's dropping on a leaf. In that way, the spider is hidden from other eyes and able to forage for its food. Various butterflies and moths are hard to distinguish from flowers, lichens and the bark of trees. Again nature frequently gives one insect a likeness to other insects; certain small spiders resemble the dreaded ant, beetles are wasp-like, flies look like small bees, and the Viceroy butterfly resembles the unpalatable Monarch butterfly.

Among higher animals, harmless snakes look like poisonous species. The sand crab fixes seaweed to its back and hides in its own garden. The tree sloth of South America grows green algae on its oily fur, hangs upside down during its daytime sleep, and is securely hidden.

The Giant Stick, an insect that is hard to distinguish from the twigs and branches on which it climbs to seek food

Life from the sea. Brilliant color, pattern and instantaneous color change are common to many fishes

The art of camouflage is skillful and colorful. Nature commonly gives her creatures a similar appearance if they dwell in the same habitat. A moth, a toad, a bird and a mammal may all be brownish. Green may be found among caterpillars, frogs and snakes living in the same community. Desert animals are generally light; water birds soft and toned in hue. Jungle birds may be gaudy; mammals, drab like the earth. Shore fishes may be brilliant with color; others, that swim in the mud, mottled and dark. In the open sea, nearly all fish are colored alike.

By confusing the eye with weird patches of design and color, nature is able to defy a clear visual perception of butterflies and moths, birds, snakes, zebras, leopards and tigers. The mallard duck, with its patches of green, blue, purple, white, black, is effectively lost amid rocks, weeds, marine flowers and the like. The peacock, macaw, scarlet tanager, hummingbird, jay, kingfisher and hundreds of others have bold colorations, which are beautiful but are primarily designed for self-protection.

When the creature is equipped with formidable weapons, nature may make it conspicuous rather than inconspicuous. Tree frogs, cobras, coral snakes, magpies, skunks have little to fear, and they flaunt their baroque raiment.

Most mammals are brownish, blackish, grayish or white. Purer hues are rare, but are seen in the faces and rumps of certain monkeys and baboons. Colors may change with change in season. The brown stoat becomes the white ermine in winter. The mountain hare dons white with the coming of snow.

COLOR CHANGE

Nature also perfected a quick-change magic. In the course of their lives, caterpillars, butterflies and crabs may modify their hues as their environments change. Shrimps may adapt their colors to their hiding places. One species will change to a transparent blue at night and remain so until the burst of dawn. Instantaneous color change is nature's most surprising legerdemain. Some crustacea (lobsters, crabs, shrimps) will match their coloration to the surface on which they rest. The crangon has a repertoire of white, yellow, red and black. Like other such protean creatures, its skin is covered with pigment cells or chromatophores. Stimulation comes through the eye, and the cells expand or contract to bring forth the numerous vestments—not only distinct colors, but even mixtures and degrees of brightness.

Flatfish, plaice, sole and flounder shift in pattern as well as hue, resembling sandy or rocky ocean bottoms. The cuttlefish has a similar ability, plus an ink bag with which it throws a "smokescreen" about its enemies. Many tropical fish have palettes as varied as the rainbow, six or more individual appearances being a natural talent. These colors will flash and shift intermittently and for no apparent reason. Authorities insist that there is not much biological significance in the guises; the fish may be affected by fright, anger or distress, but most are too agile to need the protection of camouflage. But nature, always practical, may have in

The large three-horned chameleon of the Congo. Change of color and pattern is almost continuous during waking hours

view "warning and immunity coloration, signal and recognition marks and sexual selection."

In the chameleon, the most familiar trouper in nature's show, expanding and contracting pigment cells are supplemented by refractive granules under the skin. Normally, the chameleon is a brilliant emerald green. It is extremely sensitive to light and will undergo change even while at rest. As it moves, its hues shift and melt into one another. The transformations seem to be regulated by direct-wire connections from the eye. When enraged, however, the creature will bluff its adversary with a black cloak and a great pink mouth opened wide.

Nature employs color with great versatility, using reflection, refraction, dispersion, interference and electricity. It places tiny lens-like structures in certain mosses to make them gleam, produces iridescence and fluorescence in seaweed and, using chemicals, compounds will-o'-the-wisps in swamps, phosphorescence in molds and fungi, in decayed wood and rotted leaves.

With living things nature fashions colors without end. Bacteria may be red, green or blue, giving hue to dead foliage, soupy ponds and the blue-green pus of human blood. The natural blue color of the sea is changed by minute floating organisms to green in the Arctic and red in the Red Sea.

COLORS THAT SHINE

The luminescence seen upon the still ocean is due to microscopic life that shines, according to Julian Huxley, like "miniature pillars of fire gleaming out of the dark sea." About thirty different kinds of luminous bacteria are known. Some grow on dead fish and were noted centuries ago by Aristotle. Another type has been known to attack butcher shops in seaside towns and to cause their meats to glow. Frequently, small animals like the sand hopper will make a meal of them and promptly be converted into the bright aspect of glowworms.

In less minute creatures, luminous colors shine with the intensity of lanterns. J. Arthur Thomson in *The Outline of Science* describes an expedition by the Marquis de Folin in which coral was dredged from a great depth. "There were many coral animals, shrub-like in form, which threw off flashes of light beside which the twenty torches used for working by were pale. Some

of these corals were carried into the laboratory, where the lights were put out. There was a moment of magic, the most marvelous spectacle that was given to man to admire. Every point of the chief branches and twigs of the coral Isis threw out brilliant jets of fire, now paling, now reviving again, to pass from violet to purple, from red to orange, from bluish to different tones of green, and sometimes to the white of overheated iron. The pervading colour was greenish, the others appeared only in transient flashes, and melted into the green again. Minute by minute the glory lessened, as the animals died, and at the end of a quarter of an hour they were all like dead and withered branches. But while they were at their best one could read by their light the finest print of a newspaper at a distance of six yards."

The show goes on. Luminous hues radiate from sea worms, jellyfish, various shell fish, cuttlefish, squid and the Portuguese Man-of-War. One squid emits enough light to enable a person to read.

A well-investigated crustacean has been found to produce its light by the action of a ferment upon a light-producing substance through oxidation. In 1887, Dubois, a French zoologist, experimented with a luminous bivalve which bores holes in seaside rocks. He removed luminous tissue from the animal, kept some in cold water and some in hot water, and discovered that when the two batches were mixed luminescence was again produced. Today, it is generally believed that luminescence occurs in the presence of oxygen and water and is due to interaction of two substances, one of which oxidizes the other in a rapid chemical process. This light may either be confined to certain cells, as with the glowworm, or generally secreted over the body, as with some crustaceans.

Recently, much has been learned about the luminous colors of deep-sea creatures. Some have organs like eyes, which emit light. There, at the ocean bottom, where total darkness and tremendous pressure are combined with almost freezing cold, all is calm, silent, plantless and monotonous. The creatures which haunt those forlorn places have been curiously equipped with highly developed senses of touch, and more vital, perhaps, they are nearly all luminous to some degree. Descriptions of some of them read like fantasy. One is dense black without scales but with two rows of luminous spots

Luminous deep sea fishes. From the Deep Sea Group, Hall of Fishes, American Museum of Natural History, New York

along its sides. The upper row shows green, blue and violet; the lower row, red and orange—like a double-deck steamer. A smaller fish is velvety black and has about fifteen hundred luminous organs. Another eel-like creature is luminous throughout its sleek length. A deep-sea cuttlefish has regular porthole lights. The Melanocetus carries a lantern on the end of a stalk, possibly to see with and to fish by.

Luminescence does not occur in any creatures higher than the fish and insect. At times, however, the growth of bacteria may give phosphorescence to the wings of birds and the fur of animals. Much of this colorful light is fairly intense. The glowworm's emissions have been found to contain visible light only, of a cold nature and without energy wasted in infra-red and ultra-violet radiation. The light will affect a photographic plate, produce fluorescence in many substances, cause plants to bend toward it and stimulate the growth of chlorophyll.

What is the value of luminescence to the animal? In fungi and bacteria it appears to have no purpose. The shrimp which feeds on a diet of luminous organisms dies—achieving its own destruction and the destruction of the bacteria. In deep-sea creatures it unquestionably has utility. It may prove a lure to attract food, frighten intruders, and serve as a lantern to help get about. In a definite pattern it may help kin find kin or be a sex signal. The toadfish, for example, is luminous only at mating time.

The peacock. The colors of its feathers are not due to pigments but to tiny structures that break up the rays of light

Among fireflies and glowworms, the sexual attraction of light seems to be most important. In one British species, the female is wingless, creeps on grassy banks, and is far more luminous than the male. Her signal is more prolonged and she may call a whole circle of suitors about her.

Finally, what of these colors? How varied are they? In the glowworm one can distinguish a pale green. Green is also found in certain brittle stars, blue in the Italian firefly and red in some sea squirts. Purplish color is found in coral. In general, the most common hues are pale blue and pale green. The colors of deep-sea fish are likely to be brighter and more varied, and may run the full range of the spectrum. One cuttlefish with twenty luminous spots was found to gleam with deep blue, rich red, pale blue and silvery white.

NATURAL PIGMENTS AND DYES

Nature's color art is functional and a constant reminder that color in human life should be useful as well as beautiful though, in nature, achieving beauty is only incidental to more vital concerns. To vie with nature's beauty, man has gone to nature for dyes and pigments with which to adorn his art. In doing so, he took the road of chemistry, studying pigments and compounds, the materials which provide the mediums for the art of color. Primitive man was essentially a chemist when he squeezed juices from plants to make dyes, when he dug clays and burned woods and bones to smear his handiwork and flesh.

COLORS IN NATURE

It is known today, however, that not all colors are chemical in nature. The rainbow, the luster of an opal, a drop of oil on water, iridescence in a peacock feather are phenomena of light caused by refraction, diffraction, interference, polarization, etc., and are more related to physics than chemistry. Many non-metallic colors found in birds, such as the blue jay, are formed by small air bubbles in the horny mass of the feathers. In these instances no pigments are involved,

The colors of the Mallard duck are interference colors and are iridescent, changing in hue when seen from different angles

The colors of butterflies are as varied as the rainbow and are produced in a number of ways, both physical and chemical

only a legerdemain in which bundles of white rays are scattered by suspended particles or split apart into their component colors as they pass through screen-like or crystal-like surfaces or thin films.

Structural colors and pigments are well described by H. Munro Fox and Gwynne Vevers in *The Nature of Animal Colors*. Interference colors—seen in soap bubbles and oil on water—are visible in peacock feathers, the brilliant head of the mallard duck, the wings of iridescent beetles, dragonflies and butterflies. Here, the spectrum's colors are separated by thin films and flash and change when seen from different angles.

Light diffraction accounts for the lustrous colors of mother of pearl. Scattered light accounts for the blue of the sky which "breaks up" blue rays of light more readily than red rays. At sunset, however, heavy particles in the air (dust) also scatter rich yellow, orange and red hues.

Light scattering accounts for blue eyes, blue feathers, the face and rump of the mandrill. Where the blue scattering mixes with the red color of hemoglobin in the blood, other phenomena are apparent. The blue in a man's shaved chin may be due to scattered light plus black in the hair roots.

Green, as seen in feathers, frogs, lizards and snakes, usually represents a mixture of scattered blue light with yellow pigment— much as an artist mixes paint. Probably no

Light diffraction accounts for the lustrous colors of mother of pearl. The shell itself is colorless

green pigment is involved. The whiteness in feathers and fur may be due to light scattered by tiny air spaces, a phenomenon similar to that of snow and frost.

The large majority of hues seen by the eye, however, owe their existence to selective reflection, absorption or transmission. This includes dyes and pigments. The principle is simple. A red surface absorbs most of the rays at the blue end of the spectrum and reflects the rest. In transparent material, the rays that compose red are the ones transmitted; the rest are screened out.

In nature, chlorophyll accounts for the green hue identified with plant life, and it still remains a scientific mystery. However, the particles are "green" because they nearly always reflect or transmit the rays of green light that strike them. There are other pigments besides chlorophyll, some of which are dissolved in the cell sap. Another group consists of solids, insoluble particles found in the protoplasm of cells and called *plastids*. In addition to green *chloroplastids*, there are *chromoplastids* ranging in color from yellow to red. *Carotenes* give hue to carrots, pumpkins, tomatoes, gold fish and blond hair. *Xanthophylls* color dandelions, sunflowers and buttercups. *Anthocyanins* are the particles in red, blue and purple flowers. Nature puts them there not so much to delight the eye of insect, bird and beast as to make up the efficient chemical factory that gives life and growth to the plant.

The human flesh of the races of man has five basic hues. Melanin, a brownish color, and its derivative, melanoid, when found in abundance account for the dusky shade of the Negro—when they are in short supply, for the "white" man. Ultra-violet radiation increases melanin production and accounts for sun tan.

Second is yellowish carotene. Women generally have fairer complexions because they commonly have greater amounts of carotene and lesser amounts of melanin than men.

At times sweat may also be colored. Granular pigment may be secreted, usually from hair follicles, and the sweat may be colored black, green, blue, red or pink. In 1709, an unfortunate girl who, under stress, turned "dark as a negress," was promptly accused of being bewitched. In the animal kingdom, the hippopotamus exudes red perspiration.

The fourth and fifth colors are in the blood: oxyhemoglobin and oxygen-free hemoglobin. These pigments give the blood

The hippopotamus, despite its ugly bulk, exudes red perspiration. Colored sweat is not uncommon in nature

In the ancient art of making colored pigments and dye-stuffs, purple came from the secretion of a shellfish, Murex

its characteristic pink cast and are seen in the wattles of a rooster or turkey. Blueness in the skin is due to the scattering of light, the same as in the human eye, for flesh is translucent rather than opaque and has real depth.

Where the color effect in nature involves "scattering" light and pigments, physics and chemistry join hands. This is true of the colors of eyes. Nearly all infants have blue eyes at birth. Minute particles in the fluids of the eye scatter the light that enters, just as particles in the air make the sky blue. As the child grows, a yellowish brown pigment forms behind his iris. The iris now becomes a sort of lantern slide through which blue light shines. The combination of this blue with the brown iris makes up the wide variety of green, hazel, brown, gray and black eyes seen in humans. Blue eyes may turn brown, but brown eyes are not likely to turn blue.

ANCIENT COLORS

Making pigments is an ancient art. The Egyptians practiced it as a forerunner to alchemy. Although they tried to produce hues artificially by mixing chemicals, such success was not achieved until the 19th century.

Early paints and dyes were made from colored things. According to the historian Josephus, pigments used in Biblical times were commonly derived from the cochineal insect (for scarlet), from a shellfish called Murex (for purple), from *lapis lazuli* (for blue), and from madder, pomegranate peel,

the fresh shells of walnuts and a kind of onion plant. Vermilion came from cinnabar. From soils came browns, yellows and dull reds. These substances were washed, ground and mixed with oils. For other shades certain clays were burned: a soil called umber turned from a dull grayish brown to a rich chocolate hue; sienna turned from dull yellow to rich red. Whites came from chalk, lime and gypsum.

Mineral colors came from ores such as copper, lead and iron. The word *cobalt* meant goblin, the demon of the mines and a troublesome substance to gather. It gave a permanent blue color to glass, porcelain and earthenware. Another blue was made with wood and oxblood, burned together and mixed with iron. The finest blacks were made from animal teeth and shin bones, which were crushed and roasted, from the smoke of certain oils and from burnt pieces of ivory.

The color sepia came from the inkbag of the cuttlefish, a dye which the animal used for its own protection

Sepia came from the inkbag of the cuttlefish. Two Mediterranean varieties of snail were crushed to make purple. Great heaps of the shells are still found on the Tyrian shore from which the color got its name. It is said that two hundred and forty thousand of these marine creatures, called Murex, were required to produce a single ounce of dye. It was therefore extremely costly. This led to the phrase, "born to the purple." Red came from the dried body of an insect.

The great majority of pigments, however, came from the vegetable kingdom. Red came from madder roots and from the inner bark of the birch tree. Yellow came from the sap of a tree; from the bark of the ash; from crabapple, plum and pear leaves; sumac twigs; and onion skins. Green came from elder leaves and from the bark of the larch tree. Blue came from the indigo plant, from elderberries and the roots of the iris flower. Purple came from plums and from dandelion roots. Brown came from walnut husks, the stalks of hops, waterlily roots, oak bark. And there were colors of every variety from lichens and mosses, fruits and flowers.

These colors were used in all the crafts: weaving, pottery, painting, the decoration of flesh and masks. Secret processes were guarded and passed down from one generation to another. In England today, many woolen fabrics of subtle beauty are still dyed from materials derived from nature.

MAN-MADE DYES

In 1828, Friedrich Wohler made the first organic compound, a revolutionary step in chemistry. But the real glory goes to William Henry Perkin, a lad of eighteen who discovered the first of the aniline dyes, a coal tar product, in 1856. Coal tar was at one time a waste material left over in the manufacture of gas. Perkin, in an attempt to prepare artificial quinine, discovered "mauve," the first of the aniline dyes. Later he discovered how to produce the coloring matter known as alizarin crimson, which had been made from the roots of the madder plant. Immediately, the science of chemistry took over much of the work of the old dye maker. The madder fields of France were tilled for other plants. Cochineal bugs and snails were left undisturbed. The aniline art, perfected in Germany, later forced the French and English to cross the Rhine and English Channel for dyes with which to color the red trousers and coats of their soldiers.

Thousands of dyes have since been created from coal tar, from natural carbon compounds and from artificially produced organic chemicals. How?

Generally the more complex chemical structures are built around the element carbon; secondly oxygen, nitrogen, hydrogen, and sulphur. The basis of the new art is the atom. The atoms of the elements differ in what is known as "valence," the "hands" of the atom. A hydrogen atom has a valence of one—only one "hand." Oxygen has a valence of two, aluminum three, carbon four, nitrogen five, chromium six. Hydrogen, for example, having only one "hand" can take hold of only one of the outstretched hands of any other atom.

Modern chemistry is now able to combine these atoms in various arrangements and thereby produce colors of almost infinite variety. Chrome yellow, for example, is produced by combining clear solutions of lead nitrate and sodium chromate. In many instances, the original compounds are colorless but will blaze forth with hue when mixed together. More than two thousand individual color compounds have been built around carbon and are in everyday use.

The manufacture of color has become a giant enterprise. Here a Fadeometer is used to check permanence of dye-stuffs. Courtesy, National Aniline Division, Allied Chemical Corporation

162

Chapter 16

PLANTS, INSECTS, BIRDS AND BEASTS

What are the effects of color in the so-called vegetable and animal kingdoms, the poetic flora and fauna, and what are its effects on man?

Science generally recognizes that visible light is essential to the growth of plants. Infra-red light has much the same action as darkness. Some plants are elongated while others show no reaction at all. Ultra-violet light alone is harmful and will destroy the plant. Although rays longer and shorter than visible light are found in sunlight, nature has apparently effected a practical balance so that visible light is the chief requirement of sound growth and development.

Men and plants have survived under the same conditions. Why should visible light be imperative to plants and of negative value to human beings? And why should infra-red and ultra-violet, which may have neutral or destructive effects on plants, be declared therapeutic for human beings? It is my conviction that the benefits of visible light to human life are not yet properly understood, and that time and research will eventually divulge them.

EXPERIMENTS WITH PLANTS

One of the earliest investigators of the growth of plants under colored light was Tessier of France (1783). Working with colored screens, he noted marked growth differences under various hues. However, it was General A. J. Pleasanton of Philadelphia who, during the period between 1860 and 1870, expounded a series of startling theories that inspired and enraged the botanists and horticulturists of his day. In *Blue and Sun-Lights*, Pleasanton declared that the blue sky held the secret of the bounty of life, blue "for one of its functions, deoxygenates carbonic acid gas, supplying carbon to vegetation and sustaining both vegetable and animal life with its oxygen." He constructed a special greenhouse which had one pane of blue glass for every eight clear panes. With grapes he claimed a growth of forty-five feet (with one-inch stems) for the first year, a crop of twelve hundred pounds of grapes for the second, and two tons for the third. Grapevines not so treated under blue light required five or six years to be productive at all. His facts, however, seem to have been exaggerated.

From experiments with hogs and a bull calf, Pleasanton reported to the Philadelphia

General A. J. Pleasanton's greenhouse, 1860-1870. He claimed amazing results with plants and beasts exposed to sunlight and blue light

Society for Promoting Agriculture: "If by a combination of sunlight and blue light from the sky, you can mature quadrupeds in twelve months with no greater supply of food than would be used for an immature animal in the same period, you can scarcely conceive of the immeasurable value of this discovery to an agricultural people!"

Pleasanton's rapture over blue light was not shared by other researchers who followed. In 1895, C. Flammarion reported best effects for red light. He grew plants in hothouses under red, green, blue and clear glass, attempting in a crude way to equalize light intensities. Red seemed to produce taller plants but with thinner leaves, and blue created weak, undeveloped plants.

In 1902, L. C. Corbett supplemented daylight with artificial green, blue and red illumination in a greenhouse at night. He witnessed the markedly stimulating effect of red upon the growth of lettuce.

These biological effects of illumination became something of a "rage" at the turn of the century. Yet, from the reports of numerous students, the unusual results seem to have been brought about, not so much by any positive action of colored light, but rather by the negative effect of reduced light and lack of radiation. Thus, Fritz Schanz in 1918 conducted tests in which he withheld certain energy in the sun's spectrum. He attempted to prove that ultra-violet light checked plant growth. His plants grew tallest when blue-violet energy was cut off. Schanz therefore concluded that light of short wavelength was detrimental—yet he, too, did little to equalize light intensities.

In 1926, H. W. Popp carefully worked with colored lights of approximately equal intensity. He grew plants in five small greenhouses, each covered with a special type of glass. His most startling effects occurred when short wavelengths were eliminated. Yet he also believed that a balance of light was best. "The results as a whole indicate that the blue-violet end of the spectrum is necessary for normal, vigorous growth of plants. They also indicate that ultra-violet radiation is not necessary, although it may not be without influence."

An excellent review of color and plant growth was given by Earl S. Johnston in the 1936 report of the Smithsonian Institution, *Sun Rays and Plant Life*. Johnston pointed out that under the action of light carbon dioxide and water were united in the presence of chlorophyll to form simple sugars. These sugars were elaborated into starch, proteins, organic acids, fats and other products. Most of these compounds were foods for the plants as well as for the animals that came to feed upon them. Further, the growth of the plant was vitally affected by the length of day, the intensity of light, and by color even more than by temperature and moisture (which also depend on light).

LENGTH OF DAY

Of primary importance to plant growth is the duration of sunlight and darkness. At the equator there are approximately twelve hours of sun and twelve hours of night each day. At the poles, there may be twenty-four hours of sunlight in summer and twenty-four hours of darkness in winter, and intermediate latitudes range between these two extremes. These factors may, in part, account for the wide range of vegetation in the world.

Johnston noted that some plants are short-day and others long-day, the former maturing in spring or summer, the latter in fall. In an experiment with the Mammoth Maryland tobacco plant (a short-day type), it was learned that it would not flower under long-day periods of summer light; in short, a long day delayed its seeding. Under winter greenhouse cultivation, however, it flowered naturally. When sunlight was supplemented by electric light to lengthen the day, the flowering could again be delayed.

An article by Victor A. Greulach (*Science Digest,* March, 1938) states: "Among the common short-day plants are asters, ragweeds, dahlias, cosmos, poinsettias, chrysanthemums, cypress vines, nasturtiums, soy

beans, tobacco, and all the early spring flowers such as violets and bloodroots. Most garden vegetables and farm crops are long-day plants. Wheat grows rapidly under long days. By using electric light to increase the day length, three generations of wheat have been grown in one year. The extremely long summer days in Alaska are largely responsible for the large crops of hay, wheat, potatoes, and vegetables grown there. It is principally due to the longer days in the northern part of the central valley of California that oranges from that district are ripe and ready for the market several weeks earlier than those grown four hundred miles farther south.

"We usually think of everblooming or everbearing plants as being particular species of varieties, as of roses or strawberries, but many plants may be made into everbloomers by keeping the length of day within their natural flowering range. For most plants this range is quite narrow, so we have few everblooming plants in the temperate latitudes, where the day-lengths are constantly changing. In the tropics, where the day-lengths are at or near twelve hours all year, everbloomers are the rule rather than the exception, just as you would expect."

W. W. Garner and H. A. Allard reported a strange reaction of plant growth to light exposures of extremely short duration. Their work was included in the Johnston report. Groups of plants were exposed to light each day for 12 hours, 1 hour, 30 minutes, 15 minutes, 5 minutes, 1 minute, 15 seconds and 5 seconds. The result was a steady decrease in size, height and weight for the groups exposed less than 12 hours on down to 1 minute. Then, for some unexplained reason, the plants exposed for less than 1 minute showed marked improvement. The plant exposed for only 5 seconds grew to the same height as the plant exposed for 1 hour, while the plants exposed for intermediate intervals (30 minutes, 15 minutes, 1 minute) were dwarfed. All intervals below one hour were unfavorable for flowering, however. Johnston comments: "These are exceedingly interesting growth responses to the duration of light and to date no satisfactory explanation has been given."

By using artificial light to supplement daylight, Dr. R. B. Withrow has achieved results that seem out of proportion to the

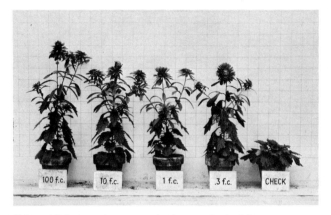

Effect of light intensity on growth of asters. Little difference was noted from less than one footcandle of light energy to one hundred footcandles. After R. B. Withrow

treatment applied. He experimented with Mazda light for night illumination and arranged intensities from 1 to 100 foot-candles. He discovered that very little difference was shown in the growth of an aster. In fact, the one exposed merely to 3 foot-candles grew almost as well as one exposed to 100 foot-candles! Dr. Withrow also experimented with color and found that responses differed for short-day and long-day plants. In the long-day plants, such as the stock, greatest response occurred in the red region. The plant grew tallest under orange-red light. The next best growth was under red. Under yellow, green and blue, the plant did not grow tall nor did it flower, although the foli-

Effects of different colored light on growth of the stock plant. Red promoted flowering; blue stimulated leaf growth. After R. B. Withrow

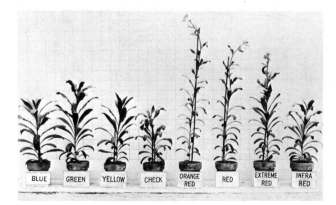

age was abundant. A plant treated under infra-red did not flower, despite the fact that the infra-red band lies next to visible red and red-orange in the spectrum. With short-day plants (cosmos, salvia), supplementary red light hindered flowering.

In the Johnston report Dr. Withrow pointed out what such control means commercially. Supplementary light and color may be used to cause earlier and increased flowering for such plants as the aster, Shasta daisy and pansy; delayed flowering may be produced in the chrysanthemum, but no significant results were noted in the rose or carnation.

RECENT INVESTIGATIONS

Much research is now being conducted on the effects of light and color on plants, with considerable influence on horticulture. Among prominent investigators in the field are H. A. Borthwick of the U.S. Department of Agriculture, Stuart Dunn of the University of New Hampshire, and R. van der Veen and G. Meijer of the Philips Research Laboratories in Holland (to mention but a few). It was Borthwick who noted an antagonism between visible red light and invisible infrared. Red would cause lettuce seed to sprout, for example, while infra-red would put the sprouts back to sleep. Similarly, red would

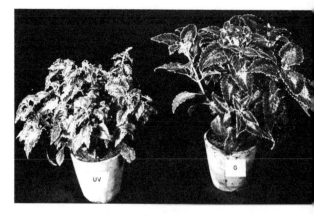

Coleus grown in white light (right) and white light with ultra-violet (left), show inimical effects of invisible short-wave radiation

inhibit flowering of short-day plants and promote flowering of long-day plants. R. van der Veen and G. Meijer reported that there was maximum absorption of red light and hence maximum plant action. Blue also has its effects, but yellow and green are neutral or reduce activity, and short ultra-violet will destroy the plant. What is unusual is that plants seem most responsive to red and blue, and inactive to yellow and yellow-green. However, the human eye finds maximum sensitivity (visibility) to yellow and yellow-green. In handling plants in a greenhouse under artificial light, weak green illumination is "safe light," for there is little, if any, plant response to it. "This safe light is to the plant physiologist what the ruby light was for the photographer."

The day is coming when there may be greenhouses without glass, and the science of phytoillumination, meaning the use of artificial light to aid plant growth, will take over. Natural light is temperamental, but artificial light can easily be controlled. Such light will probably be dominant in red and blue, with green (which the plant doesn't seem to need) kept at a minimum to conserve electric power. There will be a peak in the visible red region of the spectrum where chlorophyll absorption is maximum.

Stuart Dunn's findings in growing tomato seedlings are particularly interesting. "The yield produced by the Warm White lamps was highest of all the commercially available fluorescent lamps. Next to it stood that of

A short-day plant, salvia, grown under long-day conditions (16 hours) under red, green, blue and blue plus infra-red radiation. From Light and Plant Growth, *van der Veen, Meijer*

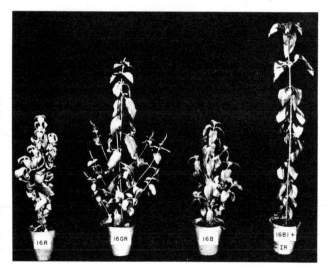

The new science of phytoillumination, the growth of plants under artificial light. View shows section of plant physiology laboratory at University of New Hampshire. Courtesy, Stuart Dunn

the Blue and Pink lamps. Green and Red were low. The experimental 'high intensity' red lamps produced the highest yield of all." (Sylvania Lighting Products, by the way, manufactures a "Gro-Lux" fluorescent lamp for phytoillumination.) "Stem growth (elongation) is promoted especially by the yellow part of the spectrum." However, "Succulence is increased by the long wavelengths (red) and decreased by blue light."

Growing flowering plants completely under artificial light is fast becoming a national hobby. And as it does, the mystery and magic of color become more impressive.

A further curiosity is that some plant life has an aura! In 1923 Alexander Gurwitsch wrote of discovering so-called "mitogenetic energy." An onion, for example, may emit rays in the shorter ultra-violet region of the spectrum, such energy passing through quartz but not through glass. Although of extremely low intensity, it has tangible and measurable existence. Though Gurwitsch's work was ignored for some years, it was later verified by subsequent investigators. Today the phenomenon is still shrouded in mystery, with various scientists holding bitterly conflicting opinions.

INSECTS, BIRDS AND BEASTS

In going from plants to animals, it is interesting to refer to some of the work of John Ott of Illinois, perhaps the greatest of time-lapse photographers. If, on TV or in the movies you happen to see brief sequences that show the budding and flowering of plants, it is probably the work of John Ott. By controlling light and moisture, Ott has been able to synchronize music to the dancing of primroses and tiger lilies. The primrose sequence, which took Ott five years to make, takes only two minutes on the screen. Working with controlled light sources as well as daylight, he has encountered several weird phenomena. Chrysanthemums can be made to flower any month of the year by regulating their exposure to light, cutting it off in the long days of summer, or lengthening the short days of winter with extra hours of artificial illumination. This practice is now universally used by florists in greenhouse cultivation of chrysanthemums and poinsettias. According to Ott, blue light and filters caused morning glory buds to open. Where the light source was "warm" in na-

Stills from a John Ott time-lapse motion picture of flowering of the passion flower

168

ture, buds tended to collapse and shrivel. Ott writes, "It is the specific band of wavelengths at the red end of the spectrum that were the controlling factor in preventing the morning glory buds from opening normally."

With the pumpkin, which has separate male and female flowers, Ott discovered quite by accident that regular fluorescent light withered the female flowers but not the male. When bluish daylight fluorescent tubes were employed, the reverse happened, the male flowers withered and the female blossomed. As Ott writes, "The fact that either male or female flowers can be brought forth by controlling slight variations in color or more length of light, opens up some interesting possibilities for investigation."

Indeed it does. In Ott's book, *My Ivory Cellar,* he notes that length of day may explain the mystery of bird migration. Chickens will lay more eggs in winter if their coops have artificial light added to the end of daylight. However, if the artificial light was pinkish, the hens tended to lay infertile eggs. Eggs from other hens exposed to daylight fluorescent light had normally fertile eggs. Ott also discovered that pink fluorescent light caused a preponderance of fish eggs to be female. With chinchillas, blue light bulbs seemed to do the same, leading to litters of more females than males. "It would . . . indicate that the sex of the offspring could be influenced well along during the pregnancy."

Ott believes in a "theory of the importance of the full spectrum of sunlight energy." He refers to the potency of daylight in the health of virtually all living things. Of human ills, he writes, "Some doctors have said cancer is a virus or at least is in some way associated with it. If this is so, then the possibilities of influencing body chemistry by the characteristics of the light energy received through the eye might conceivably be an important factor in the metabolism of the individual cells of the tissues of the body."

Living things on earth have been conditioned to solar radiation through countless ages. Had this energy been different, no doubt the world—and man—would have been different (had they existed at all). Because solar radiation is predominant in rays of light visible to the human eye, with added shorter waves in ultra-violet and added longer waves in infra-red, these frequencies must be vital to animal life (and to plants) and must influence it accordingly.

REACTION TO LIGHT AND COLOR

Most living things not only react to light but are strangely sensitive to it. The lowly amoeba, for example, "sees" with its entire organism, moving or contracting itself as the light stimulus changes. Taken out of darkness, the amoeba may grow quiet. After a while, motion may be resumed until still another intensity strikes it. However, if the change of light is gradual rather than sudden, the amoeba may go about its simple business without much ado.

Certain species may have definite preferences for light intensity, moving about until a satisfactory brightness is found. Green hydras collect in relatively weak light; medusae collect in shaded regions; some polyps have a day-night rhythm. N. R. F. Maier and T. C. Schneirla write, "The place in which the animal finally settles is mainly determined by light, by the amount of oxygen in the water, and by the temperature. Except at extreme temperatures, or when the animal has been without food for some time, light is the most important factor."

Such creatures as worms are made uncomfortable by light, and some marine forms will move until they find darkness. Light from one direction will drive them in the opposite direction. General light overhead causes them to waver aimlessly. The earthworm, of course, fears light even more than it does the robin, and will remain in nether regions until actually flooded out. Likewise, the cockroach scampers away from the light, and moths flutter toward it.

Color vision is not apparent in the lowest forms of animal life. It does exist in insects, fish, reptiles and birds, and though lacking in most mammals, is present in apes and men.

Insects' color vision differs from that of men. Scientists are largely agreed that the eye of the insect responds to the yellow region of the spectrum (but not the red) and is

The vision of the bee differs from that of man. Many insects are "blind" to red, but can see green, blue and ultraviolet

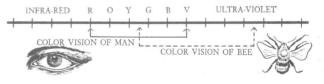

sensitive to green, blue, violet, up to ultra-violet. In experimenting with fruit flies, E. N. Grieswood noted a reaction to wavelengths invisible to man, which in shortness of frequency approached X rays. In similar tests, L. M. Bertholf found the range of sensitivity in bees to extend from about 550 millimicrons (yellow-green), through green, blue, violet and into waves as short as 250 millimicrons (ultra-violet). The human eye is sensitive to a region extending from about 700 millimicrons to 400.

Insects show definite color "preferences." Ants placed in a box illuminated by a complete spectrum of sunlight will carry their larvae (always kept in darkness) out of the ultra-violet and into the visible red. Von Frish has demonstrated that bees can be made to see the difference between a blue and a gray of the same brightness, and can also differentiate blue from violet or purple, and yellow from any of these. This has been demonstrated by training bees to fly to certain colors to obtain food. The bee is hopelessly confused by red and cannot differentiate it from neutral gray targets. H. Molitor found that when wasps enter a nest, they prefer a black entrance to a blue one, and

The enlarged head of a honeybee worker

blue to red. Red seems to interfere with normal growth of cockroaches. The Oriental peach moth, when given a choice, is most responsive to blue and violet. With silkworms, violet light is active and red light inactive. A group of researchers (H. B. Weiss, F. A. Soroci, E. E. McCoy, Jr.) in testing about 4,500 insects, mostly beetles, found that seventy-two per cent reacted positively to some wavelength: thirty-three per cent to yellow-green, fourteen per cent to violet-blue, eleven per cent to blue, and eleven per cent to ultra-violet. Few showed any attraction to warm colors. "It thus appears that in general the shorter wavelengths of light are more stimulating and attractive, whereas the longer wavelengths are considerably less stimulative and perhaps repellent in nature to coleopterous (beetles) forms of life."

INVISIBLE COLORS

Frank E. Lutz in his *Invisible Colors of Flowers and Butterflies* has assembled many interesting facts about the "invisible" colors of plants and insects. Not only does the butterfly have a sense of vision different from man's, but the patterns on its wings may also appear different to insects than to human beings. Obviously, the butterfly finds real significance in ultra-violet energy. A red zinnia, for example, does not reflect ultra-violet while red portulaca does. Hence the two flowers, while alike to men and probably to birds, appear dark and light respectively to the butterfly.

Lutz writes: "While not all yellow flowers ... are ultra-violet, most of them seem to be. In this connection a yellow spider much given to hiding in yellow flowers is interesting. According to theory, the yellow color of the spider prevents flower-visiting insects from seeing it against the background of a yellow flower in time to avoid being caught. However, the spider is only slightly ultra-violet and, so, to an insect that can see ultra-violet the yellow spider must be rather conspicuous as it sits on a yellow ultra-violet flower."

Similarly, the patterns of moths and butterflies differ under natural and ultra-violet light so the creatures "look" different to themselves than they do to man.

In experimenting with night-flying insects, L. C. Porter and G. F. Prideaux have found that brightness is a dominant factor in

attraction power. Next to this, the more a source of illumination approaches the blue end of the spectrum, the more insects it will gather; the more it approaches the red end, the fewer it will gather. "The substitution of yellow lamps for white lamps of equal candle power reduces the number of insects attracted by approximately fifty per cent." Consequently, blue is the preferred hue; red and yellow the least noticed. Thus, a yellow lamp of low wattage over the porch, with a blue lamp of high wattage placed at a distance, will effectively divert invasion on a summer night. For daylight insect traps, however, using paints and not light bulbs, yellow seems to be most useful. Frederick G. Vosburg reports, "For some reason a yellow trap will catch more Japanese beetles than any other color."

FLIES AND MOSQUITOES

"Likes" and "dislikes" of flies and mosquitoes have been carefully studied with practical ends in view. (The results below are obtained from notes assembled by Deane B. Judd and presented in *News Letter* 45 of the Inter-Society Color Council.)

For houseflies, several investigations have led to contradictory results. E. Hardy, for example, found yellow to be avoided and white preferred. On the other hand, P. R. Awati considered yellow to have the greatest attraction, red and violet the least. O. C. Lodge found no preference at all. S. B. Freeborn and L. J. Perry found the fly repelled by pale colors, while R. Newstead had reason to conclude that light colors were preferred to dark colors.

In Holland horse stables and cow stalls are frequently treated with blue to get rid of the pests. So in Holland, at least, the flies must dislike that hue. Possibly the safest conclusion is that flies are more attracted to light than to darkness; the weight of evidence seems to indicate that much.

With regard to mosquitoes, however, authorities are in better agreement. Here, light colors repel. G. H. F. Nuttall and A. E. Shipley found that the common European malaria-bearing mosquito alighted most on dark blue, red and brown, and least on yellow, orange and white. (Subsequent to this particular report, the U.S. Army withdrew its regulation shirts in malaria districts and substituted lighter colors.) During five years in South Africa, Shariff found the pink and yellow mosquito curtains did not harbor insects. When boxes were lined with navy blue, pink, gray and yellow flannel, the interiors of the blue and gray boxes were thickly covered with mosquitoes, but only two or three were found in the pink or the yellow boxes. Hoodless also found that New Caledonia mosquitoes prefer blue and avoid yellow.

One of the most exhaustive books ever written on animal vision is Gordon Lynn Walls' *The Vertebrate Eye.* A comprehensive review of visual phenomena, it is replete with data on color as a factor influencing animal survival and behavior. Walls writes, "Color vision itself is a potent aid to visual acuity in its broad sense, and was certainly evolved for this application rather than for the aesthetic ones which it has come to have in human vision." That color may be tied in with the most primitive and mundane of life processes is not often acknowledged. Nature endowed its creatures with a sense of color in order to equip them for the practical battle of life.

REACTION OF FISH

Though color in the life of fish is far less significant than brightness, form and motion, Walls points out that "No fish is known *not* to have color vision." Scientific work on color vision is plentiful. R. Hess determined that fish see green as the lightest color, then blue, yellow, orange, with red the darkest color of all. "The intensity of any color needed to balance pure yellow was only half that required to balance green." According to Walls, "Fishes generally seem either to shun red, or to prefer it decidedly." This may be due, in part, to the fact that red radiation is quickly absorbed as it passes through water and is, therefore, not a common experience for fish. In experiments with mud minnows, Cora Reeves found that respiration rate rose with the increase of brightness. When ruby glass was placed across an artificial light source, respiration rate increased even more. "In this experiment it was perfectly clear that the response was to redness as such, since the respiration rose with an increase of brightness, but rose still higher when that brightness was somewhat reduced by a filter which introduced hue" (Walls). The influence of color on the behavior of fish has been proved by experiments such as these. Working with floun-

ders, S. O. Mast painted the floors of tanks in various hues. Where a fish had been blue-adapted, it tended to choose this color as a resting place and to avoid other hues. In experiments with tropical fish, Ott studied the effects of different wavelengths and intensities. The young produced under pinkish fluorescent light resulted in eighty per cent female and twenty per cent male. No young were produced under bluish fluorescent light.

Even feeble amounts of light will affect the normal development of fish. According to Ott, "When the death rate among brook trout eggs at the New York State Hatchery, Cold Spring, suddenly shot up to the ninety per cent bracket from under ten per cent . . . Dr. Alfred Perlmutter of New York University traced the cause to installation of new forty-watt fluorescent lights in the ceiling. Another investigator, working with rainbow trout, found that the violet and blue components of white or visible light are more deadly than the green, yellow and orange bands."

Fish capable of color change depend upon visual processes and lack the ability when blinded. Here again there is a curious disregard of brightness alone. Except under extremely high or low illumination, fish will not respond to gradual changes in the amount of light entering its eye. Yet the moment its substrate or background is modified in lightness or darkness, the skin of the fish will rapidly conform in "value" to it.

A turtle's ability to find water will perhaps always remain a mystery. Theories are many. One is that the turtle avoids shadow, knowing instinctively that clear reaches of sky are without overhanging verdure and therefore must have water underneath. Another theory is that blue is the attracting force. Certainly orientation to the sun is meaningless, for turtles will persistently move in any direction that is clear and unobstructed; and color may be the clue. In turtles, as in other reptiles, color vision is well developed. While discrimination of brightness and intensity is poor, colors are readily distinguished from grays. According to Walls, "The most important hues for the turtle appear to be orange, green and violet. Yellow and yellow-green, when not accurately discriminated, were apparently most often seen as orange; but red was separated from the general orange category and seemed to be more akin to violet for the animal, which thus had a closed color circle." Wagner, in studies of lizards, noted discrimination of red, orange, yellow, yellow-green, ice blue, deep blue and violet. Vision was keenest to red and blue, and weakest to green.

REACTION OF BIRDS

Response to color reaches a high development in birds. Here the organs of sight are intricate and versatile. Many birds, for example, have two foveal areas on their retinas, enabling them to see sharply while feeding as well as in flight. The eyes of birds also contain colored droplets (red, orange and yellow) and the predominating yellow droplets in most diurnal birds are a definite aid to vision. They cut out blue light, minimize glare and dazzle, and, according to Walls, let through, "unimpeded, most of nature's hues." Similarly, the red droplets aid the bird during early morning feeding when the sun's rays, slanting through space, are reddish in tint. The kingfisher (also the turtle) has a predominance of red droplets which unquestionably aid vision in glaring water. Perhaps for the above reason, most birds are partially blind to blue but see red colors with remarkable clarity.

Nocturnal birds, however, have few if any colored droplets in their eyes. Walls mentions that F. L. Vanderplank found the tawny owl sensitive to infra-red and apparently able to see its prey in "pitch" darkness by distinguishing the radiation of body heat. Infra-red energy, which had no action on the pupil of the human eye, closed the owl's pupil and frightened the bird. A subsequent study by Hecht and Pirenne, however, disputed Vanderplank's findings. They did not find the owl (though a different kind than Vanderplank used) very sensitive to infra-red. They concluded that the owl had an exceedingly low visual threshold, about ten times as sensitive as the human eye and responsive to the same part of the spectrum.

Color preferences among birds is definite and seems to be associated with their feeding habits. Hummingbirds favor red and will feed more readily from red vials or containers. In The Color of Life, Arthur G. Abbott points out birds' disinterest in the color green. Because rodents are color blind, poisons meant to destroy field mice and rodents can be dyed green so that birds will not touch them. "In one field the oats/poisoned/

were dyed yellow and green. In a third they were left uncolored. In the uncolored area twenty-eight birds were poisoned; in the yellow area, nine birds; in the green area, no birds at all."

Bird migration has been partially explained in terms of the length of day. As summer comes to an end and days grow shorter, a reaction takes place—possibly through action of the pituitary gland—which speeds birds to more favorable climates. Migration may even take place before crops and seeds are ripe, and before nature's autumn banquet is completely set.

In a series of fascinating experiments with birds, T. H. Bissonnette and others have proved that migration and sexual cycles are less dependent on temperature than on light. With the male starling, for instance, sexually quiescent during winter, testicle development occurred when the birds were given added light. This was also true of color. To quote Bissonnette, "Birds subjected to red light and white light were stimulated to testis activity. . . . The order of decreasing amount of germ-cell activity is therefore red, white, control, green, with green inhibitory."

REACTION OF MAMMALS

Bissonnette found similar results with mammals: "Increased night lighting induces cottontail rabbits to undergo sexual activity in winter." In experiments with weasels, ferrets and mink, he was able to achieve winter fur coloration during the hot days of midsummer. "It is, therefore, indicated that the assumption of white prime pelt by mink may be induced in summer in spite of relatively high temperatures or hastened in autumn by reducing the duration of the periods of light to which the animals are exposed daily."

Similar results were achieved with goats.

Though a cow will give milk the year around, goats are less generous. Because they usually fail to breed between April and September, milk supply may be interrupted. Bissonnette has demonstrated that breeding, and consequently milk supply, can be controlled. "Results indicate that breeding cycles in goats are controlled by daily periods of light in such a way that short days induce breeding while long days inhibit it."

Because most mammals are virtually color blind, their reaction to color is all the more interesting because it demonstrates the existence of forces to which the creature is visually indifferent. Yet color does startling things. Ludwig and von Ries found the same growth rate in rats under blue light as under normal light. Under red light, however, weight increased substantially. "They also expressed the belief that the activity of a hormonal substance was increased by red light, destroyed by ultra-violet light, and could be activated again by red light" (B. D. Prescott).[16]

Warm-blooded animals apparently have little need of a color sense. Walls writes, "In a survey of mammals, we can perceive no majestic progress in the evolution of color vision from an imperfect system in primitive groups to a complex one in the highly specialized orders." Cattle pay as much, or as little, attention to green as to red. Colored clothes hung on a line, regardless of their hue, will arouse equal curiosity in a bull. Cats, however, may be more sensitive to short wavelengths than more diurnal animals. The color vision of fish and birds reappears with many added refinements in apes and men. Monkeys distinguish readily between colors and can even be taught to match hues. Like plants, men and animals may have their lives, health and well-being variously influenced by color, whether they see the color or not.

Chapter 17

REACTIONS OF
THE HUMAN BODY

John Ott writes, "There is considerable evidence that light energy is a growth-regulating factor in both plant and animal life, and that various growth responses are brought about through variation in the length of the day and night periods, intensity and distribution of wavelength energy."

There is little question that visible light and color influence and affect living things. Virtually all plant life thrives on visible light and is inhibited by infra-red and ultra-violet energy. Though medical science acknowledges the physical effects of this radiation beyond the two ends of the visible spectrum, *i.e.*, with infra-red and ultra-violet rays, and makes therapeutic use of them, it has generally ignored or disregarded the light visible to human eyes. Moreover, the medical profession has always been wary, justifiably, of any claims for color therapy, chiefly because all color experience seems to be highly personal and difficult to test and verify.

In plants of course, photosynthesis, the process by which carbohydrates are made into chlorophyll, is directly related to visible light. In many experiments, the greatest effects were achieved with the red and blue ends of the visible spectrum, and the infrared and ultra-violet bands had little significance. Animal life, which lives directly and indirectly on plant food, is similarly responsive to visible light.

As long ago as 1900, science noted the toxicity of dyes on microscopic organisms. A gelatinous creature might move in and out of intense sunlight and be literally at home. Yet, with an inert dye introduced, it could be sensitized and destroyed because of excessive light absorption. Although the destruction might be due in large part to ultraviolet, such biological effects have been traced to visible light as well.

Many people are familiar with such evidences of light sensitivity in human beings. Skin eruptions may follow exposure to sunlight after using cosmetics and ointments. "Strawberry rash" and "buckwheat rash" may be traced to light sensitivity brought about by eating certain foods. Here again, while ultra-violet may be the cause of irritation, visible light may also be involved. In some rare forms of *urticaria solare,* visible blue and violet light (with ultra-violet and infra-red excluded) have been found to cause an erythema, attended by discoloration and swelling. The medical profession has recently been impressed by the discovery that

The single-celled Amoeba. Microscopic organisms react to light. Inert dyes may destroy them by excessive light absorption

visible light may reverse or arrest the injurious effects of ultra-violet light. Investigators have shown that the death rate in albino mice brought about by severe exposure to ultra-violet may substantially be reduced where visible light is used as a palliative.

With the term phototoxicity, the medical profession refers to conditions under which the skin becomes unduly sensitive to light. In such cases, the erythema (rash) threshold is lowered. As long as a person stays in moderate darkness, nothing much happens. On exposure to sunlight or artificial ultra-violet light sources, however, the skin begins to tingle, grow painful and swell. Eventually, it turns red and starts to peel, and the discomfort may last for weeks.

Some drugs and antibiotics have this effect and baffle the physician. As Dr. Samuel Saslaw writes in a letter to this author, "In using any drug one must balance the therapeutic efficacy against potential toxicity." In other words, if after taking a medicine the skin develops a rash, be prepared to blame a combination of sudden phototoxicity and sunlight, and worry no more about it. Stay indoors, or at least keep the body covered and away from anything emitting ultra-violet waves.

Like all other living things, human beings apparently have a radiation sense, and such sense may be independent of conscious vision itself. Awareness of the existence of light is noted by completely blind individuals even where heat and ultra-violet energy are excluded. Responses to color have also been observed in blindfolded subjects, which would suggest that human reactions to color, though influenced by consciousness, are not altogether dependent on it. Some authorities believe that the visible light of the sun acts directly on the superficial layers of the skin with definite effect.

VISUAL REACTION TO COLOR

Reactions to color through the eye itself are many, varied and intriguing. In the main, color effects tend to be in two directions, toward red and toward blue, with the yellow or yellow-green region of the spectrum more or less neutral. Further, these two major colors cause different levels of reaction in the body and brain. Red seems to have an exciting influence. Kurt Goldstein writes, "It is probably not a false statement if we say that a specific color stimulation is accompanied by a specific response pattern of the entire organism." With reference to red, he mentions the case of a woman with a mental affliction who had a tendency to fall unexpectedly. When she wore a red dress, such symptoms were more pronounced. Goldstein points out that tremor, torticollis and some conditions of Parkinsonism "can at times be diminished in severity if the individuals are protected against red or yellow, if they wear, for instance, spectacles with green lenses."[17]

In this patient, the taking of an antibiotic caused phototoxicity: his skin became excessively sensitive to direct sunlight. Courtesy, Dr. Samuel Saslaw

In what is called photogenic epilepsy, flickering red light is more likely to induce radical brain waves and clinical seizures than other colors. In several cases, wearing eyeglasses which cut off the red end of the spectrum reduced the frequency of clinical seizures, even when medicine was discontinued. With infants who had no prior experience with color, Josephine M. Smith noted that blue light tended to lessen their activity and crying.[18]

Science has called attention to a general light tonus in the human body's muscular reactions. Muscular tension and relaxation are noticeable and measurable as tonus changes. Generally they rise from complete inaction to greater activity with warm colors than with cool ones. When light was directed on one eye of many animals and human beings, a tonus condition could be produced in the corresponding half of the body. Accompanying these tonus changes were changes in "the superficial and deepseated sensations, both showing a regular dependence upon optical stimuli." The influence of light, therefore, not only acts on the muscles, but is effective in producing changes in the entire body.

The experiment called for a subject to stretch out his arms horizontally in front of his body. When light was thrown on one eye, there would be a tonus increase on the same side of the body. The arm on the side of the light would raise itself and deviate toward

The polygraph, or lie detector, measures pulse, blood pressure, respiration, perspiration, skin temperature—all of which may change under exposure to different colors and degrees of brightness. Courtesy, Richard O. Arthur, New York

the side of the illumination. When colors were employed, red light would cause the arms to spread away from each other. Green light would cause them to approach each other in a series of jerky motions. In cases of torticollis (twitching), exposure to red light increased restlessness, while green light decreased it. In similar experiments, when face and neck are illuminated from the side, the outstretched arms will deviate toward the light, if red, and away from it, if blue. To quote Felix Deutsch, "This reaction takes place also when the eyes are tightly sealed to exclude light."[19]

Goldstein, who has worked extensively with color, concludes: "The stronger deviation of the arms in red stimulation corresponds to the experience of being disrupted, thrown out, abnormally attracted to the outer world. It is only another expression of the patient's feeling of obtrusion, aggression, excitation, by red. The diminution of the deviation (to green illumination) corresponds to the withdrawal from the outer world and retreat to his own quietness, his center. The inner experiences represent the psychological aspect of the organism. We are faced in the observable phenomena with the physical aspect." Goldstein also noted that judgment could be affected by color. The passage of time, for example, was likely to be overestimated under red light and underestimated under green or blue light.

Not all investigations have been able to verify such reactions as arm deviation, but the majority have confirmed the fact that there is marked activation with color. Competent experiments have shown arousal of the body and increased muscular pressure for all colors, with green causing the least increase and red the most.

FUNCTIONS OF BODY

Light and color undoubtedly affect body functions, just as they exert influence over so-called mind and emotion. By what is known as the unity of the senses, individual experiences are seldom confined to one organ or sense of the organism. As Charles Scott Sherrington, the great English physiologist concludes, "All parts of the nervous system are connected together and no part of it is probably ever capable of reaction without affecting and being affected by the other parts, and it is a system certainly never absolutely at rest." Psychologists have seen

sounds affecting color perception, and found that loud noises, and strong odors and tastes, tend to increase the eye's sensitivity to green and to decrease its sensitivity to red. Felix Deutsch also comments: "Every action of light has in its influence physical as well as psychic components." All persons are aware of "sensations and psychic excitations which, through the vegetative nervous system, boost all life function: increase the appetite, stimulate circulation, etc.; and through these manifestations the physical influence of light upon the disease process is in turn enhanced." Color affects muscular tension, cortical activation (brain waves), heart rate, respiration and other functions of the body, and also arouses definite emotional and aesthetic reactions. To date, however, research has lacked good scientific controls. Some tests have been largely empirical, others concerned only with certain human functions. To be more thorough and specific,

Brightness of color seems to draw human interest outward and to spur muscular reactions. Soft and deep colors are more relaxing and are conducive to mental concentration

what takes place and what methods may be used to deal with color in definite and meaningful terms? For sound research techniques and impressive data, the worlds of color, psychology and medicine are indebted to the recent efforts of Robert Gerard, a California clinical psychologist.

In a doctoral dissertation for the University of California at Los Angeles, Gerard has painstakingly reviewed the whole area of light and color, and their physical and emotional influences. Probably for the first time, he has tested the entire organism's reactions using advanced and modern techniques. Profiting from the experiences of others, he has evolved new approaches and has come up with a series of verifiable facts.

Gerard set out to answer several questions. Do such colors as red and blue arouse different emotions? Do they stimulate body functions, brain activity and personal feelings? Do the patterns of response have anything to do with the relative energy of the colored stimuli?

In his experiments, Gerard used red, blue and white lights transmitted on a diffusing screen. Brightness and spectral purity were balanced. Blood pressure, palmar conductance (electrodes in the palm of the hand which indicate changes through reaction of the sweat glands), respiration rate, heart rate, muscular activation, frequency of eye blinks and brain waves were all measured. Responses based on the personal experience, judgment and feeling were also recorded. These responses, incidentally, ran true to traditional form. On the personal side, red was found somewhat disturbing to the more anxious subjects; in fact, the higher their tension, the more they were affected by red. Blue had the reverse effect; anxious subjects were relaxed and calmed by it. This may be important for clinical psychology, because it points to the possibility that blue may be effective as a tranquilizer in cases of tension and anxiety.

Body reactions may be summarized as follows: blood pressure, for the most part, increased under the influence of red light and decreased under blue light. Both colors produced immediate increases in palmar conductance, but arousal after a period of time was consistently higher for red than for blue. "Respiratory movements increased during exposure to red light, and decreased during blue illumination." With heart rate, no appreciable differences were found be-

tween red and blue stimulation. Frequency of eye blinks increased with exposure of red light and decreased with blue light. The brain was greatly affected by introduction of all three lights, but with time (up to ten minutes), activation remained consistently greater for red than for blue. In general, palmar conductance and cortical activation are more likely to show effects of any stimulus. What is significant is that red consistently produced more pronounced effects than blue, both when first introduced and after a period of time.

Blue seems to have particular merits as a relaxant and tranquilizer. Gerard states, "The results obtained with blue light suggest trying out its use as an adjunct or supplemental form of therapy in the alleviation of various conditions." Because blue lowers blood pressure, it may have possibilities in treating high blood pressure. General relaxation and relief from tension experienced by the subjects suggest that blue may help to alleviate muscle spasms, and perhaps nervous twitches and tremors as well. Because it reduced eye blink frequency and was subjectively experienced as soothing, blue might also have some use in eye irritations. Because of its restful effects, dim blue illumination might be "conducive to sleep in cases of insomnia." It might further contribute to *subjective* relief of pain through its reported sedative action.

Red and white stimulation were pretty much the same. Apparently, red and other "warm" colors are in general more related to excitation. Yet red might be useful in

Control of brightness and color will lessen visual, physical and emotional strain and promote better work capacity

arousing persons with nervous depression or exhaustion. It may have value in increasing blood pressure where this action could be helpful. While white light may stimulate the body, it may also be boring to the mind. Such boredom (with white) may prove irritating and hence be reflected in human indifference. On the other hand, red seems to excite aggression, sex, fear of injury. Bodily reactions to the two colors may be similar, but there still may be a world of difference to the subject.

What is needed is more study of the different effects of color, and such research will no doubt come in time.

THE USE OF COLOR
IN EVERYDAY LIFE

Sound research and practical experience lead to the following conclusions on the use of color in everyday life:

1. There is in color and light what might be called a "centrifugal action"—away from a person's self to his environment. With high levels of illumination, warm and luminous colors in the surroundings (yellow, peach, pink), the body tends to direct its attention outward. There is, in general, increased activation, alertness and outward interest. Such an environment is conducive to muscular effort, action and cheerful spirit, and is a good setting for factories, schools and homes where manual tasks are performed or where sports are engaged in.

2. On the other hand, color and light may have a "centripetal action"—away from the environment and toward the individual self. With softer surroundings, cooler hues (gray, blue, green, turquoise) and lower brightness, there is less distraction and a person is better able to concentrate on difficult visual and mental tasks. Good inward orientation is aided. Here is an appropriate setting for sedentary occupations requiring use of the eyes or brain—offices, study rooms, fine assembly in industry, dens and bedrooms in homes.

3. Kurt Goldstein has expressed both principles aptly. "One could say red is inciting to activity and favorable for emotionally-determined actions; green creates the condition of meditation and exact fulfillment of the task. Red may be suited to produce the emotional background out of which ideas and action will emerge; in green these ideas will be developed and the actions executed."

4. Experimental work in schools and hospitals has further emphasized strategies with color in the realm of psychology. Outwardly-directed persons, "nervous" persons and small children will relax in an actively colored environment, because visual (and emotional) excitement in the environment will effectively "match" their spirits and thereby set them at ease. Attempts at pacification, through color or anything else, only serve to bottle up such spirits to a bursting point.

On the other hand, inwardly-directed persons will ordinarily prefer a more sedate environment—and it will provide the calm they innately prefer. A quiet soul, told to wear a red dress or a red tie, may by no means respond accordingly. On the contrary, such boldness may make him increasingly shy and embarrassed.

In cases of mental disturbance, however, the reverse is necessary. A person with inordinate craving for bloody red—which might lead to trouble—should probably be exposed to blue to counteract his temper. The melancholy individual tolerant only of drabness should probably be exposed to red to animate him, physiologically as well as psychically.

COLOR IN DIAGNOSIS

If modern medicine hesitates to accept color for direct therapy, it makes common use of it in diagnosis. Here, the physician finds a significance that ranks in importance with pulse and temperature.

In an article for the *American Journal of Clinical Medicine,* Dr. John Benson remarked that, as a general rule, a white tongue reveals a system in need of alkalis, while a bright red tongue probably needs acids. He pointed out that dark red is often a sign of infection or sepsis, a brownish tongue a sign of typhoid. Skin pigmentation may be even more significant. Benson presented the following interesting list: thick, dirty, muddy complexion, and also the bulbous nose, are evidence of autotoxemia. A yellow face indicates a hepatic condition. Thin, clear, transparent skin with prominent blue veins shows impaired vitality and symptoms of tuberculosis. Greenish, waxy skin and pallid lips are signs of anemia. Restricted spots of deepening red, often shading into

YELLOW

ORANGE

BLUE

GREEN

TURQUOISE

VIOLET

RED

In health and in sickness, the flesh of the human body may turn just about any color of the rainbow

purple, reveal the pulmonary lesions of pneumonia.

Any good book of diagnosis is filled with descriptions of color as tokens of disease. Color symptoms are well-known to doctors, and these random notes gleaned from medical literature indicate many ailments.

Apoplexy: an ashen-gray complexion.

Chronic Arthritis: often irregular areas of yellow pigmentation.

Chlorosis: a peculiar, sallow color which may be called "green sickness."

Syphilis: a peculiar, sallow color sometimes termed *café au lait.*

Argyria: the skin becomes bluish gray or slate color.

Cancer: color change may not be apparent in early stages. In late stages the skin may be yellowish, yellowish brown or greenish brown.

Pernicious Anemia: "The combination of pallor with good nutrition is striking. The skin, instead of presenting the white, death-like appearance commonly seen in severe anemia, is usually a peculiar lemon-yellow tint."

Diabetes: bronzing of the skin in a great many cases.

Pellagra: the skin becomes a deep red.

Tuberculous Peritonitis: bronzing of the skin, especially on the abdomen.

Osler's Disease: superficial blood vessels, capillaries and veins look full, the skin being congested. In warm weather the face may be brick red or plum color.

Chronic Alcoholism: the face is congested, causing a dusky redness. The nose is often large and red.

Carbon Monoxide Poisoning: the skin turns a bright cherry hue.

Chloasma: the skin has yellowish, brownish or blackish splotches.

Addison's Disease: the skin is bronzed, first on the face and hands, and then generally. The color ranges from light yellow to deep brown or slate.

Smallpox, Measles, Scarlet Fever, Scurvy: "Hemorrhages into the skin cause lesions of various sizes. These gradually change color and disappear."

Typhus Fever: rose spots turning to a purplish rash.

Leprosy: white patches.

Erysipelas: bright red over bridge of nose, then creeping gradually outward.

Frostbite: skin whiter than normal, then passing into dark red, reddish or reddish-black color.

The color of blood (proportion of white to red corpuscles), the color of urine, discharges from the nose and human stool are likewise important. The retina of the eye shows patches of white, gray or black, bluish green or grayish green. The membranes of the eyelids appear reddish or bluish. There may be redness of the feet. The lips may be purple. A white circle about the baby's mouth may tell of gastric or intestinal irritation. The gums are blue in lead poisoning, purplish or bluish in gum infections, and blackish in bismuth poisoning. In chronic copper poisoning, there is a green line where teeth and gums meet.

Pallor and sallowness are associated with disease in general. In pregnancy the skin may become brownish and the areola of the breast much deeper in shade. Finally, there are the signs of death, recognized as long ago as Hippocrates, who wrote, "A sharp nose, hollow eyes, collapsed temples, the ears cold, contracted, and their lobes turned out; the skin about the forehead being rough, distended and parched; the color of the whole face being brown, black, livid or lead-colored."

Arthur G. Abbott has given an excellent description of the protean aspects assumed by the human body: "The redness of blood

is influenced by oxygen and carbon dioxide. The rosy cheeks of youth indicate a healthy blood condition together with a delicate and healthy skin. A white man can appear all colors under certain conditions, so he might more appropriately be called 'colored,' whereas the Negro, whom we speak of as 'colored,' is black, which denotes an absence of color. A white man can appear nearly white from fright, loss of blood, etc.; grayish from pain; red from exertion, anger, etc.; greenish from biliousness and introduced poisons; yellow from jaundice; blue from cold, poor circulation, and lack of oxygen; brown from sun tan; purple from strangulation; and black from decay."

SIGNIFICANCE OF THE EYE

In some diseases, an afflicted person experiences colored vision, a sensation in which the field of vision appears weakly or strongly tinted. In jaundice the world appears predominantly yellowish. Red vision follows retinal hemorrhage or snow blindness, and yellow vision digitalis or quinine poisoning. Green vision is caused by wounds of the cornea, and blue vision has been reported in cases of alcoholism. In tobacco scotoma, vision may be reddish or greenish. In santonin poisoning, the world may at first appear bluish, followed by a yellow vision second stage of longer duration and a last stage of violet vision before complete recovery. Following cataract extraction, the patient may experience red vision, sometimes followed by blue vision, but green and yellow are rare.

The eye may be studied to detect a wide variety of ills. One authoritative book on the subject is I. S. Tassman's *The Eye Manifestations of Internal Diseases.* Many human afflictions somehow make themselves known through the eye, whose delicate membranes are quick to be affected and form lesions. Such lesions may be traced to hereditary causes, infections and diseases, degeneration of other body organs, or to mechanical causes. The sensitive eye promptly reacts to the disturbance.

Allergy may quickly be revealed in itchy eyelids, redness and a burning sensation. Circulatory and metabolic diseases interfere with the blood supply and become obvious in the eye. In anemia, the optic nerve head appears white, and a "cherry-red spot"

Pictures show so-called Bitot spots often associated with night blindness and vitamin A deficiency. Many pathological conditions in the human body are observable in the eye. Courtesy, Dr. David Paton, Baltimore

shows on the macular area of the retina. In scarlet fever, the eyelids are swollen and noticeably red. In whooping cough, the eyes grow bloodshot. Although hemorrhages may interfere with vision, they gradually disappear. In typhoid fever, there may be ulcers of the cornea, and significant "spots of color" may appear on the retina. In influenza, the eyelids may be affected by abscess, and pus appears about the lids. The eyeball becomes reddish and may show signs of congestion. In pneumonia, ocular lesions form during or after the course of the disease, and the eyeballs may grow pale from lack of blood. In diphtheria, eyelids may be red and swollen, and eyes become highly sensitive to light. Erysipelas of the face may be considered in part a disease of the eyelids and is hazardous to vision. It is generally accompanied by superficial abscesses and redness. Leprosy is, in many instances, accompanied by blindness. A dull gray layer forms over the eye, and heavy pigmentation appears in the iris. In undulant fever, there is a grayish clouding of the iris. Tularemia, a disease transmitted by rabbits, mice and other rodents, has been mentioned by W. S. Duke-Elder as "the only widespread disease of the human body discovered through the agency of ophthalmology." It usually affects one eye. Lids are red and swollen, and yellowish ulcers spread over the eyeball: "Yellowish polka dots on a piece of red calico."

Blindness also frequently occurs in syphilis. According to Tassman, "It has been estimated that about two per cent of all eye diseases are caused by syphilis." Lesions sometimes occur in the eye, accompanied by paralysis of the iris, lens and eye muscles. In tuberculosis, there may be growth of granulation tissue, resembling a "cockscomb," and also lesions of the lids and eyeball.

Before the general practice of vaccination, about thirty-five per cent of blindness was caused by smallpox. In that disease, pustules form and the eyes may grow sensitive to light. Though mumps rarely involves the eyes, in measles vision may be seriously attacked. Spots appear on the eyeball, accompanied by puffiness and redness of the lids. In malaria, ulcers appear on the cornea, the retina is unduly red, and "bluish-gray stripes" may create a network about the macular region.

Similarly, dental infections, tonsils, nose

A blind salamander, resident of a lightless cave. Vision is lost, and so is all color in its skin and flesh

The color fields of the retina. Area of smallest sensitivity is to green, then red, blue, yellow. Such fields may change in physical and mental illness

The visual form fields of a football halfback. His vision was better to the left than to the right. After T. A. Brombach

study of the form and color fields of the retina. Normally, the smallest area of sensitivity to color is for green, then red, blue and yellow, with the peripheral areas of the eye sensitive only to black and white. "In the abnormal field there is a marked decrease in the size of the form as well as the color. The fields are irregular in shape also, but the most decided change is that of the position of the colors. Instead of being from without in, the colors are interlaced or they may even be inverted. It may so happen that the colors extend outside of the form limits." In other words, where sensitivity to color is distributed abnormally over the retina, human beings are likely to be found mentally abnormal. Through perimetry, these fields of sensitivity to color can be measured, and by studying "psychogenic" color fields, Reeder has discovered previously unsuspected neurotic tendencies. Though Reeder admits his observations still need more objective proof, he insists that the perimetry test cannot be faked, and "therefore malingerers cannot make use of it."

and sinus infections may all show up in the eye. "Ordinary recurrent 'head colds,' which usually indicate the presence of an infection in the sinuses, may be accompanied by ocular manifestations." In alcohol poisoning, vision may be fogged. "A sensation of fluttering and spots before the eyes and colored after-images may also be complained of" (Tassman). Methyl alcohol may cause complete blindness. In epilepsy, visual auras are often found: "blurred vision," "half vision," "flashes of light" and hallucinations in which objects and colors are seen.

DIAGNOSIS OF THE MIND

In hysteria and neurasthenia, patients suffering complexes may be fearful of blindness. Cases have been recorded of "hysterical blindness," and in many psychoses the pupil of the eye does not even react to brightness. Psychological and psychiatric therapies dramatically show how much vision is a mental as well as an optical process.

In an article in the *American Journal of Ophthalmology*, James E. Reeder, Jr., writes of a possible diagnosis of insanity through

Wassily Kandinsky, Abstraction. This great non-objective painter spoke of spiritual vibrations in man's reaction to color

Chapter 18

REACTIONS OF MIND AND EMOTION

In human experience color has such a profound personal and emotional impact that many people assign to the spectrum powers which probably belong more to man's psyche. Mystics are inclined to ascribe ludicrous virtues to the spectrum, and scientists tend to discount or disdain anything emotional. Goethe wrote, "People experience a great delight in color generally. The eye requires it as much as it does light." He spoke of colors on the *plus* side (red, orange, yellow) and on the *minus* side (blue and violet). For him, yellow was bright and had "a serene, gay, softly exciting character." Red had highest energy. "It is not to be wondered at that impetuous, robust, uneducated men, should be especially pleased with this color. Among savage nations the inclination for it has been universally remarked, and when children, left to themselves, begin to use tints, they never spare vermilion." Blue was cold, gloomy and melancholy; violet or purple was disquiet-

ing. "It may be safely assumed that a carpet of a perfectly deep blue-red would be intolerable." Green was calm and livable. "The beholder has neither the wish nor the power to imagine a state beyond it."[20]

A similar, wholly personal attitude characterized the non-objective painter Wassily Kandinsky who developed fanciful theories of color—as well as of line, form and proportion. For him colors had a psychic effect. "They produce a corresponding spiritual vibration that the elementary physical impression is of importance." By this, Kandinsky meant that color had strange properties, and that harmony in art must take account of the spirit of man as well as his eye. "It is evident . . . that color harmony must rest only on a corresponding vibration in the human soul; and this is one of the guiding principles of the inner need." The spectrum was divided into colors of warmth and coolness, lightness and darkness, with four shades of appeal: warm and light, warm and dark, cool and light, cool and dark. And like Goethe, he believed, "Generally speaking, warmth or cold in a color means an approach respectively to yellow or to blue."[21]

Kandinsky thought movement was to be found among the primary colors. Yellow had a maximum spreading action. It inclined to white and tended to approach the observer. Blue inclined to black, moved in upon itself, and retreated. "The power of profound meaning is blue." Red "rings inwardly with a determined and powerful intensity. It glows in itself, maturely, and does not distribute its vigor aimlessly. . . . Orange is red brought nearer to humanity by yellow. . . . Violet is red withdrawn from humanity by blue."

Kandinsky's particular reactions are not the reactions of the rest of mankind. Although he saw "quietude and immobility" in green, unlike Goethe the hue apparently got on his nerves. He saw it as the color of the empty-headed bourgeois, of a "fat, healthy, immovable resting cow, capable only of external rumination, while dull bovine eyes gaze forth vacantly into the world."

The Neo-Impressionist painter Seurat also had his own ideas. To him "gaiety" of tone was in luminosity and warmth of hue, and was to be represented by lines rising from the horizontal. "Calmness" represented a balance of light and dark, and of warmth and coolness of hue, and was to be shown by lines running horizontally. "Sadness" of tone was dominantly dark and cool in hue, and lines to portray it ran down from the horizontal.

Seurat saw gaiety of tone rising upward. Calmness of tone had horizontal balance. Sadness of tone sank downward

INFLUENCE OF PERSONALITY

Relationships between color preference and personality are many and fascinating to study. Psychiatrists and psychologists have noted that visually, response to form seems to arouse mental processes while reactions to color are more impulsive and emotional. Small children, for example, are more color "dominant" than form "dominant." This primitive quality of color has been referred to by numerous investigators. In connection with the Rorschach method, using ink blots to analyze the mind, Marla Rickers-Ovsiankina states: "Color experience, when it occurs, is thus a much more immediate and direct sense datum than the experience of form. Form perception is usually accompanied by a detached, objective attitude in the subject. Whereas the experience of color, being more immediate, is likely to contain personal, affectively toned notes."[22]

COLOR PREFERENCES

More than a hundred competent studies have been made of color preferences. In general, warm colors—red, pink, yellow and orange—seem to be more important in the early years of life. With maturity, however, blue, red and green become dominant, a phenomenon that seems to pertain regardless of race or nationality.

In interpreting the art of children from three to five years old, a delight in color

As a rule, most persons, young or old, will prefer light colors to dark ones, pure colors to grayish ones, and primary colors to intermediate ones

Small children, if presented with different shapes in different colors, will sort them out on a basis of color. After David Katz

usually showed emotional tendencies, while frequent use of blue or black indicated self-control and repressed emotion. As might be expected, red was most exciting and revealed freedom of expression. Yellow seemed to go with infantile traits and dependence on grownups. Green showed balance, fewer emotional impulses and a simple, uncomplicated nature. Curiously, among the mentally ill green is likely to be preferred to red, cool hues pleasing to patients with hysterical reactions and warm hues to depressed ones.

In a general way the spectrum may be divided into colors of long wavelength (red, orange) and colors of short wavelength (green, blue), with yellow occupying a middle position. Human beings tend to fall into two distinct groups—those who prefer clear, distinct hues, usually warm in tone, and those who favor cooler hues and tones of less saturation. According to Rickers-Ovsiankina, "The warm-color dominant subjects are characterized by an intimate relation to the visually perceptible world. They are receptive and open to outside influences. They seem to submerge themselves rather readily in their social environment. Their emotional life is characterized by warm feelings, suggestibility, and strong

CHILDREN			ADULTS
YELLOW			RED
PINK			BLUE
RED			GREEN
ORANGE			PINK
BLUE			PURPLE
GREEN			YELLOW
PURPLE			ORANGE

This is how color preferences are likely to change from childhood to maturity. Human predilections for color seem to be inborn

effects. All mental functions are rapid and highly integrated with each other. In the subject-object relationship, the emphasis is on the object. The cold-color dominant subjects . . . have a detached, 'split-off' attitude to the outside world. They find it difficult to adapt themselves to new circumstances and to express themselves freely. Emotionally they are cold and reserved. In the subject-object relationship, the emphasis is on the subject. In short, the warm-color dominant subject is the outwardly integrated type, the cold-color dominant subject is the inwardly integrated type."

Emotionally, the red end of the spectrum is exciting, the blue end is calming. Physically, the same is true. Reds tend to increase bodily tension, stimulate body and nervous system, while greens and blues release tension and have a subduing effect. Such reactions take place independently of conscious thought. "Color perception is not an act involving only the retina and 'consciousness' but the body as a totality" (B. J. Kouwer).[23] Colors seem to differ as psychic make-up differs. According to E. R. Jaensch's observations, warm colors go with the primitive responses of children, excita-

tion, the extroverted human being and preference for the brunet complexion type.[24] The cool colors go with the more mature responses, greater peace of mind, the introverted personality, the preference for the blond complexion. Warmth in color signifies contact with environment, and coolness signifies withdrawal into oneself.

COLOR AND CHARACTER

A normal condition for human beings is to like color, and reactions and "moods" are associated with sunny weather, rainy weather, with a colorful world or environment and with a drab one. Yet in adults, excessive "longing" for color may be an indication of mental confusion, for as a person grows older, interest in form quite naturally tends to exceed interest in color. Where there is insistence upon balanced relationships between color and form, a person is apparently willing to admit an emotional life, but is determined to keep it within the bounds of reason. In general, an individual who reacts freely and agreeably to colors is likely to be a responsive personality, interested in the world at large. In

To most persons, red is exciting, yellow is cheerful, green is tranquil, and blue is subduing. Such reactions may have a deeper basis than mere emotional whim

studying the effect of alcohol on releasing inhibitions in severely introverted people, one discovers a greater response to color. In addition, abstract, non-objective and surrealist art tend to find greater acceptance among extroverts than among introverts. Love of color for its own sake seems to be characteristic of extroverts, and indifference to color, or requiring a semblance of realism in art forms if they are to make "sense," seems to characterize more introspective or introverted individuals.

PSYCHIATRY AND COLOR

The significance of color among the mentally ill has been extensively noted, particularly in case studies employing the Rorschach (ink blot) techniques. The sight of the colored test cards may cause exuberance and reversion to childish fancies about color. Manic-depressives, in particular, seem pleased with color and react with considerable and agreeable excitement to it. But in many forms of mental disturbance, color is an intrusive and disturbing factor. Patients may be visibly upset by it and reject the color as they would pain, close their eyes, turn away from it, or even try to destroy it. Schizophrenic types tend to reject color, seeing it as something which might prove "catastrophic" by breaking in upon their inner world. In looking at the Rorschach cards, they tend to volunteer a few vague comments about form, but are usually silent about color. Severe cases of depression also

frequently reject color, preferring a "gray" world and disdaining a colorful one. Patients suffering from the severest psychiatric symptoms will, as a rule, react to color but seldom if ever note anything coherent in it. Rorschach himself noted that color response among epileptics increased as the disease progressed and concluded that it might be looked on as a scale expressing the degree of deterioration.

Among emotionally disturbed persons (neurotics), it is not so much the favorable color response as the unfavorable one which sets them apart from normal persons. In writing of the Rorschach tests, Bruno Klopfer and Douglas Kelley have stated, "Probably the most important single sign of a neurotic reaction is color shock. . . . neurotics invariably show such shock, and only a small percentage of normals and other types of psychopathology display it."[25] Hysterical persons find it difficult to organize their thoughts coherently when color is one element to be considered. The same appears true of organically confused individuals suffering from exhaustion. Colors on the Rorschach cards may elicit no more than a matter-of-fact naming of the hues, with no attempt to reveal thought content. In anxiety states and obsessive neuroses, profound color shock is also revealed. The willingness of the hysteric to be affected by color is, perhaps, related to his illness.

How is color shock to be explained? In an unusual study of color-blind neurotics, experts have found reason to believe that the neurotic may react to color without having a clear perception of it. According to E. O. Fromm and H. W. Brosin, "This physical stimulus need not necessarily be in the field of awareness."[26]

PERSONALITY TRAITS

To quote from an article by Eric P. Mosse, "The difference between mental health and mental disease consists at last in nothing else but how this predicament is handled. The normally balanced individuum will face, brave and adapt himself to his problems, whereas mental disease is the manifestation of different depths of escape. With this fact in mind, we automatically understand why in achromatopsia of the hysterical the order in which the colors disappear is violet, green, blue, and finally red. Aside and above this experience we generally found in hysterical

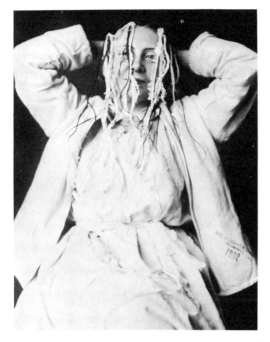

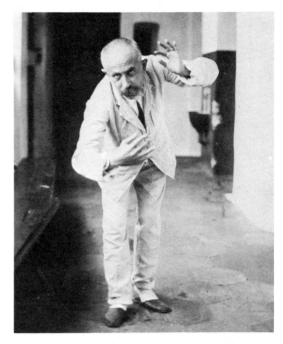

A manic-depressive patient in a happy or euphoric mood. Such persons are usually extroverted and like color

A schizophrenic patient in a catatonic position. Such persons are usually introverted and may be disturbed by color

Hysterical patient in a rigid position under hypnosis. Sight of color may cause excitement and confusion. Photographs of mental patients from Die Seele ist Alles, *by Franz Volgyesi. Courtesy, Orell Fussli Verlag, Zurich*

Manic-depressive patient in a state of elation. **There is great** *social interest and love of color*

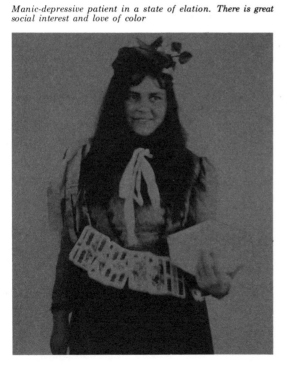

189

patients, especially in psychoneuroses with anxiety states, a predilection for green as symbolizing the mentioned escape mechanism. The emotional attack of the outside is repressed, the 'red' impulses of hatred, aggression and sex denied For the same reason we will not be surprised that *red* is the color of choice of the manic and hypomanic patient giving the tumult of his emotions their 'burning' and 'bloody' expression. And we don't wonder that melancholia and depression reveal themselves through a complete 'black out.' Finally we see yellow as the color of schizophrenia This yellow is the proper and intrinsic color of the morbid mind. Whenever we observe its accumulative appearance we may be sure that we are dealing with a deep-lying psychotic disturbance." Mosse also related brown to paranoia.[27]

A preference for red is associated with a person who nourishes a desire to be well-adjusted to the world. Red is highly prized by persons of vital temperament, who are not reflective and are more ruled by impulse than deliberation. In mental disease, red is associated with manic tendencies. Yellow, however, seems allied with feeble-mindedness. It is likely to be preferred by persons with an intellectual bent, associated both with great intelligence and mental deficiency. Kandinsky once wrote with some fervor, "Yellow is the typically earthly color. It can never have profound meaning. An intermixture of blue makes it a sickly color. It may be paralleled in human nature with madness, not with melancholy or hypochondriacal mania, but rather with violent, raving lunacy." Green can be associated with Freud's oral character, and is often the choice of superficially intelligent, social persons given to voluble habits of speech, and who often have an intense appetite for food. Green is a great favorite to the psychoneurotic and psychotic. Probably it suggests escape from anxiety, sanctuary in the untroubled greenness of nature. Under stress, those who prefer green will not as a rule crave seclusion; on the contrary, they will seek out and require companionship.

In a surprisingly high percentage of cases, narcissism is revealed by preference for blue-green. Where average human beings either prefer green or blue, the choice of blue-green indicates fastidiousness, sensitivity and discrimination. Blue is associated with schizophrenia. A majority of introverted personalities favor the color, the color

of circumspection, for it is allied with conscious control of emotions. Under stress, persons who like blue tend to take tragic flight from environment. Brown symbolizes the anal character described by Freud as having conscientiousness, parsimony and obstinacy. Brown is obviously associated with human excrement.

Convivial persons are attracted to orange; artistic persons prefer purple. A well-disciplined red personality may expose his imposed training by a preference for maroon. In what the psychiatrist terms the liberation of repressed effects, a meek, shy soul may take to brilliant hues with "fire in his eye." The aggressive mortal, to whom life has been a tough and harsh struggle, may be drawn to the tint of pink as a bright symbol of an unconscious wish for gentility.

UNSEEN COLOR

The sense of color is probably inborn in man, and even persons blind since birth have an "instinct" for color and its emotional significance. This may be due to the fact that the sense of color is more a matter of the brain than the eye. The remarkable Helen Keller, who could neither see nor hear, was quite conscious of the vital forces of the spectrum and considered them part of the human soul. In *The World I Live In*, she

Subdued colors are less distracting and allow for better thought and concentration. They are appropriate to libraries

190

wrote: "I understand how scarlet can differ from crimson because I know that the smell of an orange is not the smell of grapefruit. I can also conceive that colors have shades and guess what shades are. In smell and taste there are varieties not broad enough to be fundamental; so I call them shades. . . . The force of association drives me to say that white is exalted and pure, green is exuberant, red suggests love or shame or strength. Without the color or its equivalent, life to me would be dark, barren, a vast blackness.

"Thus through an inner law of completeness my thoughts are not permitted to remain colorless. It strains my mind to separate color and sound from objects. Since my education began I have always had things described to me with their colors and sounds, by one with keen senses and a fine feeling for the significant. Therefore, I habitually think of things as colored and resonant. Habit accounts for part. The soul sense accounts for another part. The brain with its five-sensed construction asserts its right and accounts for the rest. Inclusive of all, the unity of the world demands that color be kept in it whether I have cognizance of it or not. Rather than be shut out, I take part in it by discussing it, happy in the happiness of those near me who gaze at the lovely hues of the sunset or the rainbow."

The Prophet of St. Paul's reading the fortune of a lady. Palmistry and astrology held the answers to many burning questions

Illustration from Les Oracles, 1652. Color has always held mystical significance and meaning

Chapter 19

THE PERSONAL SIDE OF COLOR PREFERENCE

The fortune teller divined the future with cards, a crystal ball, the stars and planets

Tarot cards. Their symbols and colors told of past, present and future—as the gods of mystery and chance directed

Today it is generally agreed that it is natural for different individuals to prefer different colors. A series of character and personality studies, written in a popular style, follows. It attempts to relate color to particular types of individuals in light of my own observations and my study of psychology and psychiatry. As Remy de Gourmont observed, "Color has its importance. Before making friends, before undertaking the conquest of a woman, observe what their favorite colors are."

IF YOU *LIKE* RED

Blue, red and green are the colors most people prefer, and in that order. Red is positive, blue tranquil and green a balance between the two.

If you like red the interest of your life is directed outward. This does not necessarily mean that you have a fiery soul; indeed you may be a quiet one. Or you may once have been fiery and are now quiet. Through red the human spirit finds release for its more impassioned emotions. Red has more associations, more symbolism than any other color, signifying love and hate, patriotism and anarchy, sacrifice and cruelty, virtue and evil. A token of blood and fire, red is a color to which it is hard to be indifferent. It may be loved or feared, but it is seldom disregarded. If you love red, if its intensity is natural to your spirit, you belong in the midst of life. You are aggressive, vigorous, given to impulsive moods and actions. Although there may be a certain abruptness and crudeness in your manner, you have deep sympathy, and your feelings for your fellow man, good and bad, are easily swayed.

The child will have an uninhibited love of bright color and simple form. The adult will look for more subtlety

Because your interest is in the world, not out of it, you try to get a sure grip on life. If you don't always succeed, it may be that you lack the patience to let things catch up with you and adjust themselves.

You are quick to judge people and like them or dislike them, praise them or admonish them, as the spirit moves. Because your opinions are quickly formed, you often put up fervent but weak arguments to defend them. You may struggle to let reason prevail, but it rarely does. Taking sides is one of your habits—and people will be lucky to have you on their side. However, you are never unduly stubborn about anything. Your temper swings more like a pendulum than like an axe.

Innately you are an optimist, but when you feel despair, you are likely to see that the world is loudly informed of it. You do not cling to purposes for any length of time, and monotony is one of life's great miseries to you. If you are or become a person of outstanding accomplishments, your restless personality will probably deserve more credit than any carefully planned diligence.

In your effort to comprehend life, two enigmas never seem to straighten out in your mind. The first concerns your happi-ness. Persons who like blue may feel reconciled to the view that life is a tragic mess and that he who can wrest a small measure of happiness from it is fortunate. To you, however, life is meant to be happy, and you are upset when it isn't. Any unhappiness seems unnatural rather than natural to you. Yours is an endless quest for excitement and you are inwardly put out with yourself when you find you aren't "riding high" all the time. To blue personalities, moments of happiness are the exception; you expect them to be the rule.

The second of your problems centers on an inability to understand your own shortcomings. You may outwardly claim a liberal mind, but inwardly you are convinced that your troubles, if any, must be traced elsewhere. You may even be so naive as to be unconscious of the fact that people are meaner to you when you are in a bad mood, and far more pleasant when you yourself feel good. It's hard for you to be objective. When the going is rough, it is the world that tosses about, not the ship of your own being.

IF YOU ARE
THE COMPLEMENTARY RED TYPE

Complementary-red types may be gentle souls who envy the impetuousness of others. They may even make an effort to surmount

The hedonist is loud, forward and sensuous like the color red. Portraits are nineteenth century interpretations of The Characters of Theophrastus, a disciple of Aristotle who lived in the fourth century B.C.

their introversion, though they hardly ever succeed. However, like the true-red type, they have aggressive tendencies and are ambitious and strong-willed at heart. Should they hold to the false notion that to be reserved is to be inferior, let them be reconciled to the fact that the swaggerers of life may command most of the attention, yet the unassuming may realize greater accomplishments. Nor does the glad manner always house the glad heart. Lovers of red, when unhappy, do not understand their despair.

Of utmost significance, a preference for red in the complementary sense may involve what the psychoanalyst knows as sublimation. Writers of heroic novels about strong men and voluptuous women frequently turn out to be anything but swashbuckling themselves. Red as sublimation is a wonderful thing. If it brings joy to modest hearts, by all means it should be relished. But red cannot make extroverts out of introverts—except, possibly, for a fleeting moment.

IF YOU ARE THE MAROON TYPE

In the study of human personality maroon has an odd significance. It is passion tempered by conscience or adversity. It is ambition, bravery and strength whittled down by struggle and difficulty. It is all that is good in life, but somewhat soiled and frayed in the living. Prefer maroon and the chances are that a true-red personality has been saddled by harsh circumstances, strict parents or teachers, or possibly a demanding spouse. The confident and guileless has been turned in upon itself and made a trifle self-conscious. You are not as reckless with your friends or with the world, and consequently may be likable and generous. There is a possibility that you are a fairly great person at heart, one who has reduced intense red heat to the rich, deep glow of maroon. While discipline may have been forced upon you, it may also have been fostered by your own desire. You may have recognized at one time that red flames are a strain on others as well as on yourself. If you have a certain composure, it is not because of inflexibility of character: the qualities of red are still there. If you happen to be a saint, you are sure to have the look of sin in your eye; if you are a sinner, the expression on your face will become you, for it will bespeak atonement.

IF YOU *LIKE* PINK

Pink reflects the gentler qualities of red. While women freely admit a preference for pink, most men drawn to the tint will feel too embarrassed even to mention it by name because its association is with little girls and things feminine. Nonetheless, men frequently like pink.

As a color preference among women pink is often unique to wealth, social and financial advantage, and to the sheltered and indulged existence. Many older people grow to like it as a recollection of childhood innocence.

Psychologically, pink is a gentle form of red. It partakes of love and affection, of interest in and desire for the world, but without extreme ardor. It connotes protection and favor, probably by doting parents or relatives. Most of all, you were spared the harsher, more sordid aspects of life or else you would like red itself. You crave affection, but may be frightened by intensity of passion. You have sympathy for persons less fortunate than yourself, but it will not be your habit to associate outside your own genteel class. You have much charm, softness and warmth to your nature. You want life to be good and never bad. You aren't particularly mental, spiritual or physical; but you are likable and have a fond attachment, if not a strong capacity, for the full life.

IF YOU *LIKE* ORANGE

Strangely enough, orange often appeals to the Irish. If the relationship between orangeness and Irishness has been none too amicable, the color orange still is the good token of a cheery spirit and winsome manner.

If you favor orange, you may lack the grand passion of the red type, but you may have an equally luminous interest in life. You may well be the "hail fellow well met." You are social by nature, able to get along with all types of human beings. You have an easy smile and a glib tongue. If someone says the grin and speech are not genuine, he would be mistaken, because you honestly and profoundly want to like people, and to be liked in return. To your discredit, however, frequently your last friend is your best friend. Yet, if you are fickle, unsteady and vacillating, by and large you are the most consistent of individuals in these qualities.

The old trifler, whose best friend was always his last, took orange as a favorite color

You are good-natured, not very fond of being alone, and your love of people is more concerned with companionship than with passions. Consequently, you make the ideal bachelor or spinster. What you lack in intensity is made up in good will and a solicitous heart.

In liking orange you are inclined to defer to others' opinions and convictions. This too may be traced to a wish to be agreeable. In fact, too much seriousness and deep thought do not impress you. Your philosophy is easily summed in a few phrases and verses about friendship and the virtues of good works.

True orange personalities rarely have serious mental troubles. Nature or heredity has given them remarkable insulation against the hazardous peaks and pits of the mind; indeed, their very temperament may in itself be an inborn mental quirk. What is called euphoria (an unwarranted feeling of elation) describes the color orange.

IF YOU *LIKE* YELLOW

Yellow, a diffuse and luminous color, is the hue of imagination, novelty, nervous drive and search for great self-fulfillment. Intellectuals and idealists are taken by the hue. Those who prefer it are inclined to be high-minded and drawn to cults, reforms and pantheistic philosophies. The color usually implies depth of introspection and contemplation rather than high spirituality alone. In other words, innocent virtue floats to heaven on a pale blue cloud; divine nobility ascends a yellow ray of light.

Prefer yellow and your thoughts are sure to be neatly formed. You are much impressed by your own intellectual capacities. Your dreams, if any, are less inclined to be fantastic than lofty. You are anxious to do for the world and for people what the world and people need (in your eyes). You have a particular love for things modern, contemporary and challenging.

You have a beautifully controlled temper. At heart you are perhaps rather shy and will hesitate to do anything unbecoming in your own interest. Yet you long to be respected and you crave admiration for your sagacity.

You are the mental lone wolf, a safe friend and a reliable confidant. You are quite exacting with others without always intending to be so. If you are timid in your manner, there is no hesitancy or vacillation within you. Your philosophy is always good, because it is profound and never shallow. Yet your brain may have steel doors on well-oiled hinges—wide open when you speak, but smack shut when anyone else speaks.

It may be difficult for you to be patient with the viewpoint of others. This is because you think things through with care and your convictions are genuine. Every change in yourself is logical and consistent; as a consequence, you may live in a world apart.

IF YOU *LIKE* GREEN

Cool, fresh and comforting, green has wide appeal. The sign of balance and normality, it has the universal attraction of nature. Love green and you probably dwell in the great forest of humanity: you are a respectable neighbor, homebuilder, father or mother of spoiled children, voter, patronizer and joiner. If green is the token of civility and the good citizen, love of it makes you not too profound but frank, civic-minded and moral without being prudish. It also makes for sensitivity to social custom and etiquette, and a delight in others' scandals while avoiding them in one's own household. Though much like the social traits of orange, the social traits of greens include a greater

The sophist preferred yellow. He may have had a good mind, but he was stubborn and opinionated

preoccupation with circumstances than with people.

Green is largely upper middle-class and often typifies the American businessman and clubwoman. Such people, though mercenary, are not parsimonious. They like to live up to their neighbors, to belong to the better churches and clubs, and to make advantageous contacts and a pot of gold. Indeed, if prosperous, their good fortune is likely to be due more to patronage than to perspicacity.

To prefer green is to be educated, reputable and civilized. It makes you less likely to pioneer or originate than to do the popular thing, and if reds are extroverts and blues introspective, greens have more balance. You would make the best of teachers and, if there were more like you, the dreams of the reformers and philosophers might come true.

IF YOU *LIKE* BLUE-GREEN

First of all, a liking for blue-green (or turquoise, aquamarine, and off-shades of greenish blue or bluish green) unmistakably indicates an exacting and discriminating individual. Average human beings like blue or green, but anyone fussy enough to draw a fine distinction must be sensitive and fastidious. The few men who favor blue-green are likely to hold exceptionally high and secret opinions of themselves, to be poised and attractive to others, but to find it next to impossible to maintain a complete and unselfish love for anyone else. Neat, well-groomed and sharp-witted, they are likely to inspire envy and annoyance because of their apparent conceit.

In women, however, blue-green is a token of what psychoanalysts term narcissism or self-love! This is by no means a fault, because Freud regarded narcissism as "the purest and truest feminine type." Such women seldom give much love; instead, their need is to be loved.

Though narcissism and love of blue-green are psychologically deep-rooted, young people rarely express a preference for the color. Some deliberation seems to be involved, and the color preference, like the narcissism, may not reach full bloom until after adolescence.

If your color is blue-green, you have a sensitive nature, probably come from refined and intellectual parents, had a well-tutored childhood or achieved refinement entirely on your own. Unlike the pink type, you have far more confidence and sophistication. You also have perseverance, stability and self-assurance, but are likely to be detached.

Capable of managing your own affairs, you need little help or guidance, and may, in truth, reject both. You are willing to do

The garrulous liked green. He not only talked too much, but he also ate too much and drank too much

things for others without the least concern for gratitude or reward, yet you are cold at heart and the best of you is always kept for yourself.

You need beauty—and a mirror. You have excellent taste in clothes and are sweet and charming in your manners (when you so wish) and are wholly self-protected from the possibility of being disgraced. You are courteous without being intimate. The fact that many of your admirers and friends go to great lengths to please you probably never enters your consciousness. Like a gentle and gracious child, all good things—admiration, favor and respect are to be expected and taken for granted.

IF YOU *LIKE* BLUE

Blue has universal appeal. In virtually all tests of preference it holds top place. While red is more primitive in character and even more popular with certain classes of people, a preference for blue increases almost in direct proportion to higher education, culture and income. In many better localities, where persons of similar background, wealth, political, social and religious convictions live, more than half of them will express a preference for blue.

Blue is the color of deliberation and introspection, of conservatism and acceptance of obligations. Those who favor it have reflective minds and honest intentions, but sometimes use reason for selfish and self-justified purposes.

There are three blue types: the true type, the deep blue type, and the complementary type. Among persons born in poverty, red personalities make an assault upon their environment and remain in it, but blue personalities tend to retreat to gentler surroundings and associates. While red personalities have a hold on life and are found everywhere, blue personalities are likely to band together and be encountered in bunches.

If you have a genuine love of blue, you are sensitive to others and to yourself. You have a secure hold on your passions and enthusiasms. There is weight to your character, real and implied, though it may be a bit cumbrous to others. People respect you and are considerate (at times out of sympathy), and you greatly cherish their deference. You like to be admired for your steady character and for your wisdom and sagacity, although the

The plausible man was identified with blue. But he often carried logic and reason to an unfair excess

truth may be that you may spend little effort to warrant that admiration. You may rest too easily on your so-called natural endowments.

Cautious in word, action and dress, you are not one to take the sawdust trail or indulge in any rashness. Most of your opinions and beliefs are fixed and quite inflexible. Because your interests center upon yourself, you have considerable egotism. Your talent for self-justification may make you blind and impatient toward others' ideas and ideals. Stupidity annoys you in almost the same way superior intelligence does. What you don't understand is likely to have questionable merit in your mind.

You are sure to be social, to become a loyal friend who will stick to his circle and be skeptical of strangers. Inasmuch as you lead a sober life you feel everyone else should do the same. You find it hard to understand that irrational people have just as much right to be irrational as you have to be rational. The fact that your own affairs are well-ordered is no proof that such affairs are the height of perfection.

You are an able executive, or at least an assiduous and conscientious worker, and you may even be a good student, possibly a scholar. You know how to get things done

and, at times, how to make money, but any success for you comes from patience and perseverance rather than exuberance.

IF YOU ARE
THE COMPLEMENTARY BLUE TYPE

Eager, excitable people frequently choose blue, because it connotes the peace and equanimity they crave but find so difficult to attain. In studying human personality psychiatrists and psychologists find certain polarities. Weak persons crave strength, and the strong seek that which is gentle and kind. Extreme masculinity and extreme femininity, for example, are perfect complements. Such antitheses are necessary and essential to human welfare though, with other contrasts, they may lead to conflict and mental illness. The close mingling of love and hate, pleasure and pain, involves a confusion (ambivalence) which often causes neurotic behavior. Complementary blue types are outward or imperious by nature and·take to blue to find relief through it; blue may be seized on by impulsive individuals in a desire to become poised and composed.

The complementary blue type is not always easy to describe. For the most part he may pretty well disguise his real nature. If you watch long enough, however, the steam inside him will be seen to escape now and then. If he is an extrovert seeking to assume the personality of an introvert—either to quiet his own unrest or to come to better terms with the world—his change of character may have a certain charm, but he will never be the true introvert and will now and again probably stride on the sensitive feelings of others.

IF YOU *LIKE* PURPLE

Purple is one of the most enigmatic of colors, combining as it does the extremes of the spectrum, red and blue. Purple and violet suggest unusual and exclusive things. A preference for it reveals two distinct types—the more profound and substantial purple type, and the more affected lavender type.

For the most part the masses of population care little for purple and violet. They usually have sentimental or sympathetic connotations: orchids, mourning crepe, handkerchiefs and perfumes. The colors also suggest affectation, pomposity and the

solemn, and seldom if ever are identified with mundane and worldly things.

For all these reasons, purple is often the choice of artists who believe purple the least commonplace and crude of colors. Glints of it in nature have a will-o'-the-wisp beauty to sensitive eyes and minds, but the taste for purple is usually acquired.

If you favor purple you automatically assume—by right or by desire—an uncommon stamp among the mortals. You may deserve the color. If you do, you have a good mind and wit, and a rare ability to observe things which go unnoticed by others. At once introspective and temperamental, a combination becoming to artists, with finely keyed senses, you relish the subtle and can see magnificence in the baroque and the humble alike.

Although you may seem aloof at times, you do not have great powers of decision or consistency. You can be especially polite—to the right people—but sarcastic when your spirit is so moved.

Purple is vanity. A preference for it may be accompanied by an obvious or artful show of display, and the arrangement of situations that will lead others into admiration. Purple types, however, need discipline. If talent comes too easily, they may lean too heavily on endowment and not enough on

The vain cultivated the color purple. He had precious notions about life, but was often more cultured than humane

endurance and perseverance. They have great philosophical powers and are unconventional and tolerant. However, they may be inclined to let problems rest as they are, to acknowledge their own superior intelligence, and then do little with it. If they follow the course of least resistance, they may do so with full knowledge of where they are headed. They are adjustable but not exactly impressionable; that is, they will reconcile themselves to circumstances where others merely give in.

It is distinctly a purple trait to be verbose, grief-stricken and incensed at the sufferings and misfortunes of humanity—and then do nothing about them!

IF YOU ARE THE LAVENDER TYPE

Lavender and old lace bespeak a type of human known to almost everyone. This personality shows unmistakable preference for the color by wearing it in apparel and draping it about the home. Lavender is like a thin stratum running through the vast geology of life. In certain women it has a tint and a whiff of vanity, femininity and aloofness. Such persons are anointed and perfumed; they are presumably never soiled, and all their bodily functions have the delicacy and fragrance of lavender. They dwell in their particular stratum and never notice the heavier, cruder and coarser sedimentary rock around them.

In other women, older as a rule, lavender is the quest for culture and the refined things of life. Here, again, the stratum does not mingle with or cross the mundane and carnal; there is to be no vulgarity, war, strife, vivisection, disease or poverty. There is to be love without sensuousness, gentlemen and ladies without boors, gourmets but no gluttons. There will be a quest for high and noble causes, if only on the pretext of getting nice people together.

Lavender types are civilized, neat, expert in social ways. They surround themselves with quality people, artists and patrons of the arts. They are cultists after a fashion, busy and determined in their efforts to get the right people assembled in the right surroundings. They have an apt wit and on occasion use it sharply to get their way. Some who hunger for culture will be impressed by the lavender personality. And the lavender personality, in all sincerity, may adore and be impressed by true greatness.

IF YOU *LIKE* BROWN

Brown is an earthy color and goes with sound and substantial people. It is the farmer with his plodding, admirable ways, and the delight of poets and philosophers, who may not, however, like the color. With fondness for brown go three chief characteristics: conscientious performance of duty, parsimony and shrewdness with money, and obstinacy of habits and convictions.

Choose brown, therefore, and you are of the earth: substantial, dependable, steady. You are conservative by nature rather than by choice; you just don't like impulsiveness or showiness. There is a sameness, an ageless quality about you which may lead people to say that you never seem to change with the years.

Though not one to take the spotlight, you have very definite views. You may be inarticulate and at times clumsily hurt the feelings of others. You may fear that someone clever will change your opinions, and you don't want them changed. Your brain is slow but sure. It may move heavily, but it does move, and it surmounts most obstacles without much change or damage.

You not only refuse to shirk responsibilities, but you may have a lust for them. People could lend you money and let you handle their affairs with absolute confidence. Where you take to yourself the problems of others, you become more concerned about them than the persons to whom they actually be-

The color of the parsimonious was brown. He was a man who would take but never gave

200

long. A wonderful trait, which others may try to take undue advantage of, this sense of duty is a virtue that almost becomes an obsession.

You know how to strike a good bargain and are an astute horse trader at heart. Yet you refuse to make strenuous physical or mental efforts apart from a routine diligence. You feel reliability is one of humanity's prime virtues and may, innocently, censure the irrational or flighty person simply because you don't understand him, and because it is difficult for you to accommodate yourself to others. As a result, you are cheerfully disliked by some and adored by others.

IF YOU *LIKE* WHITE

Few persons pick the neutrals—white, gray and black—as favorites. Mostly they are second or third choices. There is little emotion in white, gray or black, so reference to them reveals a certain deliberation in which natural impulses have been lost. Choice of white is supposed to denote naiveté and innocence, but these may be assumed. White is, of course, recall to youth and purity, and sophisticates often look on it as childish. Fondness for white probably reveals a trait of simplicity, or a desire for a simple life. White is lovely, decent, virginal but wholly venial. It may inspire a man to avoid seduction unless the woman melts before his virile charms. In a woman it may betray coquetry and temptation.

With white there is a willingness to live, but without excessive gravity. It signifies the unmolded human, the person frankly honest and frankly eager to let the outside world control matters of destiny.

IF YOU *LIKE* GRAY

Gray is an unusual "color." Because of its "neutrality" it is neither limitless like white nor solid and definite like black. It is a mark of caution, a compromise between great extremes, and a search for composure and peace without much expenditure of inner resources or energy. Very few people will say much about gray, either as a shade they like or dislike. Small children don't seem to notice it at all, probably because it lacks emotional quality. Choice of gray is likely to indicate a person who has done a good deal to remake his character, or at least to effect practical and agreeable compromises.

Gray robes are often worn by dedicated people, the color symbolizing a certain renunciation of man's baser qualities but still a willingness to work hard and be of service. There is a turning away from excitement to all that is steady and sure.

Older, mature people like gray most. Perhaps they sense from experience that while red, yellow, green and blue are bright and attractive, gray is the quiet mixture of the entire spectrum. It is life on an even keel—not at top ecstasy or bottom despair—but neatly in the middle.

IF YOU *LIKE* BLACK

A preference for black, though rare, might indicate a morbid and despairing individual. Among the mentally ill it often does, for black is surely the symbol of death, inevitability and nothingness. Yet among normal people, black may be anything but lugubrious. It is a mighty, dignified and stark "color," regal without being pompous and dignified without being officious. Black doesn't "show off" in the slightest; it impresses with real substance and weight. Probably the word *sophistication* best describes the black type. Since its passive quality is exciting, the cultivation of black is therefore arbitrary, if not artificial.

A woman, for example, may wear black at a party to indicate she is neither saint nor sinner, dolt nor luminary. However, she is quite above average, worldly-wise and knows the ways of life (or would have you think so). Such an attitude is in itself indicative of the black type. Those who choose black probably lead a different life in public than in private. The woman who wears black may be striving to symbolize her mystery, real or implied. The man who admires her may accept the black as a fair challenge and see what progress he can make as a squire. Both man and woman may not have as carefree a time as those who like red and orange, nor as intellectual an evening as those who like yellow or blue, but they may have a very good time all the same.

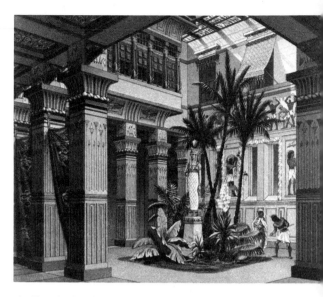

An Egyptian interior as it might have appeared in ancient times. There was great beauty of form and design, but the color choice was restricted

Chapter 20

THE ROLE OF COLOR IN DAILY LIVING

The story of color in interior decoration parallels the greater story of color. Its expression is vigorous in ancient times, becomes gaudy and baroque during the Renaissance, solemn during the Reformation, sophisticated in the days before the French Revolution, classical during Greek and Roman revivals, grandiose during the Victorian era, and is now, in these days of realism, lucid and frank.

DECORATION IN ANCIENT DAYS

The Egyptians used color brilliantly, adhering to the simple hues prescribed by the Mysteries and colors with symbolic meaning. Their colors in decoration had intensity and were often saved from crudeness by judicious use of outlines. There seemed to be a strong attraction to triad arrangements:

Red, yellow, blue
Red, blue, white
Deep red, medium yellow, blue
Deep blue, light blue, white
Blue, buff, black.

Great quantities of textiles were made as far back as 4000 B.C., frequently of white linen with patterned textures in color, probably painted. Wall paintings have left

records of the vivid color schemes used in making embroidery and tapestry.

In Babylon the decorator's palette was more advanced, due to more versatile mediums such as glazed tile. Assyrian tiles have been found in such color schemes as:

Blue-green, yellow-green, orange, brown and white

Blue, yellow, white, deep red and black

Blue, deep yellow, pale yellow and white

Pale yellow, green, blue, red, gold, black and white

Black, yellow, green, red, blue and white

Green, blue-green, yellow, white, deep red and black.

Textiles were usually patterned and generously decorated, with colored fringes and bands—often based on symbolism.

In the Orient, red, yellow and gold have always been predominant. Expression was direct and meaningful. And the same applied to the Oriental rug. George Birdwood wrote: "Whatever their type of ornamentation may be, a deep and complicated symbolism, originating in Babylonia and possibly India, pervades every denomination of oriental carpets. . . . Every color used has its significance." And again: "The very irregularities, either in drawing or coloring . . . are seldom accidental, the usual deliberate intention being to avert the evil eye and insure good luck."

Model showing interior of Greek Parthenon restored. Natural materials were usually coated with paints or adorned with gold

Greeks also used simple hues such as red, yellow, blue and black, this combination the common palette of the fresco painter. Well-preserved textiles, dating back to the 5th century B.C., show traces of vivid pigment; red with black figures; gold with blue; and Tyrian purple. Democratus tells of fabrics in blue-violet, purple and saffron, patterned and trimmed with borders. Others were in apple green, purple and white; dark violet, light violet or hyacinth color; bright red and sea green; and many were embellished with gold tinsel.

In Rome the vigorous palette was as much a part of interior decoration as of all the arts and crafts. Textiles were usually of wool and often dyed blue or red. *An Encyclopaedia of Textiles* states: "During the last centuries before the Christian era the extravagance of Roman garments was such that the import of colored fabrics was repeatedly prohibited. But it was not till during the period of the empire that luxury in dress reached its culmination point when silk was introduced. It was partly imported to Rome as raw silk, partly as finished fabrics (so-called Seric garments), and was worth its weight in gold."

There are excellent records of Pompeian interiors, many solidly painted in black, vermilion, clear blue and terra cotta, and decorated with flowers, figures, animals and elaborate paintings from mythology.

Chinese textile of the early Ching Dynasty. Every use of design and color had meaning. Creative impulses were guided by the dictates of tradition

During the Dark Ages and the prelude to the Gothic, the drab interior and the glories of the stained-glass window were side-by-side contrasts, one ashen, the other brilliant with the luster of color, red and blue most prominent.

THE RENAISSANCE

In the Renaissance there was an eloquence in color to rival the eloquence of Italian sculpture and painting, all supposed to glorify a rebirth of classical pagan ideals. But the practical symbolism of the Greek was forgotten. Art and color were now of the most garish and spectacular kind in history. Most people are familiar with Renaissance styles, the flourish of elaborate decoration and ornament, the use of architecture to set off sculpture and frame painting. Color sense was sophisticated. Florentine decoration was rich with yellow, yellow-orange, blue-green and light, slate blues. 16th and 17th century brocades had such color schemes as yellow-green ornaments on deep violet; light olive green on dark blue—subtle harmonies of a delicacy unknown in former ages. Virtually all subsequent styles of interior decoration derive from ancient and Renaissance principles. In her excellent *Historical Color Guide,* Elizabeth Burris-Meyer describes these period effects and exhibits most of them in actual color swatches.

The period of Louis XV was enthusiasti-

Venetian room at the Metropolitan Museum of Art. Symbolism for color was lost to a purely esthetic and lavish expression

A French interior of the Louis XVI period. There was a blend of Renaissance pretensions with classical formality

cally Renaissance, luxurious in its use of brilliant and refined colors—light blues, violets, odd greens, purples, grays and golds—its sumptuousness probably influenced by the Marquise de Pompadour, whose own favorite color was rose.

The Louis XVI style goes back to simpler classical ideals in design and color. Under Marie Antoinette's influence, colors were delicate and affected, and under the influence of the eminent painter David, there was extreme severity and formality.

The French Empire style was, to a large extent, inspired by Napoleon's visits to Italy. Napoleon himself showed preferences for red, green, white and gold, and Josephine for the more delicate tints of blue, violet, purple and tan.

ENGLISH AND COLONIAL STYLES

The English periods were more temperate. Georgian style was largely Roman and Pompeian, though more reserved. The Adam style was directly Pompeian. Josiah Wedgwood's classical Greek ceramics were simple in color, severe and pure in tradition. Adam, however, introduced less primary hues—soft blue, pale yellow, lilac, delicate gray, blue-green, yellow-green and pink. The craftsmanship of Chippendale, Hepplewhite and Sheraton also emphasized the subtle beauty of wood tones which were coordinated with interior schemes.

The Victorian style is flamboyant. Colors were generally low key: browns, purplish reds and deep greens. The wide use of purples and magentas has distinguished that era as the "Mauve Decade."

In America the Colonial style had its own individuality. The most common hue in the 17th and early 18th centuries was a dark red called Spanish Brown, made from a pigment dug out of the earth. Nearly always used for the priming coat on a house's exterior, it was often the only paint applied. In 1769 John Gore of Boston advertised: "Very good red, black, yellow paints, the produce and manu-

Robert Adam sought a return to the classical ideals and simplicity of color found in ancient Greece and Rome

An American interior showing the English influences. The scale was small, neat, elegant, and the colors were subtle and refined

An interior of the early Victorian period, 1830-48. There was an abundance of ornament and a heavy use of color

facture of North America." White today is perhaps overemphasized in Colonial revivals, although it did have its vogue in the late 18th century. Generally, Colonists preferred deeper, more intense hues and applied those elementary colors with a simplicity and candor that befitted their architecture.

UNIVERSAL
COLOR PREFERENCES

Personal preferences are always important in application of color. Historically, red, yellow, green and blue seem to be the most universally appealing colors. Are these predilections eternal? Are they able to embrace peoples of all ages, creeds, races, beliefs and nationalities? In purely abstract choice—color for the sake of color—a fairly stable order for all humanity is found. Infants develop color awareness at a very early age. In testing a baby, one procedure is to present several similar objects in different colors and

to note in the movement of the infant's eyes how long each color fixes his attention. Red, yellow, orange and white have been found to head the list.

Long wavelength colors seem to hold most attraction for the child. In very early years red is almost always sure to stand in first place. Yellow will also be liked enthusiastically. Yet after infancy, preferences shift toward hues of shorter wavelength, toward green, violet and most notably blue. And yellow begins to slide down to the bottom of the heap. To account for this general preference for blue among older people, one authority has suggested that it might be because the fluids of the eye become yellowish with age. This may tend to "wash out" the intensity of warmer hues and strengthen the depth of blue colors through direct complementation.

In any event, it is apparent that man has an instinctive love of the two extremes of the spectrum, red and blue, with popularity pretty much neck-and-neck. Infants seem to prefer red up to about their second year;

Late Victorian, about 1885, from the home of John D. Rockefeller. Color is everywhere, with hardly a square inch left unadorned. Restored by Museum of the City of New York. Gottscho-Schleisner photo

then they are likely to prefer blue. Yellow will delight the child, while green will have little appeal. Children in kindergartens pick blue, red and yellow, but college students pick blue, red and green. Yellow decreases in popularity with age, while green increases, although it never seems to head the list. This basic love of red and blue prevails even when children are asked to state their preferences from memory. Very young children will, in handling paints, be quite impulsive. The older they grow, the more they think of color in terms of representation. The tot will not hesitate to draw an apple, face or tree with any crayon that strikes his fancy. His older sister or brother will not be so uninhibited.

American Indians glory in red, blue and violet, and are least fond of green, orange and yellow. The Negro's color predilections are like those of other races, with blue and red ranking highest. Even among primitive peoples and the insane, the love of blue and red holds true. Dr. S. E. Katz of the New York State Psychiatric Institute and Hospital states that mental patients generally prefer blue, with green as a second choice, red third, then purple, yellow and orange. Green is liked best by male inmates, red by female. Warm hues appeal most to morbid patients and cool hues to hysterical ones.

ELEMENTS OF BEAUTY

As far as the art of color is concerned, now that color theory has reached an advanced stage of development its simple elements of appeal may be listed in a few sentences.

1. Primitively, the eye is drawn to unique hues: red, yellow green, blue, white, black. It prefers pure colors to modified colors.

2. A very recent discovery is that the eye prefers lucid form in color to indefinite form; because the eye distinguishes seven forms in the world of color, it tends to prefer precise form. A pure red, for example, will be pleasing. Yet, when mixed with a *little* white, it may appear faded and insipid—a weak form of a pure hue. When enough white is added to change it definitely to pink, however, its appeal is restored: the color has shifted from a pure hue to a precise tint.

A little black makes orange dirty and ugly. Enough black will move it from pure hue to a rich shade of brown. Newspaper stock is uncomely because it is neither clear white nor a clear gray. Borderline colors of any sort are usually disliked. To strike the fancy, color must have real character; extremely pure, bright or deep colors, or clear tints, shades, grays and tones unmistakably identified attract people.

3. The emotional quality of any color will differ as its forms differ. Ordinarily, primary hues are vigorous and impulsive. Secondary hues are more refined and perhaps easier to live with. Yet tints differ from shades or tones. Consequently, personality is as much influenced by form as by color.

4. The red, orange, yellow region of the spectrum is warm. The green, blue, violet region is cool. Warm hues generally make the most pleasing shaded colors. Cool hues make the best tinted colors.

5. In the harmony of pure hues, all look well with black and white. Combinations in which analogy exists seem to relate to emotions. Dominantly warm and dominantly cool schemes inspire radically different *feelings*. Combinations based on contrast seem to relate more to vision. Red with green and yellow with blue thrill the eye; but deep emotional qualities are lost because the warmth of one hue cancels the coolness of the other, to the detriment of both.

6. Apparently, true colors accord best when they are either similar or almost wholly unalike. J. P. Guilford writes, "There is some evidence that either very small or very large differences in hue give more pleasing results than do medium differences. This tendency is much stronger for women than for men." In short, schemes involving monochromatic or adjacent colors, or schemes involving opposites, are superior to others.[28]

7. In the harmony of color forms, pure hues combine well with tints and white; pure hues with shades and black; white with gray and black; white with tone and shade; tint with tone and black; pure hue with tone and gray—all these arrangements respect natural laws of analogy. They look right because they arrange colors in terms of sensation and seem to gratify the emotions.

8. The most neutral of all forms is a tone, not gray. Because a toned color contains pure hue, white and black, it naturally accords with all these primaries—and also with tint, gray and shade.

COLOR AND MOOD

What emotional significance do the colors of the spectrum have? What do men think of them, and how do they affect men's moods?

In the main, colors can be associated with two moods: the warm, active and exciting qualities of red and its analogous hues; and the cool, passive and calming qualities of blue, violet and green. Areas of these hues tend to enliven moods or quiet them. Likewise, light colors are active, deep colors passive. Beyond the feeling of warmth or coolness, brightness or dimness, the exact choice of a hue or tone is optional, its pleasure or displeasure depending on individual predilections.

Pure colors, however, are likely to be severe, and too much "harping" on any one color may prove distressing.

Even more pronounced in affecting "moods" are chromatic lights, greens and yellows that turn the lips black and give the flesh a cadaver-like aspect, and make the mere sight of a person's face revolting. Green light has been thrown on criminals in a mirrored room to help force a confession.

A few psychologists have tried to determine the moods people associate with various colors. N. A. Wells found that deep orange has the most exciting influence, then scarlet and yellow-orange. The most tranquilizing color is yellow-green, then green. Violet has the most subduing influence, purple next.

Dr. Robert R. Ross of Stanford University has allied colors with dramatic intensity and emotion. Gray, blue and purple are best associated with tragedy; red, orange and yellow with comedy. William A. Wellmann of California has also worked out a "theatrical" palette: red is the color of vigor; yellow, the color of warmth and joy; green, of abundance and health; blue, of spirituality and thought; brown, of melancholy; gray, of old age; white, of zest and awareness; and black, of gloom.

PRACTICAL APPLICATIONS

One of the elementary functional applications of color today is the purely physical control of light. Sunlight contains heat which travels through space but does not get "hot," so to speak, until it comes in contact with material substance, dense atmosphere or structural bodies. Man has known these facts for centuries. White clothing in the tropics, deep colors in the Arctic regions, are an old part of human costume. The coldest days on record are always sunny days, because the clarity of the atmosphere allows the heat to penetrate into the ground and so fail to form a blanket of warm air over the earth. On a mountain, people are able to skate or ski virtually in the nude, even with the thermometer near zero. Because the air is clear, the sun's rays are able to strike their bodies and be converted into heat.

Heat is efficiently controlled through use of color: black absorbs it; white casts it off. A wide black stripe painted on the ice of a New England harbor converts the thermal rays of sun into heat, melts the ice and opens the harbor to traffic far ahead of nature's normal schedule. Sailing in tropical climates, white ships will be at least ten degrees cooler on the inside than black ships.

Such strategies are numerous. In raising chicks, red light has been used to get maximum production. Cannibalism, brought about by the sight of blood, either when the pin feathers push through the skin or when one chick pecks at another, is minimized when red light (red goggles on some farms) neutralizes the hue of the blood and quells the chick's sanguinary tendencies.

George W. Hartmann has found that the seeing ability of one eye may be increased by strongly illuminating the other eye. Vision operates most efficiently under good light, and even illumination of one eye will help the other. What kind of light is the best? Many authorities argue that the eye is more efficient under yellow light than under white. The best evidence, however, supports white as better illumination than yellow or yellowish green. Seeing is handicapped when illumination is deeply hued with pure red or blue. An environment is most pleasant when its true colors seem normal and undistorted by chromatic light. Ideal lighting conditions exist when illumination is appropriately strong at every point and in almost every plane, when light sources and deep shadows are eliminated, when glare is absent and when adaptive optical changes are not demanded.

The colors most visible in light are red first, then green, yellow, white, blue and purple. Visibility depends largely on the attraction any light source will have for the eye. Although white and yellow light travel

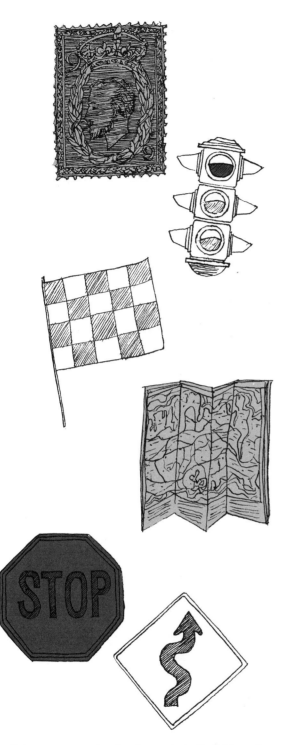

Color serves many functional uses—in traffic lights, postage stamps, maps, flags, road signs. It is easy to recognize

further in distance, they are not so quickly recognized as red or green.

In legibility of colors, black on yellow holds first place, then green on white, red on white, blue on white and black on white. In strong illumination light colors on dark are superior; in dim illumination the light background seems essential, with dark characters clearly contrasted on it. Visibility depends almost entirely on contrast, with yellow superior to white as a background because it produces less blur and compels attention. For books and magazines the combination is inferior to black on white, however, because of the disturbing after-image produced by yellow.

Identification by color has led to countless uses. Traffic signals are red, yellow and green as tokens of danger, caution and safety. In the railroad industry red means stop, yellow to proceed with caution and at reduced speed, and green that the track is clear. A green and white signal is used to stop a train only at flag stations on its schedule. Blue warns that workmen are about or under an engine, car or train. Purple is a so-called dwarf signal and means to stop.

On maps, filing systems, postage stamps, billiard balls and targets, simple colors add efficiency and meaning.

In automobile racing, green is the starting signal. A white flag means to stop for consultation, a red flag to come to a complete stop. The yellow flag calls for caution. An orange flag with a blue center indicates that one car is attempting to pass another. The "King's" blue flag marks the last lap, and the familiar black and white checkered flag, the finish. There are similar flags in yacht contests and air races.

On sea and shore the Coast Guard uses white as a symbol of fair weather, blue for rain or snow, a white flag with a square black center for a cold wave, a red flag with black center to warn of a storm or hurricane. Wind directions are indicated by combining the storm flag with a red or white pennant placed above or below. A black pennant refers to temperature. Placed above the weather flag, it means warmer weather is in store; placed below, it means colder. There is also the international code of flags and pennants used to identify the letters of the alphabet, numbers and, in various combinations, matters of inquiry, direction and distress. These are recognized throughout the

world. Floating in the breeze, they give information to those who understand them—and a thrill of color to everyone.

THE SUMMING UP

The scientist is said to be a man who learns more and more about less and less, while the philosopher learns less and less about more and more. Somewhere between is the true artist, who neither lets himself be limited by fussy detail nor overwhelmed by sweeping generalizations.

The general study of color is a conglomeration of the mysteries, traditions, customs, religion, healing, and all branches of the arts and sciences. Into it goes man's primitive conception of the universe, the colors of the elements and those of the planets. Next follow the haloes of saints, the green turban of the Mohammedan, the yellow robes of the Oriental priest, the veils of the Jewish tabernacle, the canonical vestments of the Catholic priest, the castes of India and China, the arms of heraldry, flags and emblems and auric emanations, words and metaphors. Then come the palettes of the artist, the materials of the sculptor and architect, the colored scales of the musician.

Thousands of amulets and charms, the retorts of alchemy, medicines, lamps and filters are included. And of late, science has added its prisms and spectroscopes, the color circles and solids of countless theorists, as well as the eyes and images and all that the psychologist, physicist, chemist, engineer, artist and decorator have propounded.

Today, man finds the same colored ambrosia and nectar which have always been the food of the gods—four morsels; one red, one yellow, one green, one blue; steeped in the juices of purple, white and black. If there is a deep, abiding law of color, it is brewed of these simple, forever appealing hues.

Here are the international code flags and pennants, with corresponding letters of the alphabet and numbers. Red, yellow, blue, white and black are the colors used

NOTES

1. Page 16: from "The Education of Svetaketu," in Chhandogga Upanishad, *Prapathaka* VI.

2. Page 17: from *The Works of Aristotle,* translated by W. D. Ross, Clarendon Press, Oxford, 1913.

3. Page 18: A translation of Buddhaghosha's *Visuddhimagga* by Pe Maung Tin. Oxford University Press, London, 1922.

4. Page 22: from *The Buddha-Charita,* Book XIII, *The Sacred Books of the East,* edited by F. Max Müller. Clarendon Press, Oxford, 1894.

5. Page 23: from *Shrichakrasambhara Tantra,* edited by Kazi Darva-Samdup, being Vol. VII of *Tantrik Texts,* under general editorship of Arthur Avalon. Luzac & Co., London, 1919.

6. Page 27: from James Fergusson's *Anacalypsis.*

7. Page 44: Richard Payne Knight, *The Symbolic Language of Ancient Art and Mythology,* J. W. Bouton, New York, 1876.

8. Page 48: from Boutell's *Manual of Heraldry,* Frederick Warne & Co., London, 1931.

9. Page 56: *Celsus on Medicine,* C. Cox, London, 1831.

10. Page 57: O. Cameron Gruner, *A Treatise on the Canon of Medicine of Avicenna,* Luzac & Co., London, 1930.

11. Page 90: A. C. Krause's article, "The Photochemistry of Visual Purple," in the symposium, *Visual Mechanisms,* Cattell & Co., Lancaster, Pa., 1942.

12. Page 90: George Wald, an article "Visual System and the Vitamins," ibid.

13. Page 104: Heinrich Klüver's article in the symposium, *Visual Mechanisms,* ibid.

14. Page 123: Dr. C.S. Myers' article, "Individual Differences in Listening to Music," in the British *Journal of Psychology,* Vol. 13.54.

15. Page 151: Selig Hecht, in an article in the *Journal of the Optical Society of America,* Vol. 21, No. 10, October 1931, titled "The Interrelation of Various Aspects of Color Vision."

16. Page 173: B. D. Prescott in "The Psychological Analysis of Light and Color," Occupational Therapy and Rehabilitation, June 1942.

17. Page 175: Kurt Goldstein, "Some Experimental Observations Concerning the Influence of Color on the Function of the Organism," Occupational Therapy and Rehabilitation, June 1942.

18. Page 176: Josephine M. Smith, "The Relative Brightness Values of Three Hues for Newborn Babies," Univ. Iowa Stud. Infant Behavior III, 1936, 12:1.

19. Page 177: Felix Deutsch, "Psycho-Physical Reactions of the Vascular System to Influence of Light and to Impressions Gained through Light," Folia Clinica Orientalia, Vol. I, Fascicle 3 and 4, 1937.

20. Page 185: *Goethe's Theory of Colours,* translated by Charles Lock Eastlake, John Murray, London, 1840.

21. Page 185: Wassily Kandinsky, *The Art of Spiritual Harmony,* London, 1930.

22. Page 186: Maria Rickers-Ovsiankina, "Some Theoretical Considerations Regarding the Rorschach Method," Rorschach Research Exchange, April, 1943.

23. Page 187: B. J. Kouwer, *Colors and Their Character,* Martinus Nijhoff, The Hague, 1949.

24. Page 187: E. R. Jaensch, *Eidetic Imagery,* London, 1930.

25. Page 188: Bruno Klopfer and Douglas Kelley. *The Rorschach Technique,* World Book Co., Yonkers, N. Y., 1946.

26. Page 188: E. O. Fromm and H. W. Brosin, ''Rorschach and Color Blindness,'' Rorschach Research Exchange, April, 1940.

27. Page 190: Eric P. Mosse, ''Color Therapy,'' Occupational Therapy and Rehabilitation, February, 1942.

28. Page 209: J. P. Guilford, ''The Affective Value of Color as a Function of Hue,'' Journal of Experimental Psychology, June, 1934.

PICTURE CREDITS

The author is grateful for the help extended to him in the collection of illustrations. In some isolated cases, credit is given in the picture legend. Otherwise, repetitious acknowledgments have not been made out of consideration to the reader. However, full credit is warranted and is given herewith. Major help has been extended by the Metropolitan Museum of Art, the American Museum of Natural History and the Picture Collection of the New York Public Library.

For convenience, the following acknowledgments and credits are presented for each chapter. Where no reference is found, the reader may assume that the illustration came from the author's collection or was specially prepared for this book.

1. OF MAN AND THE EARTH ABOUT HIM. The prehistoric drawing (10), American Indian (15), Indian sand painting (15) are from the American Museum of Natural History. The Babylonian Cylinder (12) is from the Metropolitan Museum of Art. The engraving of Pythagoras (16) is from the Picture Collection of the New York Public Library.

2. COLOR AND THE GODS OF THE UNIVERSE. The Assyrian Winged Bull (20), the statue of Brahma (21) and the Buddhistic painting (22) are from the Metropolitan Museum of Art. The Temple at Karnak (21) is from the American Museum of Natural History. The Chinese painting of the seventh century (23) is from the Art Institute of Chicago. The Indian temple (22), the portrait of Confucius (24) and Mohammed (25) are from the Picture Collection of the New York Public Library.

3. TOWARD THE RELIGIONS OF THE WEST. The Tower of Babel (27), the Druid temple (32), the Tabernacle in the Wilderness (33), the 1487 concept of God (33), the engraving of heaven and hell (34), the Hebrew priest (34), Noah's Ark (34) and the portrait of Swedenborg (38) are from the Picture Collection of the New York Public Library. The signs of the Chinese zodiac (28), the northern constellation (31) and the symbol of the rainbow god (33) are from the American Museum of Natural History. The two Persian drawings (28) are from the Metropolitan Museum of Art.

4. OF CULTURE, TRADITION AND SUPERSTITION. The Egyptian wall painting (40), the painting of the Chinese emperor (44), the Egyptian coffins (46) are from the Metropolitan Museum of Art. The American Indian (42) and the painted Africans (44) are from the American Museum of Natural History. The engraving of human sacrifice (42), the sacrificial rites of Bacchus (42), the Jewish marriage rite (45), the birds, fishes and crosses of heraldry (47) are from the Picture Collection of the New York Public Library. The Egyptian cat (43) is from the Art Institute of Chicago.

5. THE SACRED ART OF HEALING. The shaman (51) is from the American Museum of Natural History. The engraving of Hermes (55), and Paracelsus (59) are from the Picture Collection of the New York Public Library. The column from the Papyrus Ebers (56) and the handbill of the quack doctor (60) are from the New York Academy of Medicine. The Peter Breughel engravings (58) are from the Metropolitan Museum of Art.

6. THE EARLY QUANDARIES OF SCIENCE. The Zoroastrian priest (67), Hermetic conversation (70), portrait of Goethe (72) and Schopenhauer (74) are from the Picture Collection of the New York Public Library. The universe as conceived by Ptolemy (68) is from the American Museum of Natural History. The well-dressed philosopher (70) is from Descarte's Dioptrices, 1677. The diagram and color circle from Newton (71) are from his Optice, 1706.

7. THE MODERN CONCEPTIONS OF SCIENCE. Engraving of the French Academy of Science (75) is from the Picture Collection of the New York Public Library.

8. THE WONDERS OF HUMAN VISION. The woodcut of the human eye (85) is from the Picture Collection of the New York Public Library. The enlarged view of the house fly (91) is from the American Museum of Natural History.

9. THE HUMAN SIDE OF SENSATION. The ancient symbol of the universe (99) is from the Picture Collection of the New York Public Library.

10. MYSTERIES OF THE HUMAN AURA. The engraving of Apollo (106) is from the Bettman Archive. The Belgian tapestry (106) is from the Metropolitan Museum of Art. The engraving of Christ (109) and the old 1537 engraving (110) are from the Picture Collection of the New York Public Library.

11. THE LANGUAGE OF THE SPECTRUM. The Blake etching (118) is from the Metropolitan Museum of Art. The Chinese Dancers (120) is from the American Museum of Natural History.

13. COLOR IN THE ART OF PAINTING. The painting from the school of Pesellino (130), the paintings of Titian (131), Rubens (131), Rembrandt (132), Vermeer (132), Velasquez (133), El Greco (133), Reynolds (133), Courbet (134), Manet (134), Pissarro (135), Delacroix (135), Monet (136), Renoir (136), Signac (137), Van Gogh (137), Cézanne (138) are from the Metropolitan Museum of Art. The paintings of Derain (139), Vlaminck (139) and Matisse (140) are from the Collection, Museum of Modern Art.

14. COLOR THEORY—ORDER OUT OF CHAOS. The Egyptian paint box (141) is from the Metropolitan Museum of Art.

15. NATURE'S ART OF COLOR. The picture of the Giant Stick (156), chameleon (157), luminous fish (158), peacock (159), Mallard Duck (159), butterfly (159), shell (160), hippopotamus (161), Murex (161) and cuttlefish 161 are from the American Museum of Natural History. The engraving of fish (156) is from the Picture Collection of the New York Public Library.

16. PLANTS, INSECTS, BIRDS AND BEASTS. The enlarged head of the honeybee (170) is from the American Museum of Natural History.

17. REACTIONS OF THE HUMAN BODY. The Amoeba (175) and blind salamander (182) are from the American Museum of Natural History.

18. REACTIONS OF MIND AND EMOTION. The Kandinsky Abstraction (184) is from the Collection, Museum of Modern Art.

19. THE PERSONAL SIDE OF COLOR PREFERENCE. The Prophet of St. Paul's (192) and the fortune teller (193) are from the Picture Collection of the New York Public Library.

20. THE ROLE OF COLOR IN DAILY LIVING. The Egyptian interior (202) is from the Picture Collection of the New York Public Library. The Chinese textile (203), model of Parthenon (203), Venetian room (204), French interior (205), Adam interior (206), American interior (206) and Victorian interior (207) are from the Metropolitan Museum of Art.

INDEX

International code flags and pennants, 211, Illus., 212
Introversion, 187-188
Inverted image in vision, 86, Illus., 85
Invisible colors, 170
Iris (of eye), 86
Iris, goddess of the rainbow, 32
ISAIAH, 35
Isis, 20, Illus., 20
IVES, HERBERT, 144

J

Jade, 41, 54
JAENSCH, E. R., 103, 187
JAMES, WILLIAM, 105
JAMESON, D. D., 125
Japan, religion, 24; superstitions, 24
Jet, 41, 54
Jewish persecution, yellow as symbol, 44, Illus., 119
Jewish rites, 33-35
Jewish traditions, 46
JOHNSTON, EARL S., 164
JONES, JOHN PAUL, 50
JOSEPHINE, wife of Napoleon, 205
JOSEPHUS, 17, 35, 161
JUDD, DEANE B., 93, 171

K

Kabbalah, The, 35-36, Illus., 36
Kan, in Mexican myth, 41
KANDINSKY, WASSILY, 139, 185, 189, 190; abstraction, Illus., 184; color movement, 185; Illus., 185
Karnak, temple of, Illus., 21
KARWOSKI, THEODORE F., 128, Illus., 128
Kasinas, meaning of colors in, 22, 23
KATZ, S. E., 209
KEATS, JOHN, 118
Keblah, 25
KELLER, HELEN, 102, 190-191
KELLEY, DOUGLAS, 188
Kether, 36
KEY, FRANCIS SCOTT, 50
Keys, color-music analogies, 122-123
KILNER, WALTER J., 111
King Arthur cycle, 37
KLEIN, A. B., 121-122, 126
KLOPFER, BRUNO, 188
KLÜVER, HEINRICH, 104
KNIGHT, RICHARD PAYNE, 44
Knights of the Holy Grail, 37
Koran, 24-25
KOUWER, B. J., 187
KRAUSE, A. C., 90

L

Ladd-Franklin theory of color evolution, 93
LAMBERT, J. H., 147
Lancastrians, 48
Language of spectrum, 113-120; colloquial speech, 119-120; in literature, 116-118; root words, 113-114; sources, 114-116
Lavender, related to personality traits, 200
Laws of simultaneous contrasts, 148
LEADBEATER, C. W., 107
Le BLON, J. C., 143-144, Illus., 143
Legibility of color, 211
LEO, ALAN, 124
Leprosy, color diagnosis, 180
Lie detector, Illus., 176
Light, art of, Illus., 127; as color, 159-161; diseases caused by, 174-175; effect on body functions, 177-179; effect on plants, 163-168, Illus., 165, 166, 167; importance in plant and animal growth, 163-175; non-visual reaction to, 169; primaries, 83, Illus., 83; refraction, in Newton's diagram,

71, Illus., 71; relation to egg-laying, 169; types, 83; vision in, 95-96
Light diffraction, related to color, 160, Illus., 159, 160
Lighting, most efficient use of color in, 210
Light phenomena, theories of da Vinci, 141-142, Illus., 142
Light scattering, 160
Light sensitivity, in animals, 168-173; in human beings, 174-175; in insects, 169-171; in plants, 163-168
LIND, E. G., 126, 128
Literature, color references in, 116-120
LODGE, SIR OLIVER, 109
LOUIS XIV, Illus., 75
LOUIS XV, decoration in period of, 204-205
LOUIS XVI, decoration in period of, 205
Lucifer, 37
Lumia, art of light, 127, Illus., 127
Luminescence, 157-159; in animal life, 158-159; in fishes, Illus., 158
LUTZ, FRANK E., 170

M

MAIER, N. R. F., 169
Mallard duck, Illus., 159
Mammals, reaction to color, 173
Man, ideal proportions according to da Vinci, Illus., 65
Mandrake, 52-52, Illus., 52
MANET, 134, Illus., 134
Manic-depressive patient, reaction to color, 188, 190, Illus., 189
Mara, 22
Marduk, 39
Maroon, in relation to personality, 195
Marriage and fertility rites, 45; Jewish, 45, Illus., 45
MAST, S. O., 172
MATISSE, 139, Illus., 140
MATTHEWS, WASHINGTON, 117
Mauve, discovery, 162
"Mauve Decade," 120, 205
MAXWELL, JAMES CLERK, 98, 144-145
MAYER, TOBIAS, 146-147
Meaning of color, astral hues, 107-109
Mecca, 25
Medicine, 51-63; ancient Egypt, Illus., 56; Paracelsus, 59, 109-110, Illus., 59; quackery, 54, Illus., 58, 59, 62; sixteenth-century hospital, Illus., 59. See also Healing.
MEIJER, G., 166
Melanin, 160
MELANTHIUS, 129
Melody related to color, 125
Mental disease, color reactions, 183, 188-190
Mexico, gods, 41, 42, Illus., 41
MICHELANGELO, 130
Microcosm, man as, 36
Middle Ages, conception of universe, Illus., 18
Migration of birds, 169, 173
Mineral colors, 161
Mitre, sacred in Jewish rites, 35
Miyakko, 24
Mobile color, 128
Modes of appearance, 98-101, Illus., 101
MOHAMMED, 24, Illus., 25
MOLITOR, H., 170
MONET, 136, Illus., 136
Moonstone, 41
MOSES, 35
Moslem religion, colors in, 25
Moslem shrine, Illus., 25
Moslem temples, emanations from, 109-110
Mosquitoes, color preferences, 171
MOSSE, ERIC P., 188-190
Mother of pearl, 160, Illus., 160

Mother's Day, 50
Mourning colors, 46
Müller theory of vision, 93
MUNSELL, ALBERT H., 146, 148-149; color circle, Illus., 145-148; color solid, Illus., 149
Murex shellfish, 55, 161, Illus. 161
Music, 121-128; color music, 123; color organs, 124-127; effect of in astral space, 128, synesthesia, 121-123
Musical compositions, color related to, 122-124
Musical instruments, sound of related to color, 122
Musical scales, related to color, 123-124, Illus., 126
Music composers, works of related to color, 122-123
Mysteries, 13; Greek, 16
Mythology, American Indian, 13, 14; China, 14, 17; Egypt, 13; Mexico, 41-42

N

Names of colors, 113-120, Illus., 115; derived from other sources, 114-115; history, 113-120. See also Color, Language of color.
NAPOLEON, 205
Narcissism, 190
Nature's art of color, 155-178
Nature-spirits of Paracelsus, 109
Navaho legend, 15
Nebuchadnezzar, temple of, 27
Neo-impressionism, 136
NERO, 44
Nether world, in Indian lore, 15
Neurosis, revealed in color, 188
New Jerusalem, 37
New Testament, colors mentioned in, 37
NEWTON, ISAAC, 70-72, 124, 143; color circle, Illus., 71; color particles, Illus., 97; diagram of observations, Illus., 71, spectrum, Illus., 125
NICHOMACHUS, 129
Night blindness, in World War II armed forces, 96
Night vision, 95-96; affected by eye color, 96; characteristics, 96; effects of vitamin deficiency, 96; Negroes, 96; night blindness, 96; red illumination most efficient, 96
Nimbus, 36, 37, 105-106, Illus., 106
Noah's ark, 35
Non-chemical colors, 159-160
Non-objective motion picture, 127, Illus., 128
Non-objective painting, 185, Illus., 184

O

Oceanic animals, 155-158, 171-172
ODBERT, HENRY S., 128, Illus., 128
Odic light, five forms, 108-109
Odyssey, 32, 113, 116
Opal, 41, 54
Optical system of human eye, 86-92
Orange, related to personality traits, 195-196
Oregon, arms of, 49
Orient, predominance of red, gold, yellow in art of, 203; religions, 19-25; use of color in decoration, 202
Orphism, 139
Osiris, 20, Illus., 20
Osler's disease, color diagnosis, 180
OSTWALD, WILLIAM, 145, 146, 150-151; color circle, 145, Illus., 145; color solids, 150-151, Illus., 150
OTT, JOHN, 168-169
Oxygen, relation to vision, 95

P

Painting, 129-140; abstract, 139; Ce-

8/12/9